The World Underfoot

The World Underfoot

Mosaics and Metaphor in the Greek Symposium

HALLIE M. FRANKS

OXFORD
UNIVERSITY PRESS

OXFORD
UNIVERSITY PRESS

Oxford University Press is a department of the University of Oxford. It furthers
the University's objective of excellence in research, scholarship, and education
by publishing worldwide. Oxford is a registered trade mark of Oxford University
Press in the UK and certain other countries.

Published in the United States of America by Oxford University Press
198 Madison Avenue, New York, NY 10016, United States of America.

© Oxford University Press 2018

Library of Congress Cataloging-in-Publication Data
Franks, Hallie M.
The world underfoot : mosaics and metaphor in the Greek symposium / Hallie M. Franks.
New York : Oxford University Press, 2018.
Includes bibliographical references and index.
LCCN 2017054087 (print) | LCCN 2017056728 (ebook) | ISBN 9780190863173 (updf) |
ISBN 9780190863180 (epub) | ISBN 9780190863197 (online content) |
ISBN 9780190863166 (hardcover)
LCSH: Mosaic floors—Greece—Themes, motives. |
Symposium (Classical Greek drinking party) | Metaphor in art. |
Art and society—Greece—History—To 1500.
LCC NA3765 (ebook) | LCC NA3765 .F73 2018 (print) |
DDC 720.938–dc23

9 8 7 6 5 4 3 2 1

Printed by Sheridan Books, Inc., United States of America

Contents

List of Illustrations

Acknowledgments

AS IS THE case with any book project, this one was possible only through the support of many friends and colleagues. I extend my deep thanks and appreciation to each and every one. I am especially grateful to have known the creativity, intellect, and generosity of my mentors, Gloria Ferrari, Irene Winter, and Carmen Arnold-Biucchi. I think of them more often and rely on them more heavily than they could possibly know, and they each continue to inspire and guide me in ways that I will never be able to express.

I am thankful, too, for those who offered challenges, questions, ideas, and inspiration. Kathryn Topper's work has been crucial to my own thinking, and this manuscript is far stronger for her many thoughtful and candid comments, as well as her enthusiasm. Melissa Eppihimer, Lisa Goldfarb, Laura Hutchison, Fiona Kidd, Theodora Kopestonsky, Kenneth D. S. Lapatin, Dimitri Nakassis, Nikos Manousakis, John Oakley, Robert Pitt, Lana Radloff, Betsey Robinson, Dylan Rogers, Andrew Romig, Alan Shapiro, Anna Sitz, Laura Slatkin, Matthew Stanley, Andrew Stewart, Barbara Tsakirgis, and Angela Ziskowski all offered comments, guidance, or encouragement along the way. And I send special gratitude and love to Emily S. K. Anderson. With the help of many glasses of wine and many plates of cookies, our conversations have traversed the world and some four thousand years.

Special thanks and appreciation go to those who generously shared their own work, granted me access to material, and sometimes went far out of their way to help me acquire images and photographs. The assistance of Erifili Kaninia, Veronika Scheibelreiter-Gail, and Thierry Theurillat was indispensable. Dimitra Aktseli, Spiros Vasilieiou, and their team at Olynthos made a productive research trip into a fond memory. Dieter Salzmann kindly shared his reconstruction of the Sikyon mosaic. I owe further gratitude to Samuel Holzmann for his 3-D imaging expertise, Rebecca Levitan for her beautiful

illustration of the Eretria Skylla, and Matilde Grimaldi for her incredible talent and responsiveness.

I frequently have cause to remember how fortunate I am to be surrounded by my creative, thoughtful, individualized colleagues at The Gallatin School. I especially thank Susanne Wofford and Millery Polyné for their support.

The groundwork for this project was laid while I was a Visiting Research Scholar at the Institute for the Study of the Ancient World in 2012–2013, and I completed the manuscript while a National Endowment for the Humanities Fellow at The American School of Classical Studies at Athens in 2015–2016. Any views, findings, conclusions, or recommendations expressed in this publication do not necessarily reflect those of the National Endowment for the Humanities, the Institute for the Study of the Ancient World, or the American School. The support of the ASCSA has been especially critical to the completion of this project, and I thank Ioanna Damanaki, Dimitra Minaoglou, Nicholas Blackwell, Dylan Rogers, and Jim Wright for their gracious assistance and support.

I am also grateful to all at Oxford University Press who ushered this work through the publication process. The two anonymous reviewers for OUP provided new avenues for thinking as well as guidance that improved the final manuscript. Karen Donohue's careful and insightful help with the manuscript was invaluable.

It is risky to begin thanking those who contributed to a project like this in less tangible ways, since important someones will undoubtedly be left out. Even so, I mention some of the most important people who supported it indirectly, probably unknowingly, through their friendship, good humor, and occasional ass-kickings. Mama, Sara, Rachel, Randy—I love you all.

The World Underfoot

Introduction

He grew according to his father's design in the fragrant cave, numbered among the immortals. After the goddesses had raised him, god of much song, he took to going about the wooded valleys, wreathed with ivy and bay; the nymphs would follow along as he led, and the noise of the revel pervaded the boundless woodland.[1]

THUS *HOMERIC HYMN* 26 (5–10) describes Dionysos, the god who gifted the world with wine—a delight and a poison to mankind, an elixir that brings men joy and, in turn, drives them to madness. It is in the same spirit, wreathed and leading the revel, that Dionysos appears in a mosaic from the Villa of Good Fortune at Olynthos (figure I.1). He drives a chariot (figure I.2); rearing panthers, forepaws outstretched, are his steeds. Maenads surround him, their heads thrown back and arms raised in ecstatic dance to the rhythms of tympana and Pan's pipes (figure 3.7). Eros flies before him, and a satyr runs ahead, as if to announce his coming. This Dionysos, riding confidently with his retinue, decorates the floor of the villa's andron, the room where citizen men gathered for the symposium, during which they drank wine together and entertained one another with conversation and contests. Here, in this andron, the god is not only symbolically present in the spirit of the wine and as the patron of the symposium; he is also present visually, at the physical center of the space. As one enters this realm of Dionysos, he is a witness to the spectacle of the god.

The Villa of Good Fortune mosaic is one of dozens of surviving pebble floor mosaics from such rooms in Greek houses, primarily dating from the late fifth to the mid-third centuries BCE.[2] Some, like this one, offer complex figural scenes, while others feature geometric or floral patterns, or animals.

1. Trans. West 2003 (LCL 496). Translations from the Loeb Classical Library are designated here with LCL and the library volume number.

2. All dates are BCE unless otherwise indicated.

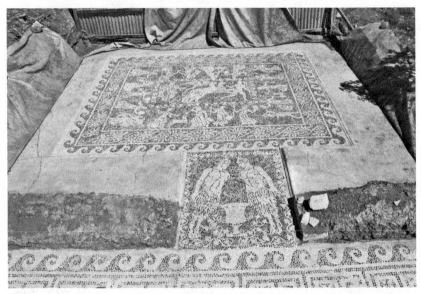

FIGURE 1.1 Dionysos and followers, pebble mosaic from Room a, Villa of Good Fortune, Olynthos, late fifth or early fourth century. In situ. Photo H. M. Franks

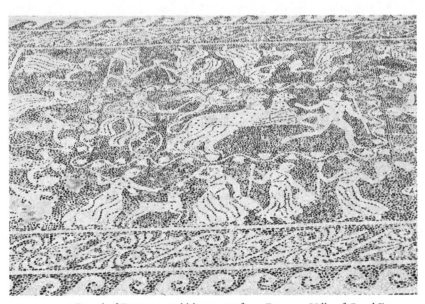

FIGURE 1.2 Detail of Dionysos, pebble mosaic from Room a, Villa of Good Fortune, Olynthos, late fifth or early fourth century. In situ. Photo H. M. Franks

In a mosaic at another house at Olynthos, for example, the hero Bellerophon attacks the Chimaira. At Pella, Dionysos rides a panther on the floor of one andron, while in another Phorbas and Theseus abduct Helen, and in still others, young men are hunting. To the south, at Eretria, lions, griffins, and the monstrous Skylla are all on the attack. A floor at Sikyon is a lush tapestry of vines and flowers.

These mosaics are permanent imagery in the rooms in which they appear, an integral part of the setting for the symposium. Scholars have long acknowledged the ways in which vase painting—the imagery that decorates serving vessels and wine cups—takes visual advantage of this context. Some images, for instance, are seen only from the perspective of the drinker, who alone confronts the interior bottom of the cup as he drains it of wine. Others play with the perspective of one's fellow symposiasts, whose view of the drinker's face is obscured, like a mask, as he tips the cup to drink.[3] The paintings on vases might respond to a vessel's physicality, its function, the way a cup was held and passed from person to person, or, in the case of serving vessels, seen from various angles across the room. And in this way, we understand these objects as participating actively in the symposium, helping to generate the transpositions, illusions, and metaphors that are central to the experience. While the pottery and its imagery have been extensively and very justifiably explored, less attention has been paid to other imagery in the andron and its capacity to engage the event in a similarly active way.[4]

As Molholt claims in her article on labyrinth mosaics from Roman bath complexes, the study of ancient mosaics is often biased toward vertical viewing, in that it treats them as paintings transferred to the floor. Following Benjamin's assertion that the modern privileges the vertical, Molholt suggests that horizontal viewing is a different kind of experience, in which "form is perceived in parts whose import must be reconstructed imaginatively by the viewer or reader. Fragments and discontinuity characterize the horizontal,

3. For various discussions of this visual play, see Boardman 1976; Simon 1976, p. 46; Ferrari 1986, esp. pp. 11, 16–20; Frontisi-Ducroux 1989, pp. 154–155; 1995, pp. 100–103; Kunisch 1990; Steinhart 1995, pp. 55–68; Hedreen 2007; Mitchell 2009, pp. 36–41; Yatromanolakis 2009, esp. pp. 454–464. Bundrick (2015) has argued for reconsideration of the strong identification of the "eye cup" (the cup most often associated with the potential of "masking" the drinker's face) with the sympotic context, especially given the popularity of this type as an export from Athens to Etruria, where sympotic practices were different.

4. It is not possible to offer a comprehensive bibliography of the scholarship of images on sympotic vases, but as an introduction, see Durand, Frontisi-Ducroux, and Lissarrague 1989; Lissarrague 1990a, 1990b; Neer 2002; Osborne 2007, 2014; Catoni 2010; Topper 2012.

whereas integration and transparency distinguish the vertical."[5] As regards the Roman labyrinth mosaics that are her subject, Molholt is particularly concerned with the kinesthetic experience, and how the "ambulatory occupation" of the tactile horizontal surface redefines space and viewer alike.[6] In the earlier andrones of Greece, I am less concerned with bodily movement across the horizontal surface of the mosaic, since symposiasts reclined on couches positioned around the perimeter of the room, and did not, at least habitually, cross the floor themselves. But, as we will see, movement within the andron, including patterns of circulation *around* rather than across the mosaic floors, was central to the phenomenal, synesthetic experience that was the sympotic event. The consideration of the floor mosaic not only as a horizontal surface that is viewed in fragments, potentially from oblique or obstructed perspectives, but also as a surface that actively engages the movements of a complex lived experience, opens to us entirely new ways of understanding the space of the andron and the social operation of the symposium.

The focus of this book, then, is on the complicated problem of reading imagery in relationship to an occupied physical space—a problem particularly acute in the study of the ancient world, where we necessarily reconstruct not only the habits, expectations, and variations of the body's experience, but also the spaces themselves, which, even in the best-case scenarios, are fragmentary. Put briefly, it argues that the mosaic imagery of certain andrones presents imagined settings that reframe the symposium as a metaphor for another kind of experience altogether—a sea voyage, a journey in the footsteps of the god, or a visit to a utopic past. The chapters to follow are organized around the mosaics' iconography, which I consider in relationship to the sensory experience of the andron during the symposium (including architectural space, the arrangement and physical proximity of guests, and, importantly, the influence of wine), the circularity of movement that enlivens and structures (indeed, that defines) the event, and the discursive contexts through which the meaning of the symposium was culturally constructed and reinforced. The imagery is considered, in other words, as part of a nuanced spatial and bodily, rather than an exclusively visual, experience.

Just as vase paintings might engage with the symposium context differently, some more actively than others, mosaics might as well. Because of this, the

5. Molholt 2011, p. 287.

6. Molholt 2011, p. 287.

current study is not a comprehensive survey of all pebble mosaics, or even all pebble mosaics that appear in andrones. Rather, I concentrate in particular on mosaics that respond to patterns of sympotic activity, and I hope that this study will be a foundation for thinking in new ways about the experience of viewing in ancient Greece, as well as how imagery and its spatial context both shape and are shaped by lived experience.

Theoretical foundations

Metaphor infuses the symposium. The wine cup can be a ship, which, when moving quickly, might "jostle" (*otheto*; Alkaios, fr. 346, lines 5–6) the one ahead, or it is a chariot, driven by the wine server around the room with speed (Xen. *Symp.* 2.27).[7] Symposiasts are exhorted to follow the "middle course" of moderation (Theognis 335), and during the symposium "trample everything underfoot" (Anak. *Anakreontea* 48).[8] The wine at the center of the event may be personified, open to praise and blame (Theognis 873–876); it fortifies (*thorexomai*; 413) the drinker, or overpowers him (*biatai*), taking control of his head and feet (503–508). It "sends a man's thoughts soaring on high" (Bacchyl., fr. 20B, line 10).[9]

We primarily access metaphors linguistically—often, and especially when dealing with the ancient world, as tools of literary expression.[10] But in *Metaphors We Live By*, Lakoff and Johnson argue for metaphor as a conceptual structure—a basic organizing mechanism of human thought and interaction with the natural and social worlds—that allows us to understand one experience through its similarity to another kind of experience.[11] Interactions with the world, in other words, are not just expressed by, but are fundamentally understood through the mediation of metaphor, which creates meaning by "weav[ing] together into a fresh constellation the brute 'literal' facts of the world."[12] Often, though this is not their exclusive function, metaphors

7. Alkaios, trans. Campbell 1982 (LCL 142). For extensive discussion of the metaphorical networks involving the sympotic cup, see Gagné 2016.

8. Theognis, trans. Gerber 1999 (LCL 258); Anakreon, trans. Campbell 1988 (LCL 143).

9. Trans. Campbell 1992 (LCL 461).

10. See, as a recent example of scholarship on literary and philosophical metaphors, Worman 2015.

11. Lakoff and Johnson 1980. The argument is made throughout, but helpful articulations appear on pp. 3–6, 77–86, and 229–237.

12. Tilley 1999, p. 8.

facilitate the understanding and articulation of the abstract ("feelings, aesthetic experiences, moral practices, and spiritual awareness") through more concrete interactions.[13] Time, for instance, may be made sense of in spatial terms ("at the end of the day"), as a container ("within the hour"), or as a commodity that we "have plenty" or "run short" of. Knowledge is a territory (*terra incognita* to be charted, a frontier subject to exploration, or ground to be covered), and academic arguments follow a path or build on a foundation.[14] There is no objective similarity between the two domains; rather, metaphor creates conceptual links by applying to the primary subject the "commonplaces," to use Black's term, of the subsidiary subject.[15] These "commonplaces" are distilled, culturally established characteristics appropriate for comparison. If, as in Black's example, man is a wolf, this depends not only on knowledge of what a wolf is, but also on knowledge of a cultural mythology of the wolf—here, as a dangerous predator, despite the more complex reality of its nature. Thus, both memory (or imagination: if, as Pat Benatar suggests, love is a battlefield, those who have not been on an active battlefield are expected to imagine the experience in a certain way) and cultural context (including access to a shared conceptual system that guides the imagination of certain experiences and that distills them into commonplaces) play critical roles in this process. And, further, while culture shapes these metaphors, in that it provides the commonplaces that elucidate a given concept, it is also shaped by those structures, since "metaphors provide a basis by means of which communities create and understand their collective experience."[16]

That this superimposition of experiential domains is often articulated linguistically is clear, as the above examples demonstrate, but Lakoff and Johnson's emphasis on experience raises the possibility that certain metaphors may be accessed or communicated in other ways, through, for instance, image, object, or place—even, as Ferrari has explored, through "correspondences in representations of imaginary places."[17] Here, Tilley's notion of the solid metaphor, or what we might think of as an experiential or

13. Lakoff and Johnson 1980, p. 193.

14. For the metaphorical in anthropological discourse, see Salmond 1982.

15. Black [1954–1955] 1981, esp. pp. 74–75 on "commonplaces"; see also Lakoff and Johnson 1980, pp. 192–194; Ferrari 2006, esp. pp. 225–227 on metaphor.

16. Tilley 1999, p. 10.

17. See Ferrari (2006, p. 234) for the capacity of the sacred space to operate as a metaphor for religious experiences in ancient Greece. For itinerant priests to stand in for sacred space, see Herrero de Jáuregui 2015.

spatial metaphor, is of help.[18] In this kind of metaphor, the bodily experience of one physical domain calls to mind the structure of another experience, image, process, or conceptual space.[19] Rather than the "application of a word that belongs to another thing" (*Poet.* 1457b7), as Aristotle says of verbal metaphor, an experiential metaphor depends on multisensory phenomenal interaction—including vision, the privileged sense of the Western tradition and ancient Greece, as well as smell, touch, sound, and taste.[20] Perception, and, crucially, experience of the world is "synaesthetic, an affair of the whole body moving and sensing. And this sensing is not natural or instinctive but culturally constituted."[21] Individual experience is central, therefore, but such experience is understood collectively through similarities between certain aspects of one domain and the (culturally determined) commonplaces of another.[22]

What follows from this is the possibility that a social space (and, in particular, a ritualized way of interacting with that space) might manipulate experience to emphasize those culturally understood resemblances. Ferrari has argued, for instance, that the architecture and form of Greek sanctuaries "lays out a metaphor that casts sacred space as the palace of the god," configuring the sacred in political terms based on commonplaces of the "idea of 'ancient palace.' "[23] I believe that androns do something similar. Indeed, a central premise of this book is that metaphorical understandings of the symposium, in which the event is experienced as, or in terms of, or as having the same result as another activity, were not simply applied to the institution through language and from the outside, but in fact arose from the sympotic experience and were actively constructed during the event.

18. Tilley 1999, esp. pp. 6–11, 260–273.

19. Tilley 1999, pp. 180, 267. Tilley's book includes extensive anthropological case studies, which are too detailed and complex to be succinctly reviewed here, but, using them as models, examples of solid metaphors might include the understanding of landscape or architecture as "encapsulating essential characteristics of the cosmos" (p. 43) and the "anthropomorphic mapping of the human body onto" (p. 48) architectural structures or objects.

20. Trans. Halliwell et al. 1995 (LCL 199). For the dependence of linguistic metaphors on imagery and on the sensory, see Ricoeur 1977, esp. pp. 207–215; Worman 2015, pp. 10–12. For the prevalence of sight and its theorization in ancient Greece, see Squire 2016, with bibliography.

21. Tilley 1999, p. 180. The Western privileging of sight (for which see, e.g., Cic. *De Or.* 3.160–161) is a broad example of the ways in which this cultural structuring of experience works; see Porteous 1990, esp. pp. 4–5; Squire 2016.

22. Tilley 1999, p. 205.

23. Ferrari 2006, p. 235.

Fundamental to my treatment of the Greek andron and its imagery, then, is the concept of space as more than a simple setting or passive backdrop—a frame or neutral container—for social interactions. Rather, space is actively involved in the production of those interactions.[24] And so it will be useful here to tease out more fully the process through which experiential metaphor emerges, since, in addition to the phenomenal experience of space, it also depends on networks of internalized associations. In understanding these dialectics, I have found useful Harvey's *relative* and *relational* categories of space, which describe how we perceive and make sense of the *absolute* (space in its physical form, experienced phenomenally).[25]

Relative space is the occupation of and movement through absolute space, including the routine flow of people and their variations in experience, as well as the flow of resources, commodities, power, energy, or ideas. The measurement or articulation of relative relationships between any two things (objects or people) within a space varies, depending on the individual perspective and on the process or processes that connect them. We might, for instance, "create completely different maps of relative locations by differentiating between distances measured in terms of cost, time, modal split (car, bicycle or skateboard)."[26] *Relational* space involves internalized images, previous experiences, dreams, memories, histories, or mythologies that may be brought to bear on one's experience; it is how a space takes on meaning. "An event or a thing at a point in space cannot be understood by appeal to what exists only at that point A wide variety of disparate influences swirling over space in the past, present and future concentrate and congeal at a certain point to define the nature of that point."[27] The relational includes an individual's access to personal memories or ideas about a place as well as shared (cultural, social, or political) understandings of it. It is worth noting here that in both the relative and relational categories, the temporal asserts its inseparability from the perception of physical space, but time operates somewhat differently in each. Because it involves movement, the relative accounts for processes that unfold within space over time, while the relational accesses internalized knowledge of both personal and cultural pasts to create meaning.

24. Lefebvre 1991, pp. 93–94.

25. Harvey 2006.

26. Harvey 2006, p. 273.

27. Harvey 2006, esp. pp. 279–283, quote from p. 274.

It is through the interactions between the absolute, relative, and relational that I understand the emergence of experiential metaphor. How does this happen, and, specifically, how might it work in the andron during the symposium? As an absolute space, the andron is isolated; it is within a domestic setting, but cut off from it and, physically, at least, from the external world of the polis. The room is likely decorated: the walls may be painted and imagery may be present in a mosaic floor. Couches are arranged around the walls of the room so that the participants are in a (nearly) closed circle. Here, almost immediately, we move from the absolute to the relative space of the occupied andron, since the room is deliberately structured to encourage, as much as possible, a consistent relative experience among those present. The room is of a size and is arranged so that no one is excluded from the flow of conversation or obscured from sight; all are, at least symbolically, equidistant from the center. There are first and last couches, but the space deliberately suppresses major differences in spatial experience.

Like the circle of the seats, the rhythm of sympotic movement—the ritualized circling of the wine cup and of the turn to speak around the room, to be discussed in greater detail in the next chapter—works in some respects to control relative space and to ensure the comparability of experience by regularizing each participant's turn with the cup and in the (metaphorical) spotlight. It is this movement that brings life to the event, and that imposes pattern and structure, bounding it both temporally and spatially. As the cup travels around the room, its progress marks each turn to speak, and its completed circles signal each successive challenge, topic, or game. Like a path worn into the landscape over time, the circling cup inscribes the temporality of the symposium onto the space of the andron.

A symposiast experiences all of the various aspects of the symposium together—the absolute space of the andron, the smell and taste of wine, the company around him, and the relative spaces of his position in relationship to others and to the cup's circle. He brings with him, too, personal associations and memories, the relational connections through which the space takes on meaning: perhaps he has been to a symposium in the same room previously, perhaps he has complicated relationships with those present, perhaps he aspires to impress or simply wants to drink. Perhaps he has prepared a new poem on an old theme, or has a familiar repertoire of speeches or characters, or a favorite zinger to lob at a companion. These most intimate and individual relational associations with space we of course cannot reconstruct. But the relational also involves the situation of both the symposium and the andron within an extensive, culturally constituted and culturally understood relational network,

which includes knowledge of the expectations of sympotic behavior, relevant literature and mythology, histories, and the social and political relationships at stake. To this aspect of the relational, we do have some access.

Processes of ritualization govern the symposium.[28] From the event's very beginning, formalized actions—the sequestering of its participants, the introduction of special equipment, the performance of libations to and invocations of the gods that begin the evening, and, then, the patterns of movement and expectations of behavior that structure most of the evening— organize the event. Like other ritual acts, the symposium is made up of a set of practices, habitualized and given meaning through social interaction, that privileges this space and moment, and marks it as distinct from the activities of quotidian life.[29] These internalized processes (that is, processes that need no explicit justification) play out in relative space, but it is through the networks of relational space that the ritualized patterns within the symposium might be given additional meaning through association with the commonplaces of other kinds of movements. This kind of metaphor is attested in literature, but, as I have suggested above, there is reason to think that it was also experienced during the symposium. It is the variety of these experiential metaphors that is the subject of the chapters to follow. Each takes as its point of departure mosaic imagery, which, I will argue, had the capacity to structure and direct experiential metaphor by actively recasting the relative patterns of the circling cup as, for instance, the journey of a ship on the seas or the rhythmic, cyclical patterns of the cosmos.

In considering the power of these relative and relational spaces and their participation in the generation of experiential metaphor, we confront two aspects of the andron that do not quite fit comfortably within the limits of Harvey's triad. The first is where the interpretation of imagery happens in the spatial experience. To be sure, the relationship of iconography to the relative and absolute spaces of its display remains vital to the way it is understood here. It is through these aspects of space that the impact of the horizontal viewing experience may be especially felt: the mosaic image is not necessarily a dominant visual centerpiece, since one's view of the whole or of certain parts

28. For ritualization, I follow Bell 1992. In her emphasis on practice, Bell (1992, pp. 74–93) depends on Bourdieu, and particularly his notion of *habitus*. As the material embodiment of what he terms "cultural capital" (the symbolic elements that one acquires through social status), *habitus* includes an internalized structure of habits, tastes, and skills that organizes both individual and collective practices and their perception in social environments; see Bourdieu 1977, pp. 78–95; 1984, pp. 170–171.

29. Bell 1992, esp. pp. 81, 93.

may be obstructed by a krater, a servant moving to refill a cup, or by the tables set alongside the couches; the view may change as a drinker shifts his position on the couch, or it may be forgotten entirely in the midst of conversation and performance. Unaccustomed as we are to thinking of images through this fractured, discontinuous mode of viewing, it is not necessarily a disadvantage; indeed, as I will argue in chapters 2 and 3, the glimpses of a scene on the floor might intentionally mimic partial or interrupted observations that characterize other kinds of experiences, like the view of a foreign landscape from a distance or the sudden appearance of a god. In other mosaics, like the floral designs, a full view of the mosaic is not necessary to understand the whole. Nevertheless—and this is the salient point here—images make use of a relational space outside that of the symposium experience, since they depend on associations, including visual vocabularies and traditions, that are distinct from the spatial associations (indeed, it is for this reason that I at times make use of comparanda outside of the sympotic context). We must be careful, in other words, not to flatten the necessarily complex processes by which images are read, contextualized, and understood; these processes cannot be entirely conflated with or subsumed into spatial experience.

The second aspect of the andron that defies easy categorization into Harvey's absolute, relative, or relational, is the effect of drinking. Wine was not simply present in the andron symbolically; it was consumed, sometimes in great quantities. There is surely no question that inebriation facilitated both sympotic performance and its reception, the wine's "psychoactive properties" opening the mind to new experiences.[30] It may have also participated in the structuring of experiential metaphors. After all, intoxication profoundly affects one's physiological relationship to and perception of space. The consumption of wine might distort the perception of absolute space, impede or intensify the movements of relative space, and expand the spectrum of relational associations. Further, it changes how the body *feels* space during the symposium: drinking can impact balance and cause swaying and staggering; it slows speech and muddles thoughts; it blurs images; in extreme cases, the room itself spins round and round (*peritrechei*, as in Theognis 505). Wine, then, fundamentally transforms the body and its relationship to space, and it therefore primes the drinker for a further, more profound transformation through the experiential metaphor.

30. Dietler 1990, esp. p. 359. And see Dietler's 2006 overview of the anthropological study of drinking in ancient cultures, with bibliography. See also, for the various effects of sympotic drinking, Osborne 2014.

Outline of chapters

Although this is not a book on the symposium, that is my starting point in the first chapter, since it is the rhythms, expectations, and bodily experience of the live event with which, I argue, the imagery engages. Chapter 1 lays out my narrative of the current understanding of the symposium, the andron, and pebble mosaics. I place particular emphasis on the institution's interest in establishing equity and balance as a means of creating commensality. Wecowski's recent work on the circling of the wine cup and of the turn to speak *epidexia*, from left to right, offers a critical new way of understanding how this equity was performed and regulated during the event.[31] It is the primary pattern of movement through which the andron's relative space was structured and experienced, and with which the mosaics actively engaged.

In chapter 2, I consider the symposium as a journey at sea—a construction that takes particular advantage of the bodily experience of wine and its similarities to sailing. This chapter takes as its subject exotic mosaic imagery that is not easily identified as "sympotic," through an association with Dionysos. Using mosaics from androndes at Eretria and Sikyon, I argue that exotic imagery, particularly when paired with nautical or watery themes, refers to distant parts of the world, accessed by journey over the ocean. The prescribed movement of wine cups around the perimeter of the room, in conjunction with the exotic imagery, evokes the metaphor, amply attested in literary sources, of the symposium as a journey at sea, during which the symposiast-sailors see foreign shores. Other kinds of imagery bring to mind not distant shores, but, instead, the dangers and delights of the open seas.

Dionysos himself, often shown on vases alongside his retinue of revelers, is a natural subject for the decoration of the room in which the symposium is held. Pebble mosaics, however, place particular emphasis on the god's identity as a traveler. Although Dionysos is Greek, he was raised on distant Mt. Nysa, from which he returned to Greece in a triumphal procession that crossed the known world. His return introduced to his homeland knowledge of wine and winemaking. In andron mosaics, he is shown in the process of this journey, mounted in a chariot drawn by panthers (as at Olynthos), or riding an exotic large cat (as at Pella and Eretria). Chapter 3 contends that such mosaics present Dionysos as a kind of *theoros*—a traveler whose exposure to the unfamiliar brings new knowledge that he conveys to his homeland. In this way,

31. Wecowski 2002; 2014, pp. 85–124.

Dionysos provides a model for the metaphorical journey of intellectual transformation that wine and the experience of the symposium ideally produce in the event's participants.

The four-spoked wheel that is the subject of chapter 4 has a number of possible identifications: a wheel can be a children's toy, a noisemaker, or a torture device that doubles as a love charm, and it may also be an emblem of the circle of fate or fortune. In each of these contexts, it is the wheel's spinning that gives it resonance, and this leads me to argue that the (stationary) icon of the wheel, which appears in andron mosaics in Athens and at Olynthos, stands for the motion of turning. As such, it draws attention to the living revolutions of wine and conversation that unfold in the andron, aligning sympotic circling with cyclic patterns of movement that carry a deep cultural association with universal rhythms and harmonies. The result of rhythmic turning elsewhere—in the *choros* (the dance), or in the movements of the stars—is balance, unity, constancy, order. These are also the values of the ideal symposium, and the mosaic wheel, in highlighting the pattern of *epidexia* as a stable cycle, points drinkers toward the promise of these results.

Chapter 5 deals with mosaics that depict flowers and vegetation, imagery that is often considered purely decorative or symbolic of Dionysos's chthonic identity. In her recent interpretation of sympotic vase painting, Topper proposes that certain vases, particularly those in which participants recline on the ground instead of on couches, represent Classical Athenian notions of the earliest (as opposed to contemporary) symposia.[32] This chapter suggests that the lush abundance of the floral mosaics also references these ancient symposia, which, despite their primitive nature, were idealized in the Classical period as belonging to the formative years of the polis. Unlike the mosaics discussed in the previous chapters, which facilitate the geographical removal of the symposiast from the quotidian to a foreign or exotic landscape, these mosaics resituate the symposiasts temporally, relocating them in a distant— and equally exotic—past. This past can be utopic, but it is not necessarily so, since mosaics featuring centaurs evoke a time when wine consumption had not yet become civilized and could be the cause of destructive incivility.

The relatedness of space and temporality reappears in chapter 5, therefore, in a slightly different way than it does in earlier chapters: rather than recasting the cup's circulation as another type of physical movement, these andrones situate the drinkers in relationship to the long process of the passage

32. Topper 2012, pp. 23–52.

of historical time. That the Classical and Hellenistic Greeks were acutely concerned with deep mytho-history should come as no surprise, since they looked frequently to the past in the formation of their identity. And yet even constructions of the past can be conceived spatially. For the Greeks of the fifth and fourth centuries, who positioned themselves near the center of the world, the distant, unreachable edges of the inhabited earth continued to be the home to composite monsters (griffins) and peoples (Amazons) that characterize Greece's mythical past. The symposia of early Greece, while geographically local, are nevertheless distant and uncivilized, belonging to an era whose closest parallels exist, according to the Classical Greeks, among their foreign contemporaries. While some metaphorical encounters with the unfamiliar might happen through travel abroad, therefore, these androns suggest that others might happen through confrontation with bygone eras. In this way, in dealing with experiential metaphors, we deal not only with the spatiotemporalities of the andron itself, but also with those of the metaphorical worlds that might be mapped onto it, including diverse histories and mythologies, in addition to landscapes and geographies.

The conclusion to this book reiterates the claim, made throughout the case studies, that experiential metaphors played a crucial role in creating and solidifying social bonds among symposiasts. The metaphorical spaces and the journeys and adventures that the andron actively produced would have been, to be sure, part of the evening's entertainment. But more than this, the solid metaphors intensified the immediacy and intimacy of the sympotic group by foregrounding the event as a unique, shared experience. Together, participants escaped to foreign shores, followed in the footsteps of the god, or emerged victorious from heroic combat, and, together, they risked devastation and isolation—shipwreck, wandering, defeat, chaos—should the symposium tip out of balance. The pebble mosaics that are the focus of this study are much more, therefore, than a thematic or iconographic reinforcement of the sympotic context. They take an active part in a larger spatial process that also depends upon the relative patterns of movement that unfold within the andron, the effects of wine on the body, and the relational associations that position the phenomenal experience of this space in relationship to other experiences. Like the cups that move around them, the mosaics are inseparable from the event of the symposium, and they participate fully in it. They create a space of illusion and spectacle in which the drinkers themselves are transformed, and they introduce to the andron both the promise of unity on which fellowship is built and the threats that put it to the test.

1

The Symposium, the Andron, the Mosaics

"MY HEAD IS heavy with wine," Theognis complains to Onomakritos in one of his poems. "It overpowers me, I am no longer the manager of my judgement, and the room is going round and round. But, come, let me stand and find out whether the wine has hold of my feet as well as the mind" (503–508).[1] The symposium—the setting for the poet's overindulgence—is literally the occasion of drinking (*posis*) together (*syn*), although this short etymological definition fails to convey the event's complexity as a social activity and its centrality to polis life. Without denying that convivial feasting and festive drinking took place on many different occasions, this book treats the symposium as a distinct institution defined by its focus on communal wine consumption and agonistic performance among the participants, and by its promotion of commensality among the male citizens of the Greek polis. Indeed, symposiasts are men: "respectable" women of citizen families were certainly excluded from the symposium, although a woman could be present as a paid entertainer (a flute girl, for instance), and *hetairai* (courtesans) are known to have participated alongside the men.[2]

Our picture of the symposium in all of the variations of its practice remains somewhat murky, but it is still the case that we know it—or, at least, how Greeks thought about it—remarkably well through written sources of various genres, including poetry, comedy, and philosophy. We are particularly indebted to monodic poetry of the Archaic period (composed, it seems, for

1. Trans. Gerber 1999 (LCL 258).

2. For further bibliography, see Kurke 1997; Burton 1998; Hammer 2004, esp. pp. 499–503; Blazeby 2011; and Corner 2012, esp. p. 34, n. 2. For flute girls, see Davidson 1998, p. 81.

performance in the sympotic context), as well as, in periods more closely contemporaneous with the mosaics, to Aristophanes, to Xenophon's and Plato's sympotic dialogues, and, finally, to the third-century CE *Deipnosophistae* ("The Learned Banqueters") of Athenaeus, who makes frequent use of sources from prior centuries.[3] Although substantial, this evidence often describes the event only obliquely, or presents perspectives on the institution shaded by comedic, political, or cultural nuances; further, it must be said at the outset, it is heavily Athenian, so our view of the institution elsewhere in Greece is much more opaque. In addition to the textual, we also depend heavily on abundant, if similarly complex, visual and material evidence. Various kinds of symposia and sympotic practices are represented in black- and early red-figure painting on the cups and serving vessels that took an active part of the proceedings.[4] Such vases were produced a century or more prior to the high point of pebble mosaics, and, though they are Athenian, large numbers of these vases seem to have been produced for export, a fact that complicates our understanding of their imagery and its intended audience.[5] In addition, like the literary sources, and indeed, "like all representation . . . sympotic depiction is rhetorical: it is constructed and constructs; it is communicative and it 'persuades.' "[6] In other words, these sources, visual and textual alike, make certain assumptions about the form of the event, and we cannot depend on them to provide to us a single or objective account of the "real" symposium, whatever that might have been. That said, they can help us to think about how the symposium was experienced, how it existed in the Greek "social imaginary," and what was at stake in its practice.

Also at our disposal is archaeological evidence of the sympotic space. Andrones appear in houses from the late fifth century into the third. Rather than sitting to drink, symposiasts reclined on couches (*klinai*) arranged along the walls, and the andron is in part recognizable because it features a perimeter band on its floor that marked their placement (see, e.g., Room a in figure 3.1). Privacy from the rest of the house was sometimes ensured by doors

3. On Athenaeus, see König 2012, esp. pp. 90–120.

4. For the diverse and sophisticated use of vases and vase imagery in the symposium, see, e.g., Lissarrague 1990a, esp. pp. 47–143; Neer 2002, esp. pp. 9–26; Hedreen 2007; Topper 2012.

5. The scholarship on the Athenian ceramics trade and the interpretation of imagery on exported vases is extensive, but see, as examples and for further bibliography, the following: Boardman 1988; Reusser 2002; Lewis 2003; Avramidou 2006; Langridge-Noti 2013, 2014; Bundrick 2015, esp. pp. 303–309.

6. Hobden 2013, p. 4.

or an anteroom. The andron's form follows that of dining rooms or *hestiatoria* in ritual and public contexts of the Archaic and Classical periods, and it may be that, before the incorporation of a permanent andron into domestic architecture, these spaces were the settings for symposia as well as ritual dining of other kinds. Since they are so central in the chapters to follow, the andrones and their decoration—namely, their mosaic floors—will be taken up in greater detail below.

The symposium

A symposium could follow a *deipnon* (a meal), but the activities were distinct, so that if there was substantial food at an early stage of the gathering, it was cleared before the drinking began.[7] A series of ritual actions marked the beginning of the symposium, differentiating it in quality, time, and space from any preceding activities.[8] Attendees washed, and may have garlanded their heads and anointed their bodies with oil; the krater was brought in; they poured out a toast of unmixed wine to the Good Daemon (perhaps a version of Dionysos), made libations to other gods, including Zeus the Savior and Hygieia, and sang hymns (Pl. *Symp.* 176a; Xen. *Symp.* 2.1; Athen. 11.486f–487c).[9] The formal preliminaries also involved the setting up of drinking equipment (cups, an oinochoe or ladle for serving, and perhaps a psykter for cooling the wine), the election or appointment of a symposiarch or *basileus* (the leader of the symposium), and the mixing of the wine.[10] In contrast to the non-Greek custom of drinking wine unmixed, *akratos* (a practice attached, if

7. Murray 1990b, p. 6. Despite this distinction, it is notable that equal distribution and commensality were potentially central to the *deipnon* as well as to the symposium. Investigating vase paintings in which symposiasts are shown with tables of food before them, Schmitt-Pantel (1990, esp. pp. 18–20) proposes that these images present a montage of moments from the meal (plates laid out with identical meals) and the symposium (reclining participants drinking, not eating, and hand gestures suggesting speech) as a way of representing equal distribution, exchange of conversation, and commensality within the framework of civic activities. See also Schmitt-Pantel (1992) on banqueting in Archaic Athens. The vase paintings, however, are difficult to take as direct evidence of a typical symposium, and in any case, it seems likely that tables with snacks, as opposed to heavier dinner fare, were present in some, perhaps even many symposia, while they may have been absent in others; see Lynch 2011, p. 135.

8. Bell 1992, pp. 74, 88–93; Kurke 2005, esp. pp. 82–84.

9. Davidson 1998, pp. 45–46. For a more detailed description of the equipment in the archaeological record, see Lynch 2011, pp. 77–78.

10. The designation of a symposiarch may have helped to limit the power of the host over the proceedings; see Wecowski 2014, p. 37.

inconsistently, to the Skythians, as in Hdt. 6.84 and Pl. *Leg.* 637e, and a charge leveled against Philip of Macedon, according to Diod. Sic. 16.87.1), the Greeks diluted their wine with water.[11] This must have been a necessary step when three, four, or more kraters of wine might be consumed in a single sitting, although, to be sure, certain contests or games between the symposiasts seem to have challenged their tolerance by requiring them to partake of the wine neat or in extreme amounts.[12] The symposiarch would likely oversee the mixing, since, ultimately, his duty was to preserve moderate conviviality between the extremes of sobriety and excessive drunkenness. As Theognis advises, "If one drinks wisely, wine is not a bane but a blessing" (212).[13] This ideal is one that, if we believe the sources, was not always met.[14]

Happily recumbent, one or two to a couch, perhaps with tables bearing snacks within reach, the symposiasts focused on wine and entertainment (figure 1.1).[15] Especially in the late fifth and fourth centuries, hired performers (singers, musicians, or dancers) may have provided diversions at certain points during the evening and may have also been available for sexual amusement.[16] But at the heart of sympotic commensality was conversation and competition among the guests themselves, the mixing of these activities—like the mixing

11. For Skythian wine-drinking habits, see Hartog 1988, pp. 169–170; Miller 1991, esp. pp. 67–68.

12. Wecowski 2014, p. 41. The ratio of wine to water, in any case, seems to have been variable: some advise equal parts wine and water, others recommend something between one-quarter and one-third wine in the mixture, while heavier drinkers might add much less water. Since, in the symposium, all were expected to enjoy the same amount of wine, the group may have agreed, as they do at the start of Plato's symposium (*Symp.* 176a–e), on the ratio of wine to water and on the number of kraters to be consumed, or, as in Xenophon's (*Symp.* 2.26–27), on the size of the cups and frequency of the rounds.

13. Trans. Gerber 1999 (LCL 258).

14. Pellizzer 1990, esp. pp. 178–179; Davidson 1998, p. 47; Fisher 2000, esp. pp. 369–371.

15. That the Greeks themselves attributed special meaning to the reclined position is suggested by the expectation that any youth not of age to attend the symposium in his own right would sit, rather than recline, next to his chaperone (Xen. *Symp.* 1.8). Lynch (2011, p. 77) notes that reclining both "demands the attention of a servant," and so suggests status, and "emphasizes the participant's disengagement with physical activity for the evening."

16. Kallias, the host of Xenophon's symposium (*Symp.* 2.1–2), brings in two girls (one a flute player and one a dancer "skilled in acrobatic tricks") and a boy (very handsome, who played the kithara and also danced)—all three in the employ of a Syracusan who "managed" the act—for his guests' enjoyment; trans. Todd 2013 (LCL 168). See, for discussion of this passage, Jones 1991, esp. pp. 190–192; also Davidson 1998, p. 81; Coccagna 2011; and Wecowski 2014, p. 49. For the increase in professional musicians in the latter fifth century, see Bundrick 2005, pp. 199–200.

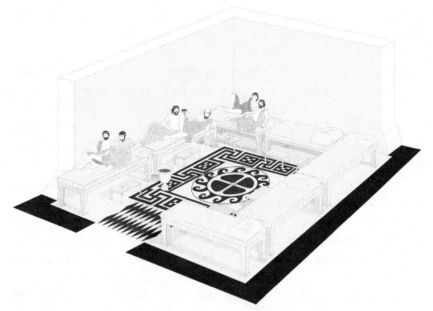

FIGURE 1.1 Artist's rendering of an andron. M. Grimaldi

of wine—falling to the symposiarch, who, according to Plutarch, should heed "the testimony of many that the pleasantest sailing is along the coast, while the pleasantest walk is by the sea, [and] throw in something playful alongside the serious" (Plut. *Quaest. conv.* 1.4.621D).[17] Loosened by the wine, the participants might sing verses or recite poetry, make speeches, or participate in drinking games. They might pose and answer riddles, finish a song or quotation started by another, or toast (or roast, to use a modern term) their companions.[18] They might play a role, introducing another persona to the group.[19] And there could be physical tests as well. The best-known of the sympotic games is *kottabos*, in which participants flung the dregs of wine at a target and were judged on both the aim and the elegance of their throw, but challenges also included drinking without holding the cup or taking a breath. Prizes might be awarded for the winners of these competitions, and the losers risked paying a penalty. Such contests, inevitably becoming more difficult as

17. Trans. Clement and Hoffleit 1969 (LCL 424). See Lynch 2011, p. 77.

18. For treatment of the sympotic pastimes, see Wecowski 2014, pp. 40–55; Pellizzer 1990, pp. 179–180; Bowie 1993; König 2012, pp. 7–11.

19. For sympotic role-playing, see esp. Hedreen 2007, pp. 234–239.

wine was consumed over the course of the evening, tested the participants' self-control: the great challenge was to strike the balance between inebriation and command of body and mind.[20]

Wine was often served in a cup that was passed to each member of the group in turn, repeatedly refilled by a servant along the way. Wecowski has recently demonstrated how important this custom was in structuring the event. Since my arguments below depend heavily on this movement as part of the spatial experience of the andron, I risk duplicating some of his points by reviewing here the primary evidence for this practice.[21] As Wecowski establishes, sixth- and fifth-century texts describe the cup as "speeding" (*seuomenan*; Bacchyl., fr. 20B, line 7) "round and round" (*perinisomenaon*; Phocylides, fr. 14, *apud* Athen. 10.427f–428b).[22] In particularly enthusiastic parties, one cup might even "jostle" another (Alk., fr. 346, lines 5–6)—*otheto*, implying that multiple cups might even circulate at once and that one could be rushed along by the next.[23] Similar descriptions continue into the fourth century, so that, in Xenophon's *Symposium*, the slave is asked to refill frequently, driving the cup around with increasing speed, like a charioteer (2.27). This movement most often had a specific directionality, *epidexia*, from left to right (probably counterclockwise, starting to the right of the room's entrance). In the *Republic*, Plato's Socrates imagines potters "reclin[ing] on couches from left to right" (420d–e), while in the *Symposium*, Socrates, Aristophanes, and Agathon talk through the night, "drinking . . . from left to right" (223c).[24]

What is more, the turn to speak or perform—to cap or match another's song, to answer a toast or riddle, to contribute to the rhetorical (or philosophical) conversation, or even, it seems likely, to play *kottabos*—was also passed,

20. Wecowski 2014, p. 52.

21. This argument is laid out in Wecowski 2002; 2014, pp. 85–124. Although I pull on occasion from earlier sources, I concentrate below on evidence from the fifth and fourth centuries, since this is more closely contemporary with the andrones.

22. Bacchylides, trans. Campbell 1992 (LCL 461); Phocylides, trans. Gerber 1999 (LCL 258).

23. Trans. Campbell 1982 (LCL 142). Vase paintings do seem to show multiple cups in circulation during a symposium, but whether such images are faithful and objective representations of symposia is unclear, as discussed above. Because of this, I do not consider them as providing persuasive evidence against the passing of a single cup. One explanation for the appearance of multiple cups, for instance, might be that they depict a particularly raucous or excessive symposium, as Topper (2012, pp. 109–112) has argued of over-the-top sexual acts that appear in other representations of the symposium.

24. Trans. Shorey 1930; Lamb 1925 (LCL 166).

circulating in rounds together with the wine cup (Xen. *Symp.* 4.64, 8.1).[25] Kritias describes vessels and the "extending of toasts to the right" (fr. 6, lines 5–7, *apud* Athen. 10.432e).[26] Fragments of Dionysios Chalkous include a toast sent from left to right (fr. 1, lines 1–3, *apud* Athen. 15.668e–669e) and hymns that "pour out, like wine, to the right" (fr. 4, line 1, also *apud* Athen. 15.668e–669e).[27] In Anaxandrides' comedy *Boors* (*Agroikoi*), an unrefined character receives instruction in sympotic customs from his son, who proposes that they speak to the right in honor of the drinker (fr. 1, *apud* Athen. 11.463f).[28]

Despite the predominance of *epidexia*, there is also some suggestion that practices of passing the cup could vary. A particular kind of song, the *skolion*, was apparently so named because of its crooked—that is, random or, at least, irregular—progress around the room.[29] This may be an exception that proves the rule, since it seems to be named for its distinctive divergence from the standard *epidexia*, but patterns of directionality could also, it would seem, vary according to local traditions. Athenaeus records a passage from Kritias's *Spartan Constitution*, in which he compares the habits of various Greek cities, probably, as Wecowski points out, to contrast the reputed self-indulgence of some *poleis* to the restraint of others: "The Chian and Thasian man makes pledges from large cups passed to the right, the Athenian from small cups passed to the right, and the Thessalian pledges enormous cups [passed] to whomever he wishes, but the Lakedaimonian drinks individually from the cup at his side" (338A F10, DK 88[81]B33, *apud* Athen. 11.463e).[30] Even within a context that seeks to make a larger rhetorical point about moderate and immoderate practices and that does include passing to the right in three of these five examples, this passage underlines for us that a number of sympotic customs must have coexisted and fallen in and out of fashion over the period considered here. As Wecowski argues, particular sociocultural circumstances in Thessaly and Sparta may have shaped local practices in ways that caused them to diverge from the norm of passing *epidexia*. But it may also be that because we depend so heavily on sources from Athens, where passing to the right

25. Wecowski 2002, esp. pp. 355–361; 2014, pp. 47–48, 93.

26. Trans. Gerber 1999 (LCL 258).

27. Trans. Gerber 1999 (LCL 258).

28. See Rusten 2011, p. 463.

29. Dikaiarchos, *On Musical Contests, apud* scholiast on Pl. *Grg.* 451e; see Campbell 1993 (LCL 144), pp. 274–277.

30. Trans. Morrison in *BNJ*. See for discussion, Wecowski 2014, pp. 98–99, 306–307.

clearly dominated, the assumption that it was a fundamental principle of the symposium requires some qualification. Nevertheless, with the exception of the Spartans, who were considered unique in passing neither cups nor toasts (Kritias, fr. 6, lines 1–4, *apud* Athen. 10.432d–e), it does seem to be the case that *movement*—the physical progress of the wine, accompanied by the turn to speak, either to the right or, potentially, across the room—was indeed a crucial element in structuring and defining the Greek sympotic experience.[31]

The movement of the cup helped to ensure the ideal of commensality, putting into practice the expectation that all would contribute equally to the conversation and partake equally of the wine, and this was further reinforced in the absolute and relative spaces of the andron. Positioned on their couches around the perimeter of the dining room, the symposiasts formed a closed circle broken only by the doorway. As Lissarrague describes, each symposiast was situated so that he was able to see and hear everyone present; nothing took place out of sight or behind the back of another participant; and all, at least for the duration of the evening, were equal.[32] These friends (*philoi*), Westgate notes, "thus became bound by ties of mutual hospitality and loyalty (*xenia*). Dining in these various groups helped to build up the network of interpersonal connections which formed the basis of the community of the polis."[33]

The competitive nature of sympotic pastimes and, more generally, the agonistic nature of Greek culture to which they belong, may at first seem difficult to reconcile with the "rigorous equality" of the participants in a given symposium.[34] And there were surely moments in which the desire for individual distinction was acutely felt within the convivial setting—even Socrates quips in Plato's *Symposium* that it is unfair for him to be on the last couch, since he has no chance of competing with those whose turn precedes his own (177e). Equity, however, is located not in the victory, but in the playing field: true competition, after all, can only exist among equals. The turn to compete was, at least in a properly functioning symposium, apportioned evenly to all present, so that no single attendee might dominate except by his skill. Ideally, then, sympotic competition ensured and was regulated by parity, even if there might be a single winner of a given contest, and the tension between

31. For the Spartan customs, see Rabinowitz 2009.

32. Lissarrague 1990a, p. 19.

33. Westgate 1997–1998, p. 97.

34. Wecowski 2014, pp. 71, 122–123, quote from p. 123.

the agonistic and convivial was yet another equilibrium that the symposium strived to maintain.

Still, despite the ideals of balance and self-control, the appointment of a symposiarch to enforce them (Pl. *Leg.* 640d, 671b–d), and the understanding that this was a context appropriate for the discussion of serious matters, the potential for the symposium to succumb to these pressures and exceed the bounds of moderation was considerable.[35] Indeed, the competitive nature of both the pastimes and drinking make overindulgence and loss of control a likelihood, and literary sources reveal a preoccupation with this possibility. Putting words into the mouth of Dionysos himself, Euboulos (fr. 94, *apud* Athen. 2.36b) describes the effect of each krater on the guests:

> Because I mix up only three bowls of wine for sensible people. One is dedicated to good health, and they drink it first. The second is dedicated to love and pleasure, and the third to sleep; wise guests finish it up and go home. The fourth bowl no longer belongs to me but to outrage. The fifth belongs to arguments; the sixth to wandering drunk through the streets; the seventh to black eyes; the eighth to the bailiff; the ninth to an ugly black humor; and the tenth to madness extreme enough to make people throw stones.[36]

Even the god of wine disavows responsibility for the drinkers' behavior after the third krater!

Some sympotic rowdiness, while vulgar, might be comical. Aristophanes parodies the potential for crude behavior amid refined aspirations in his *Wasps*, when the uncultured Philokleon attends his first symposium and, becoming outrageously drunk, starts to "prance about, fart, and make fun of people" and then, on his way home, physically assaults everyone he encounters (1299–1325).[37] According to Epicharmos (146 KA, *apud* Athen. 2.36c–d), drinking leads to the wandering *komos*, the *komos* to swinishness, swinishness to a lawsuit, and a guilty verdict leads to shackles, stocks, and fines.[38] As this and the passage from Euboulos above suggest—and, indeed,

35. See, e.g., Murray 1990a, p. 158; Hobden 2013, esp. her chapter 4, "Politics in Action" (pp. 157–194).

36. Trans. Olson 2007 (LCL 204); see also Hunter 1983, pp. 66, 185–189.

37. Trans. Henderson 1998 (LCL 488).

38. Trans. Olson 2007 (LCL 204).

as even Aristophanes hints—both the symposium and the raucous *komos*, the drunken procession of the group through the streets at the end of the evening, could serve as the setting for behavior beyond mere mischief or disruption of the peace. In a soberer counterpart to Philokleon's comedic drunken attacks on passersby, Demosthenes' speech *Against Konon* (54.7–8) describes a nearly deadly assault on the Athenian Ariston by a group of men who had gathered to drink at the house of Pamphilos. In another speech, Demosthenes cites behavior in a Macedonian symposium in his charges of corruption against Aischines (*On the False Embassy*, 19.196–197).[39] According to Demosthenes, who learns about these events from a third party, Aischines attended, while at Pella, a symposium at the house of Xenophron. During this symposium, a captive woman from the conquered (Greek) city of Olynthos was led into the room. When this woman repeatedly refused—as a respectable free Greek woman would be expected to do—to participate in the symposium by reclining and singing, Aischines and his companions accused her of hubris and ordered her to be stripped and whipped. This is a complicated story on many levels, not least of which is that Aischines' defense differs in details that include even the name of the host, but what is notable for us here is that Demosthenes illustrates the hubristic character of the defendant through shocking violations of sympotic decorum: that the Greek woman was asked to participate as a man would in the symposium is a prologue to the more violent transgression of treating her as a slave, and is implied evidence of both Aischines' disregard for fellow Greeks and for his anti-polis leanings. As the gathering place for *hetaireiai*, close-knit groups of companions and, often, political allies, the symposium of late-fifth-century Athens was also implicated as the setting for blasphemous performances of mock Mysteries and the plotting of the Mutilation of the Herms of 415, one of the most notorious political conspiracies of Greek antiquity (Thuc. 6.27–28; Andok. *On the Mysteries*, 12–17; Plut. *Vit. Alk.* 22.3).[40] The ideal equilibrium and temperance of the symposium, then, was not always—perhaps, even, not often—achieved, and sympotic misbehavior had, rhetorically at least, substantial implications for the well-being of the polis at large.[41]

39. For an extensive analysis of this speech, see Hobden 2009.

40. See Murray 1990a.

41. See, for instance, Fisher 2000. Theognis in particular cautions symposiasts against the possibility of false friendships, in addition to overindulgence; see Theognis 87–92, 93–100, 101–104, 371, 372, 415–418, 979–982.

While it is through the sharing of sympotic conviviality that citizen *philoi* forged deep bonds outside of the spheres of kinship, the promise of commensality was still limited to a self-selected group. Who, exactly, was included within this group and what that participation meant socially and politically are issues of substantial and ongoing modern debates, which focus in large part on the Archaic symposium and the possible origins of the institution. Recent studies have pushed against and complicated the prevailing view of the early symposium as an aristocratic institution that originated in the Archaic period under the influence of elite Asiatic customs, discernible especially in the practice of reclining on couches.[42] In shifting the defining ("tracer") element of the symposium from reclining to turn-taking, Wecowski has convincingly moved back the symposium's emergence in Greece, locating earlier forms in the communal drinking parties of the Early Iron Age. He thus effectively undermines the argument that the institution's origin is the result of a process of elite "Orientalization" (that is, in this case, the conscious adoption or imitation of practices that originated in the eastern Mediterranean or the Near East) in the eighth and seventh centuries, even if aspects of its form— including reclining—were introduced at that time.[43] Meanwhile, Hammer and Corner have successfully problematized the dominant understanding of the Archaic symposium as an exclusively aristocratic, elitist event.[44] The groundwork has been laid, then, for a more extensive rethinking of the role of

42. Reclining may have roots in the imitation of elite Asiatic (Phoenician, Near Eastern, or Anatolian) banqueting practices. Commonly cited in support of this origin is a passage from the eighth-century Book of Amos (6.4) that admonishes Samarian elites in part for reclining on beds of ivory, and a seventh-century relief from Room S (Slabs B and C) of the North Palace of Assurbanipal at Nineveh, in which the Assyrian king is represented reclining on an ornate couch while feasting in his garden (London, British Museum ME 124920: Barnett 1976, pls. LXIII–LXV). Murray (2016, pp. 24–27) also looks at the *marzeah*, the Near Eastern group drinking practice.

For discussions on the possible relationship between the symposium and eastern practices, see Fehr 1971, pp. 7–25; Dentzer 1971; 1982, pp. 51–58, 71–76; Murray 1983a, esp. p. 263; 1983b, esp. p. 198; 1983c, esp. p. 50; 1994, esp. pp. 48, 53; Boardman 1990, esp. pp. 124–126, 129–130; Rathje 1990, esp. p. 284; Burkert 1991; 1992, p. 19; Matthäus 1993, esp. pp. 177–179; 1999–2000; Morris 2000, pp. 182–184; Catoni 2010, pp. 66–70; Miller 2011; Hobden 2013, p. 9; O'Conner 2015, p. 102.

43. Wecowski 2002; 2014, pp. 191–247, 288–294; see, however, Murray's (2016, pp. 19–27) recent response to Wecowski and reiteration of his position that the Greek symposium is a product of changes in the eighth century.

44. Hammer 2004; Corner 2010. Hammer points, in part, to the problematic eliding of economic and cultural equality (or equality of lifestyle, *isodiaitoi*) with political equality (*isonomia*) on which this understanding depends. Corner, for his part, sees the ideology at the heart of the symposium as the practice of balance, equity, and reciprocity: its success depends

the symposium in what must have been diverse and evolving responses to the substantial political and social changes of the Archaic city.

I am particularly concerned with the symposia that were held in andrones from the late fifth century on, and so the origins of the symposium, its possible imitation of Asiatic banqueting practices, and the extent to which it was an aristocratic institution in the Archaic period are tangential here. A detailed pursuit of these debates would take us on a lengthy digression. These issues, however, have influenced readings of some mosaic iconography as itself originating in or referring to the cultures to Greece's east, despite the fact that such interpretations do not account for how the Greeks themselves understood the history of the symposium.[45] By the early Classical period, the symposium was a well-established cultural institution, of which both reclining and equitable turn-taking were constitutive features, and the Greeks had developed their own ideas about its origins. In her recent analysis of the symposium in Athenian vase painting, Topper makes a crucial distinction between the institution's historical origins, with which scholars are primarily concerned, and the ways in which the Late Archaic and Classical Greeks themselves might have imagined its earlier forms.[46] She looks to black- and red-figure images of symposiasts reclining on the ground or on cushions, rather than *klinai*, and persuasively interprets them not as contemporary variations in sympotic practice, but, instead, as representations of symposia as they were imagined to have existed in the distant Athenian past.[47] I review Topper's argument in detail in chapter 5, but her understanding of the images gives us good reason to think that, whatever the actual origin of reclining, certain Classical Greeks did not see the posture as the imitation or adoption of Asiatic habits, as modern scholars have. Rather, for them, reclining, whether on the ground or on a couch, was the natural human position for drinking and "a practice that linked the civilized symposiast of the contemporary world to his most remote

upon an ethics of moderation—the suppression of self-interest and individual appetites—that transcends class distinction and that, in fact, aligns with polis values.

On the symposium as an aristocratic site that self-consciously defied the "middling" values of the Archaic city, see Murray 1990b; Morris 1996; Kurke 1997, esp. p. 110; Morris 2000, pp. 182–184. Pauline Schmitt-Pantel's work on the symposium is foundational in broadening definitions of the symposium and to moving it into the world of polis politics: Schmitt and Schnapp 1982; Schmitt-Pantel 1990.

45. See, for instance, von Lorentz 1937; Guimier-Sorbets 1999; Westgate 2011, pp. 294–299.

46. Topper 2009; 2012, pp. 23–43.

47. Topper 2012, p. 42.

ancestors."[48] The crucial implication here is this: if reclining did not necessarily signify eastern luxury practices, then we should also call into question the interpretation of "exotic" mosaic imagery as referring to the symposium's foreign roots, even if (or, in fact, especially because) the mosaics date to a period slightly later than the vase paintings on which Topper concentrates.

There is, to be sure, a sense that the symposium itself transformed in the fifth and fourth centuries, just as androns and pebble mosaics begin to emerge in the archaeological record. Lynch and Rotroff, both focusing on the Athenian symposium, refer to a period of democratization in the Late Archaic period, while Wecowski speaks of the institution a century later as undergoing "decomposition."[49] Hobden notes a general increase in social and political opportunities for communal dining, both private and public, over this period.[50] The introduction of androns in private houses—that is, the dedication of a permanent domestic room designed to accommodate this particular activity, whether or not it was used in other ways as well—may indeed suggest transformation in the institution, including, perhaps, changing expectations around who might host or participate. Just as ceramic evidence from the early fifth century suggests that modest Athenian households might have hosted symposia, androns of the next century do not appear only in the largest houses, indicating that the symposium may indeed have been widely practiced.[51] The fifth century also witnessed a decline in the specially composed poetry that was central to the Archaic event, and increased dependence on professional performers. But the implications of such change—whether decomposition or democratization—and what else, exactly, it entailed, are not entirely clear. It may be the case that the current re-evaluations of the aristocratic affiliations of the Archaic institution will impact our understanding of the nature of the Classical event and the degree that it may have transformed over the course of the fifth century.[52]

48. Topper 2012, p. 42.

49. Wecowski 2014, p. 11; Rotroff 1996, p. 27; Lynch 2007, p. 243; 2011, pp. 170–173. See also Schmitt and Schnapp 1982, pp. 71–73.

50. Hobden 2013, p. 12. See also Fisher 2000, pp. 356–369.

51. In the Athenian archaeological record, the appearance of andron seems to broadly correspond with an increase in kraters; Rotroff (1996, p. 27) proposes that the introduction of state-funded public dining inspired a greater range of citizens to purchase kraters for private use. Regarding the symbolism of the krater, see also Luke 1994.

52. Wecowski 2014, p. 12. Part of this debate is a question of definition, and whether a nonaristocratic drinking party should qualify as a symposium: on the one hand, Davidson

It seems, in any case, that the defining elements of the symposium were securely in place through at least the end of the fourth century: the symposium continued to be a nocturnal gathering of citizen *philoi*, who, reclining, drank from a shared wine cup, spoke or sang in turn, and engaged in friendly competition. It continued to promote, in theory if not always in practice, the values of moderation, equity among the group, and commensality for the purpose of creating bonds of friendship within the polis outside of the spheres of kinship. The Classical symposium, our fourth-century sources suggest, remained a site of complex, nuanced, and evolving discourse around political and social relationships. It is not until the end of the fourth century that there are signs of major changes in its fundamental form and social function. Macedonian androns of this period suggest a trend toward larger groups and less secluded drinking, and as of even the early third century, the way was opened to extravagant Hellenistic banquets, in which the kind of equitable commensality sought in the symposium was neither possible nor, probably, desirable.[53]

I wish to suggest with the above overview that, on the one hand, the symposium was an institution that we may fairly treat as distinct and consistent—its fundamental features recognizable at least over the entirety of the Classical period—and an institution that, in fact, we know relatively well from a variety of sources. On the other hand, like any social institution that persists in varied and localized forms and over centuries of profound social and political change, the symposium is a site in which a range of tensions, ideals, dramatizations, adaptations, and even contradictions, real and rhetorical, circulated: "Symposiasts spoke about and orientated themselves in relation to past and present, to the world outside, and to the community within. Quite how and why varied from *polis* to *polis*, group to group, poet to poet, singer to singer, verse to verse."[54] It was a setting that scrutinized and challenged the participants' view of the world as frequently as it reinforced it.

A detailed look at the event itself has been necessary, since I depend heavily on the kind of behavior that was anticipated in the symposium, including the physical movement involved, the ideal result of the event, and the

(1998, p. 237) points out that "the market for sex, for wine, for fine foods was a complex system with a range of prices," and that, by the end of the fifth century, experience with the symposium could depend on one's generation rather than economic standing (see Ar. *Vesp.* 1207–1263); but for Wecowski (2014, pp. 10–11), nonaristocratic drinking parties, while they surely happened, should not be considered symposia.

53. Strootman 2014, pp. 188–189.

54. Hobden 2013, p. 8.

potential points at which it might fail. Surely, no two symposia were alike, but the highly ritualized structure of the event and the consistency of its social function meant that the space that hosted it was designed with certain assumptions about how it would be put to use.

The andron

The room in the Classical house that we call the andron is easy to recognize in the archaeological record.[55] Its most distinctive feature is a paved floor that includes a *trottoir*, an undecorated band, sometimes raised slightly above the floor's surface, on which the couches for the symposium would be set.[56] Its doorway is off-center to accommodate the placement of couches, usually numbering seven or eleven, end-to-end around the perimeter of the room.[57] The room is most often square, although some larger, rectangular examples exist. Many have drainage channels to facilitate cleaning.[58] In addition, they may be decorated with painted walls or, enclosed by the undecorated *trottoir*, a pebble mosaic floor. Anterooms preceded certain andro[n]es, separating them from the domestic interior, and extant threshold blocks suggest that some andro(n)es had doors to allow for further seclusion.[59] While the andron may be considered the most public room of the house, since men outside of the family were entertained there, Greek houses of this period were inward-looking, and visitors would have accessed it by moving through the interior domestic courtyard.[60]

The domestic andron appears in the archaeological record from the second half of the fifth century, and continues as a feature of houses of the fourth and third centuries. The bulk of the extant examples come from the

55. The literature on androand on the Classical house is extensive. For an overview, see Nevett 2010, pp. 43–62.

56. The *trottoir* usually measures between 90 and 120 cm wide. For various measurements, see Bergquist 1990. For alternatives to the typical encircling *trottoir*, compare Houses A.VI.1 and A.VI.5 at Olynthos: *Olynthus* VIII, pl. 97.

57. The number of couches a room contained was a kind of shorthand of measurement for the Greeks in referring to the size of the space; see McCartney 1934. The couches are approximately 1.8–1.9 meters in length.

58. Nevett 1995, p. 369.

59. Nevett 1995, p. 372; 2010, p. 48.

60. See Nevett 1995, p. 369; 2010, p. 49. Westgate (1997–1998, pp. 100–102) suggests that floor pavements and wall decorations may have helped to direct visitors through interior spaces to the andron.

northern Greek site of Olynthos, which remains the best preserved and most extensively excavated site for Classical domestic contexts, in large part because of its limited occupation: the site expanded in the last decades of the fifth century, and was destroyed and abandoned in 348. Although Olynthos is crucial, other andrones have been uncovered throughout Greece, including at Eretria, Halieis, Pella, Athens, and elsewhere in Attica.[61] The current evidence suggests that this room type does not have a clear predecessor in earlier houses, although the form closely follows that of dining rooms that survive from Archaic and Classical sanctuaries and public spaces.[62] If symposia were held within the Archaic household, they may have taken place in other kinds of spaces—in courtyards, less formal dining rooms, or multipurpose rooms— and it is possible that this arrangement continued in those many Classical houses without dedicated andrones.[63]

The andron begins to appear as a distinct domestic space at a time when the Greek house is also undergoing other changes: over the Classical period, rooms in Greek houses become bigger, more numerous, and more specialized than in the previous era, and the range of house sizes and complexity expands. This trend may be related to broad economic growth—indeed, many andrones belong to houses of moderate size rather than those of extreme wealth—as well as changes in ideology that encouraged the expression of status through the size and ostentation of private property, the management of the household, or the stricter stratification of groups, including women and slaves, within the domestic context.[64] In this milieu, the andron, a whole room dedicated to a male social event and often luxuriously decorated, both makes conspicuous the owner's ability to dedicate spatial and economic resources to such a specialized space, and simultaneously asserts his commitment to the social practices that defined citizenship.[65] While this is

61. See, generally, Nevett 1999, pp. 53–125, and esp. pp. 123–125; Ault 2000, pp. 487–488.

62. Nevett 2010, pp. 50–56. The Sanctuary of Demeter and Kore at Corinth serves as a particularly well-documented example of sanctuary dining. Here, dining rooms were in use from the third quarter of the sixth century to the destruction of the city in 146. Even the earliest of these bear some formal resemblance to the later andrones, most notably in the positioning of couches around the walls of the room, and the doorway's accommodation of this arrangement. Early, single-room units were later expanded to include additional rooms for cooking and washing. See Bookidis et al. 1999, pp. 5–11. Other examples include the sanctuary of Artemis at Brauron, for which see Kondis 1967. For a summary of additional contexts, see Morgan 2011, pp. 274–277.

63. See, for instance, Goldberg 1999, p. 152; Tsakirgis 2005, p. 77; Lynch 2007.

64. Hodder 2005, pp. 115–117; Westgate 2015, pp. 48–51, 78–85.

65. Nevett 2010, p. 62.

surely the case, it is difficult to generalize about the socioeconomic status of houses of the Classical period, and even more difficult to do so across Greece. Even at Olynthos, excepting the "villa area," the houses with mosaic floors cluster around an average size, so neither house size nor the related finds offer a "direct index of the affluence of the household."[66] Architectural elements like a mosaic floor or plastered walls must, indeed, have been a way of setting one's house apart from its neighbors, and it is certainly true that hosting symposia in one's own permanent andron would have required a financial commitment that not everyone could afford, but it remains the case that we cannot fairly generalize the various ways in which these spaces may have correlated to household or economic status in the fifth and fourth centuries.

At the end of the fourth century, however, the great influx of wealth to the Aegean after the campaigns of Alexander the Great and the foundation of the royal courts of his Successors stimulated clear, unprecedented displays of affluence. To this period belong two houses near the agora at the Macedonian capital of Pella: the House of Dionysos (House I.1) and the House of the Abduction of Helen (House I.5). These private luxury residences are, as Stewart suggests, more appropriately called mansions, since they are surpassed in size only, as far as we know, by the Macedonian palaces.[67] They boast multiple andrones—all larger than the typical 7-couch room, but still, technically, andrones in that they are small enough to encourage the commensal atmosphere of the symposium—and some of the finest extant examples of pebble mosaics. The House of the Abduction of Helen, though not fully excavated, had at least five (Rooms B, Γ, Δ, Θ, K), the smallest of which (Θ and K) accommodated 11 couches. The palace at Vergina, dating probably from the late fourth or early third century, had at least nine rooms for dining around its central courtyard (Rooms D, E, G, H, S, R, M_{1-3}; if N_{1-4} along the north side of the courtyard are included, the total is 13); the smallest of these rooms

66. Nevett 1999, pp. 74–79, quote from p. 79. Likewise, of the house associated with the assemblage of sympotic pottery of well J 2:4 in the Athenian Agora, Lynch (2011, p. 168) notes that it seems to be of relatively modest size, but that its status is "difficult to assess without comparative evidence. Since so few houses excavated in Athens preserve sufficient evidence to characterize their household artifact assemblage, there is no context in which to place the markers of status (or lack of status) from this house"; see also Tsakirgis 2005 for houses around the Athenian Agora. For the general trend of increasing household sizes between 800 and 300 and the difficulties in determining economic status from archaeological material, see Morris 2005, esp. pp. 115–117 on domestic architecture. See also Hoepfner and Schwandner (1994) for the potential importance of ideology in determining the form of domestic spaces.

67. Stewart 2014, p. 197.

were andrones that fit 15 couches, while the largest were truly royal banquet rooms, with space for 30 couches.[68]

Distinctive as the andron is in the archaeological record, it presents a series of complexities and controversies that we cannot avoid addressing here, since they have implications for the contextualization of the pebble mosaics. The first issue, which Morgan has pursued in depth, is one of terminology.[69] The modern identification of the ancient term "andron"—literally, "the space of men"—with this particular type of room comes from Vitruvius, who says that the Greeks called "andrones" those rooms in which they held the men's dinner parties (6.7.5). Apart from Vitruvius's late date in the first century, his description of the Greek house, in which the andron is mentioned, seems to take as its model not a typical Classical house, but rather, wealthy houses of the Hellenistic period.[70] Neither Plato's nor Xenophon's *Symposium* is set in a room explicitly called the andron, although they take place in the private houses of Agathon and Kallias, respectively.[71]

Complicating the confusion around the andron is another term, *andronitis*, which ancient authors do use to refer to the Classical domestic setting and which describes the men's space in contrast to the *gynaikonitis*, the women's quarters. But even in the case of the *andronitis* and *gynaikonitis*, which literary

68. For these examples, and for discussion of changes to the andron and to pebble mosaics in the Hellenistic period, see Westgate 1997–1998, pp. 104–115.

69. Morgan 2011.

70. Antonaccio 2000, p. 524.

71. The early appearances of "andron" in Herodotos and tragedy seem to refer most often to a room or suite of rooms in the palaces of eastern kings or tyrants, and Morgan (2011, pp. 269–272) argues that even when sources from the end of the fifth century use "andron" to describe a room in the house of a private Athenian citizen, they do so with the intent of implying (unfavorably) his imitation of eastern luxury and power. Androns are mentioned at Hdt. 1.34 (in Croesos's palace), 3.77–78 (at Susa), 3.121, 123 (in Polykrates' house on Samos), 4.95 (in Salmoxis's residence in Thrace); Aesch. *Ag.* 244, *Cho.* 712; Xen. *Symp.* 1.4.3–7. Complicating this picture, perhaps, are the two rooms, Androns A and B, at fourth-century Labraunda, a Karian site in southwest Turkey. These rooms are identified as androns in inscriptions that also tell us that they were dedicated by the Hekatomnids Mausollos (ca. 377–353) and Idrieus (ca. 351–344), respectively, to Zeus Labraundos. On the one hand, these huge 20-couch rooms, dwarfing the 7-couch andron of the Classical house and dedicated by Persian dynasts, seem to confirm Morgan's claim that the term "andron" describes rooms associated with the luxurious constructions of eastern dynasts. And that they are feasting rooms in a sanctuary rather than a domestic context is a crucial difference from "private" androns. On the other hand, Androns A and B both have a plaster border for couches, and so it would seem that "andron" is used in this fourth-century context (that is, long before Vitruvius) to describe a specialized room for men's reclined banqueting. For the Labraunda androns, see Hellström and Thieme 1981; Hellström 1996, 2011. The inscriptions are published in *Labraunda* III.2, pp. 9–11 (Andron B, no. 14), 11–13 (Andron A, no. 15).

sources suggest we should interpret as distinct architectural areas, archaeological remains have offered no clear physical division of the typical Greek household into separate, gendered quarters.[72] Indeed, confronted with the difficulty of locating such areas in fixed domestic architecture, scholars have recently looked instead to the ways in which portable furniture, physical presence, and culturally readable behaviors might have helped to establish space as temporarily gendered.[73] While certain physical elements, like doorways, curtains, or furnishings (some discernible in the archaeological record, and some not) may be read as marking a certain kind of space, "visual, verbal, even aural cues would also enable the change and shifting of territories with daily routines, special occasions, or seasonal change."[74] Many gendered boundaries (and other kinds of boundaries as well) within the Classical house, therefore, may have been flexible—though, we should be clear, these boundaries were no less real, despite their physical absence from the archaeological record. While productive in many respects, this potential flexibility in the Classical house raises two questions that get to the knottiness of the andron as a concept and as a physical space. First, is any place where men gather to drink and dine an andron, even if temporarily? And, second, the room that we identify as the andron accommodated a "gender-specific function," but was the room itself gender specific, or, during times when there was no symposium, could this space have been put to other (non- or differently gendered) uses?[75]

While the former question is outside the scope of our concerns here, the latter introduces a further issue, to which Morgan has also pointed: the variety present among the spaces that we have designated as androns. While they share certain features—a paved floor, a band for the placement of couches, an offset doorway, as outlined above—rooms identified as androns vary in size, shape, and decoration, and they are inconsistent in their placement in the house, especially in relationship to the house's entrance. The category, in other words, implies a conformity that the archaeological record does not always

72. The literary sources on which this distinction is based are Lys. 1.9 and Xen. *Oec.* 7–10, esp. 9.5. For an attempt to locate women's quarters in the Classical house plan, see Walker 1983. For the difficulties with this and an alternative approach, see Jameson 1990a, pp. 104–106; 1990b. Nevett (1994) discusses both approaches and attempts to strike a balance in her call for examining finds distribution in addition to plans.

73. Lynch 2011, p. 76; Morgan 2011, p. 272. For further discussion of gendered spaces in the Classical house, see Jameson 1990a, p. 104; 1990b, pp. 183–191; Nevett 1994, pp. 107–110; 1995, pp. 373–374; 1999, pp. 72–73; Goldberg 1999; Morgan 2010, pp. 117–142. For some of the theoretical concerns and approaches to domestic space, see Kent 1990; Small 1991.

74. Antonaccio 2000, p. 531.

75. Ault 2000, p. 490.

bear out. Morgan's concern is that other potential, and anomalous, functions of such rooms might be overlooked.[76]

The variations that are possible within the type of room that we call the andron are worth remembering as we move forward, and they may indeed reflect substantial flexibility in the function of this domestic space. When an andron is present in a house, but not in use for a symposium, we could imagine it serving as a guestroom, an office for private negotiations, a site for ritual dining, or even for storage.[77] These roles, however, are hypothetical, since finds associated with andrones do not consistently help to articulate a spectrum of use.[78] And, as Westgate points out, there is at least one reason why these rooms may not have been regularly put to other uses: the devotion of space in the house to male socialization—"this unusually *in*flexible use of space," at a time when most houses still did not have a dedicated dining room—conspicuously demonstrates the owner's abundance of space and positions him economically and socially.[79]

Morgan's overarching argument, bolstered by both her critique of our use of "andron" and her emphasis on the variations in its form, is that semantics matter—and her point is an important one. Our identification of certain rooms as andrones has privileged textual sources by applying to the archaeological evidence an apparently precise term whose ancient implications we do not, in fact, fully understand. Further, our use of "andron" assigns to these spaces a relatively limited and highly gendered function that perpetuates the study of men's social space at the expense of women's or family space. I admit that I will not correct this inequity in this book. Whatever the other uses to which these spaces were put (and surely this depended on a given household's needs—spatial, personal, or social—at a given moment), what is clear from the archaeological record is that the rooms we have come to call andrones were explicitly and primarily designed to accommodate reclined dining and drinking: a specific number of couches, whose place is permanently designated by the *trottoir*, determine the size of the room and the placement of the doorway. Further, by designating the setup of couches around the room,

76. I embrace Morgan's caution around the relatively uniform modern treatment of andrones and her work toward rethinking the spectrum of private and semipublic roles that this space (and, by extension, any household) may have played, but find unsupported her implication (2011, pp. 277–280) that perhaps buildings with andrones at Athens and Olynthos were not houses at all; see also Tsakirgis (2016) on recognizing Greek houses.

77. Jameson 1990b, pp. 189–190.

78. Cahill 2002, pp. 186–187.

79. Westgate 2015, p. 85.

the space encourages the construction of group identity through circularity, which, as we have seen and will address in more detail below, is a crucial function of the symposium. I will proceed, therefore, to refer to the rooms under discussion here—rooms that I do believe are recognizable as distinctive in the archaeological record, despite their variety—as androness, and I will concentrate on the use of these rooms as a setting for the symposium.

Pebble mosaics

Like their later Roman counterparts, pebble mosaics are exclusively floor decorations, but instead of cut glass, stone, or ceramic tesserae, they are made of small, naturally shaped and colored stones set into plaster or clay.[80] While the inconsistencies in the shape and size of the pebbles make it difficult to set them flush with one another, a few of the finer examples—featuring small, densely set stones and the articulation of important details like contour lines in terracotta or lead strips (as in figure 1.2)—demonstrate the precision possible in the medium. Black and white pebbles dominate in the earliest mosaics, but other colors, particularly shades of gray, red, purple, and yellow, are also

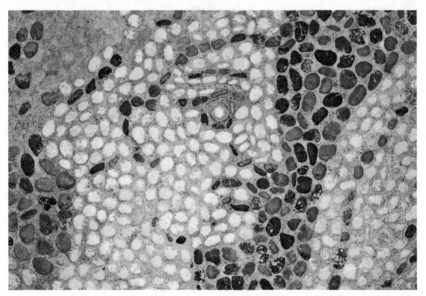

FIGURE 1.2 Detail of sphinx, pebble mosaic from Rhodes, early third century. Rhodes Archaeological Museum. Photo H. M. Franks

80. For overviews, see Baldassare 1984; Walter-Karydi 1988, pp. 56–64; Ling 1998, pp. 19–28; Dunbabin 1999, pp. 5–17; Fiori, Tolis, and Canestrini 2003, p. 15, fig. on p. 17.

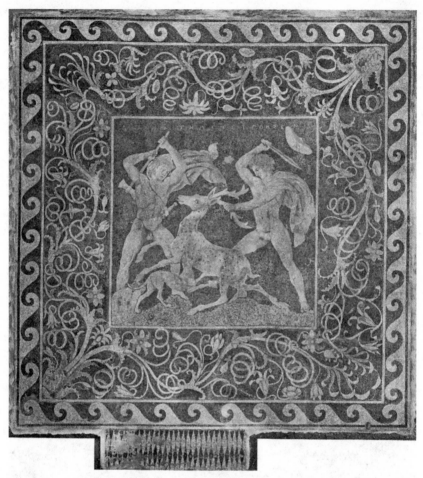

FIGURE 1.3 Stag hunt, pebble mosaic signed by Gnosis, from House I.5 (House of the Abduction of Helen), Pella, late fourth century. In situ. Photo © Hellenic Ministry of Culture and Sports, Archaeological Ephorate of Pella

incorporated to highlight details and, by the end of the fourth century, to create nuanced modeling and shading. The colors are used particularly skillfully in a mosaic depicting a stag hunt from Pella's House of the Abduction of Helen (figure 1.3), probably dating to the late fourth century, and in the mosaic of Hades abducting Persephone from the second chamber of the recently discovered tomb near Amphipolis.[81]

81. On the Pella mosaic: Picard 1963; Andronikos 1964a, pp. 295–296; Petsas 1978, pp. 95–97, 99–102, 107–111; Cohen 2010, pp. 30–38, 308, n. 62, with further bibliography. The Amphipolis tomb has not been published, but its excavation was widely reported in the international press; see, with an image, *Amphipolis* 2014.

FIGURE I.4 View of Centaur Bath, Corinth, last third of the fifth century. In situ. Photo courtesy American School of Classical Studies at Athens, Corinth Excavations

The patterned, floral, and figural pebble mosaics discussed here appeared with regularity in Greece from the second half of the fifth century, and they flourished in the fourth. Our earliest examples are from Kerameikos Z1 in Athens, which, although no longer extant, may have dated to the last third of the fifth century, and the central room of the Centaur Bath in Corinth (figures 1.4 and 1.5) from the same period.[82] Although rare examples of pebble pavements from Bronze Age and Archaic Greece survive, the origin of patterned mosaic floors in the Classical period is obscure.[83] From the eighth century, pebble floors, some with patterns or an array of geometric designs, were more common to the east, in Anatolia and north Syria, the best known and most exceptional of which are from Gordion in Phrygia.[84] But the precise

82. Knigge and Kovacsovics 1983, pp. 218–220, on the Kerameikos; Williams and Fisher 1976, pp. 108–115, on the Centaur Bath.

83. See, generally, Dunbabin (1999, p. 5), as well as examples from Podzuweit and Salzmann 1977; Demangel 1923, p. 16, fig. 22; Driessen et al. 2008, p. 95. The date of a fine pebble pavement mentioned in Dawkins (1929, p. 7) is unclear.

84. For an overview of the Gordion mosaics, see Young 1965. There are also contemporary mosaics from Arslan Tash (Thureau-Dangin et al. 1931, p. 43, fig. 31), Til Barsib (Thureau-Dangin and Dunand 1936, pp. 23–25, pl. 42; Bunnens and Russell 2012), and Tille (French 1985, p. 6; 1986).

FIGURE 1.5 Detail of centaur, pebble mosaic from the Centaur Bath, Corinth, last third of the fifth century. In situ. Photo courtesy American School of Classical Studies at Athens, Corinth Excavations

relationship between these examples and the Greek mosaics is unclear, as is the later development of tesserae, which appeared by the mid-third century and replaced pebbles almost entirely by the end of the second century.[85] Our best evidence for experimentation around this later transition are mosaics that use stone chips or artificially shaped stones in place of pebbles, or that combine various techniques by including, for example, naturally shaped pebbles alongside regularized tesserae (as in the mosaic of Erotes hunting a stag from Shatby, near Alexandria, and figure 1.6, a mosaic from Rhodes depicting a griffin).[86] In any case, as this brief overview suggests, the group of images considered for this book is restricted naturally: by concentrating on pebble mosaics from andrones, I am primarily limited to contexts of a long fourth

85. For discussion of this later transition, see Dunbabin 1979, 1994; Salzmann 1982, pp. 59–62; Westgate 2002, pp. 225–230; Fiori, Tolis, and Canestrini 2003, pp. 48–52.

86. For the great variety of these combination techniques, see Dunbabin 1979, pp. 266, 268–269 (chip technique), 270–273 (irregular tesserae), 274–276 (mixtures). For the Erotes mosaic, see Daszewski 1985, pp. 75–78, 103–110, 180–181, color pl. c, pls. 4–7; Salzmann 1982, pp. 62–64, for the technique. For the Rhodes griffin mosaic, see Konstantinopoulos 1973, pp. 119, 121, fig. 10; Michaud 1973, pp. 389, 392, fig. 302.

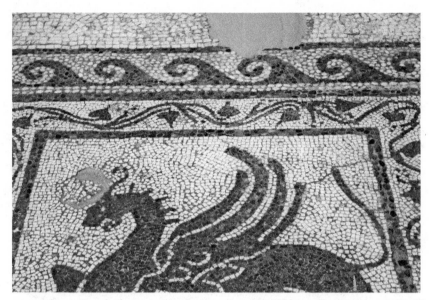

FIGURE 1.6 Detail of mosaic showing mixed use of pebbles and tesserae, second half of the third or first half of the second century. Rhodes Archaeological Museum. Photo H. M. Franks

century (from the late fifth into the early third), and, with a few exceptions, to sites on the Greek mainland.[87]

Although pebble mosaics, as stone floor decoration, can survive beautifully in the archaeological context, one of the major challenges to the expansion of the extant corpus has been their concentration in domestic contexts, which, on the whole, are not widely preserved or excavated. Like the evidence for the Classical household, most of the examples of pebble mosaics come from Olynthos and Eretria, with others from Athens, Rhodes, Sikyon (where domestic architecture of this period is more spottily preserved than in the former sites), and Pella (which features unusually wealthy Early Hellenistic homes) (figure 1.7).[88] In some cases, the andron context might only be hypothesized through the size, shape, or design of the extant mosaic, as at Sikyon, where chance finds as early as the 1930s led to the recovery of mosaics from contexts now lost. The destruction of Olynthos in 348 provides a crucial terminus ante

87. In the Hellenistic period, the geographical range of the "Greek" world expands, and there are examples of pebble mosaics in the Greek style as far east as Ai Khanoum in Afghanistan, but these mosaics are not associated with Classical-style androns.

88. For an overview of the sites with pebble mosaics, see Fiori, Tolis, and Canestrini 2003, pp. 25–31, with map on p. 31.

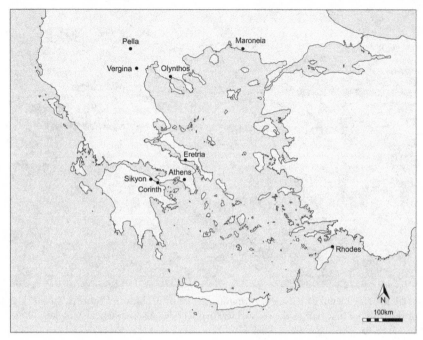

FIGURE I.7 Map of Greece showing sites with pebble mosaics represented in this book. M. Grimaldi.

quem that serves as a linchpin in the construction of a relative stylistic chronology of the extant mosaics. The scaffolding of this chronology was developed primarily by Salzmann, who depended upon careful comparison of the mosaic imagery with iconographic and stylistic trends in vase painting and sculpture.[89] His 1982 study, *Untersuchungen zu den antiken Kieselmosaiken*, remains the foundational work on and most comprehensive catalogue of pebble mosaics in the Greek world. It is now, of course, several decades out of date, but the periodic international colloquia of the Association international pour l'étude de la mosaïque antique (AIEMA) and its published proceedings and bibliographies are helpful in filling in certain gaps.

As a perusal of Salzmann's catalogue makes clear, pebble mosaics did not appear exclusively in private houses. But the archaeological evidence suggests that this was their predominant context: according to Westgate's 1998 calculations, 78.5 percent of Classical and Hellenistic mosaics in identifiable buildings (288 of 367, including pebbles and tesserae) are in domestic

89. Salzmann 1982, pp. 9–41.

settings; the remaining 21.5 percent are split among religious buildings, public spaces, baths, and tombs.[90] Further, the pebble mosaics that survive in domestic contexts are overwhelmingly associated with andrones. Westgate's study suggests that of the extant pebble mosaics whose location in the house is known, nearly 80 percent appear either in an andron (65 percent of the total) or in the anteroom to an andron (14 percent).[91] This close association of mosaics with the andron is a logical one: mosaic floors, after all, are relatively easy to clean (not an unimportant consideration in a room for wine drinking), and, along with painted walls and other decoration, they would attest to the resources and taste of the owner, as discussed above.[92] Pebble mosaics seem so deeply connected to the sympotic context, in fact, that Westgate has suggested that the distinctive Classical design—consisting often of concentric bands of decoration around a central vegetal or geometric motif—may have developed in Greece for the very purpose of paving the andron, since this arrangement of imagery accommodates viewing angles from various points around the periphery of the room.[93]

Some have posited a relationship between mosaics, particularly those of high quality, and painting, a medium that also flourished in the fourth century, but is now largely lost.[94] Focus for this comparison has landed easily on the Pella stag hunt mosaic, mentioned above (figure 1.3), since this work depicts dramatic, overlapping forms through complex ("painterly," it may be said) shading and modeling that is achieved by subtle variations among the pebbles' colors. It is also unique in its inclusion of an artist's signature, *Gnosis epoesen* ("Gnosis made [it]"), across the top—although who exactly Gnosis was, we do not know. The nature of any potential influence, whether mosaicists would have recreated specific paintings or pulled from pattern books, or whether they primarily borrowed stylistically, remains obscure, as it does for the relationship between mosaics and other arts, like textiles,

90. Westgate 1997–1998, p. 94, n. 2.

91. Westgate 1997–1998, pp. 94–97. Of Westgate's total of 76 pebble mosaics in houses, the location of 17 is unknown. The percentages here are taken from the 59 pebble mosaics whose location is known, 46 of which are in an andron or anteroom; if the 17 mosaics from unknown locations are included in the percentage calculations, the known pebble mosaics from andrones or anterooms is still a majority, at just over 60 percent (46 of 76).

92. Westgate 1997–1998, p. 97; 2002, p. 222; Nevett 2010, p. 48.

93. Westgate 1997–1998, p. 102.

94. See, e.g., Robertson 1982, pp. 241–242, 247; Ginouvès 1993, pp. 130–132; Stewart 2014, pp. 200–201.

which have also been cited as a possible inspiration for the stone "carpets."[95] The newly exposed mosaic from the tomb at Amphipolis bears a remarkable resemblance to the painting of Hades abducting Persephone on the interior wall of Tomb I at Vergina, and may promise some forward movement on this front.[96]

The subject matter and compositions of mosaics in androngs are surprisingly varied, but we may discern some loose patterns. As mentioned above, one popular organization of pebble mosaic floors is a series of bands that circle a central image. The concentric frames in this schema often feature patterns of waves, vines, meanders, or checkerboards, and the central motif might be a star, wheel, flower or series of flowers, or other vegetation. Floral patterns in particular may ignore the concentric design model and take over the entire floor. Figures, of course, also appear, sometimes as the subjects of the central scene, although they may also be included in the frames. When appearing in a single scene as the central panel, figures are normally oriented to be seen from the doorway, presumably so that the whole may be observed as one enters the room.[97] Westgate's estimates are that about 40 percent of pebble mosaics depict figural scenes, including humans or fauna.[98] Of these, animals feature about twice as often as human or divine figures.[99] These animals are domesticated (horses, dogs), wild (hares, stags, boars, birds, lions, and the big cats that Classical scholars often call panthers, although they may be spotted), mythological (griffins, sphinxes, centaurs, a harpy), and aquatic (fish and dolphins, as well as composite sea creatures like tritons, *ketoi*, and Skylla, which might also be considered mythological). Scenes of hunting are rare, but the lion and stag hunts at Pella (figures 1.3 and 1.8, from Houses I.5 and I.1, respectively) suggest the popularity of this theme among, at least, the Macedonian elite, and the appearance of dogs elsewhere (as, for instance, in an andron mosaic at Sikyon) might allude to the activity.[100] Depictions of mythological subjects

95. Bruneau 1976, p. 20; Guimier-Sorbets 1999, pp. 33–34; Fiori, Tolis, and Canestrini 2003, pp. 23–25.

96. *Amphipolis* 2014; for Tomb I at Vergina, see Andronikos 1994.

97. Westgate 1997–1998, p. 102; see also Stewart (2014, pp. 197–198), who emphasizes the orientation toward the presumed position of the *symposiarch* near the doorway.

98. Westgate 2011, p. 291.

99. Westgate 2011, p. 296.

100. Salzmann 1982, p. 112, no. 119, pls. 10.1–2, 11.1–4. See Westgate (2011, pp. 303–304) for this mosaic and its potential use of the dog and hare as symbols of the human sport of hunting, and of the lion and boar as symbols of warfare.

FIGURE 1.8 Lion hunt, pebble mosaic from House I.1 (House of Dionysos), Pella, late fourth century. Pella Archaeological Museum. Photo © Hellenic Ministry of Culture and Sports, Archaeological Ephorate of Pella

are likewise uncommon—surprisingly so, given the popularity of such scenes in other media. As we will see, the subjects of these scenes are also surprising, since they are not always, at least at first glance, obviously "sympotic."

Previous interpretations of these various mosaic themes have, generally, read the imagery as related to the "Dionysiac" realm, as symbols of eastern luxury, or as metaphors for masculine behavior. These are not necessarily mutually exclusive interpretations, and they do not necessarily conflict with the analyses offered in the chapters to follow—in fact, my arguments often build on this work. The association of certain imagery with the world of Dionysos arises from the function of the andron as the site of the symposium, where the god was naturally a presence, embodied in the wine. Although Dionysos himself is represented only rarely, certain motifs and visual themes, including those that appear most frequently in mosaic imagery, might indeed evoke the Dionysiac realm without explicitly depicting the god.[101] Some animals, in particular griffins and panthers, are frequently shown in the company of Dionysos in vase painting: the panther was an animal specially associated with the god, perhaps because of its own reputed love of wine, and the griffin may have become attached to Dionysos through Apollo and their shared occupation

101. Guimier-Sorbets 2004.

of the sanctuary at Delphi.[102] Other animals might evoke the wildness that is part of Dionysos's nature or his cultic connection to the eastern goddess Kybele, the mistress of animals, while vines and foliage might symbolize his chthonic identity.[103] Centaurs, ever the wine enthusiasts, "are regular members of Dionysos' entourage" by the fourth century.[104] Marine life may represent the close association of Dionysos to the sea that arises, in part, from various episodes of his mythical biography or from metaphorical links between wine and the sea.[105] That these themes have a general connection to wine and the Dionysiac realm, broadly defined, is clear. But that connection does not explain why these subjects were chosen, while others were not: satyrs and maenads, who abound in vase painting alongside the god, appear only rarely in the mosaics; likewise, references to theater, another arena under Dionysos's patronage that might be seen as having rich potential for parallel in sympotic performances, are absent from the mosaic corpus in the period under study here. So, while many of the images in pebble mosaics might indeed have a relationship to the world of Dionysos, that association does not necessarily make a motif appropriate for andron decoration, and this encourages us to look for further significance in the images that do appear.

Some have identified certain motifs, particularly griffins, sphinxes, and big cats, as well as animal combats, as evoking not only the world of Dionysos, but also the exotic luxury of the east, where they have a long visual history. Westgate, for instance, has argued that in the andron, a Greek might display these "eastern" motifs—symbols of the power of the foreign king (as the sphinx, for instance, in Egypt, or the attacking lion motif)—to convey an "aura of power and authority."[106] Guimier-Sorbets proposes that the mosaics replaced textile carpets imported from regions like Phrygia, and, in doing so, imitated their iconography.[107] In the context of the andron, these general associations of "exotic" iconography with the east have been buttressed in no small part by the traditional understanding of the symposium itself as

102. Westgate 2011, p. 298. For the panther as a special animal of Dionysos, see Detienne 1979, pp. 38–39; an image of Dionysos's *thiasos* includes a panther on, e.g., London, British Museum 1772,0320.143 (F81) (red-figure bell krater, 400–380): *ARV²* 1442.2. For the griffin shared between Apollo and Dionysos, see Delplace 1980, pp. 372–376.

103. Guimier-Sorbets 2004, pp. 901–910, for wild animals, 912–918, for vegetation.

104. Westgate 2011, p. 298.

105. Guimier-Sorbets 2004, pp. 910–912.

106. Westgate 2011, pp. 294–299, quote from p. 299.

107. Guimier-Sorbets 1999, pp. 33–36.

a custom that emerged in the Archaic period from aristocratic imitations of Asiatic luxury practices, adopted as an expression of a specifically elitist ideology.

This package is not, however, as neat as it first seems—even if we put aside debates over the symposium's origins and ancient Greek narratives about those origins. Certainly, the mosaics themselves are a sign of individual status, as is the andron, and they undeniably create, along with additional interior decoration, an ostentatious setting for the symposium. But it is not clear that, by the time the andron appears as a distinct architectural space in the Classical period, these motifs carry with them, exclusively or even primarily, connotations of "eastern" luxury and royal power. Indeed, by the end of the fifth century, the griffin, for instance, had been a common element of Greek iconography for centuries. As I will discuss in chapter 2, the Greeks had a lively mythology for the griffin that identified its habitat as the distant, mysterious landscapes at the edges of the world. The beast may indeed evoke a foreign setting, but its attachment to an exotic habitat is different from seeing the griffin as an imported symbol of Asiatic (Assyrian or Achaemenid) royal authority. That is to say, while certain animals may be exotic, their iconography was not—at least not necessarily: it existed already in the visual vocabulary of Greece, and it is in relationship to this visual tradition that it takes on meaning. Stripped, then, of an "Orientalizing" sympotic context, the identification of mosaic decoration as primarily "Orientalizing" becomes problematic.

The other main interpretation of the mosaic imagery is that it presents a model of masculinity for the Greek male audience. Both wild animals and scenes of heroic combat could serve, Westgate proposes, as "embodiments of ideal masculine qualities such as courage, aggression, strength, athleticism and physical attractiveness, which a male viewer might have liked to feel were shared by himself and his friends."[108] Cohen has focused in particular on the potential relationship among the mosaics from the House of the Abduction of Helen (I.5) at Pella, which include the stag hunt mentioned above, Theseus's abduction of Helen (for which the house is named), and an Amazonomachy.[109] These themes would have been especially salient in Early Hellenistic Macedonia, particularly among an increasingly wealthy elite, who may have participated in or profited from Alexander's campaigns abroad. Together, they present a program of control and dominance over, respectively,

108. Westgate 2011, p. 300.

109. Cohen 2010, pp. 20–63.

animals, women, and foreign (female) enemies; each "serves as a monoscenic *paradigm* of masculine glory through bodily exertion."[110] Cohen looks, too, at exotic animals, and particularly animal combat vignettes in various media, including pebble mosaics, proposing that they express the theme of predation, which might serve as a simile for any number of (masculine) human behaviors, including the hunt, sexual conquest, or warfare. This, "the agonistic spirit" of such images, may have seemed especially appropriate in the political upheaval and violence of the early Hellenistic period.[111] It also points to—and potentially reframes—the competitive tension among equals that features in the symposium. Cohen's interpretation of the Pella mosaics beautifully explains the imagery with which she is concerned, but the paradigm of masculinity is not easily applied to all andron decoration.

Aside from the very general iconographic groups described above, what most defines the andron mosaic is, at least in the current state of our corpus, the unique status of each work. While this seems to put us at a disadvantage, it is worth remembering that variety also characterizes the iconography of vase painting on sympotic vessels, and we can learn here from the treatment of this diversity, which scholars have shown to relate to the symposium context in a variety of ways. So I certainly proceed with caution, since different images may be appropriate to this setting for different reasons. But it is also the case that the mosaics share important features in their horizontal positioning and in the specialized context of the andron. It is from this foundation that this book moves forward.

110. Cohen 2010, pp. 62–63 (Cohen's emphasis).

111. Cohen 2010, pp. 114–115.

2

The Journey Out

SYMPOSIUM AT SEA

IN SHAKESPEARE'S *Twelfth Night* (1.5.130–133), an exchange between Olivia and Feste plays upon the watery overlap of shipwreck and festive drinking:

> OLIVIA: What's a drunken man like, fool?
> FESTE: Like a drowned man, a fool, and a madman. One draught above heat makes him a fool; the second mads him; and a third drowns him.

Like the modern proposal that we "drown our sorrows," or the description of someone drunk as being "three sheets to the wind," Feste's quip suggests a metaphoric link between drinking and the sea. In ancient Greece, this connection was deeply felt, and the symposium, the domain of Dionysos (a sailor himself), offers an ideal setting for its exploration.

This chapter takes as its subject the symposium-at-sea, a corollary of this larger cultural association that brings together the conceptual realms of the Classical drinking party and the nautical journey as an experiential metaphor in the space of the andron and during the symposium. I concentrate on two pebble mosaics from Eretria and Sikyon that incorporate fantastic imagery that cannot be easily explained as simply Dionysiac. These mosaics serve as the foundation for understanding the way in which the absolute, relative, and relational spaces of the andron engage one another to produce the metaphor of the symposium as an imagined journey at sea, during which the symposiast "sailors" glimpse exotic, foreign landscapes in the mosaic imagery before them. I then turn to mosaics depicting the sea monster Skylla, which offer

an alternative perspective—threatening devastation, even while presenting maidenly appeal, to those symposiasts lost at sea.

The mosaics

Eretria's House of the Mosaics is prominently located near the foot of the ancient city's acropolis, at the intersection of two important roadways—one leading south to the Temple of Apollo Daphnephoros and the agora, and one running between the east and west city gates to the theater and Temple of Dionysos (figure 2.1).[1] According to the excavators, the house was constructed in the first third of the fourth century and was destroyed in an unknown event

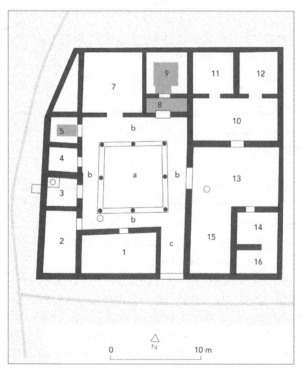

FIGURE 2.1 Plan of the House of the Mosaics, Eretria. Courtesy Swiss School of Archaeology in Greece

1. For the significance of this location, see Ducrey 1989, pp. 59, 62. Hardiman (2011, pp. 196–197) raises the question of whether the size and prominent location of the house indicate that it had a public function, but ultimately argues that it was a private domicile. Portions of the argument in this chapter were anticipated in Franks 2014.

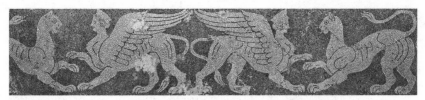

FIGURE 2.2 Griffins and panthers, pebble mosaic from Room 8, House of the Mosaics, Eretria, first third of the fourth century. In situ. Photo courtesy Swiss School of Archaeology in Greece

a century or so later.[2] The roof and walls collapsed inward, helping to preserve the pebble mosaic floors for which it is named. The House of the Mosaics may have had as many as three androns, each of which accommodated a different number of guests. The largest of these, Room 7, in the northwest corner, had a plain mosaic floor and painted stucco walls (red, yellow, and white), as well as decorative appliques, including a Gorgoneion and the heads of satyrs.[3] It would have held eleven couches. Room 5, with a floral floor mosaic featuring a Gorgoneion, was likely a small, three-couch andron.[4] Room 9, accommodating seven couches, boasts particularly elaborate mosaic decoration.

The rooms of the house are organized around a central peristyle court, and a visitor to Room 9 would enter from the peristyle and through a small anteroom (Room 8), decorated, like the andron proper, with a mosaic floor (figure 2.2). Here, a border of alternating palmettes and lotuses surrounds a rectangular panel in which a pair of sphinxes in the center face outward, each confronting a panther. The sphinxes possess the body of a lion with the breasts and head of a woman, as well as feathered wings that emerge from the shoulders. The panthers are well muscled, their shoulders and haunches defined by lines of black pebbles. The architecture of Rooms 8 and 9 may have added to the visual elaboration of this cluster of rooms: Reber has

2. Ducrey and Metzger 1979, pp. 4, 12–13; Ducrey 1989, pp. 51–52; Reber 1989; *Eretria* VIII, p. 177. The house's mosaics, which will be the focus here, are dated to this period as well, although Salzmann (1982, pp. 27, 90–91) argues that the mosaics are more appropriate to the middle of the fourth century, ca. 350–340, based on their style and use of color. After its collapse, the house was left apparently undisturbed until the first century, when a tomb was built on the site; see *Eretria* VIII, pp. 159–175.

3. For the decoration of Room 7 (6.7 x 6.7 m), see Ducrey 1989, p. 57; Reber 1989, p. 5. For a reading of the decorative scheme of the house as a whole, see Hardiman 2011.

4. For Room 5 (room = 2.9 x 2.9 m; mosaic = 2.2 x 1.36 m), see *Eretria* VIII, pp. 45–46, 85–86. For the Gorgoneion in mosaics, see Panagiotopoulou 1994.

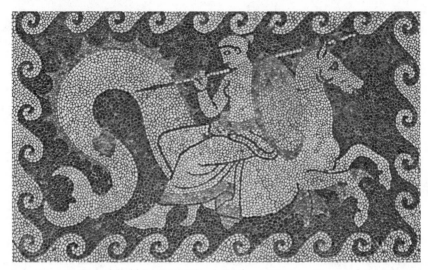

FIGURE 2.3 Nereid, pebble mosaic threshold from Room 9, House of the Mosaics, Eretria, first third of the fourth century. In situ. Photo A. Voegelin, courtesy Swiss School of Archaeology in Greece

proposed that Doric columns on a parapet separated the andron proper from its vestibule.[5]

At Room 9's threshold, in the place where the symposium couches break their circle, is a rectangular mosaic panel (figure 2.3). In it, a Nereid, a sea goddess, rides sidesaddle on a hippocamp and carries a spear and shield. The image likely refers to a scene called the arming of Achilles, a mythological episode in which the Nereids, sisters of the hero's mother, Thetis, deliver his armor and weaponry from Olympos.[6] Often, Achilles himself is shown seated, with Thetis nearby. A mosaic from the Villa of Good Fortune at Olynthos, roughly contemporary with the Eretria mosaic, is a typical example (figures 2.4 and 2.5).[7] In the Olynthos image, two Nereids ride their hippocamps to the left; one holds a shield and the other a spear and helmet. Achilles, identified by name, is seated at the left, and Thetis stands between her son and her sisters. The Eretria Nereid, shown without the company of her sisters or the figure of Achilles, presents a "quotation" of the full narrative, introducing to

5. *Eretria* VIII, pp. 58–61, with a rendering in fig. 65. Reber (1989, pp. 6–7, fig. 4, pl. I:5) usefully compares the proposed arrangement to the image of a symposium from a calyx krater in Leningrad (B 2338) in which two columns are present behind a row of reclining symposiasts.

6. Barringer 1995, pp. 17–48, and, for images of the arming, pls. 1–60.

7. Robinson 1934, pp. 508–510, pl. XXVIII; Salzmann 1982, pp. 102–103, no. 88, pl. 14:1.

FIGURE 2.4 Delivery of the arms of Achilles, pebble mosaic from Room g, Villa of Good Fortune, Olynthos, late fifth or early fourth century. In situ. Photo H. M. Franks

FIGURE 2.5 Detail of Achilles, Thetis, and Nereid, pebble mosaic from Room g, Villa of Good Fortune, Olynthos, late fifth or early fourth century. In situ. Photo H. M. Franks

those entering Room 9 the notion of travel by sea—a theme underlined by the border of waves surrounding her.[8] It is worth noting that, in addition to being a kind of sea traveler herself, the Nereid is also a protector of sailors.[9]

In a second mosaic panel that decorates the room's center, two square borders frame a central emblem (figure 2.6). The outer border consists of a

8. For an example of the wave pattern in connection to other explicitly nautical imagery, see Salzmann 1982, p. 118, no. 139, pl. 72:1.

9. Westgate 2010, pp. 499–501; Barringer 1995, pp. 39–41, 55–58.

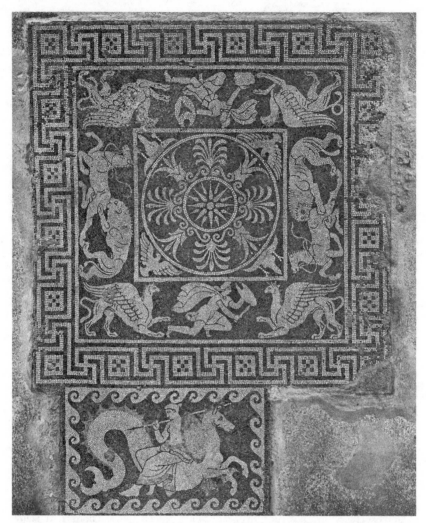

FIGURE 2.6 Grypomachies, pebble mosaic from Room 9, House of the Mosaics, Eretria, first third of the fourth century. In situ. Photo A. Voegelin, courtesy Swiss School of Archaeology in Greece

meander pattern, and the inner band features figural decoration. On its east and west sides, a lion mauls a horse, which is riderless but outfitted with a noseband and reins. Alternating with these lion attacks, on the north and south sides, are two grypomachies, battles against griffins. The griffin is a common subject in Greek art, and the Eretria griffins correspond to the typical representation of this composite beast: they have the body (including the front paws and long tail) of a lion, the head and wings of an eagle, and a

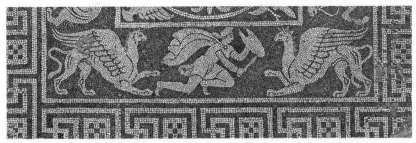

FIGURE 2.7 Detail of south grypomachy, pebble mosaic from Room 9, House of the Mosaics, Eretria, first third of the fourth century. In situ. Photo A. Voegelin, courtesy Swiss School of Archaeology in Greece

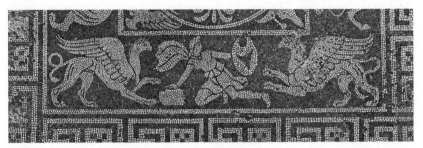

FIGURE 2.8 Detail of north grypomachy, pebble mosaic from Room 9, House of the Mosaics, Eretria, first third of the fourth century. In situ. Photo A. Voegelin, courtesy of the Swiss School of Archaeology in Greece

spiked crest that extends down the neck.[10] In the mosaic, the beasts converge on figures dressed in clothing that is, in the Greek visual tradition, typically "eastern": the figures wear a long, belted tunic, long sleeves, leggings, shoes, a cloak fastened at the neck, and the *kidaris*, a soft hat with side lappets. Both are armed with a *pelta*, a distinctive shield that has the appearance of a thick crescent. The figure on the south (figure 2.7) wields a sword, in what might be read as an aggressive lunge toward the griffin on the right, while the northern one (figure 2.8) appears to be less confident, leaning to the viewer's left and raising the *pelta* against one of the flanking griffins. In addition to the figural scenes and outer meander border, the mosaic includes eagles and *boukrania* (ox skulls) in the inner spandrels, and an alternating pattern of palmettes and lotuses surrounds a central 16-pointed star.

10. Written sources elaborate on the details of the griffin's appearance, saying that it is covered in feathers (black, with a red chest and white wings: Ktesias, *Indika* F45 sec. 26, *apud* Phot. *Bibl.* 72; Ael. *VH* 4.27) or spotted like a leopard (Paus. 8.2.7).

Metzger has connected the grypomachies and lion attacks of Room 9 to Dionysos.[11] Although griffins are most often associated with Apollo, who is sometimes represented traveling on griffinback, Dionysos has ties to India, where exotic and dangerous beasts like the griffins might be found, and he too, on occasion, rides a griffin.[12] Indeed, common as they are in Greek art, griffins are not associated with the landscape of Greece. According to Greek literary sources, they lived at the extreme northern or eastern edges of the earth (Ktesias, *Indika* F45 sec. 26, *apud* Phot. *Bibl.* 72; Ael. *VH* 4.27; Philostr. *VA* 3.48, 6.1).[13] Herodotos, for one, locates the griffins in the region immediately inland from the mysterious Hyperboreans, the most distant race of men on earth (4.13, 4.27; see also Pind. *Pyth.* 10.35). The historian's information about the griffins comes from the seventh-century poet Aristeas, who wrote of his journey to the distant land of the Issedones, a race of men living beyond the Skythian kingdoms on the far side of the Black Sea. From his Issedonian hosts, Aristeas heard stories not only of the griffins but also of Arimaspians, the race of one-eyed men to which the title of his poem, the *Arimaspeia*, refers. Aristeas's poem is lost, but the griffins are well known in other literary and visual sources for their fearsome conflicts with these Arimaspians, who invade the griffins' territory to collect gold that springs from the earth there (Aesch. *PV* 802–806; Hdt. 3.116, 4.13, 4.27; Pl. *HN* 7.10, 33.66; Pompon. 2.1; Philostr. *VA* 3.48, 6.1).

The conflict between the griffins and the Arimaspians is a popular subject on Greek vases of the fourth century (figure 2.9).[14] In these images, the Arimaspians are clothed in an exotic garb close or identical to that worn by

11. Metzger 1980; Salzmann 1982, pp. 49–52. See also Hardiman (2011, esp. pp. 193–196), who emphasizes its agonistic qualities.

12. For Apollo riding a griffin, see, e.g., Vienna, Kunsthistorisches Museum 202 (red-figure cup, fourth century): *ARV²* 1523.1. Franks (2009, p. 469, n. 55) discusses Apollo's association with the griffins in greater detail. For Dionysos riding a griffin, see Cracow, Cracow University 1079[129] (red-figure bell krater, fourth century): *CVA* Cracow, Collections de Cracovie, p. 42, pl. 10.1; Mainz, Johannes Gutenberg Universität 178 (red-figure calyx krater, fourth century): *CVA* Mainz, Universität, pp. 2, 20x, 21, suppl. 3.2, pl. 9.1–6; London, British Museum 1925.10–15.1 (red-figure bell krater, fourth century): *ARV²* 1453.9. For Dionysos with a thyrsos in a chariot drawn by a bull, griffin, and panther, see Paris, Musée du Louvre MNB1036 (red-figure pelike, fourth century): *ARV²* 1472.3.

13. Mayor (2000, pp. 15–53) introduces the intriguing possibility that stories of the griffins come out of early Skythian encounters with the fossilized bones of the Protoceratops in the area to the southwest of the Altai Mountains in central Asia. See also Mayor and Heaney 1993.

14. For example: London, British Museum, E434 (red-figure pelike, ca. 400–360): *ARV²* 1474. In the sixth and fifth centuries, the subject is rare but not unknown. Miller (2003, p. 41) cites a black-figure hydria in London (London, BM 1923.4–19.1, ca. 540–510) and the

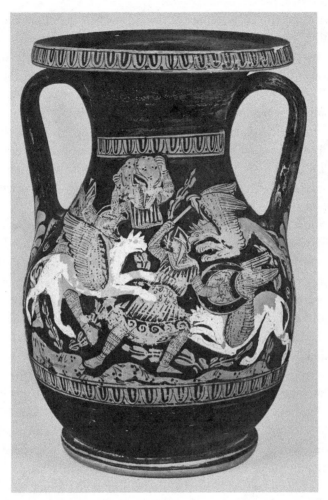

FIGURE 2.9 Grypomachy, red-figure pelike, ca. 400–360. London, British Museum E434. Photo © Trustees of the British Museum

the Eretria griffin fighters and, elsewhere in Greek iconography, by other "eastern" figures, including Persians and Amazons, the race of warrior women. This similarity in dress among these eastern characters has, in fact, led to some difficulty in distinguishing between them in certain scenes. As Miller explains, the general guidelines for individuals in such costumes are that "bearded figures are Persians, beardless figures are Arimasps or Amazons."[15]

so-called Kelermes mirror, a Skythian mirror from the early sixth century (St. Petersburg, State Hermitage Museum, Kou 1904, ca. 580–570).

15. Miller 2003, p. 41.

This may be useful, depending on the example in question, but further clarification between Amazons and Arimaspians (or Arimaspians and Persians, in scenes where bearded figures fight griffins) remains difficult, since, in the case of the Arimaspians, the single eye—their most distinctive feature and the one on which the literary sources focus most of their attention—is never explicitly represented in imagery.[16]

At Eretria, it is somewhat unclear whether the figures should be called Arimaspians, because they battle griffins, or Amazons, because they appear to have breasts.[17] Both are known as riders, and so the horses on the east and west sides of the mosaic—if, indeed, they should be associated with the grypomachies—point us in no particular direction.[18] Under either identification, however, the central point is that the imagery evokes a distant place with which the Greeks had no contact, a place where griffins dwell and where one-eyed men and women who act like men offer equally extreme departures from the Greek norm.

The pendant lion-and-horse vignettes in the Eretria mosaic reinforce the exotic flavor of the scene. The lion is best known in the Greek world as heroic prey: Herakles' defeat of the Nemean lion was the first and most frequently represented of his twelve labors. In Classical Greece, lions were not unheard of, and there seems to have been a small population that occupied the northern mountain ranges (Hdt. 7.126; Xen. *Cyn.* 11.1; Arist. *De an.* 6.31/597b7, 8.28/606b15; Paus. 6.5.5).[19] But historical—and even mythical—encounters with lions were rare, and the few lions that are mentioned in sources from this period seem to represent natural forces, interpreted as warnings to be heeded or threats to be tamed by heroic men. In one instance, the athlete Polydamas of Skotoussa, who fancied himself a latter-day Herakles, killed with his bare

16. Boston, Museum of Fine Arts 85.709 (red-figure pelike, fourth century): *ARV²* 1464.41, offers an example of a bearded griffin hunter. Is he a Persian or an Arimaspian?

17. Some of the griffin fighters of vase paintings also seem to have breasts, as on London, BM F230 (red-figure hydria, ca. 330–300, attributed to the Ixion Painter): *CVA* Great Britain, British Museum, p. 2, pl. 8:6; Baltimore, Robinson Collection, 13452 (red-figure pelike, ca. 360–350): *CVA* Baltimore, Robinson Collection, pp. 3, 34–35, pls. 309, 310, 15:2.2A–B, 16:1A–B. Stephani (1864, p. 74) suggested that these figures are Amazons and that the images correspond to an alternative tradition of Amazon-griffin battles that is no longer extant in literature. Metzger (1951, p. 331), however, identified them as female Arimaspians. Both are discussed in Miller 2003, pp. 40–42. See also Schefold 1934, pp. 147–153.

18. The Amazons are widely known as good riders, and are frequently depicted on horseback in Greek imagery. As for the Arimaspians, Aeschylus (*PV* 805), gives them the epithet *hippobamon* ("mounted on horses").

19. Helly 1968; Briant 1991, pp. 236–239; Franks 2012, pp. 38–39.

hands one of the lions that roamed Mount Olympos (Paus. 6.5.5). And in another episode from Macedonian mytho-history, Karanos, the ancient founder of the Macedonian kingdom, erected a trophy to celebrate his victory over neighboring Kisseus; a lion descended from Mount Olympos, toppling and crushing the trophy as a warning against such monuments (Paus. 9.40.8–9). In the Eretria mosaic, the lions, free to attack horses that are domesticated (as evidenced by their harnesses and reins), suggest that we are indeed far away from the civility and safety of the Classical city. While the lions that lingered in the Greek landscape served as occasional reminders of a past heroic age, lions were also associated with the Persian east.[20] In either case, they are beasts that were rare and rarely—if ever—encountered by citizens of the polis, hinting at a landscape that exists outside of their control.

When viewed as part of the lived event of the symposium, the wild, exotic beasts of a mosaic might create the impression of a foreign landscape, viewed from a distance. In this way, they reframe the experience of sympotic movement as a metaphorical journey to lands potentially accessed by the sea or bordered by the Ocean. Before exploring this possibility further, however, let us turn to another mosaic, this one from Sikyon, in the Peloponnese, which incorporates similarly exotic imagery.

Housed in the Archaeological Museum of Sikyon, this work is dated by style and technique to the middle of the fourth century, roughly contemporary with the Eretria example.[21] It presents some problems: to begin with, it is extremely fragmentary, although the reconstruction by Salzmann is convincing on many accounts (figure 2.10). Further, its context is unknown; it is associated with other mosaics from the plain to the east and west of the Asopos River—a region that Lolos has suggested belonged to wealthy houses located outside of the city proper.[22] Nevertheless, in addition to its likely

20. Alexander the Great's lion hunts in the Achaemenid hunting parks, the *paradeisoi* of conquered Persian capitals, were memorialized in literature and art alike, and inspired both the public display and royal activities of Hellenistic kings. For Alexander's hunts, see Curt. 8.1.1–16; Pl. *HN* 34.66; Plut. *Vit. Alex.* 40.4. For the influence of these hunts on Hellenistic kings, see Pl. *HN* 35.138; Polyb. 22.3.9; Athen. 5.102 b–c; Plut. *Life of Demetr.* 50.6. Modern analyses of the Achaemenid and Hellenistic lion hunts are extensive, but for good overviews, see Briant 1991, pp. 222–225, 242–243; Carney 2002, pp. 63–65; Seyer 2007, pp. 125–173.

21. For the Sikyon mosaic (est. 4.14 x 4.14 m), see Salzmann 1979; 1982, p. 111, no. 116, pl. 19:1–3.

22. Lolos 2011, p. 274. It seems as though the mosaic came to the museum in fragments over many years, but the accounts are at odds. Salzmann (1979, p. 292) indicates that some fragments were associated with the museum as early as 1935, while others arrived in 1941; Votsis (1976, p. 583) associates the mosaic with chance finds in 1968. For other finds in the area of the Asopos plain, see Votsis 1976; Charitonidis 1968.

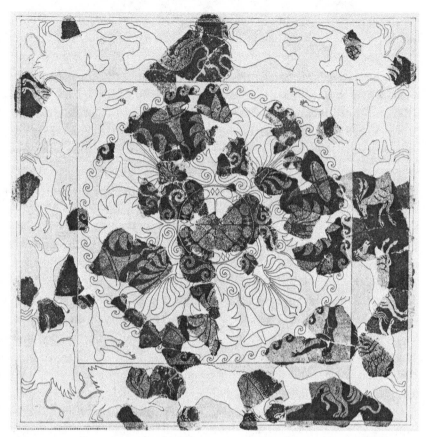

FIGURE 2.10 Reconstruction of pebble mosaic with animal frieze, Sikyon. D. Salzmann, after Salzmann 1979, p. 305, abb. 13 [*source image unmodified*]

origin in an extraurban elite house, there are good reasons to think that the mosaic is from an andron. These include the strong association of elaborate mosaics with such rooms during this period, the mosaic's (reconstructed) size and square shape, and the arrangement of the imagery so that it can be viewed from every side.[23]

The mosaic's square border includes horses, deer, big cats, at least one boar, and griffins—a series of animals that range from the familiar to the exotic. A circular vegetal pattern with a rosette, palmettes, and trumpet-shaped

23. Votsis (1976, p. 583, fig. 9) assumes that the pavement belonged to an andron. It would have been a relatively large room: adding 90 cm to each side of the reconstructed mosaic to accommodate the approximate width of the couches indicates that the room would have been close to 6 x 6 m. Androns of this size are certainly not unheard of; comparably sized examples exist at Olynthos, at House A.V and the Villa of Good Fortune, and, near the end of the century, at Pella. The 11-couch andron, Room 7 of Eretria's House of the Mosaics, is 6.7 x 6.7 m.

FIGURE 2.11 Ethiopian figure and animal frieze, pebble mosaic fragments, Sikyon, middle of the fourth century. Sikyon Archaeological Museum. Photo © Hellenic Ministry of Culture and Sports, Archaeological Ephorate of Corinth

flowers occupies its center. In the spandrels between the square border and circular interior are figures rendered in black pebbles (figure 2.11). Fragments of three survive, and their posture seems to be unusual: one leg extends behind the other, and in the single surviving fragment of an upper body (the figure in the lower right corner of the reconstruction), the arms are outstretched. The lack of firm interaction with a discernible setting gives the impression that they are floating, swimming (a possibility perhaps reinforced by the wave pattern nearby), or even jumping or dancing.

The figures' black skin suggests that they are Ethiopians and brings to mind a setting in the distant regions of the earth, where, according to Greek geography, such men lived.[24] This blessed race is in some ways the southern counterpart to the northern Hyperboreans: they are the "farthest of men [*eschatoi andron*]" (Hom. *Od.* 1.24), dwelling near the "streams of Ocean" (Hom. *Il.* 23.205) at the "edge of the *oikoumene* [*eschate ton oikeomeneon*]" (Hdt. 3.114), the inhabited world.[25] Like the Hyperboreans to whom Apollo makes his annual visit, the mythic Ethiopians are a pious race that enjoys a

24. Salzmann (1979, p. 302) has argued that these figures are not Ethiopians but athletes, who are rendered in black not as an indicator of skin color but instead to provide contrast to the white ground; the white ground, in turn, is a compositional necessity that distinguishes between the black ground of both the outer border and the central circle. It is the case that non-Ethiopian figures are rendered in black pebbles in later Hellenistic mosaics, and, as Salzmann notes, the single extant head at Sikyon has none of the physiognomic features that often designate Ethiopians in Greek vase painting and sculpture. But such detail is difficult to render at this scale in the relatively inexact medium of pebbles. Guimier-Sorbets (2004, p. 915) identifies the figures as dancers in a Dionysiac *thiasos*, an identification that is problematic, since only maenads and satyrs, not human men, typically take part in such celebrations. Given that neither athletes, Dionysiac celebrants, nor, admittedly, Ethiopians have extensive contemporary comparanda in this medium, I am inclined to remain with the identification of the figures as Ethiopians, since the rendering of the skin in black and the hair in red bears a suggestive similarity to the representation of Ethiopians on earlier head vases.

25. Romm 1992, pp. 45–67. See, for the Ocean's relationship to the limits of the *oikoumene*, Kaplan 1975, pp. 130–137.

special relationship with the gods and a quality of life unlike that of other men. Part of the exceptional nature of their country is its inaccessibility and remoteness from worldly strife, so that in Homer, it becomes a kind of holiday destination for the Olympians, who are unreachable during their stay there and enjoy plentiful feasts in their honor (*Od.* 1.23–27; *Il.* 1.424–426, 23.205–207).

Indeed, given our interest in the sympotic context, it is worth noting the repeated emphasis that Greek literary sources place on abundance and consumption in Ethiopia. Herodotos describes an exchange between the Persian king Cambyses and a mythic version of the Ethiopians called the Macrobians ("Long-lived"), who live on the southern sea (3.17–25). These Ethiopians are the tallest and most handsome of men, they customarily live 120 years, and, once dead, are buried in chambers that protect against decomposition. They feast from the legendary Table of the Sun, on which meats, said to be produced by the earth itself, appear daily. Hoping to find out about the Table of the Sun and to conquer these men, Cambyses sent spies disguised as emissaries, who presented the Ethiopian king with extravagant gifts, including gold jewelry, a purple-dyed robe, myrrh, and wine. The king, however, intuited Cambyses' true purpose and rejected the gifts, except for the wine, which he found he quite liked. Thus insulted, Cambyses marched against the Macrobians, leaving in such a rush that he arranged no provisions for his army. But the land of the Ethiopians was so distant that the army was forced to resort to cannibalism for sustenance, causing Cambyses to turn back—an ironic twist, given the king's original interest in the copious Table of the Sun. Herodotos's emphasis on feasting—which appears in magical abundance and cannibalistic perversion—underscores the Homeric implications of Ethiopian plenty (and isolation), and the introduction and Ethiopian appreciation of wine incorporates an element that is particularly familiar to a Greek audience. Loosely connected to this tradition may be certain Athenian cups, dating to the first half of the fifth century, that depict reclined drinkers attended by wine pourers with African features; Topper has suggested that these images may represent the symposia of (heroic) Ethiopians.[26]

In the Sikyon mosaic, as in the Eretria example, the imagery evokes a distant setting by including people who look different and who have customs (battling griffins or dining with the gods) different from the Greek symposiast-viewer. The collection of animals around the frame can be brought

26. Topper 2012, pp. 96–97.

to bear on this interpretation as well. Some of the animals seen here, mixing with the more exotic species of panther and griffin, are familiar in Classical Greece—namely, the horse, boar, and deer. But the very diversity of fauna is a trait of distant landscapes. Aristotle, for one, cites the proverb "Libya is always bringing forth something new," and he attributes its origin to the fact that because there is so little water in places of extreme weather in the distant parts of the world, all kinds of animals converge at springs and mate, producing new composite species out of familiar ones (Arist. *Gen. an.* 746b7–10).[27] That is to say, the profusion and variety of animals here, if not the particular kinds of beasts, could point to a foreign landscape.

The *periplous*

Outside of the heroic world, no Greek ever traveled to the far reaches of the *oikoumene*, where the Arimaspians and griffins lived, where different species mated, and where gods banqueted with men. Perhaps because of this, these fantastic landscapes ignited the Greek imagination.[28] The possibilities introduced by new and unknown regions attracted the interest of scientists and explorers alike, and they inspired substantial literature devoted to the survey of the exotic lands that one happened upon during a real or imagined journey. Since Greek ships hugged the coastline rather than moving across open waters, sailing presented substantial opportunity for such encounters, and one genre of this travel literature is the *periplous*, the "coasting voyage," or, literally, the "sailing around" that refers to both the journey itself and the travelogue it produced.[29] Herodotos mentions an early *periplous* of the Ionian Skylax of Karyanda, who recorded his exploration of the coast from the Indus River to Arabia undertaken in the service of the Persian king Darius I (4.44). Skylax detailed the various places and peoples he observed along the voyage, including men who shade themselves with their own massive ears or feet, and others who are called one-eyed or ear-sleepers (Tzetz. *Chil.* 7.629–639). Likewise, the later *Periplous* of the Carthaginian Hanno, perhaps dating as early as the fifth century, narrates his exploratory voyage along the coast of

27. Trans. Peck 1942 (LCL 366).

28. As Romm (1989, p. 100) discusses, Herodotos (2.23) refers to the most extreme parts of the earth as "unseen" (*aphanes*), underscoring the lack of witness accounts; see also, on these kinds of journeys, Baslez 2003.

29. See Allain (1977, pp. 2–34) for an overview of the genre and a brief history of its study in early scholarship.

Africa.[30] He, too, saw strange people, animals, and landscapes: cave dwellers who reportedly run faster than horses (7), earth that blazes with fire (13–16), and savage women whose bodies were covered in hair (17).

A lengthier fourth-century *Periplous*, composed by an author that modern scholars call Pseudo-Skylax, catalogs the peoples and cities along the Mediterranean and Black Sea coasts.[31] His account of people and landscapes is generally rather dry in comparison with those of Hanno or the Ionian Skylax, and he is clearly most concerned with compiling a kind of literary atlas— he moves from one landmark to the next, describing cities, harbors, and distinctive landscape elements, as well as the distance between them, given in stades or in the days and nights sailed.[32] Even so, he occasionally elaborates on certain peoples, including the Ethiopians, upon whom one comes after sailing through the Pillars of Herakles (the Straits of Gibraltar) and southward along the coast of Africa (112.8–11). Pseudo-Skylax seems to draw on various sources in his description of the Ethiopians as sacred (cf. Hom. *Od.* 1.22–24), as the tallest and most beautiful of all men, and as meat eaters and milk drinkers (cf. Hdt. 3.17–24); he further notes that they are winemakers.

An emphasis on the genre of the *periplous* is relevant in the context of the andron mosaics for two reasons. First, the observation of exotic people and phenomena like those in the mosaics discussed above was a typical feature of such voyages, even when they were undertaken for other purposes, whether political, economic, or colonial. Second, the Greeks drew frequent connections between the sea and wine and between the nautical journey and the symposium. Both activities, after all, depend on communal identity: like the crew of a ship, symposiasts are a company of men who are isolated within

30. The log, presumably composed in Punic, was set up in the sanctuary of Baal (of Kronos, in the Greek sources) after his return, and it survives, in Greek, in a tenth-century CE manuscript now at the University of Heidelberg, Universitätsbibliothek: Codex Heidelbergensis 398; a translation is given in Carpenter 1966, pp. 83–85. Virtually nothing is known of Hanno apart from the *Periplous*, although his name appears in a number of ancient sources. The fifth-century date of the voyage is deduced from Pliny, who says that it was made at the height of Carthage's power (*HN* 2.67, repeated at 5.1), but Carpenter (1966, p. 83) points out that this might also apply to the early third century. The scholarship on Hanno is substantial; see Carpenter 1966, pp. 83–100; Blomqvist 1979, pp. 52–56, 59–63; Oikonomides 1977, pp. 16–24, 94–97; Demerliac and Meirat 1983, pp. 63–152; Jacob 1991.

31. For the *Periplous*, including a new translation, see Shipley 2011.

32. The purpose of the *Periplous* is unclear: as Shipley (2011, pp. 9–13) points out, it is unlikely that Skylax himself knew most of this information from a first-person voyage, it is not so detailed as to serve as a guide at sea, it is not a map, and it does not seem to reflect a political or economic agenda (recording Greek colonies, for instance). Shipley concludes that it is an academic endeavor that combines interests in geography, history, and ethnography, and that privileges different interests at different moments.

a contained space and who enter into solidarity with one another.[33] Added to this are their similar physical effects, which might include swaying, loss of balance, and nausea.

Natural as the roots of this association may seem, Slater, Davies, and, most recently, Gagné have shown how varied and complex its cultural expressions can be; it plays out in different ways across a variety of Classical sources, often in a metaphorical structure that scholars refer to as the "symposium-at-sea."[34] In literature, for instance, symposiasts might be figured as sailors, who rhythmically ply the cup as an oar in Dionysiac rowing (Dionysios Chalkos, fr. 5, *apud* Athen. 10.443d).[35] They enjoy tranquil seas or endure the chaos of storms in a reflection of the relative temperance or excess of their symposium: banqueters swim on a "sea of golden wealth" (Pind., fr. 124ab.6) or they are thrown overboard (Xenarchos, *The Twins* fr. 2, *apud* Athen. 15.693b).[36] In a particularly scandalous episode, the symposiasts become so drunk that they hallucinate, and, believing they are in a ship during a storm and need to jettison the ship's cargo to avoid sinking, they begin to throw furniture out of the house's windows (Timaeus, fr. 566, *FGrH* F149 *apud* Athen. 2.37b–d). When the city officials are called, one young man, who had taken refuge under a "rowing bench," mistakes them for Tritons, and promises to set up altars to them once he reaches a safe harbor. In still other examples, the ship is not the room but the symposiast himself, "loaded right up to the top deck of [his] belly" with the "cheerful cargo" of drink (Eur. *Cyc.* 503–506) or toasting a friend with the "oarage" of his tongue (Dionysios Chalkos, fr. 4).[37]

33. For the isolation of the symposiasts, see Stehle 1997, pp. 217–218. In general, ships and sailing seem to have had a wide range of metaphoric potential in the ancient world. They could describe love and life more generally, as discussed in Slater 1976, p. 161. They can likewise describe poetry, in which the poet becomes a kind of traveler on a journey, or a skilled shipbuilder, constructing his poetic ship from raw material, for which see Dougherty 2001, pp. 19–60. Another popular trope is the ship of (the democratic) state, for which see Slater 1976, pp. 168–170; Gentili 1988, pp. 197–215; Corner 2010, pp. 364–370.

34. Slater 1976; Davies 1978; Lissarrague 1990a, pp. 107–122; Corner 2010; Cazzato 2016, esp. pp. 185–190; Gagné 2016.

35. West 1992.

36. Pindar, trans. Race 1997 (LCL 485); Xenarchos, trans. Edmonds 1957–1961, vol. 2, p. 595. In general, the Greek relationship to the sea was characterized by ambivalence; see Buxton 1994, pp. 97–104; Beaulieu 2016, pp. 1–2.

37. *Cyclops*, trans. Kovacs 1994 (LCL 12); Dionysios Chalkos, trans. Gerber 1999 (LCL 258). The symposiast might also become the sea itself, as in a fragment of Eratosthenes of Cyrene, who describes a strong wine that "whirls [men] around, as the north or south wind does the Libyan Sea, and it reveals what is hidden in their depths" (fr. 34, *apud* Athen. 2.36f, trans. Olson 2007 [LCL 204]).

The correspondence is expressed in other ways as well—for instance, in Homer's description of the sea as "wine-dark"[38] or in the word *pitulos*, which can refer to both the sweep of a ship's oars or the splash of wine in the cup.[39] And not unlike the English word "vessel," a number of terms for wine cups were applied equally to ships, as in the *chrysoun kantharon* of Menander's *The Ship Owner* (fr. 348, *apud* Athen. 11.474b–c) and the seaborne *kantharoi* of Aristophanes (Ar. *Peace* 143).[40] These literary examples, which present various structures for the verbal analogy of the sympotic and the nautical, have additional counterparts in the visual tradition. Ships are sometimes painted, for instance, on the visible interior rims of cups, kraters, or *dinoi*, seeming to float on the sea of wine inside.[41] And Dionysos himself sails across the interior of a black-figure wine cup from the sixth century, signed by Exekias and now in Munich (figure 3.8).[42] This image visually weaves together the nautical and sympotic aspects of the god's identity: surrounded by both dolphins and grapevines, he reclines aboard his ship as he would on a *kline* during the symposium, and the cup itself, which might, in Menander or Aristophanes, float upon the sea, here contains a sea of wine.[43]

Another example of such visual transpositions appears on the interior surface of a red-figure cup in the Vatican, dating to the first half of the fifth

38. The phrase *oinopa ponton* (or *oinopi ponto*) is found throughout Homer's epics: *Il.* 2.612, 5.771, 7.88, 23.143, 23.316; *Od.* 1.183, 2.421, 3.286, 4.474, 5.192, 5.349, 6.170, 7.250, 12.388, 19.172, 19.274. For a discussion of the relationship to Dionysos, see Daraki 1985, pp. 41–44.

39. In *Iphigenia in Tauris* (1050), Euripides uses *pitulos* to refer to the sweep of a ship's oars, and in his *Alcestis* it refers to the splash of wine in the cup, although this particular usage plays on the term's double meaning. Here, Herakles suggests that "the splash [*pitulos*] [of wine] falling on the cup removes from anchorage [*methormei*] gloomy and thoughtful hearts" (797–798, my translation). Other nautical words, too, are used to describe drinking: e.g., *saleuo*, to toss, roll, or rock (compare Xen. *Oik.* 8.17, with Plut. *Quaest. conv.* 1.1.5 = 614D).

40. Menander, fr. 348 in Edmonds 1957–1961, vol. 3B, p. 695. *Kantharos* also refers to the dung beetle, and Menander's use may also make a pun of this animal-cup; see Gagné 2016, pp. 215–216. Plutarch (*Thes.* 25) records a supposed oracle from Delphi that mentions traveling the Ocean as on an *askos*. Other such terms are *kumbi, pristis, akatos*, and *gaulos*, for which see Davies 1978, p. 77. Gagné (2016, pp. 214–216) discusses these overlaps and draws attention to the English-language parallel.

41. For these vases, see Morrison and Williams 1968, pp. 92–95, 102–108, 113–114, pls. 14, 17, 18, 21; Schauenburg 1970, p. 34; and Lissarrague 1990a, pp. 112–114. For ships on vases generally, see Morrison and Williams 1968, pp. 73–117, 169–180; Basch 1987, pp. 202–203, 270–293.

42. Munich, Antikensammlung 2044 (black-figure cup, ca. 530, signed by Exekias): *ABV* 146/21; Mackay 2010, pp. 221–241.

43. See Mackay 2010, p. 238. Csapo (2003) argues that dolphins, sometimes represented as composites with the features of men, are often figured as a circular dancing chorus in an expression of their intimate connection to the Dionysiac realm.

FIGURE 2.12 Herakles in a dinos, red-figure cup interior attributed to Douris, first half of the fifth century. Vatican, Vatican Museums 16563. Photo © Governatorato SCV–Direzione dei Musei, All Rights Reserved

century. Here, Herakles, holding his club and bow and surrounded by fish and octopodes, floats along in a massive *dinos* (figure 2.12).[44] This image refers to one of the hero's labors, during which he sailed the Ocean to the island Erytheia in order to steal the giant Geryon's cattle. For his boat, he was given (or forcibly took) the golden cup of Helios, who, after riding his chariot through the daytime sky from east to west, returns to the east during the night

44. Vatican City, Museo Gregoriano Etrusco Vaticano 16563 (545) (red-figure cup, ca. 500–450, attributed to Douris): *ARV²* 449/2.

by sailing this cup along the Ocean's northern circuit in a kind of *periplous*, following the perimeter of the *oikoumene* back to his starting point.[45] In the Vatican image, Helios's cup is visualized as a mixing bowl afloat on the sea, presenting an image that literalizes the comedic *kantharoi*-ships mentioned above. Further, like Exekias's sailing Dionysos, the full visual effect of this Heraklean voyage depends upon the sympotic context: as the symposiast drinks the wine, Herakles appears at the cup's bottom, sailing on a sea that is actually wine dark. These playful layers of transposed identities—the *dinos* that usually holds the wine now floats upon it, and a cup that might elsewhere be a ship now holds a sea of wine—is typical of the sophisticated imagery associated with sympotic vases.[46]

We might press even further here, given the cup's role in the symposium. The essence and focus of the event was the wine, usually passed, as discussed in chapter 1, in a single cup around the room. Along with the turn to speak or perform, the wine made its own journey around the andron in a prescribed way, circling *epidexia* from one participant to the next. This movement of the cup and of the group's attention is central to the unfolding of the symposium as an event, and it is, necessarily, motion punctuated by pauses: each symposiast drinks the received wine and engages the attention of the group for a time. In this way, a wine cup's course around the room mimics that of ancient ships, which sail not from origin to destination in one smooth motion over open seas but, instead, hug the shoreline, advancing from harbor to harbor on their routes. As Gagné has recently argued, the mythic cup of Helios, which "enabled passage to the extremities of the world," presents a macrocosmic conception of the wine cup's circulation around the andron.[47] In the case of the Vatican cup, the converse construction is also in play: the physical progress of this particular vessel, and, with it, the image of the hero in his cup-as-ship, from couch to couch during the symposium presents a microcosmic version of the journey to Erytheia. As the space in which this travel

45. Apollod. *Bibl.* 2.10.4; Pherek. 3.18a, *apud* Athen. 11.470c–d. Helios's cup is called by different names, including *depas* (Athen. 11.469d) and *poterion* (Steisichoros, fr. 8, *apud* Athen. 11.781d). For images of Herakles and the Sun's bowl or chariot, as well as the geography of this story, see Ferrari and Ridgway 1981. For more on Herakles as a sailor of distant waters, see Beaulieu 2016, pp. 27, 47–52.

46. Lissarrague 1990a, p. 112.

47. Gagné 2016, p. 214. See also Davies (1978, p. 81), who points to a fragment of Machon (in Gow 1965, fr. 11.109–111, with commentary pp. 84–85), which seems to suggest that symposia began with a toast to the sunset. Davies wonders whether this led the symposiasts to imagine themselves sailing with the Sun along the Ocean on his nocturnal journey.

is inscribed, the circle of symposium couches becomes figured as the Ocean that Herakles traverses on his journey. And this might be understood more broadly, as well: *any* symposium cup may be said to act like a Greek ship as it is passed around the andron, moving from symposiast to symposiast, as if from harbor to harbor.

The symposium as nautical journey

It is at this intersection of image, physical space, and movement that theorizations of space and spatial metaphor become useful. As argued in the introduction, the bodily and sensory mediation of the absolute, relative, and relational aspects of the andron during the symposium has the capacity to bring to the drinkers' minds the commonplaces belonging to another domain. It is from these overlaps that experiential metaphor emerges.[48] The "nautical" effects of wine, the visual confrontation with (absolute) mosaic imagery that seems to represent a foreign destination, the (relative) isolation of the group, and the movement of the cup around its perimeter, or all of these things together, call to the symposiast's mind a deeply seated (relational) association between this experience and the journey at sea. The metaphor produced, then, is one in which the andron becomes a setting for a *periplous*, enacted by the cup-as-ship as it progresses—"sails"—around the room, stopping for a time at symposiast-harbors along its way.

Crucial here is the capacity of prescribed movement and bodily experience of the symposium to elicit the spatial metaphor of the event as a nautical journey, particularly when considered in conjunction with relevant imagery. The literary sources mentioned above—the main sources through which the symposium-sea relation has been understood—primarily apply the metaphor from outside the performance of the symposium itself. The abundance of nautical imagery on sympotic vases, however, indicates that the symposiasts accessed this metaphor not only through the verbal but also through the phenomenal, synesthetic experience of space *during* the symposium—they produced "images in the mind forged from images in the world," as Tilley puts it.[49]

In this way, the pebble mosaics and their arrangement in the andron become vital participants in the construction of the experiential metaphor

48. Tilley 1999, p. 267.

49. Tilley 1999, p. 268.

of the symposium-at-sea. At Eretria, the Nereid mosaic underlines the watery potential of the perimeter space: located between the "first" and "last" couches, she introduces, even as one enters the andron, the theme of the nautical journey. Once seated in the andrones at Eretria and Sikyon, and while the cup makes its way around the room, the symposiasts look inward to the mosaic floor. Dominating that space are griffins, lions, and eastern Arimaspians or Ethiopians—precisely the kinds of distant, fantastic landscapes, animals, and men that might be encountered on a *periplous*. In these andrones, therefore, the mosaic's imagery builds on existing cultural metaphor, specifically inviting the symposiasts to imagine themselves as part of a *periplous*, witnesses to a foreign landscape, arrived at by sea.

Like Hanno and Skylax on their actual *periploi*, the group experiences this foreign landscape in glimpses, brief vignettes that exemplify the exotic life there. Hanno, hugging the coast on his journey, watched Ethiopians who fled from the ship in fear (*Periplous* 11), and saw savages dressed in animal skins (9), rivers filled with crocodiles (10), and a coast of flames (16). In a similar way, the symposiasts at Eretria and Sikyon catch a glimpse of the exotic in the mosaic "shore" before them: there are inherent dangers and curiosities in the roaming wild beasts, and there are potential delights as well in the beautiful Ethiopians, famous for their abundant feasts. A group of symposiasts might view this landscape from the perspective of the ship, as though they were the ship's crew on their own *periplous*, arriving, for instance, at the distant shores of Ethiopian lands, which promise plentiful feasting (and perhaps even a chance to mingle with the gods). Alternatively, each symposist might imagine himself in the role of a harbor for the sailing cup, a point of encounter between the familiar and the unknown. These shifts in perspective and in the viewer's proximity to the foreign also have parallels in periploutic literature. Hanno witnesses some peoples only from afar (Ethiopians), others he hears but does not see (as through the island cymbals), and still others he interacts with closely (the Lixites, whom he convinces to travel with him [6–8]).

As is the case with the interpretation of any given cup and its imagery, the elaboration of the metaphoric journey for a given group of symposiasts at Eretria or Sikyon must have depended on the company, the content of the sympotic conversation and songs, and the symposiast's own experience with this particular set of cultural associations—all factors that fall under Harvey's relational aspect of space.[50] Certainly, the metaphoric *periplous* does not necessarily surface in the performance of every symposium, and the inverse is also

50. Harvey 2006, pp. 273–274.

true: this figurative structure cannot explain all sympotic mosaic imagery, as we will see in the following chapters. But what is essential here is the potential of the andron to generate spatial metaphor by drawing from, on the one hand, the cultural discourse within which the metaphor resides, and, on the other hand, the expectations of how the space will be simultaneously used, experienced, and made sense of during the event of the symposium. Thus, the andron engages actively in the sympotic experience as, to use the terms of Lefebvre, both a social product and a social process.[51]

Skylla

While I have focused on the Eretria and Sikyon mosaics here, there are other andron mosaics that may also participate in the particular experiential metaphor of the symposium as sea journey. A fragmentary mosaic from Athens (Odos Menandrou 9), dated to the end of the fourth century, features foreign fauna similar to that of the Sikyon mosaic.[52] The decoration is arranged in circular bands, although only the outer portions are preserved, so the subject of the central medallion is unknown. The outermost band features a variation on a cross meander, and the next shows a continuous palmette pattern. The third band, separated from the palmettes by a bead-and-reel motif, includes animals: traces of two griffins and a panther are preserved. As in the mosaics discussed above, the wild and composite beasts of these examples situate the symposiast as a witness to the spectacles of unfamiliar landscapes.

Other mosaics offer a kind of reverse, focusing on the sea itself rather than the shore. A fourth-century andron mosaic from the Solon area just below the acropolis at Aigeira, discovered in the Austrian School's excavations in 1999, features in its center a robed figure on a sea monster (perhaps a Nereid), surrounded by a wave pattern and a frieze of griffins and panthers.[53] This combination of beasts is particularly resonant with the notion of the symposium-at-sea, in which participant "sailors" might confront monsters of the deep instead of or in addition to the exotic fauna of distant shorelines. The mosaic floor of Room G, one of the androanes in the palace of Vergina,

51. Lefebvre 1991, esp. pp. 34–37.

52. Votsis 1976, p. 584, figs. 13, 14, with bibliography; Salzmann 1982, p. 87, nos. 21, 22, pls. 42:2–4, 43:3.

53. This mosaic is reported in the excavation reports (Ladstätter 2000, 2001), and will be more fully published in Scheibelreiter-Gail (forthcoming). The largest segment of the mosaic is 2 x 4 m in a room that measures 6.60 x 6.60 m.

is extremely fragmentary, but hints at a similarly watery theme.[54] The border features white waves on a blue-gray field. In the corners, winged erotes ride on the backs of dolphins or sea monsters with dolphin-like tails. The preservation of hooved legs belonging to an animal, perhaps a bull, at the center, have led Kottaridi to suggest that the mosaic once depicted the abduction of Europa. Another mosaic, likewise fragmentary, in the andron of the central of three Classical houses on the northeast slope of the Areopagus (area Omega) in Athens, features sea creatures, including a dolphin, a yellow and white *ketos*, and various fish.[55] Though unusual for this period, this design looks forward to later mosaic traditions. Fish mosaics similar to this one were popular in the Roman period, and they show a similar variety of marine life.[56] This popularity is likely due in part to both Hellenistic interests in zoology and to a Republican and Early Imperial fondness for fish ponds, as Dunbabin notes, but these mosaics also play with the kinds of visual transformations— between liquid and solid, appearance and reality—that are also central in the symposium: the fish mosaic at Praeneste (Palestrina), for instance, was the floor of an artificial grotto, designed so that it was submerged in real water.[57] In any case, whatever its successors, we can easily imagine how the mosaic of the Omega house's andron could contribute to the imagining of the symposium as a sea journey, the metaphorical symposiast-sailors peering from their *klinai*-boats into the depths of the water.

While some mosaics treated drinkers to the delights of the sea, others suggested its threats. In a third-century pebble mosaic from the andron (Room α) of House D/10 at Eretria, a band of waves borders a plain white ground, at the center of which is a medallion portraying Skylla (figure 2.13).[58] She has the torso of a woman, and is nude except, it seems, for a piece of drapery that is wrapped around her bent left arm and flutters near her shoulder. She raises her right arm above her head, preparing, perhaps, to hurl the

54. Kottaridi et al. 2009, pp. 139–140, and pp. 65–67 for plates; Kottaridi 2011, p. 324.

55. The andron mosaic likely dates to a late fourth-century remodeling of the house, possibly just before 325; the house was destroyed in the first half of the second century. See Shear 1973, pp. 151–156.

56. Dunbabin 1999, p. 47; Meyboom 1977.

57. See Dunbabin's brief description (1999, pp. 47–51), and Meyboom (1995, pp. 1–42) for a more detailed overview, and chapter 5 in this volume.

58. The mosaic is 2.65 x 2.65 m; the diameter of the central circle is 1.02 m. Petrakos (1961–1962) identifies the figure as Dionysos on a panther; Themelis (1970b) identifies the figure as a Triton on a hippocamp, and Michaud (1970, p. 1097, fig. 456) follows him. The identification as Skylla appears in Themelis (1970a, pp. 252–253, figs. 217:β–γ) and is retained from this point forward. See also Themelis 1979; Salzmann 1982, p. 92, no. 42, pls. 49:3, 50:2, 102:3.

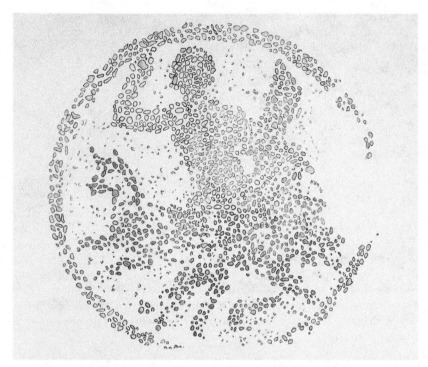

FIGURE 2.13 Skylla, artist's rendering of pebble mosaic from House D/10, Eretria. R. Levitan

stone held in that hand. Her bottom half is made up of the foreparts of three dogs, which lunge in various directions. The right side of the mosaic is badly damaged, but Skylla is well known as a visual type, and it seems likely that this side depicted her twisting tail.[59] She is the subject of at least three additional floors, all of which are problematic, but suggest, at the very least, her popularity as a pebble-mosaic theme. One, probably dating to the late fourth century, was discovered by chance under the Roman-period House of Dionysos at Nea Paphos on Cyprus (figures 2.14 and 2.15); the original context of this mosaic, however—particularly whether it had once decorated an andron, and even its original shape—is unclear.[60] The second was uncovered at the Serangeum at Piraeus in 1897. It is fragmentary and its context is likewise unclear.[61] The third, featuring Skylla in combat, perhaps with a Triton, and a

59. For visual comparisons, see Themelis 1979, pp. 128–144; Hopman 2012, pp. 91–112.

60. Nikolaou 1983, p. 219.

61. Fowler 1897, p. 350; Dragatsis 1925–1926, pp. 4–5, fig. 3; Salzmann 1982, p. 109, no. 108, pl. 25:2.

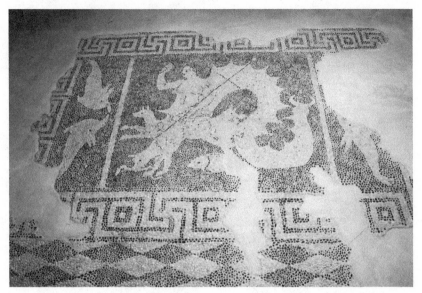

FIGURE 2.14 Skylla, pebble mosaic from under the House of Dionysos, Nea Paphos, late fourth century. Paphos Archaeological Park. Photo courtesy of the Department of Antiquities, Cyprus

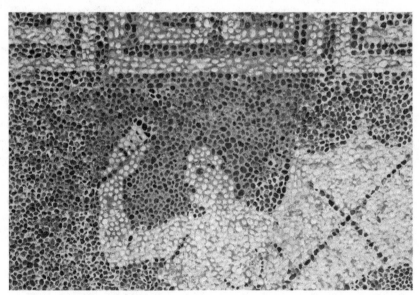

FIGURE 2.15 Detail of Skylla, pebble mosaic from under the House of Dionysos, Nea Paphos, late fourth century. Paphos Archaeological Park. Photo H. M. Franks, published courtesy of the Department of Antiquities, Cyprus

border of running dogs, was found in 1996 on Eretria's Odos Timokratous Phanokleous, but to my knowledge, it is unpublished.[62]

Skylla presents an alternative (and particularly frightening) version of the sea journey. Operating within the same spatial metaphor described above, this mosaic evokes not distant shores but, instead, the open sea and the perils that lie in wait there. While her habitat provides a clear link to the figuring of the symposium as a sea voyage, the complexity of this figure, lucidly illuminated in Hopman's recent work, presents a further opportunity to deepen the potential conceptual networks at play in the andron. Indeed, Skylla herself, as Hopman argues, operates across "metaphorically related conceptual domains"—woman, dog, and sea—that are combined and contextualized in various ways.[63] In the *Odyssey* (12.89–92), the monstrous Skylla is a predator, an anthropophagus, to whom Circe attributes twelve misshapen feet, six necks, and three rows of teeth in each of her six heads, though most of her body remains hidden in her cave. Her name's etymology is explained obliquely in the description of her voice, which is like that of a newborn puppy (12.86).[64] She is positioned in the rocks on one side of a narrow strait, opposite the whirlpool Charybdis, and when Odysseus's ships pass close enough, she snatches and devours six of his men (12.234–260). For Hopman, this voracity brings together the arenas of beast (dog) and sea, conflating these "separate categories of experience" and eliciting the cultural metaphor of the sea as a devouring animal.[65]

In Homer and elsewhere, the sea is frequently described in bodily terms that focus in particular on the mouth and throat, and on the actions these parts of the body perform: harbors are mouths, as are the points at which rivers empty into the sea; straits are necks; the whirlpool Charybdis, Skylla's geographical and literary pendant, swallows down (*anerroibdese*) and belches up (*exemeseie*) water.[66] In the case of "rocky Skylla" (*Skyllen petraien*),

62. Blackman 2001, p. 38.

63. Hopman 2012, p. 18.

64. See Hopman (2012, p. 55) for the "she-dog" etymology of Skylla to which this passage points: her voice like that of a newborn puppy, *skylakos neogillis*, becomes *Skyl[akos neogill]is*.

65. Hopman 2012, pp. 52–70.

66. Hopman (2012, pp. 65–69) gives extensive examples of sources that use parts of the body to describe the sea, a practice common in Homer and throughout the Classical period. For Herodotos (4.85.3), the narrow portion of the Bosphoros is its neck (*auchen*), which Darius yokes with his bridge. Homer (*Od.* 10.87–91) describes the headlands at the mouth (*stomati*) of the Laestrygonian harbor, and uses the oppositional sucking down (*Od.* 12.236, 12.431) and vomiting or belching up (*Od.* 12.237, 12.437) of water to describe Charybdis's actions. This

Homer elides her body with the cliffs of the straits, so that Odysseus's captured companions are drawn up them (12.231) to be devoured at the mouth of her cave (12.256–257). Her monstrous voracity translates to the voracity of the straits themselves, their bestial capacity to consume sailors and ships reinforced in Odysseus's solitary return through the straits, at which point Charybdis swallows and then vomits up his raft (12.426–440).

As Hopman demonstrates, this metaphor illuminates an anxiety in the Archaic mind around the dangers of traveling over the sea, during which one risks being swallowed, either by an unknown creature or by rapacious waters. This danger also presents Odysseus, the commander of the ships and their navigator, with a quandary: as Circe describes, there is no safe passage through the straits— he will lose some of his men to Skylla or risk losing all to Charybdis. Odysseus faces an aporia that "multiplies the intellectual challenges raised by navigation," and leaves the hero, known for his *metis*, in mental uncertainty.[67]

The Odyssean Skylla and the concerns that surround her remain influential after the Archaic period: Classical sources attach her to specific locations (particularly the Straits of Messina, but also the Hellespont and Bosphoros) known to pose danger or difficulty for sailors.[68] But in the Classical period, Skylla also takes on an additional layer of meaning and threat grounded in her feminine identity. She is associated with women—Klytemnestra and Medea— who subvert gender roles and destroy men; what is more, her role as a hunter and, to use a remarkably appropriate modern epithet, a man-eater, allows a recasting of her voracity and aggression as sexual.[69] This further underscores Skylla's bestial nature as, in particular, a bitch—an animal representative of female lust and biting.[70]

vocabulary is common in modern English descriptions of bodies of water as well, of course, in the mouths of harbors or rivers, and in extreme scenarios when waves swallow a ship or a swimmer.

67. Hopman 2012, pp. 72–83, quote from p. 83.

68. See Hopman 2012, pp. 135–138. Hopman cites, for Skylla's association with Messina, the following: Thuc. 4.24.6, 5.53; Archestratos of Gela, fr. 52.2, *apud* Athen. 7.311 e–f, in Olson and Sens 2000; and Polyb. 34.2–3.

69. Hopman 2012, pp. 114–131. In Aeschylus's *Agamemnon*, Kassandra describes Klytemnestra as an "amphisbaena, or some Scylla dwelling among the rocks, the bane of sailors" (1233–1234, trans. Sommerstein 2009 [LCL 146]). As for Euripides' *Medea*, Jason accuses Medea of being a lioness with a nature more savage than Skylla's (1342–1343), while Medea, for her part, is unfazed: "Call me a she-lion, then if you like, and Scylla, dweller on the Tuscan cliff!" (1358– 1359, trans. Kovacs 1994 [LCL 12]).

70. Graver 1995; Hopman 2012, p. 128. The analogy is underlined in Kassandra's description of Klytemnestra as a "hateful hound" or "hateful bitch" (Aesch. *Ag.* 1228; *misiti*, translated here as

Visual representations of Skylla, of which the Eretria example is typical, depart noticeably from Homer's description: she has the upper body (torso, arms, neck, and head) of a maiden, the twisting, often scaly lower body of a sea monster, and, gathered around her pelvis, at the point where the human upper body and piscine lower body come together, are the foreparts (the head and forelegs) of dogs. Hopman points out that this representation is a bricolage that effectively visualizes the three conceptual areas—woman, dog, and sea—that also overlap in the epic creature, while underlining the complex gendered concerns of the Classical period.[71] The dogs clustered around her waist and genitals suggest the threat of castration, and Hopman sees this as part of a multilayered metaphor, in which Skylla's three aspects aggregate around the concept of engulfment: the biting mouth of the dog stands for her genitals; female genitals are an analogy for the dangerous narrow straits of the sea that are her habitat; the sea can be, as well, a devouring animal.[72] Simultaneously, Skylla's feminine aspect presents her as a maiden, a *parthenos*, whose wild nature, like that of a dog or of the sea, remains an underlying threat even after the appearance of domestication.[73]

As a sea creature in the space of the andron, Skylla naturally evokes the experiential metaphor of the symposium as a sea journey.[74] But the complex layers of connotation culturally embedded in this figure suggest that her appearance has implications for the conceptual space of the andron beyond the witnessing of exotic landscapes (or, for that matter, seascapes). As she does for Odysseus, the figure of Skylla complicates, or even confuses, the navigation of the symposium at sea. She introduces associations around the themes of appetite and engulfment that are appropriate for the sympotic context, where the consumption of wine can lead (metaphorically) to dangerous

"hateful," also takes on implications of lewdness or lustfulness), which appears just before she compares Klytemnestra to Skylla.

71. Hopman 2012, pp. 91–112.

72. Hopman 2012, pp. 136–141. For the analogy of female genitals to gates, passageways, and straits, see Henderson 1991, pp. 137–138; Hopman 2008. As Hopman (2012, p. 136) discusses, the body/landscape metaphor—including the added bodily metaphor between the female genitals and mouth—is exemplified in the term *auchin*, which can mean neck, cervix, and straits.

73. Hopman 2012, pp. 142–172, esp. 156–159; see also Calame ([1977] 1997, pp. 238–244), who discusses the metaphor of the *parthenos* as an animal to be tamed. Both Hopman and Calame focus on the act of "yoking" (*zeygnymi*), which, in literature, describes the harnessing of horses (as in Hom. *Il*. 23.130), the joining of two banks with a bridge (as in Hdt. 1.206.2), and joining by marriage (as in Eur. *Med.* 673).

74. See Themelis 1979, pp. 148–153.

waters. Indeed, an excessive appetite for wine in the symposium might end in wreckage—Choerilos of Samos's "shipwreck of banqueters" (fr. 329, *apud* Athen. 11.464b).[75] Similarly, in Xenarchos's *The Twins*, a cup in honor of Zeus the Savior "was no sooner poured than I was done; it threw me overboard" (fr. 2, *apud.* Athen. 15.693b).[76] To shipwreck within the grasp of Odysseus's Skylla is a terrifying notion, and her appearance could stand as a caution to the rowers of the cup. But her visual form as a maiden may soften the blow, evoking her potential for metaphorical domestication by one who masters rough waters.

The symposiasts around the mosaic, then, might imagine themselves as sailors, confronted with the simultaneous threat and allure of the maiden-monster and the problem of navigation that she presents. A drinker might even become Odysseus himself, facing this peril alongside his companions or (perhaps inevitably or perhaps depending on the evening's progress) alone.[77] Indeed, a hint that Odysseus may be an especially appropriate persona for a symposiast to take on may be found in Theognis's advice to emulate the *poulupous* ("many-footed [thing]," octopus; 213–218, quote from 215), an animal that Homer also uses to describe Odysseus (*Od.* 5.432).[78] And it might be, too, that the first-century CE grotto at Sperlonga is a kind of successor to this particular iteration of the symposium-at-sea.[79] The Sperlonga triclinium is set on an islet within the cave, surrounded by actual water and by sculptural groups that depict epic episodes, including Odysseus's blinding of the Cyclops Polyphemos and, in the center of the pool, his crew's desperate struggle against the massive Skylla. Here, in the Roman context, where we are more accustomed to the performative potential of banqueting, the connection between dining and watery settings is more explicitly laid out, rather than generated through experiential metaphor: the cave and the water here are not imagined, but real (if highly curated), although the devouring monsters remain only visions.

Back in the less grandiose andrones, a symposiast confronted with a pebble Skylla in the andron need not necessarily become an Odysseus or even a sailor.

75. Lloyd-Jones and Parsons 1983, p. 152; trans. Corner 2010, p. 362.

76. Trans. Edmonds 1957–1961, vol. 2, p. 595.

77. See Westgate (2011, p. 296) for the suggestion that the symposiasts might imagine themselves "in the persona of Odysseus."

78. The cleverness of the octopus, which camouflages itself against the rocks, is fitting for Odysseus, also known for his cunning, but it is ironic that this ability, emphasized in Theognis's poem, also describes Skylla, who, in the *Odyssey*, is invisible against the rocks (12.232–233).

79. The literature on Sperlonga and its sculptural program is extensive. See Balland 1967; Conticello and Andreae 1974; Stewart 1977; *Ulisse* 1996; Himmelmann 1996; Ridgway 2000; Carey 2002.

He might instead provide safe harbor to the cup-as-ship, promising protection from the vastness and dangers of the open seas. There is another possibility as well. As the cup circles the room, the complex experience of space through the negotiation of the absolute (the room and its mosaic imagery), the relative (the circular movement of the cup), and the relational (the epic pairing of Skylla with Charybdis, and the identity of both as monsters that consume) might call to mind Skylla's epic counterpart. The symposiasts, who swallow the contents of the cup-as-ship as it makes its way in circles around the room, might be thought of as emulating the whirlpool Charybdis's cyclical rhythm of sucking down and belching up.

As a final comment on Skylla, it is notable that, even though she is a sea monster, she does not live under the sea. Her habitat in the cliffs of the strait is a rocky one, and, as mentioned above, Homer elides her body with the cliffs themselves. She is not just "Skylla of the rocks" (*Skyllen petraien*), but she is also, Odysseus finds, impossible to distinguish from the cliffs where she lives: "Nowhere could I descry her, and my eyes grew weary as I gazed everywhere toward the misty rock" (*Od.* 12.232–233).[80] With this further aspect in mind, could the mosaic Skyllas, rendered in pebbles, be a play on her epic "rocky" nature? If it is, it serves as more than a clever pun, since it reinforces a conscious engagement of the absolute space with relational meanings and metaphors that emerge during the lived experience of that space.

In his identification of the symposium-at-sea trope, Slater proposed that its function was to set up the symposium as "a haven from the storms of care that raged outside," and others have agreed, describing it as an escape from the everyday.[81] Part of this experience was the solidarity among the symposiasts, who seek "freedom from the boundaries of reality" together.[82] This chapter has introduced to this long-standing discussion the physicality of the andron, underlining the capacity of the room itself and its imagery to participate in the production of experiential metaphor through the active mediation of the senses. The imagery of the mosaics joins a network of cultural analogies, relative experiences of motion in and through the isolated space of the andron, and the "nautical" effects of wine, and it is from this combination of spatial relations that the metaphor of the symposium as a journey at sea emerges—not

80. Trans. Murray 1919 (LCL 104). The epithet *petraien* appears at Hom. *Od.* 12.231; *petraios*, though it means rocky, has special associations with sea rocks, and is even an epithet of Poseidon (*Petraios*, "Cleaver of the Rocks," as in Pind. *Pyth.* 4.138).

81. Slater 1976, p. 161. See also Davies 1978, p. 81.

82. Davidson 1998, p. 45.

as literary trope applied from outside of the event, but as social practice within and during the event. The unfolding of journeys—literal, as the cup moves around the room, and imagined—resituates the symposiasts in an unfamiliar landscape, facilitates a confrontation with the foreign, and marks the andron as the kind of space where the illusions, metamorphoses, and transpositions expected of the symposium might be achieved. After all, as Neer describes, "role-playing pervades all aspects of the symposium," in which participants emulated the wealth of easterners, introduced other personae to the group, and played different roles during their songs.[83] What better setting to allow such fluidity of identity than a part of the earth distinct and distant from the familiar? The imagined journey offers, on the one hand, "a wonderland of wine and sea" as a retreat from the world and, on the other, potential danger in the shipwrecks and epic monsters that threaten to break the group apart.[84]

83. Neer 2002, pp. 14–23, 41–43, quote from p. 19; Hedreen 2007, pp. 238–239. Stehle (1997, p. 213, n. 1, with bibliography) discusses the role of the first person in sympotic poetry.

84. Quote from Davies 1978, p. 81. Corner (2010, pp. 363–364) discusses the literary acknowledgement of the shattered ideal of harmony and the dissolution of the group identity in the symposium.

3

The Journey In

DIONYSOS THE TRAVELER

> They say the sea is loveless, that in the sea
> love cannot live, but only bare, salt splinters
> of loveless life.
> But from the sea
> the dolphins leap round Dionysos' ship
> whose masts have purple vines,
> and up they come with the purple dark of rainbows
> and flip! they go! with the nose-dive of sheer delight;
> and the sea is making love to Dionysos
> in the bouncing of these small and happy whales.[1]

DIONYSOS, MOST CLOSELY associated with wine and vine, seems, perhaps, an unlikely god to find on the water. But Lawrence's jubilant poem is faithful to an ancient image of the god moving over the seas on a ship, its mast entwined with grapevines, surrounded by a chorus of dancing dolphins.

As patron of the symposium, Dionysos is commonly represented on wine cups and mixing bowls, where he is often surrounded by his retinue of maenads and satyrs, overseeing the process of winemaking, observing the revelry, or participating in mythological events. And yet, in spite of his fitting presence in the sympotic context, he is only rarely the subject of pebble-mosaic floors in the andron. When he does appear, he is, like the sailor of Lawrence's poem, a god on the move—although in the mosaics, he rides in a chariot or on the back of a panther rather than on a ship.[2] This chapter, like the previous one, looks to

1. Lawrence, "They Say the Sea Is Loveless," in Aldington and Orioli 1933, p. 15.

2. I use the designation "spotted panther" below instead of "leopard." It is not clear that Greek artists distinguish between the leopard and panther as different animals, since "panther" seems to have been applied widely to a variety of big felines, and I prefer to avoid anachronistic

the journey as a way of conceptualizing and experiencing the symposium, but here I consider the paradigmatic potential of Dionysos as a god of epiphanies and arrivals from elsewhere—a god in transit. The significance of Dionysos's consistent appearance as a traveler in this context is elucidated through the structure of the *theoria*, a kind of journey that involves going abroad, encountering the spectacle of the foreign, and returning home with new knowledge, and that emphasizes transformation as a product of time away from the familiar. While Dionysos does not officially go on a *theoria*, he does traverse the world, eventually returning to his homeland to share his new knowledge of viniculture. In this way, the Dionysos of the andron mosaics presents a potential model for symposiasts, who travel only metaphorically, but who might nevertheless experience real enlightenment during the symposium.

Dionysos in the Villa of Good Fortune

I focus, to begin, on the floor of the andron (Room a) in the Villa of Good Fortune at Olynthos, possibly dating to the end of the fifth century or the early fourth (figures 3.1 and 3.2). In the central panel is a chariot drawn by rearing panthers (figure 3.3).[3] The god himself, wreathed (as indicated by a line of small red pebbles through his hair) and dressed in a long chiton, drives the chariot, his cloak billowing behind him (figure 3.4). He grasps the reins in his right hand and holds in his left a thyrsos, the end of which is just visible behind the wing of Eros, who, wielding a goad, flies above and to the right of the chariot car. A nude figure runs ahead, looking back over his right shoulder; he is likely a satyr, since he lacks the goat legs of Pan, he has no visible tail, and he appears to have horns. In his left hand he holds a staff, topped by an ovoid shape with short rays.[4]

identification of the representations with modern categories of cat. On the association of Dionysos and panthers, see Detienne 1979, pp. 38–39.

3. Robinson (1934, p. 507) dates the mosaic to after 425 based on the style of the decorative motifs and their similarity to vase painting of the Meidian School. He reiterates this date with additional comparanda as part of his Excursus on Pebble Mosaics in *Olynthus* XII, pp. 341–368. See also Salzmann 1982, p. 102, no. 87, pl. 14.2, 15.1, with bibliography, who dates this to 370–360. For publication of the Villa of Good Fortune, see Robinson 1934; *Olynthus* VIII, pp. 55–63.

4. In *Olynthus* XII (p. 345), Robinson discusses this strange object, ultimately identifying it with a Paeonian representation of the sun, known only from the second-century CE Maximus of Tyre (2.8) as a disk attached to a pole. Certainly, it is visually distinguished from the thyrsoi held by Dionysos in the central panel and by the maenads in the surrounding border. As Robinson remarked in his publication of the mosaic, this figure has the position and pose of the *proegetes* (the leader of the bride's car) in a Greek wedding procession, an association that the presence of Eros could reinforce. For the *proegetes* and his representation in vase painting, see Oakley and Sinos 1993, pp. 27, 31–32.

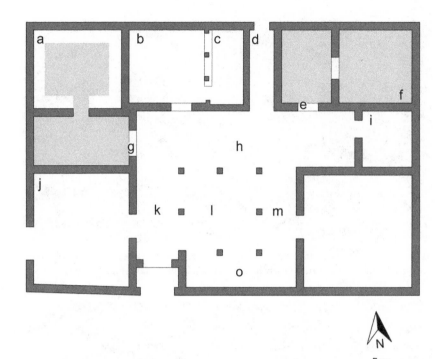

FIGURE 3.1 Plan of the Villa of Good Fortune, Olynthos. M. Grimaldi after D. M. Robinson 1934, fig. 1, courtesy *American Journal of Archaeology* and the Archaeological Institute of America

FIGURE 3.2 View of Rooms a (andron) and g (anteroom), Villa of Good Fortune, Olynthos, late fifth or early fourth century. In situ. Photo H. M. Franks

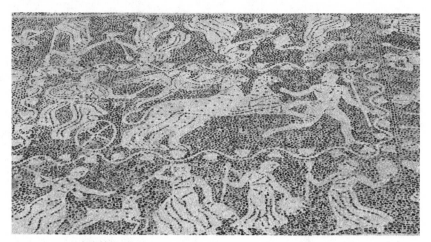

FIGURE 3.3 Dionysos and maenads, pebble mosaic from Room a, Villa of Good Fortune, Olynthos, late fifth or early fourth century. In situ. Photo H. M. Franks

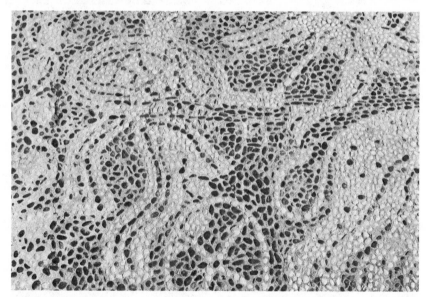

FIGURE 3.4 Detail of Dionysos, pebble mosaic from Room a, Villa of Good Fortune, Olynthos, late fifth or early fourth century. In situ. Photo H. M. Franks

Separated from the god by a border of ivy, maenads revel in the frame around the central scene.[5] Some hold thyrsi and tympana, others hold what may be a fringed tambourine, and some throw their heads back or raise their

5. Although I use the term "maenad" here, it seems likely that these women do not represent mortal worshippers of Dionysos, but instead nymphs; for this distinction, see Carpenter 1997, pp. 52–53, 121.

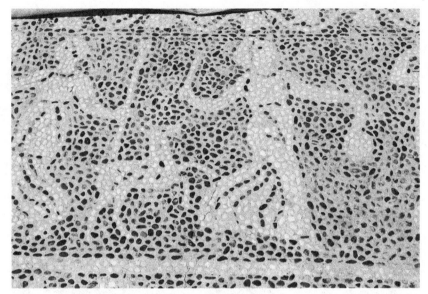

FIGURE 3.5 Detail of reveling maenads, pebble mosaic from Room a, Villa of Good Fortune, Olynthos, late fifth or early fourth century. In situ. Photo H. M. Franks

arms in ecstatic dance (figures 3.5, 3.6, and 3.7). Among them, three pairs of maenads threaten or attack small deer, presumably in reference to the mythical maenadic practice of shredding live animals (*sparagmos*) and eating the raw flesh (*omophagia*) while in Dionysiac frenzy: on the south side of the border, two women flank a hind, holding their thyrsi as spears; on the west side, another pair clutches the legs of a hind between them, and the maenad on the left seems to hold a knife in her right hand; on the north, one has grasped the horns of a stag in her left hand, and she raises her right above her head, while the maenad facing her brandishes a knife.[6] Joining the women is a satyr, his tuft of a tail just visible, in the southeast corner. He plays a double

6. Euripides' Lydian bacchants, for example, celebrate the "glad meal of raw flesh" (*omophagon charin*, *Bacch.* 139, trans. Kovacs 2002 [LCL 495]). In the mosaic, the figure on the north side holding her right arm above her head seems to also hold something in that hand: a single line of pebbles extends between the arm and elbow and continues, ending in a bulb below the raised elbow. This posture, the holding of the prey's head back to expose the neck, while raising a weapon to deal the death blow, is a popular one in hunting scenes. It is similar, for instance, to the pose of one of the stag hunters depicted in a pebble mosaic from Room Δ of the House of the Abduction of Helen (I.5) at Pella, dating to the end of the fourth century. The maenad on the west side, who grasps the deer's hind leg in her left hand and raises her right hand to her head, also held something in her right hand: a line and bulb are visible below her raised elbow. Here, the medium of the pebble mosaic and the small scale of the figures makes the rendering of such details imprecise, but given that two maenads on the southern side of the border wield their thyrsoi as spears, it seems that the northern and western maenads may use thyrsoi as clubs, in place of the swords or axes that a hunter would raise.

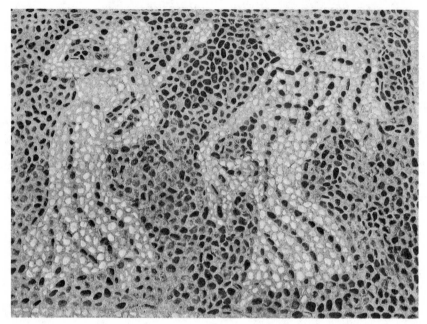

FIGURE 3.6 Detail of reveling maenads, pebble mosaic from Room a, Villa of Good Fortune, Olynthos, late fifth or early fourth century. In situ. Photo H. M. Franks

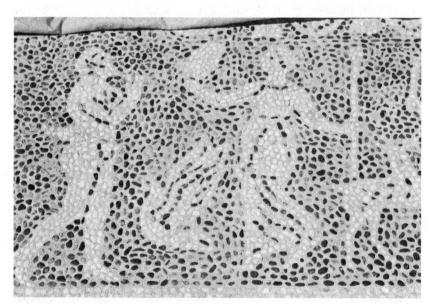

FIGURE 3.7 Detail of reveling maenad and satyr, pebble mosaic from Room a, Villa of Good Fortune, Olynthos, late fifth or early fourth century. In situ. Photo H. M. Franks

flute. And in the center of the west side is a pan, frolicking on his goat legs and raising his tympanum high. Surrounding this inner border is a scroll of repeated palmette pairs, and, in the outermost frame, a wave pattern.

While Dionysos's own suitability for the andron is clear, the mosaic's emphasis on his female followers in a room for male drinking requires some attention. Morgan takes their presence, along with the mosaic of Thetis in the anteroom (figures 2.4 and 2.5), as evidence that this suite of rooms may have carried meaning for a female audience, and therefore may have served a relatively public role as a site for bridal baths and wedding feasts.[7] In this reading, the maenads would present negative models for the bride, in contrast to the positive exemplum of motherhood offered by Thetis. As discussed in chapter 1, it may indeed be the case that androres were used for activities other than the symposium, and perhaps wedding feasts were among those activities. But while maenads are women, their images do not necessarily imply a female audience. Their presence is, foremost, a celebration of Dionysos.[8] The relatively orderly linearity of their *thiasos* underlines the left-to-right momentum of the god's chariot in the central panel and, along with the suggestion of music, the processional quality of movement within the image.[9] Further, like the griffins of chapter 2, the gathering of maenads, satyrs, and fauns locates this movement in a remote place—one that is, at the very least, outside of the order and constraints of the polis, if not at a great distance from it. But if that is the case, where is the god, and where is he going?

God on the move

Montiglio has shown that, while both involve outward movement, the ancient concepts of traveling and wandering carry different implications, as they do in

7. Morgan 2011, p. 282. Her identification of the villa as a kind of public or semipublic building is based on McDonald 1951. Cahill (2002, p. 230), however, has argued that the storage quantity is consistent with household usage, and there is no reason to see the villa as a hostel or inn.

8. It is unclear, in any case, that maenads serve as monolithic representations, negative or positive, of any kind of motherhood. The madness of the women of Euripides' *Bacchae*, which includes Agave's celebration of the death of her son, is indeed terrifying, but their frenzy is a far cry from the regular (and sanctioned) ritual practice of maenadism in the Greek polis. The nymphs that initially accompany Dionysos in his mythological retinue are those who raised him on Mt. Nysa, complicating both the identification of every female follower of Dionysos as a maenad and the notion that his female followers are not maternal (see, for example, *Hymn. Hom. Bacch.* 26). For the differences between maenadic myth and actual ritual practice, see Henrichs 1982, pp. 142–146; 1990.

9. As Hedreen (2004, pp. 41–42, 45) describes, processions include music and a crowd, and those of Dionysos also tend to be slow-moving, with the retinue traveling on foot.

the modern context.[10] A traveler might wander, but traveling usually implies direct movement to a particular place: with the possible (and relevant) exception of "world travel," in which the whole world becomes the "destination," travel focuses primarily on the journey's end, while movement is what defines the wanderer. Wandering, moreover, involves increasing distance from the familiar and exclusion from one's social world, a deeply ambivalent condition that, on the one hand, entails hardship, pain, and even madness, but, on the other hand, promises the acquisition of new knowledge.[11] This kind of movement can unfold over land, but the sea is also an appropriate setting for wandering: since water moves in all directions, it is "shapeless," no clear routes are inscribed upon it, and one is always at risk of being swept off course.[12] Odysseus, thus, is the quintessential wanderer, stripped of his companions and at the mercy of the sea, which forces him from his path to the shores of lands so distant, they may as well be imagined.[13]

Dionysos both wanders and travels. A god of transition and transformation, of epiphanies from nowhere and untraceable disappearances, Dionysos "cannot be pinned down. Humans cannot identify his presence or track his movements."[14] An anonymous hymn to the god calls him *Plagkter* (Hymn 524, line 17), Wanderer, an epithet that underlines the constancy of his movement and that suggests a relationship to both the sea and to a distinctive feature of Dionysiac roaming: madness.[15] The adjectival form, *plagktos*, can refer to the drift of a ship or of one's wits: as Merry, Riddell, and Monro explain in their commentary on its usage in the *Odyssey*, "The literal meaning . . . is 'sent adrift,' hence 'unsettled,' 'crazy.'"[16] Indeed, it is because Hera imposed madness on the young Dionysos that he was forced to roam the world, arriving, finally,

10. Montiglio 2005, pp. 2–5.

11. See Herrero de Jáuregui 2015, pp. 685–688.

12. Montiglio 2005, pp. 7–11.

13. Beaulieu 2016, p. 24.

14. Montiglio 2005, p. 74.

15. Paton 1917 (LCL 84). For Dionysos's madness and wandering, see Montiglio 2005, pp. 75–78.

16. Merry, Riddell, and Monro (1886–1901, vol. 2, p. 214), on *Od.* 21.363, where *plagktos* may be translated as "distraught." As the commentators point out, the adjective (*plagtai*) is applied to the rocks around Skylla and Charybdis because they moved around (*Od.* 23.327). For another example of the metaphorical usage applied to the wandering of the mind, see Aesch. *Ag.* 593.

in Phrygia, where Rhea purified him, restored his sanity, and taught him the rites of initiation (Apollod. *Bibl.* 3.5.1–2).[17]

His susceptibility to being psychologically adrift suggests Dionysos's difference from the other Olympians and his closeness to humanity, and it foreshadows the effect that he will have on mankind.[18] The same hymn that calls him *plagkter* also calls him *phoitaliotes* ("he who maddens," connected to wandering through *phoitao*, "to roam wildly") and *psychoplanes* ("he who makes the soul wander"), suggesting that a particular symptom of Dionysiac madness is roaming.[19] In its extreme, bacchic madness, and the wild, erratic wandering that results, is used to punish those who deny Dionysos's divinity or reject his cult. When the daughters of Proitos refused to accept the god's rites, they became mad, roaming all of Argos and into the desert (Apollod. *Bibl.* 2.2.2), and the Theban women of Euripides' *Bacchae* were similarly driven, delusional, to the mountains.[20] But wandering is also typical of Dionysos's devoted followers, who are called *nyktipoloi* ("night roamers"; Eur. *Ion* 717), *peripoloi* (literally, those who go around: "attendants," "followers," "patrollers"; Soph. *Ant.* 1150), and *periplanetheisai* ("those who wander about"; Plut. *De mul. vir.* 13). In contrast to the frenzied Theban women, those in the chorus of Euripides' *Bacchae* are not out of their minds. But like Agave and her sisters, these Lydian bacchants have left their home. They follow Dionysos to Greece, they "rush to the mountains" (140), they dance (862–865), and they leap (166–167).[21] "To follow the god, then, means to experience mad wandering. Dionysus's devotees must accept wandering both as his travel companions . . . and as the recipients of his possession."[22] Like the sea and like wine, the god himself is capable of bestowing, on the one hand,

17. See also Nonnos *Dion.* 32.125–129, 33.269–271, for another version of his mad wandering, and Montiglio 2005, pp. 76–77.

18. Montiglio 2005, p. 76.

19. Montiglio (2005, p. 77) suggests that the anonymous author of the hymn may have arranged the words *plagkter, phoitaliotes, psychoplanes* to reflect Dionysos's progression "from maddened to maddening" (although she also acknowledges that alphabetical order may have been the primary consideration).

20. In Nonnos's *Dionysiaca* (21.166–169), a late source for us, Zeus punishes Lykourgos of Thrace for his attack on Dionysos by blinding him and forcing him to wander, raving and turning around and around in circles.

21. Trans. Seaford [1996] 2015.

22. Montiglio 2005, p. 79. For discussion of maenadic myth and ritual, and their possible differences, see Henrichs 1982.

horrors and destruction, and, on the other, freedom, vitality, and bliss—both endings that are deeply connected to, and even enacted through, movement.[23]

Once Rhea purifies him of his madness, Dionysos himself no longer wanders; he becomes, instead, an active world traveler.[24] Born once from his mother, Semele, as she was destroyed, and a second time from Zeus's thigh, the infant Dionysos is raised by nymphs on Mount Nysa. That ancient sources disagree on the site of this mountain—located variously in Ethiopia (Hdt. 2.146), Arabia (Diod. *Sic.* 3.66), Egypt (Ap. Rhod. *Argon.* 2.1214), Syria (Xen. *Cyn.* 11.1), and, likely beginning in the Hellenistic period, India (Plin. *HN* 6.78)—suggests that its principal feature was its distance from Greek cities.[25] Otto compares Nysa, "a distant land of fantasy," to the country of the Hyperboreans, since it is from these extreme regions that Dionysos and Apollo, respectively, come to (Greek) mankind. Dionysos arrives in Greece, to be sure, but only after he has traveled everywhere else. In the *Bacchae*, he returns to Thebes, having visited the whole of the east (13–22):

> Leaving the gold-rich lands of the Lydians and Phrygians, going on to the sun-beaten upland plains of the Persians, and the Baktrian walls, and the harsh land of the Medes, and wealthy Arabia, and the whole of Asia that lies along the salty sea with fine-towered cities full of Greeks and barbarians mixed up together, I come to this city first of the Greeks, after having there (in Asia) set them dancing and established my initiations so as to be a visible god for mankind.[26]

Later in the play, the chorus prays to him to lead them to Cyprus, Paphos, Pieria, and Olympos (402–415). He is decidedly a "god on the move," an identity that positions him as a *xenos*, a "strange stranger" and a guest, if still also a Hellene.[27]

23. Otto 1965, pp. 108–113, 150, 163.

24. Montiglio 2005, p. 77. The spread of viniculture is central to this concept; see Henrichs 1975.

25. There is a Nysa mentioned in Euboea (Soph. *Ant.* 1131) and on Helicon (Strabo 9.405), but the primary association seems to be with the east or south; see Otto 1965, pp. 61–63. As Boardman (2014, p. 14) remarks of *Hom. Hymn* 1, which places Nysa in Phoenicia (1–9), "Geographically, all this means is 'somewhere far off to the east.'"

26. Trans. Seaford [1996] 2015.

27. For Dionysos's travel generally, see Gould [1989] 2001, "god on the move" from p. 278. For the connection of traveling to Dionysos as a bringer of civilization, see Buccino 2013, p. 5. Regarding Dionysos as *xenos*, see Detienne 1989, pp. 9–14, "strange stranger" from p. 10. *Xenos*, as opposed to *barbaros*, points to a Hellenic foreigner rather than a non-Hellene: "Nowhere was Dionysos ever characterized as a barbarian god" (Detienne 1989, p. 9). According to Massenzio

Like the Dionysos of the *Bacchae*, who arrives in Thebes in the guise of a stranger, the Dionysos of *Homeric Hymn* 7 appears as a young traveler. In the hymn, he is captured and brought aboard a Tyrrhenian pirate ship, whose crew mistakes him for the son of a wealthy king and hopes to ransom him.[28] The captain wonders aloud where the youth is headed, whether to Egypt, Cyprus, to the land of the Hyperboreans, or perhaps even further, implying the uncharted outer Ocean as a possible destination. Dionysos, however, foils his captors' plans, first astonishing and terrifying the crew with a series of miracles, and then transforming them into dolphins and taking the ship for himself (35–52). This story features certain elements typical of Dionysian revelation or revenge myths: the god appears in disguise; he demonstrates his divine power through miraculous displays and transformation; those who do not recognize him are punished.[29] But, more importantly here, this encounter with the pirates reminds us of Dionysos's connection to the sea and his comfort in traversing it as part of his world travels.[30]

Indeed, Dionysos is not god of wine alone; his domain extends to all moisture and liquid.[31] Some of his epithets, including *Pelagios* ("of the sea"), *Aktaios* ("of the sea coast," at Chios: *CIG* 2214e), and *Limnaios* or *Limnagenes* ("[born] of the lake": Thuc. 2.15.4), and the description of him, like the sea, as *oinope* ("wine-colored": Nonnos *Dion.* 38.16, 40.70) underscore that his appearance at sea in the episode of the Tyrrhenian pirates—and, much later,

(1970, pp. 104–109), *xenia* designates not only arrival from elsewhere, but also strangeness, as displayed in Dionysos's dress and behavior.

28. The story also appears in Apollod. *Bibl.* 3.5.3; Philostr. *Imag.* 1.19; Hyg. *Fab.* 134; Ov. *Met.* 3.630–691; Nonnos *Dion.* 31.86–91, 44.231–252, 45.105–168. The date of *Hom. Hymn* 7 is debated; James (1975) argues that it is the oldest of the extant versions of the myth.

29. For the "vengeance" or "resistance" myths of Dionysos, see McGinty 1978.

30. On the connections between Dionysos and the sea, generally, see Otto 1965, pp. 160–170; Daraki 1982; D'Agostino 1999; Csapo 2003; Pailler 2009. Guimier-Sorbets (2011, pp. 444–445) uses this connection to explain the appearance of aquatic themes (including Skylla, discussed in the previous chapter) in mosaics. In addition to the biographical examples mentioned in the text, there are also overlaps in the larger world of wine and winemaking: seawater was sometimes used in the preparation of wine (Plin. *HN* 14.10.78), and the pine was sacred to Poseidon and Dionysos alike—Poseidon because pine was the most suitable timber for shipbuilding, Dionysos because the grapes grown in the vicinity of pine trees were thought to produce sweeter wine (Plut. *Quaest. conv.* 5.3.1 = 675D–676C). See Davies 1978, pp. 73–74, 76.

31. Otto 1965, pp. 160–171; Daraki 1982. Pailler (2009, pp. 194–199) also highlights Dionysos's relationship with the sea as connected to his role as a god of circulations and junctions, but concentrates in particular on Dionysos's connection to the sea as an interest in its economic capacity, since Dionysos, a god of abundance, brings wealth on his ship.

in Lawrence's poem—is neither anomalous nor superficial.[32] The infant Dionysos is washed onto the shores at Brasiai (Paus. 3.24.3–4), Perseus throws him into the lake at Lerna, from which he is later called (schol. *Il.* 14.369T; Plut. *De Is. et Os.* 35 [364F]), and, in an episode that recalls the Nereids' roles as saviors to sailors, he flees the king Lykourgos to the protection of Thetis and her sisters (Hom. *Il.* 6.130–140; Nonnos *Dion.* 20.352–369, 21.170–177).[33] Repeatedly, he takes refuge in the sea, and from the sea he reveals himself to mankind.[34]

It is his epiphanic appearance from the sea that seems to be celebrated in festivals like the Ionian Anthesteria, during which, as certain Athenian black-figure vase paintings depict, an image of the god was transported through the city streets on a wheeled ship.[35] We are not privy to the circumstances of the seminal arrival that is commemorated in the procession, but other early vase paintings, in which the god is a passenger on a ship at sea, may

32. Otto 1965, p. 163; Daraki 1985, pp. 34–41. For Dionysos Pelagios, see Maass 1888. For *CIG* 2214e, see McCabe and Brownson 1986, pp. 22, 90, no. 45.

33. Otto 1965, pp. 162–163. In another episode, the Methymnians retrieve an olive wood head from the sea, and, when they ask the Pythia about it, she tells them to worship Dionysos Phallos; they send a bronze copy of the head to Delphi, where it is set up next to a statue of the diver Skillis, who had damaged Xerxes' boats in the Persian Wars (Paus. 10.19). See Pailler 2009, p. 191.

34. Otto 1965, pp. 77–82.

35. The festival of the Anthesteria celebrated the arrival and presence of the god. As Sourvinou-Inwood (2005, pp. 151–162) describes, in such events, "the bringing in, or 'finding' of the statue is a visible articulation of the deity's advent . . . because the statue's arrival and presence gave material manifestation to the deity's arrival and presence" (p. 151). In Athens, the City Dionysia also involved the entrance of Dionysos's statue into the city, where it was received and entertained as a ritual reenactment of the god's initial entry and the establishment of his cult; for the City Dionysia and its connection to the Anthesteria, see Sourvinou-Inwood 2003, pp. 67–120, and esp. pp. 104–106. There is substantial literature available on the Athenian Anthesteria, although the ship-car procession of Dionysos was celebrated elsewhere, including at Erythrai, Miletos, Priene, Ephesos, and Smyrna. For useful overviews, see Deubner 1932, pp. 93–123; Kerényi 1976, pp. 160–169; Parke 1977, pp. 107–124, esp. pp. 109–110; Simon 1983, pp. 92–94; Burkert 1985, pp. 237–242; Graf 1985, pp. 74–96; Sourvinou-Inwood 2005, pp. 149–168; Papadopoulos and Markoulaki 2013–2014.

The procession involving the ship-car is now often identified as part of the Anthesteria, though see Hedreen 1992, p. 92, n. 11. It is likely the subject of two fifth-century Attic black-figure skyphoi, for which see Frickenhaus 1912, pp. 61–64; Simon 1983, p. 94, fig. 12; Guarducci 1983; Schwarzmaier 2008, p. 91, fig. 12. Such a ship is also the subject of fragments of a black-figure vessel found in Karnak, now in the Ashmolean: Oxford, Ashmolean Museum 1924.264 (black-figure vase fragments, ca. 550–540): Boardman 1958; 2014, pp. 3–5. It is most likely the product of an East Greek painter, rather than an Athenian; here, the ship is not wheeled, but is instead borne on the backs of men, and while the figure of Dionysos is not preserved, the presence of satyrs on deck suggest that he may also have been present.

show this mythological journey.[36] Sometimes in these images he is accompanied by satyrs and nymphs or maenads, who, as on a black-figure amphora in Tarquinia, man the oars.[37] Other times he sails alone, as he does on the inside of the cup by Exekias in Munich, mentioned in chapter 2 (figure 3.8).[38] Exekias's Dionysos is nude from the waist up and crowned with an ivy wreath. He grasps a drinking horn in his right hand, and reclines across the deck, leaning on his left arm as he would on a symposium couch. Two dolphins are painted in white on the side of the ship, and the eye on its prow suggests that the vessel itself might become a fish.[39] Intertwined behind the mast and sail, and stretching above and over the boat are two vines, from which seven grape clusters hang. Against the coral-red ground, seven dolphins swim around the ship.[40]

36. Following Simon 1969, pp. 280–281, Hedreen (1992, pp. 69–83, esp. pp. 75–79) identifies the arrival by ship as part of a body of Dionysiac myth centered on the island of Naxos, where he collects his bride Ariadne and his retinue of silens.

37. Tarquinia, Museo Archeologico Nazionale 678 (black-figure amphora, late sixth century): *CVA* Tarquinia 1, tav. 5 (1137)1.3. See Hedreen 1992, pp. 67–68; Mackay 2010, pp. 233–234. Dionysos's ship is depicted twice, appearing on both sides of the amphora. These ships, despite riding on waves, do bear some similarities to the ship-car of the Anthesteria: they are both missing a mast and sail, and the hatched screen that is not a feature in representations of actual boats, but that does appear in the images of the wheeled cart at the Anthesteria, also appears here at the stern of the ship on side B. This suggests to Mackay (2010, p. 233) that "the painter sought on this vase to relate the festival practice of the ship-car to the mythical event that it seems to have celebrated: the arrival of Dionysos by sea." Hedreen (1992, p. 68) connects this image to a story told in Philostratos (*Imag.* 1.19) in which pirates ambush Dionysos, who is on a ship with satyrs and nymphs.

38. Munich, Antikensammlung 2044 (black-figure cup, ca. 530, signed by Exekias): *ABV* 146,21. For an extensive treatment of the cup and bibliography, see Mackay 2010, pp. 221–241. Mackay (pp. 232–234) briefly discusses the possible reasons for the limited appearance of the marine Dionysos in vase painting to the late sixth and early fifth centuries, for which see also Guarducci 1983, pp. 114–118.

39. Daraki 1982, p. 4.

40. See Csapo (2003) for the cultural trope of the dolphin as a dancer. This metaphor explains a series of images in which dolphins are represented with human legs or feet: they are not pirates in the middle of transformation (that is, a representation of the *Homeric Hymn*), but dolphin-dancers with, as a dithyramb attributed to Arion describes, "nimble flingings of their feet leaping lightly" (Ael. *NA* 12.45.6, trans. Scholfield 1959 [LCL 449]). Csapo associates the dolphins with the circular dance of the dithyrambic chorus, which "acquired clear and compelling associations with Dionysus" (2003, p. 95). In other words, the transformation of the Tyrrhenian pirates into dolphins stands for their transformation into a chorus of Dionysiac dancers (p. 91). For further discussion, see chapter 4.

 The Exekias cup in particular has been the subject of much discussion, focusing in part on whether the scene represents the story of the Tyrrhenian pirates also preserved in *Hom. Hymn* 7. Recent opinions have circled two general possible readings: first, the image represents a version of the Tyrrhenian pirates episode, but is not an illustration of the *Hymn* (see, for

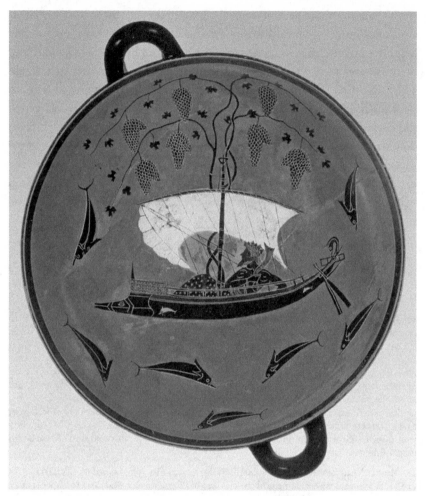

FIGURE 3.8 Dionysos sailing, black-figure cup interior by Exekias, ca. 520. Munich, Staatliche Antikensammlungen und Glyptothek 8729. Photo R. Kühling, courtesy Staatliche Antikensammlungen und Glyptothek München

This vase, dating to the latter half of the sixth century, is significantly earlier than the period to which our mosaics date, and I do not intend to draw a parallel between the way that it might have been viewed during a symposium and the later mosaic images of Dionysos in the andron. But it is nevertheless

instance, Hedreen 1992, p. 67: "The deviations from the account . . . are not enough to warrant serious doubt about the subject of the scene"); second, the image represents instead the epiphanic arrival of the god that is celebrated in the cult festivals (for which see, for instance, Henrichs 1987, pp. 110–111). A selection of additional discussions includes Simon 1969, pp. 285–288; Lissarrague 1990a, p. 121; Mommsen 2002–2003, pp. 21–22; Mackay 2010, p. 235.

useful to note how Exekias visually alludes to the god's epiphanic nature by playing with his appearance on the bottom of the vessel: a drinker tips the cup to reveal the god, who emerges from the wine-sea to then sail upon it. As the cup suggests visually, the intimate relationship of Dionysos to the liquid worlds of wine and the sea has a metaphorical correspondence in his ability to transform himself, to facilitate transformation in others, to make boundaries—even those between life and death—fluid.[41] In *Homeric Hymn* 7, pirates turn into dolphins; in a ship-car procession, paved streets become waterways; in the Exekias cup, a boat doubles as a *kline* and as a fish, while the cup itself fills with a sea of wine. In myth and ritual alike, Dionysos is submerged, and the sea rebirths him to life. And like the liquid from which he emerges, Dionysos has the capacity to reach all places.

It is this widespread and long-standing cultural image of the god as being consistently on the move—across land and sea alike, always transitioning between presence and absence—that is of interest to us here. Black-figure vases from the sixth century show the god in a chariot, surrounded by reveling satyrs and maenads, and sometimes with his consort, Ariadne, by his side.[42] Hedreen associates these images with a body of Dionysiac myths that make reference to or take place on Naxos, the island where he discovered the abandoned Cretan princess and took her as his wife, and from which he may have recruited his retinue of satyrs and silens.[43] Whatever the precise setting, "these and other chariot scenes featuring Dionysos and the silens indicate travel between two distinct places."[44] While the visual theme of Dionysos as a sailor, in particular, does not seem to continue much beyond the Archaic period, the image of Dionysos traveling in a chariot or on an exotic steed appears from the sixth century into the fourth (and, in fact, into the Roman period) in a variety of contexts. On a mid-fourth-century calyx krater in Zurich, the god's chariot, surrounded by reveling maenads and satyrs, is drawn by two panthers (figure 3.9); that one satyr has fallen to the ground, apparently in surprise,

41. For discussions of Dionysos as a dissolver of boundaries and facilitator of transition, see Pailler 2009, pp. 194–197; Daraki 1982, pp. 7–8; D'Agostino 1999.

42. See, as an example, a black-figure amphora in London from the latter half of the sixth century that features, on one side, Dionysos and his consort, Ariadne, both seated, and, on the other side, Dionysos in a four-horse chariot: London, British Museum 1836,0224.38 (Attic black-figure amphora of Panathenaic shape, attributed to the Leagros Group, ca. 550–500): *ABV* 369,120.

43. Hedreen 1992, pp. 70–79.

44. Hedreen 1992, p. 77. See also Simon 1969, p. 282.

FIGURE 3.9 Dionysos in a chariot, red-figure calyx krater attributed to Group G, ca. 360–350. Zurich, Archäologische Sammlung der Universität 3926. Photo F. Tomio, © Archaeological Collection, University of Zurich

gives the impression that the god has materialized suddenly.[45] On a red-figure pelike in Paris, he speeds to the left in a chariot drawn by a bull, griffin, and panther; on an Apulian situla in the Metropolitan Museum in New York, he

45. Zurich, Archäologische Sammlung der Universität 3926 (Athenian red-figure calyx krater, attributed to Group G, ca. 360–350): *ARV²* 1470.164. On this vase, see Isler-Kerényi 1982; 1983; 2015, pp. 226–227. Isler-Kerényi (1983) argues that the vase depicts Dionysos as a bringer of hope and harmony, and suggests that this Dionysos was influenced by the rise in eastern cults in the fourth century.

rides in a griffin-drawn chariot; elsewhere, he is perched directly on the back of a panther or griffin.[46]

Likely beginning in the Early Hellenistic period, Dionysos's movement is formalized as a triumph, an event extravagantly re-enacted as part of the Grand *Pompe* held in Alexandria in the early third century, during the reign of Ptolemy II Philadelphos.[47] After Alexander the Great's campaigns in India, Dionysos—widely known, of course, to have traversed the known world—came to be attached to that region, where he was said to have defeated the Indians in a great battle.[48] It is this success (unmatched until Alexander's conquests) and the god's subsequent crossing of the *oikoumene* (now reimagined as a victory procession) that the *Pompe* celebrated: according to the description of Kallixenos of Rhodes, the procession included Dionysos's image, carried on an elephant and surrounded by spoils and captives representing the defeated Indians (*apud* Athen. 199a–d).[49]

Foucher, remarking on the stateliness of Dionysos's movement in the pebble mosaic of the Villa of Good Fortune's andron, identifies this image as the celebratory march of a triumph or a wedding procession marking his marriage to Ariadne—or, potentially, as both at once.[50] As Foucher points out, later sources seem to consider these processions as interchangeable: Roman images of the Dionysiac procession sometimes include both Ariadne and Victory in the triumphal chariot, and certain literary sources conflate Dionysos's triumphal and nuptial processions, so that it is on his victorious return from India that Dionysos and his retinue discover the abandoned Ariadne on Naxos (e.g., Nonnos *Dion.* 47.419–469).[51] It is less clear whether the equation of

46. Paris, Musée du Louvre MNB 1036 (red-figure pelike, ca. 400–390): *ARV²* 1472.3; New York, Metropolitan Museum of Art 56.171.64 (Apulian red-figure situla, ca. 360–340): von Bothmer 1972, p. 6; see also Buccino 2013, pp. 14–15. Dionysos on a panther, in a procession with maenads and satyrs: Paris, Musée du Louvre G511 (red-figure bell krater, fourth century): *ARV²* 1413.2; *CVA* Paris, Louvre 5 III IE.4, III IE.5, pl. (379) 3.1.3. Dionysos on a griffin: London, British Museum 1925.10–15.1 (red-figure bell krater, fourth century): *ARV²* 1453.9. See, for Dionysos's connection to the griffin, Delplace 1980, pp. 372–376.

47. Buccino 2013, pp. 11–12.

48. Jeanmarie 1951, pp. 351–372; Buccino 2013, pp. 19–62; Boardman 2014, pp. 17–18.

49. For the Grand Procession and Kallixenos, see Rice 1983; Thompson 2000; Hazzard 2000, pp. 60–93. The date of the procession is debated, but was likely at the end of the 280s or in the 270s.

50. Foucher 1965.

51. On the Dionysiac triumphal/wedding procession in Roman mosaics, see Dunbabin (1971), who looks at similarities and variations in the theme and the implications of those details for understanding the artistic process. One of her conclusions is that, in the Roman context, "there

these processions is a possibility in the fourth century, particularly in images when Ariadne is not present. In fact, even a triumphal Dionysos is a knotty concept in this period, since there is no clearly established tradition of the military triumph in fifth- and fourth-century Greece. There is good reason, however, to think that the later Hellenistic and Roman triumphs borrowed from festivals like the Anthesteria. Hedreen discusses such processions, which honored the epiphany of Dionysos by transporting him bodily into the city, as celebrations of his victory over nonbelievers; these cyclical rituals, Versnel has argued, eventually take on a military identity.[52] So in the fourth century, before the Grand *Pompe*, Dionysos's procession is likely not a triumph—a "historical-political manifestation of a personal victory," as Versnel describes the later event. But it may nevertheless be triumph*al*, associated primarily with the god's (re)appearance in Greece as a fully recognized divinity and the successful establishment of his cult over the *oikoumene*.[53]

The subject of the mosaic in the andron at the Villa of Good Fortune, then, is the Dionysos we have been discussing here: a Dionysos who travels, who traverses, who appears, who moves on. It depicts a god who has conquered the world symbolically by traveling its entirety, establishing his worship throughout, and delivering the gift of wine to mankind. Indeed, it is tempting to think that the wave pattern that frames the mosaic, enclosing the image of Dionysos and his followers as the Ocean encloses the *oikoumene*, hints toward the possibility of Dionysos as having reached all "corners" of the world: passing over all that lies between those waves, he has established the whole as his domain.

In addition to the iconographic depiction of the god on the move, the composition of this mosaic and its positioning within the room also allude to Dionysos's habit of appearing from nowhere. Unlike the Eretria mosaic of the previous chapter and unlike its own border of reveling maenads, the god's chariot is positioned in the Olynthos mosaic so that he is seen "right-side up"

was clearly a feeling that Dionysus ought to be accompanied on the Triumph by both Ariadne and Victory, but some confusion in the model as to which was which" (p. 58). Monteagudo (1999, pp. 36–39) discusses a fourth-century CE mosaic from Fuente Alamo in which Dionysos reclines in a chariot pulled by tigresses and is accompanied, probably, by Ariadne. Even so, the triumphal nature of this procession is made explicit through its juxtaposition with the battle of Dionysos against the Indians, an image rare even in Roman mosaics.

52. Hedreen 2004, pp. 47–49; Versnel 1970, pp. 252–253, 300. See also Buccino 2013, pp. 5–18. Indeed, even Dionysos's mythological conquering of the world is eventually cast as a military victory, as in Nonnos *Dion*. Books 13–15, which detail the gathering of troops and the war.

53. Versnel 1970, p. 253.

only from the side of the room with the doorway, and he is off-center within the panel. Once settled on their couches, drinkers would glimpse his image from different, oblique angles, at some distance, and his image might be hidden from view or made visible as a wine pourer moved across the room or a table was shifted. In other words, the mosaic plays with Dionysos's epiphanic appearance in two senses: the first is iconographic, in that such epiphanies are a natural extension of the god's itinerant nature, as depicted in the scene; the second is an effect of its position in horizontal space, which conceals or reveals the image of the god to different drinkers throughout the evening.[54]

The theme of movement, so clear in the andron mosaic, may carry over into its anteroom, the villa's Room g, where the mosaic floor (positioned so that it is seen right-side up from inside or as one leaves the andron) features the Nereids delivering armor to Achilles (figures 2.4 and 2.5). Traveling on the backs of serpentine sea monsters, one holding the hero's new shield, the other his spear and helmet, the sisters approach Thetis and Achilles (both labeled). The hero sits at the left end of the panel on a rock, presumably on the shore. Although only two are present, the Nereids, one arranged after the other, present a marine *thiasos*—an image that resonates with the processional nature of the Dionysiac *thiasos* in the nearby andron and that sets up a watery context for its wave-patterned frame. For a symposiast up on his mythology, the pair of images might also bring to mind a younger Dionysos, not yet triumphant, who took refuge with Thetis and her sisters under the sea. The mosaic panel between the rooms also works to transition the visitor between the liquid worlds of Ocean and wine (figure 3.10): two Pans, with furry goat legs, hooves, pointed ears, and horns, lean over a calyx krater. An ivy vine frames the panel. Together, therefore, the mosaic images from this andron and its anteroom present a web of potential associations to be made around the figure of Dionysos as a god who transforms, who is found in all liquids, who is on the move, and who may appear unexpectedly.

Dionysos does not always travel over land in a chariot, and two additional mosaics show him riding a panther instead. In these mosaics, he is alone, traveling without the company of the entourage that surrounds him at the Villa of Good Fortune—although in any andron that is in use, of course, sympotic revelers literally surrounded the god. On the floor of one of the andrones of Pella's House I.1, called the House of Dionysos after this mosaic, Dionysos rides a spotted panther (figure 3.11).[55] He sits directly on its back, with both

54. See Platt (2016, p. 169) for the synesthetic experience of the divine presence.

55. Lilimpaki-Akamati and Akamatis 2003, p. 25, fig. 15.

FIGURE 3.10 Two Pans, pebble mosaic from the threshold of Room a, Villa of Good Fortune, Olynthos, late fifth or early fourth century. In situ. Photo H. M. Franks

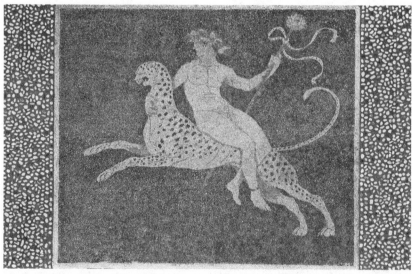

FIGURE 3.11 Dionysos riding a panther, pebble mosaic from House I.1 (House of Dionysos), Pella, late fourth century. Pella Archaeological Museum. Photo © Hellenic Ministry of Culture and Sports, Archaeological Ephorate of Pella

legs to one side, his right arm around the cat's neck. The feline steed rears onto its hind legs, mouth open in a grimace or snarl. The god is beardless, nude, and youthful, though apparently mature—the emphasis on the outlining of his pectorals and his thick middle abdomen convey a fully developed body, despite his lack of pubic hair. The god's face is rendered in profile to the left. The artist articulated certain details, including the profile outlines of both the god's and panther's faces, and Dionysos's fingers, toes, and locks of hair with either lead or terracotta strips. His eye was also likely inlaid with a different, larger stone, now missing; he wears a wreath, probably of ivy, and grasps a thyrsos in his left hand. The background here, as in the Olynthos mosaic, is solid black. One might imagine a groundline supporting the panther's back feet, but there is no setting in which to place the figure.

In this mosaic, the god is, like the Dionysos of the Villa of Good Fortune, seen fully and right-side up from the doorway, but the relative size of the god—who is substantially larger at Pella than at Olynthos—does not necessarily mean that he was more easily or more fully seen from the surrounding couches. Those elements of the lived symposium that might reveal or obscure the god completely in the villa's andron (an oblique viewing angle, a shift in posture, the position of a table, or the movement of a servant) would likely conceal parts of the Pella Dionysos from the seated viewers. In this way, the god may be constantly visible throughout the event, but only partially so. This fractured mode of horizontal viewing may have the effect of suggesting his presence, while denying the viewer visual confirmation of his full corporeality.[56]

A mosaic from Eretria, preserved, as far as I can find, only in a drawing from the nineteenth-century *Mémoire sur la partie méridionale de l'île d'Eubée*, featured a similar subject (figure 3.12).[57] If the drawing is accurate, Dionysos rides his panther to the left, holding a thyrsos and wearing an ivy wreath and a short garment, perhaps a fawn skin. He holds an additional object, but the drawing indicates that the mosaic may have suffered damage in this area. The figure appears in the mosaic floor's central medallion, a circle enclosed by a square. Birds, possibly doves, appear in the square's corners; the one nearest the entrance holds a serpent in its beak. Another, larger square, turned 90

56. For the complexities of viewing the god, see Platt 2016, pp. 175–177; although she is not interested primarily in representations, the incomplete view of the body of the god that I describe here has some similarities to the witnessing of an epiphany.

57. Rangabé 1852, p. 205, fig. 2. The mosaic is 4.73 x 4.68 m; Salzmann (1982, p. 91, no. 39, pl. 49:1) dates it to the second quarter of the third century.

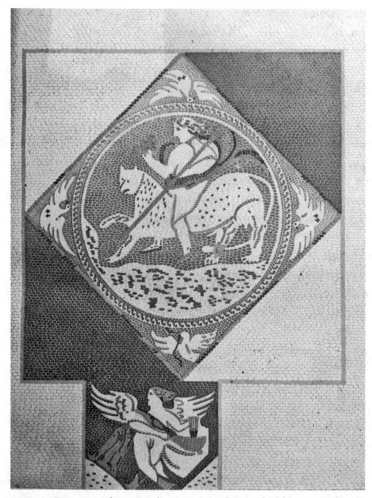

FIGURE 3.12 Dionysos riding a panther, artist's rendering of pebble mosaic from Eretria. Artist unknown, after A. Rankavé 1852, p. 205, fig. 2 [*source image unmodified*]

degrees from the inner and set on the angle of the medallion, encloses the whole. The triangular corners between the inner and outer squares alternate black and white. At the entrance is a siren, winged and with bird legs, her face in profile to the left; she wears a chlamys and holds an object, possibly a lyre, in both hands, her right arm reaching across her chest.

Although his mode of transportation is different, the Dionysos of the Pella and Eretria mosaics, like the Dionysos at the Villa of Good Fortune, is a god on the move, traveling over the *oikoumene*—reaching, his exotic steeds remind us, even its most distant frontiers—and appearing, often unexpectedly, to introduce to the mortal world his cult and the gift of wine.

But why emphasize this aspect of Dionysos in the andron and, by extension, in the symposium? To help elucidate the relevance of Dionysos's journeys in the sympotic context, I turn to a particular model for thinking about travel: the *theoria*.

Theoria

As we have seen, a journey abroad, not unlike wine, presents both great danger and great promise. On the one hand, wandering threatens to alienate an individual from social order. On the other hand, the deep connection between travel, observation of the foreign, and intellectual inquiry and growth was a "cornerstone of Greek thought."[58] The reason for this, as O'Sullivan describes, is that "as the traveler encounters new people and places, his or her understanding of the world broadens; there is knowledge that can only be gained by being away from home."[59] This deep relationship between travel and the accumulation of knowledge is exemplified in the Greek concept of the *theoria*, a trip out of one's home city with the special intent of observing the unfamiliar, usually in a sacred context (at a sanctuary or festival, for example). The *theoria* consists, essentially, of three steps: first, the *theoros* departs from his city; second, while away, he witnesses foreign spectacles, through which he acquires new knowledge; third, he returns, enlightened, to convey what he has learned.[60] The *theoros* might be a civic representative, traveling with a group of fellow citizens to consult an oracle, attend festivals on behalf of the polis, or to perform the ambassadorial duties of a civic envoy, which entailed an official recounting of what he observed upon his return home.[61] Or he might be an individual, traveling for the "private" purposes of investigation, enlightenment, or the pursuit of knowledge.[62] In this respect, Solon, who

58. O'Sullivan 2011, p. 98. For the ambivalence around wandering, see Montiglio 2005, pp. 24–41.

59. O'Sullivan 2011, p. 98.

60. As Nightengale (2004, p. 54), asserts, although much of the evidence for the *theoria* is Athenian, the practice is distinguished by the fact that it is "international and cross-cultural."

61. Dillon 1997, pp. 11–26; Rutherford 2000, pp. 133–138; Nightengale 1998; 2004, pp. 40–71.

62. See Nightengale 2004, pp. 63–68. The term "private" to describe individual *theoria* in search of wisdom is problematic, and is used here primarily in contrast to those *theoriai* that are city sponsored, conducted in groups, and focus primarily on a ritual event. But the result of the journey of the private *theoros* was also a contribution to the well-being of his home city, and so the two types serve this goal. One example is Solon's discovery of a law in Egypt that he intended to put into practice on his return to Athens (Hdt. 2.177; Nightengale 2004, p. 64),

traveled for the sake of seeing (*theories… heinekan*; Hdt. 1.30), was a *theoros*, his wisdom enhanced by his time abroad.[63] Herodotos was as well, since he traveled to further his historical inquiry.[64] Love of knowledge and its acquisition led other thinkers too, including the Skythian Anacharsis and Hekataios, to travel widely.[65] Demokritos, a philosopher of the fifth and early fourth century, is said to have visited Egypt, Persia, the Red Sea, and to have ventured even as far as Ethiopia and India in pursuit of knowledge (Diog. Laert. 9.41–42, DK 68[55]A1).[66] Plato's *Laws* specifically allows for individual *theoria* as a means of either securing the conviction that one's native laws are right or discovering ways to improve them (12.951a–e).[67]

The *theoros*, then, was foremost a traveler abroad: his departure from one space and the "encounter with otherness" were crucial to the successful *theoria*.[68] As Nightengale explains, the detachment of the *theoros* from the familiar, including from the social and political affairs (and ideologies) of his polis, allowed for confrontation with and contemplation of the foreign, opening him to transformation.[69] "The *theoros* experienced freedom from ordinary domestic and civic affairs during the period of the journey; but this condition was temporary, and ceased upon his return."[70] Likewise crucial was the phenomenal—and, especially, the visual—experience of the unfamiliar. This is suggested in one possible etymology of the word, which refers to the sensory observation of a sight or spectacle (*thea*).[71] Plato, for

and another is Anchises, the Skythian sage, who attempted to import the foreign practices of the Kyzikenes, and was killed for it (Hdt. 4.76; Nightengale 2004, pp. 64–65).

63. On Solon as *theoros*, see Hdt. 1.30.2; Ker 2000.

64. Redfield 1985; Rutherford 2000, p. 136; Nightengale 2004, pp. 67–68; O'Sullivan 2006, p. 140.

65. Montiglio 2000. For Anacharsis, see Hartog 1988, pp. 62–75. On Hekataios, *FGrHist* 1 T 12a.

66. Graham 2010, p. 519, Dmc 4. See also Freeman 1946, pp. 289–329, esp. pp. 290–293 on his travels; Montiglio 2000, p. 89.

67. Plato's hypothetical *theoriai* are restricted to men in their fifties, of high military and political repute, and the re-entry of the *theoros* is particularly structured, given the potential for corruption that his observations may carry. He reports first to a council of elders and selected, worthy men, who decide what information might be conveyed to the citizens at large (12.951d–952a).

68. Nightengale 2004, p. 69.

69. Nightengale 2001; 2004, pp. 3–4, 68–69, 100, 117.

70. Nightengale 2004, pp. 117–118.

71. Bill 1901, p. 198; Boesch 1908.

instance, refers to a certain kind of visitor at the festivals of Magnesia as "actually" (*ontos*) a *theoros*, who attends to the sights and music with his eyes and ears (*Leg.* 12.953a).[72] Some have suggested that the word derives instead from *theos* (god), referring to the religious destinations of early *theoriai*, and scholars have recently preferred to accommodate both aspects of the term by describing the journey as "religious spectatorship" or "sacred tourism," although here I would still underline the importance of observation.[73]

Because of its dual emphasis on travel abroad and on the phenomenal (especially visual) experience of spectacle, the *theoria* has substantial promise as a metaphorical structure. And indeed, in the fourth century, philosophers take up the *theoria* as a way of describing the journey of the mind, in which the figure of the philosopher becomes a kind of ambassador of thoughts.[74] Their use of the concept was not systematic, changing to illustrate different points in different contexts—and it is, in part, the potential of *theoria* for abstraction and its flexibility in such uses that interest us. Plato makes use of the structure in the *Republic* (Books 5 and 7), the *Symposium*, and the *Phaedo*, depending primarily on the journey of the civic *theoros* as an analogy for the philosophic pursuit of the truth.[75] The Allegory of the Cave (*Rep.* 7.514a–517c), which both describes the philosopher's encounter with the Good and suggests his relationship to the polis, models his usage. The soul's ascent (7.517b) is here figured as the philosopher's movement from the cave, in which forms are observed as shadows, to the upper world. At first he is dazzled by the brightness of this new landscape, but as his eyes adjust, he begins to see

72. See Nightengale 2004, p. 46: in the *Republic*, Plato says that *theoroi* are *philotheamones* ("lovers of sights," 5.475d2) and *philekooi* ("lovers of sounds," 5.475d3, 476b4), and he connects this (5.475e) to the true philosopher, who is attracted in a similar way to truth. In contrast, see Stigen (1961, p. 30), who de-emphasizes the importance of sight in Aristotle, and notes that, for Aristotle, "hearing is of paramount importance for developing the moral virtues."

73. Those who prefer the *theos/theia* etymology include Buck 1953; Koller 1958, pp. 276–279. For the debate over whether the word derives from *thea* (spectacle) or from *theos* (god), see Ker 2000, pp. 308–309. Here, Ker follows Rutherford (1998, p. 135) in recommending "sacred tourism"; Nightengale also encourages a kind of compromise in "sacred spectating" (2004, p. 45). See also Elsner (2000, pp. 61–62) for his concept of "ritual-centered visuality."

74. Nightengale 2001, pp. 36–37; O'Sullivan 2006, p. 140.

75. Nightengale (2004, pp. 78–93) examines cases in which Plato makes use of the civic and private *theoria* as models. See also Squire (2016, pp. 13–15), who discusses the dependence on the visual as a metaphor for the acquisition of understanding, even among philosophers skeptical of the senses, and Platt (2016, p. 172), on visual witnessing as opening access to truth or knowledge. Movement and travel also are central to Aristotle's conceptualization of metaphor, for which see Derrida 1974; Worman 2015, pp. 8–9, 28–65; on Aristotle's use of *theoria*, see White (1980).

reflections, objects, the heavens, and, finally, the sun, which stands for the Good, the source of reason and truth. Having witnessed this spectacle and acquired from it knowledge that leads him to "virtuous action," he returns.[76] Although Plato's philosopher, unlike the Presocratics mentioned above, does not physically travel to accomplish his enlightenment, he nevertheless follows the three-part structure of the traditional *theoria*: he makes an intellectual journey to the metaphysical domain, detaching himself from the present and the mundane; he encounters and visually observes "the spectacle of truth"; he returns, his soul profoundly transformed, to impart the wisdom he has received.[77]

In the *Phaedo*, the philosophical *theoria* is cast in vaster geographic terms when a philosopher journeys to the *eschata* at the distant edges of the world and ascends into the ether—an odyssey of particular interest not only because it uses the metaphor of a journey, but also because it underlines points made in chapter 2 about the special capacity of the earth's peripheral regions to introduce spectacle and to facilitate transformation.[78] It is from this literally elevated position that this philosopher sees the earth and its inhabitants: "He would see things in that upper world; and, if his nature were strong enough to bear the sight [*theorousa*], he would recognise that that is the real heaven and the real light and the real earth" (109e–110a).[79] From this privileged vantage point, "the earth is a sight [*theama*] to make those blessed who look upon it [*theaton*]" (111a).[80] This conceptualization of philosophic *theoria*, like the ascent from the cave, entails a journey from the familiar (not simply to the geographically distant, but to the elementally distinct ether), and the witnessing of sights there, including the spectacle of the whole earth.[81]

So the *theoria* is both an undertaking of actual travel that promises the accumulation of wisdom through an investigation of the world, and a metaphorical journey of contemplation that culminates in visually witnessing

76. Nightengale 2004, p. 97.

77. See Nightengale 2004, pp. 78–84, quote from p. 82. Plato's philosophic *theoria*, with its emphasis on journey and witnessing, is not simply a structural analogy that is imposed on his works from outside analysis. In the *Symposium*, Diotima uses the theoric structure of pilgrimage and mystic revelation of the Eleusinian Mysteries to describe the philosopher's journey, at the culmination of which he "theorizes" (*theoron*) the Form of Beauty (210a–e), and in the *Republic*, the philosopher encounters the Forms in a "divine *theoria*" (517d).

78. On Aristotle's use of *theoria*, see White 1980; Nightengale 2004, pp. 187–252.

79. Trans. Fowler 1914 (LCL 36).

80. Trans. Fowler 1914 (LCL 36).

81. Nightengale 2004, pp. 141–157.

a "spectacle" of truth. Both uses of *theoria* depend upon a cultural belief in the transformative potential of travel and the observation of spectacle, whether divine or foreign, that it involves. Indeed, the three-part structure of the *theoria* could be overlaid onto other kinds of journeys, including the *periplous* discussed in chapter 2, that also result in a greater experience—unavoidably sensory and potentially spectacular—of the world. But that is not to say that this structure applies equally to all travel: mad wandering consists of movement out, but the foreign is encountered differently in the altered mind; mercantile travel involves priorities other than the accumulation of knowledge for the sake of the individual or the polis; and travel for the purposes of colonization or warfare does not necessarily culminate in a return home (while the Homeric Odysseus is the quintessential "wanderer also *qua* man of learning,"[82] the Homeric Achilles, who is, in any case, hardly a man of learning, will never see his home again). That is also not to say that every *theoria* was successful or productive. As Ker points out, Thucydides (6.24) is concerned about the young citizens' "excessive desire for *theôria*," and "Plato's critique of poetry is partly a critique of the impressionable gaze of a theoric audience."[83] Even so, Plato's intellectual *theoria* is useful for us precisely because it demonstrates the promise of physical travel as an effective metaphor for internal journeys.

This connection between the physical and the internal extends in another direction as well, to the capacity of bodily movement to prepare the mind for or to prompt its intellectual journey. As O'Sullivan has shown in the Roman context, the philosophic dialogue was sometimes associated with movement of the body in the *ambulatio*, the act of walking, which served both as a literal counterpart to the movement of the mind and as a reminder of "the popular image (both literary and cultural) of strolling Greek philosophers."[84] Certain Roman spaces, like the villa, even participated in this generation of philosophical *theoria*: their architecture, sculpture, painting, and landscaping reminded visitors of Hellenic spaces and, at the same time, "of activities, patterns of movement, and styles and topics of conversation that were all marked as Hellenized."[85] Such places produce what O'Sullivan, following

82. Montiglio 2000, p. 88.

83. Ker 2000, p. 305.

84. O'Sullivan 2006, p. 138. Examples of the evocation of such literal and metaphoric journeys include Cic. *De or.* 2.20, *Att.* 1.18.1; Sen. *Dial.* 12.8.4–6.

85. O'Sullivan 2006, p. 138; see also 2007, pp. 498–526. Hadrian's Villa at Tivoli is the most famous example of such emulation (*Historia Augusta Hadrianus* 26.5). O'Sullivan (2006,

Bergmann, calls a "landscape of allusion" that evokes another time and place, facilitating the contemplative journey as the thinker moved through his literal *ambulatio*.[86] "The walk through the villa therefore afforded the visitor the opportunity to travel in his mind not only to other spaces, but to other times."[87]

While these landscapes offered a particular vision of Classical Greece in which Roman thinkers could imagine themselves, their association of philosophic thinking with physical movement was not an anachronism.[88] For Plato, walking—and, particularly, walking together in conversation and with a destination in mind (that is, not wandering)—can serve as a kind of warmup for philosophical discussion. In *Protagoras*, Socrates and Hippokrates walk together, and Protagoras is walking in his portico when the pair arrives at his house (311a8–b1, 315a8–b1). But the dialogue only truly begins once all are seated (317e3), suggesting that the movement of the body prepares the mind for philosophic discussion; it "sets the thinking process in motion."[89] The association is even stronger for Aristotle, who "made choice of a public walk [*peripaton*] in the Lyceum where he would walk up and down discussing philosophy with his pupils Hence the name 'Peripatetic' [*peripatêtikon*]" (Diog. Laert. 5.1.2).[90]

These walks in preparation for philosophic discussion are not called *theoriai*, as the intellectual journey itself might be. But they provide further evidence of the deep and complex ways in which the internal and the physical might intersect: what happens in the mind (or in the "mind's eye") is not simply articulated through analogy to bodily experience, but might in fact depend upon it. O'Sullivan's landscapes of allusion affirm that, when combined, an absolute space and the relative movements that unfold within it can produce powerful associations with other kinds of experience, which then take on meaning through relational associations. Thus, in Roman villas, the visual

p. 149) notes that while he concentrates on the private villa, public intellectual spaces in Rome similarly encouraged the association of physical movement and philosophical conversation.

86. For the Roman villa's "landscape of allusion," see Bergmann 2001, pp. 155–157.

87. O'Sullivan 2006, p. 146. These landscapes might also evoke the idealized Roman past or the idealized pastoral Roman present, for which see Bergmann 1992, pp. 28–34.

88. Montiglio 2000, pp. 86–105.

89. Montiglio 2000, p. 94. Standing, in contrast, corresponds to deep individual thought, as opposed to thought that originates in conversation with others. Socrates seems to have been well known for staying rooted to a spot, arrested in the process of movement, while pondering a particularly troublesome problem (Pl. *Symp.* 175b1–2, 220c2–d5).

90. Trans. Hicks 1972 (LCL 184).

allusions to a Hellenic setting (absolute), helped those moving through the space on their *ambulatio* (relative) to imagine themselves as Classical thinkers (relational).

Traveling with Dionysos in the andron

Let us bring the various strands of our own journey together and situate them in the andron. Dionysos, as a god who travels and who arrives suddenly to reveal himself to mankind, might be thought of in relationship to the *theoria* in two ways: first, as a world traveler, the god himself might be thought of as a kind of *theoros*, supplying a paradigm for the transformative journey of the symposium; second, his divine presence is the kind of spectacle that mortal men might experience corporeally as the culmination of a *theoria*. I take up these two potential aspects of Dionysos in turn, but would like to emphasize here that I see them working together, and, indeed, simultaneously, in the andron.

The flexibility of the *theoria* as an individual or civic undertaking, its assumption that encounters with the unfamiliar are productive, and the role it serves in the social and political fabric of the Greek city helps us to understand more fully the potential significance of Dionysos as a god who travels. For all of his journeys, Dionysos is never (as far as I know) explicitly called a *theoros*, and his time abroad is never cast as a *theoria*. But his life does roughly adhere to the three-part structure of an outward journey, encounter with the foreign, and return home that characterizes the *theoria* as well as other kinds of knowledge-gathering travel. When Dionysos first leaves Greece, it is by force and in his infancy, rather than by choice. But his time abroad is formative: he is raised by the nymphs of Nysa, wherever it might be, and his experience in foreign lands endows him with specialized knowledge of viniculture. He travels more broadly, too. He wanders first under the influence of madness, arriving in Phrygia, where he acquires more knowledge—the sacred rites of initiation, which he learns from Rhea. Once purified, he continues to move over the *oikoumene* in order to establish his cult. To be sure, in both his mad wandering and his postmadness travels he differs from the canonical *theoros*, whose role as a kind of ambassador requires mindfulness and who typically gathers knowledge rather than imparting it to the foreign people he encounters (although Solon, who famously delivers advice to Kroisos, offers an important exception). These world travels ultimately comprise, however, a complex and extended return home to Greece, where he finally arrives via Naxos or Thebes. Having returned, he may seem exotic

or even foreign himself, appearing in the *Bacchae*, for instance, disguised as a Stranger in Lydian dress, and in vase paintings wearing animal skins and accompanied by panthers and griffins. But, not unlike a returned *theoros*, he shares the knowledge accumulated during his time away: his divinity, the initiation rituals of his cult and mysteries, the cultivation of the vine, and the making of wine.[91] Despite some initial resistance to its import, this knowledge becomes not only a "joy to mankind" (Hom. *Il.* 14.325), but also—like the laws in which Plato's *theoroi* are interested—a civilizing force vital to Greek culture and to the polis.[92] While we cannot call Dionysos a *theoros*, he nevertheless returns to Greece *like* a *theoros*, bringing with him new and specific knowledge that enhances civic culture, social practices, and sacred ritual.

Integral to his identity as a god in motion, who arrives and departs suddenly, is Dionysos's habit of revealing himself to mortals, emerging from the sea or arriving in disguise, as he does in *Homeric Hymn* 7 and the *Bacchae*. To be sure, while Dionysos is not the only god who makes appearances in the human world, his mythological epiphanies ("the manifestation of deities to mortals") are especially connected to his itinerancy, and his status as *xenos* is celebrated in cult through the re-enactment of his seminal arrivals.[93] It is not just the god who is on the move, however: witnesses to divine epiphanies, too, are frequently travelers. Some encounter deities in liminal landscapes like riverbeds, seashores, mountains, caves, or even the Ocean—spaces outside of the polis where gods are likely to appear; others, of course, are themselves *theoroi*, who have traveled specifically to observe the spectacle of the divine.[94] As Platt has argued, the recitation of certain hymns in ritualized contexts guided audiences, preparing them for epiphanic viewing by simultaneously invoking the god's presence and narrating mythic instances of his or her manifestation in the mortal world. Platt uses as an example *Homeric Hymn* 7 to Dionysos, in which the performative telling of the god's mythical epiphany to the Tyrrhenian pirates would have invited him in to re-enact his appearance in cult festivals like the Anthesteria, where, contrary to the

91. For the traditions of Dionysos's discovery of the vine, see Detienne 1989, pp. 33–37.

92. Detienne 1989, p. 37; Henrichs 1975, pp. 141–144.

93. Detienne 1989, p. 5; Henrichs 1990, pp. 269–270; Platt 2011, pp. 31–76, quote from p. 7; Petridou 2015, p. 302. Platt (2016, p. 169) notes that, in general, divine epiphanies are often described in terms of motion ("ascent," for example) and arrival or return. For a recent review of scholarship on epiphanies, see Platt 2011, pp. 9–24; Gordon (1979) and Versnel (1987) are foundational.

94. Petridou 2015, pp. 196–208; see also Prier 1989, pp. 41–117.

mythic narrative, he would be properly recognized and welcomed.[95] Platt also looks at representations of the divine in votive reliefs, set up as dedications in sanctuaries in the late fifth and fourth centuries. In these reliefs, a worshipper or group of worshippers are depicted bringing offerings to the god's sanctuary, while the god him- or herself—appearing as a living divine presence and not, notably, as a cult statue—looks on. Serving as an offering themselves, as documentation of an event that has (ostensibly) already taken place, and as a model for future ritual behavior, these reliefs depict the successful reciprocal relationship of mortal dedication and divine epiphany.[96] Unlike the hymns, the reliefs represent the god's manifestation in a contemporary ritual context, but both effectively anticipate their audience's encounter with the divine.

The Archaic experience of epiphany is described as a *thauma* (a "wonder") that was "asserted in profoundly physical terms . . . as a sensory extravaganza" and that often had a "transformative effect" on witnesses.[97] By the fourth century, accounts and representations of epiphanies—as the votive reliefs suggest—privilege the visual recognition of the god.[98] This emphasis may be grounded in the cultural association between seeing and knowing (e.g., Arist. *Metaph.* 980a), a relationship that also underlies both the practice and the metaphorical uses of *theoria*. But even in the context of the fourth century, the experience of the divine is not an exclusively visual one; the presence of a deity can still be said to have been experienced synesthetically. Rather, epiphanies point to a particular point of tension in the association between sight and knowledge, since the vision of a god in corporeal form allows for the recognition of the god, even while deities are not, in their actual existence, corporeal—in fact, they are "resistant to sensory contact and cognitive processing."[99] What this complex (and, often, contradictory) understanding of epiphanies suggests for us is that vision is central to the confirmation of the god's presence, but that the other senses are also active in the perception of the divine.

How, then, might the vision of a Dionysos-on-the-move be read by those participating in the symposium? I suggest—and hope I have laid this

95. Platt 2011, pp. 62–63, 72–76. For the performance of choral poetry as an act of ritualization, see also Kurke 2005.

96. Platt 2011, pp. 31–50; for the reciprocal relationship, see p. 33. See also Klöckner 2010.

97. Platt 2011, p. 56.

98. Neer 2010, pp. 58–65; Platt 2011, pp. 10–12, 59–60; see also Squire 2016, pp. 8–19.

99. Platt 2016, p. 172. See also Marinatos and Kyrtatas 2004, pp. 229–232.

foundation with the above discussion—that the mosaic image of Dionysos at once casts the symposium itself as a journey, in which the metaphorical travelers on the *klinai* follow the god's model, and anticipates bodily experience of the god in the form of wine. As in chapter 2, I proceed here with the premise that the andron is an active space in which the intersection of the absolute, relational, and relative has the capacity to produce a complex spatial metaphor, and I underline three aspects of the andron that, I believe, play a particular role here: the ritualization of space, which shapes the symposiasts' understanding of what is possible, the interrupted view of the god in the mosaic, and the circling of the wine cup. The symposium is an event demarcated from the quotidian by a process of ritualization in which the "social body" interacts "within a symbolically constituted spatial and temporal environment."[100] Like others, this particular ritualized space is marked by a "formality, fixity, and repetition" that includes the sequestering of participants, their purification, the introduction and use of special equipment, the pouring of libations, the invocation of gods, and the singing of hymns.[101] Thus, the symposium is marked as a kind of space, not unlike the sanctuary spaces that are both the subject and context of the votive reliefs, in which an encounter with the divine might be possible.

Within this context, once symposiasts were reclining on their *klinai*, with the symposium underway, the image of Dionysos in the mosaic floor would have appeared to the men gathered around him in disconnected moments, in pieces, and from extreme angles. Here, the fragmented experience of horizontal perspective contributes to the representation of the god's movement: by revealing and obscuring parts of the god in turn, it suggests that he is in motion, and so never fully visible at any given moment; at the same time, the incomplete view mimics the confusing and fleeting visual experience of epiphany. Like the votive reliefs or the *Homeric Hymns*, which, in the ritual context, invoke the god and prepare worshippers for his appearance, the visual suggestion of Dionysos's corporeal manifestation in the mosaic floor (during a similarly ritualized event) anticipates a more intense physical encounter with the god. It is the case, after all, that Dionysos appears twice in the andrones under consideration here: he is visualized in the image on the room's floor, and he is made material in the wine. Sympotic drinking was, like the divine epiphany, a phenomenal encounter with the god, experienced as a "sensory extravaganza": participants would have smelled and tasted the wine,

100. Bell 1992, p. 93; see also pp. 7–8, 74.

101. Bell 1992, p. 91.

of course; they would have heard the splashes of mixing and pouring, held the cup in their hands, and felt the effects of drunkenness on their bodies. They would have watched as the wine moved in the cup around the room. Interaction with wine happens, in other words, on "profoundly physical terms": through wine, the god transforms the drinkers' experience of their own physicality.

So the mosaic image of Dionysos, and, in particular, of Dionysos as a god on the move, experienced along with the ritual invocation of the god and the symbolic sequestration of the participants from the world of the mundane, prepares symposiasts for a transformative interaction with the god. While this bodily encounter is happening, the wine itself is on the move. In its cup, it circles the room, defines the andron's relative space, and makes its way around or across the andron to each individual. The wine in the cup, in other words, re-enacts in microcosm the god's triumphant travel over the whole of the *oikoumene*, the journey to which the mosaic imagery alludes. The connection that the pebble mosaics set up between Dionysos and travel, then, is not simply represented visually; it is also "performed" by the wine as part of the live event.

And it is thanks to wine and its transformative physical effects that Dionysos is not the only traveler in the andron. The drink "warms the soul and removes its stiffness It frees us from restrictions, prohibitions, habits; it allows for a brief excursion outside normal boundaries."[102] In other words, its profound physical effects include a distortion of the senses, making the mind more open and influencing how the body perceives the space and spectacle around it. The performative elements of the symposium—elements that Xenophon's Socrates describes in *theoric* terms as "delights for eye and ear" (*theamata kai akroamata hedista*; Xen. *Symp.* 2.2)—take advantage of this altered physical and mental state, encouraging participants to play different roles or to explore the unfamiliar through conversations, songs, and recitations. Wine emboldens the participants as performers, and makes them receptive audiences.

As we have seen, productive travel results in transformation, whether through a witnessing of the spectacle of the foreign, an encounter with the divine, or a metaphorical exploration of the unknown. Facilitated by wine and performance, and following the model set by Dionysos and visualized in the mosaic, such encounters and explorations might also happen within the symposium. Like a *theoros*, symposiasts withdraw from the civic sphere

102. Lissarrague 1990a, pp. 10–11.

and from the quotidian concerns of domestic life; they encounter strange characters, new ideas, and spectacle, and they experience a sensory engagement with the god himself; they then "return," transformed by what they have experienced—or, at the very least, what they have imbibed—to re-engage with polis life. Dionysos's appearance might also, it must be said, warn of the dangers involved in both wine consumption and wandering abroad: isolation and madness, which the god himself was forced to endure, are always possible consequences for those who are not properly prepared for the sympotic journey or a phenomenal encounter with the god. But ideally, the symposium is a space of transformation, and it is this process that the image of the traveling Dionysos both promises and prompts. The mosaics present the god-on-the-move as both the means and the model for transformation, preparing the symposiasts for the bodily experience of wine and, simultaneously, encouraging their imitation of the god's own journey and its productive results. With Dionysos as their paradigm and wine as their transport, the symposiasts become metaphorical travelers, whose encounters with the unfamiliar, unfolding during the symposium in conversation and performance, might result in new knowledge and intellectual transformation.

Bellerophon

As a coda to chapters 2 and 3 and their common themes of traveling and transformation, let us consider the hero Bellerophon, whose adventures are featured in two pebble mosaics—a limited number, to be sure, but notable given the rarity of heroic subjects. Like Dionysos, Bellerophon is both a traveler and a wanderer. And his mythological journeys, like Dionysos's, might offer another ambivalent model for the transformative journey.[103] Falsely accused of trying to seduce the wife of Proitos of Argos (the same Proitos whose daughters were driven mad by Dionysos), Bellerophon was sent to Lycia. He carried with him a message from Proitos to the king of Lycia with instructions, unknown to Bellerophon, that the hero should be killed upon his arrival. The Lycian king, hoping to avoid dispatching this visitor himself, instead sent him to hunt the Chimaira—a monster with the body and head of a lion, a serpent as tail, and a fire-breathing goat head emerging from her back. Bellerophon searched for the Chimaira in the mountains near the city of Phaselis, a coastal

103. The story is preserved in Hom. *Il.* 6.14–211; Hes. *Theog.* 319–325; Pind. *Ol.* 13.60–93; Apollod. *Bibl.* 2.3.1; Paus. 2.4.1–3, 2.31.9; Strabo 8.6.21.

town known in Classical sources as an important commercial harbor.[104] When Bellerophon defeated the monster, the king sent him to battle the Solymi and the Amazons, and even ordered the best Lycian warriors to ambush him. Bellerophon was victorious again and again, and the king finally relented, awarding the hero his daughter's hand in marriage and half of his kingdom in place of execution. The oldest preserved version of these events, related in the *Iliad* as part of the genealogy of Glaukos, does not mention Pegasos, although the winged horse is the hero's constant companion in imagery and in other literary sources.[105] In the *Theogony* (326), Hesiod attributes the defeat of the Chimaira to "Pegasos and noble Bellerophon," and Pindar (*Ol.* 13.87–90) and Apollodoros (*Bibl.* 2.3.2) both describe the man's great advantage in doing battle from the air while on Pegasos's back.[106]

The Homeric version of Bellerophon's story also avoids relating the details around the end of Bellerophon's life, although Glaukos does allude to later events: the gods came to hate Bellerophon, he says, and the hero eventually "wandered alone over the Aleian plain, eating his heart out, and shunning the paths of men" (Hom. *Il.* 6.200–202).[107] The hubris by which Bellerophon earned this enmity may have been his attempt to enter the heavens and the company of the gods, an episode that is described in Pindar's *Isthmian* 7 (43–48) and that may have been dramatized in Euripides' *Bellerophontes*, known only from fragments.[108] In Pindar's version—and, it seems, in the Euripidean version—Pegasos threw his master to the earth, leaving him, crippled, to wander Cilicia as punishment. In other words, the hero attempted to travel beyond the bounds set for men, and was punished with perpetual wandering. It is this aspect of Bellerophon's journeys— which begin as travels to a foreign land and end with solitary roaming— that make him of interest here.

In an early fourth-century mosaic from the andron (Room b; figure 3.13) of House A.VI.3 at Olynthos, the central circular image features Bellerophon

104. Hom. *Il.* 6.129–195; Hes. *Theog.* 319–326; Pind. *Ol.* 13.84–91. According to Pliny, the fourth-century author Ktesias claimed that the beast's fiery breath continued to burn on Mount Chimaira there (*HN* 2.236; Ktesias, *Indika* 20). For the maritime interests of Phaselis, see Thuc. 2.69; Dem. *Against Lacritus* 35.1.

105. For Bellerophon's bridling of Pegasos at Corinth, see Robinson 2011, pp. 32–44; Ziskowski 2014, pp. 83–86.

106. Trans. Most 2007 (LCL 57).

107. Trans. Murray 1924 (LCL 170).

108. For the fragments of Euripides, see Collard and Cropp 2008 (LCL 504), pp. 289–310, frr. 285–312.

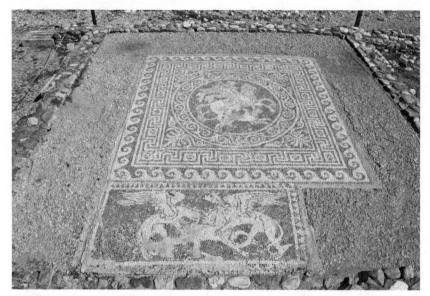

FIGURE 3.13 View of Room b and threshold, House A.VI.3, Olynthos, early fourth century. In situ. Photo H. M. Franks

flying on Pegasos to the right, spear raised at the Chimaira (figure 3.14).[109] Although most of Bellerophon's body is hidden behind Pegasos's wing, his cloak trails behind him, and he wears a wide-brimmed *petasos* on his head; he sits not directly on Pegasos's back, but on the skin of a spotted panther. The monster, easily recognized by her three heads, runs or leaps below, forepaws outstretched. The body and lion's head face to the right, while the goat head turns to the left to confront the hero, and the snake of the tail curls menacingly toward Pegasos's flank. This round central image is surrounded by a border of vine scrolls, and then framed by a square border with a meander pattern; acanthus plants decorate the corners between the inner circle and square frame that encloses it. Framing the whole is a wave pattern. In the mosaic of the room's threshold, two griffins attack a stag (figure 3.15).

A later pebble mosaic from Rhodes, dated by Salzmann to the first third of the third century, also depicts Bellerophon (figures 3.16 and 3.17).[110] In this

109. Payne 1931, p. 199; Robinson 1932, pp. 17–19; *Olynthus* V, pp. 4–6, pls. 1, 3, 12, 13:a; Salzmann 1982, p. 99, no. 78, pl. 13, with bibliography.

110. Orlandos 1977; Touchais 1977, p. 643, fig. 301; Salzmann 1982, p. 111, no. 114, pl. 45, 46:1. This mosaic (measurements unavailable), discovered in 1976, and the centaur mosaic discussed in chapter 5 belonged to a single house near the modern Odos Ayia Anastasia. The threshold mosaic to the Bellerophon is a sphinx, to be discussed further below. Lead strips are used to

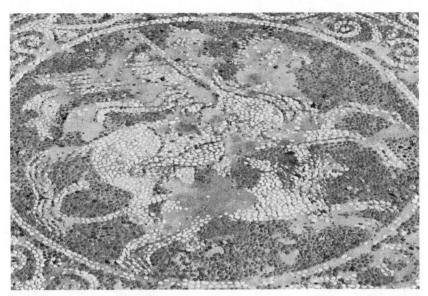

FIGURE 3.14 Detail of Bellerophon attacking the Chimaira, pebble mosaic from Room b, House A.VI.3, Olynthos, early fourth century. In situ. Photo H. M. Franks

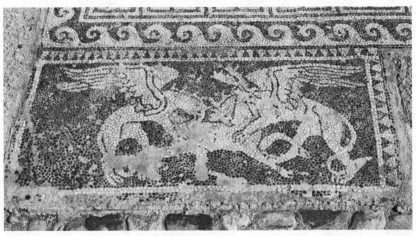

FIGURE 3.15 Griffins attacking a stag, pebble mosaic threshold from Room b, House A.VI.3, Olynthos, early fourth century. In situ. Photo H. M. Franks

image, too, he rides the winged Pegasos, spear raised toward the Chimaira, which, this time, confronts him and crouches low, all three heads facing the hero (figure 3.18). This Bellerophon wears laced boots that come to midcalf

delineate certain facial features of Bellerophon and Pegasos and the hero's spear, as well as the sphinx's eye, brow, and headdress.

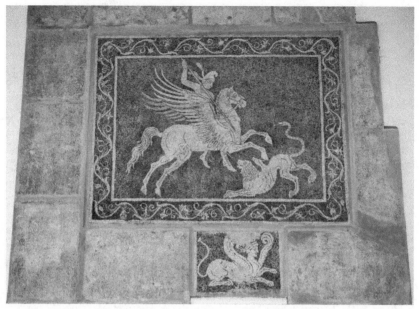

FIGURE 3.16 Bellerophon attacking the Chimaira and sphinx, pebble mosaic from Rhodes, early third century. Rhodes Archaeological Museum. Photo H. M. Franks

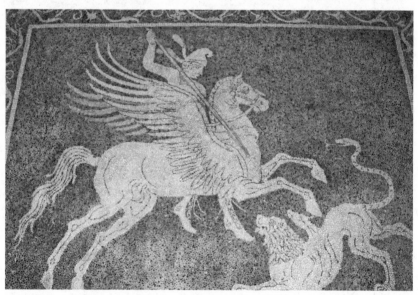

FIGURE 3.17 Detail of Bellerophon attacking the Chimaira, pebble mosaic from Rhodes, early third century. Rhodes Archaeological Museum. Photo H. M. Franks

FIGURE 3.18 Detail of Chimaira, pebble mosaic from Rhodes, early third century. Rhodes Archaeological Museum. Photo H. M. Franks

and a curved *kidaris*, a hat of soft material that here has been tied with a band of fabric, the ends of which flutter behind the hero's head.[111] A line at his raised right wrist suggests that he may also wear long sleeves.

The cap and boots, as well as the long sleeves, if they are indeed present, are typical elements of "eastern" dress in the Greek visual tradition, as discussed in chapter 2, and the spotted panther skin on which the Olynthos Bellerophon rides may also have exotic connotations. But these attributes do not necessarily indicate that Bellerophon—a Hellenic hero, after all, with attachments to Argos and Corinth—is foreign. Recent work in Greek vase painting has expanded the potential semantic range of such foreign attributes in a way that is helpful in the case of Bellerophon.[112] As Thucydides suggests when speculating as to why Homer did not use the term "barbarians," the heroic world was one in which "the Hellenes on their part had not yet been separated off so as to acquire one common name by way of contrast" (1.3).[113] That is to

111. The ancient terminology for this kind of cap is unclear, and its form varies in Greek iconography. For the difficulties in establishing a "language of dress," especially regarding the treatment of foreign elements, see Miller 1997, pp. 183–187.

112. I depend here primarily on Topper 2012, pp. 92–98.

113. Trans. Smith 1919 (LCL 108).

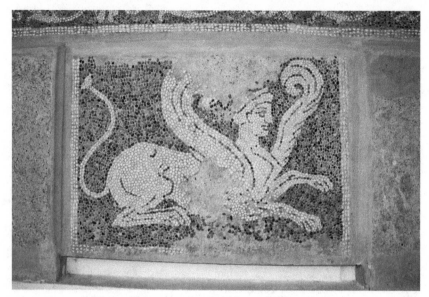

FIGURE 3.19 Sphinx, pebble mosaic threshold from Rhodes, early third century. Rhodes Archaeological Museum. Photo H. M. Franks

say that, according to Thucydides, the heroic world predated Hellenic self-definition. What is more, and as we will see in chapter 5, the customs of the early Hellenes were imagined as being similar to those of the barbarians of Thucydides' present day (Thuc. 1.6). With this construction of mytho-history in mind, rather than signifying a hero's ethnic identity, foreign attributes attached to a (Hellenic) hero may function in a more complex manner, associating him with a particular geography—Memnon with Ethiopia, or Achilles with Skythia, for instance—or identifying him as an inhabitant of the "barbarian" past.[114] Bellerophon's foreign attributes in our mosaic, then, might suggest the Lycian setting of the deed and Bellerophon's eventual rule in that area. Or they might refer to the distant past in which his story takes place, since, as Thucydides' observations suggest, to travel back in time is to travel to a foreign land.

In both of the mosaic examples, additional elements may further underscore the foreign setting of Bellerophon's deed. The griffins at the threshold in the Olynthos example suggest a distant landscape, as might the couchant sphinx at the threshold of the Rhodes andron (figure 3.19). While I dealt extensively with the griffins in chapter 2, the sphinx is new to our discussion,

114. In addition to Topper's discussion (2012, pp. 92–98), see also Ferrari Pinney 1983; Ferrari 2003, pp. 41–43.

and she brings with her a network of associations that might be further brought to bear on the sympotic context. She is best known from the story of Oedipus, whom she confronted on his journey to Thebes where she posed a special threat to travelers: she blocked the road, presenting them with a riddle; those who failed to guess its solution were sentenced to death, while Oedipus's correct answer bought his passage and vanquished the monster. It is the case, of course, that riddles, albeit with lower stakes, are a favorite sympotic pastime.[115] The sympotic *griphos* ("riddle," which literally means "net," and, it seems important in this context to point out, is distinct from *gryps*, griffin) commonly revolves around wordplay that casts a metaphorical net and twists meanings, and that engages the agonistic spirit of the event, since those who fail to guess the riddle may be punished (Athen. 10.448c, 458f–459b).[116] It is true that the sphinx's riddle is not a *griphos*, but, as the sources consistently call it, an *ainigma* (Apollod. *Bibl.* 3.5.8; Paus. 9.26.2). The difference, according to a scholion on Lucian's second-century CE *Vitarum auctio*, is that an *ainigma* poses a direct question, while the *griphos* seems at first to be a simple statement, and only reveals a hidden meaning under scrutiny (schol. Luc. *Vit. auct.* 14).[117] But this distinction is not necessarily as clear in the period to which our mosaics date. The types of *griphoi* described by the fourth-century Klearchos of Soloi are wide-reaching puzzles that require the listener "to use a process of intellectual inquiry to discover what is being referred to, and that is articulated with an eye to a reward or a punishment" (Klearchos, Wehrli fr. 86, *apud* Athen. 10.448b).[118] Aristotle's description of *ainigmata* as metaphorical, in which a description of one sphere of experience may be applied to another experience or object, is similar to Klearchos's first category of metonymic *griphoi* (Arist. *Rh.* 3.1405a–b; 2.1394b–1395a).[119] And Plato, who is suspicious of riddles as things that seem to be one thing, but are another, uses as an example of sympotic riddling a children's *ainigma*—not a *griphos*—about a eunuch (Pl. *Resp.* 5.479b–c). So there is perhaps room for an *ainigma* alongside or as the *griphos* in the symposium, and, thus, there is

115. Neer 2002, pp. 13–14, 40, 46–47, 62–63; Wecowski 2014, p. 51.

116. Neer (2002, p. 62) has argued that the *griphoi* have a kind of visual equivalent in certain vases, *eikonikoi griphoi* ("picture riddles") that serve as "the pictorial equivalent of sympotic 'double-meaning,' *homonymia*."

117. Luz 2013, p. 97.

118. Trans. Olson 2009 (LCL 274).

119. Luz 2013, p. 85–87.

perhaps a place in the andron for the sphinx as a monster who confronts the symposiast-travelers to test their wits.[120]

The threshold mosaic at Rhodes, then, as well as the frieze of double sphinxes that decorate the mosaic floor of the andron (Room b) of House B.V.1 at Olynthos may introduce to the symposiasts the theme of the *ainigma* and the ambivalence—the double meanings and metaphors—on which, like the symposium itself, such puzzles turn.[121] While a drinker might hope for victory in the contest of intellects, a sphinx also presents the possibility of defeat. After all, even Oedipus's victory over the sphinx is temporary, since it only leads to tragedy in Thebes. The same is true of the image of Bellerophon with which the sphinx is paired in the andron at Rhodes. To be sure, both the mosaics at Olynthos and Rhodes directly represent the hero's major accomplishment, but the image of him in flight on Pegasos might also hint at his later attempt to enter the realm of the gods, a journey that aimed not to explore the boundaries of the world, but to transgress them. As punishment, Bellerophon wanders in shame—not maddened, but physically lamed, and so aggrieved that he shuns the company of men. His final fate underscores not only the transience of human fortune, but also the deep ambivalence of movement abroad in the Greek mind. He presents a model that reverses the one that Dionysos offers: both leave Greece, both travel, and both wander. But whereas Dionysos wanders in madness and, having recovered, continues to travel to the limits of the world before eventually returning home, Bellerophon attempts to travel beyond the limits set for mankind, and is sentenced to wandering, from which he never returns.

The Bellerophon mosaics, then, could be considered aspirational images. Cohen's investigation of agonistic imagery—particularly her detailed discussion of the andron pebble mosaics of the House of the Abduction of Helen at Pella—focuses on the capacity of hunt, abduction, and battle scenes to present a "*paradigm* of masculine glory through bodily exertion."[122] Like other heroes who defeat monsters, Bellerophon's deed is neither fully hunt nor fully battle, but his attack on the Chimaira clearly aligns with these themes of predation

120. I thank Kathryn Topper (pers. comm.) for suggesting this possibility regarding the sphinx and her potential role in the symposium.

121. The double sphinxes of the House B.V.1 mosaic at Olynthos feature a frontally rendered face and chest flanked on both sides by a winged torso, as though the single torso is seen simultaneously from either side. The threshold mosaic pictures a lion mauling a stag. For this mosaic (3.17 x 3.70 m;), see Robinson 1932, p. 20; *Olynthus* V, pp. 10–11, pls. 6, 15; *Olynthos* VIII, p. 132, pls. 46:2, 103:1; Salzmann 1982, p. 101, no. 84, pl. 12:3.

122. Cohen 2010, pp. 24–63, quote from p. 63. See also Westgate 2011, pp. 296–304.

and dominance.[123] In a symposium, such a deed, achieved far from home, may promote the great promise of the journey abroad and of confrontation (literal, for Bellerophon; metaphorical, for the symposiast) with the foreign. But these images also offer a potential caution to symposiast-travelers not to exceed the boundaries of propriety: once those boundaries are crossed, even a hero might not return home.

123. On animal attacks, see Cohen 2010, pp. 93–118.

4

The Journey Around

TURNING AND TURN-TAKING

KEPLER'S *HARMONICES MUNDI*, published in 1619, takes up the old problem of the geometrical and mathematical correspondences—the consonances—of the cosmos.

> But now, Urania, there is need for louder sound while I climb along the harmonic scale of the celestial movements to higher things where the true archetype of the fabric of the world is kept hidden. Follow after, ye modern musicians By means of your concords of various voices, and through your ears [Nature] has whispered to the human mind, the favorite daughter of God the Creator, how she exists in the innermost bosom.[1]

His premise—that the earthly and the celestial share an underlying rational order discernible visually in the movements of the stars and aurally in the rhythms and tones of music—resonated deeply in Greek antiquity. Pythagoras is credited with first identifying the celestial orbits with musical ratios, and his influence is evident in Plato, who, of the extant sources, most fully explores the ability of earthly *choreia*—music and dance (harmony and rhythm) together—to bring the human soul into concord with the harmonic revolutions of the divine cosmos.

In this chapter, we shift focus to the turning patterns of the symposium. Like the orbits of the stars tracing their paths across the heavens, the movement of the wine cup from couch to couch visually inscribed circles onto the space

1. Trans. Wallis [1939] 1991, p. 200, §295.

of the andron, and the voices of the symposiasts, rising and falling silent in turn, provided of aural reinforcement of this motion. While these revolutions may have sped up or slowed down, they were continuous, and all present were equally subject to them. This chapter argues that, rather than building an imaginary space to which symposiasts might escape, mosaics that feature the icon of a wheel worked to characterize the movement *epidexia* as measured and constant, its rhythmic circulations serving as a metaphor for the balance and equity that were the foundation of the sympotic experience and the bonds of friendship that were its ideal result.

The mosaics

The image of the wheel in Greek art is easy to recognize: it normally has four spokes, set at 90 degrees or forming an X rather than a Greek cross; the spokes are attached at a central round hub and, sometimes with buttressing, at the circular rim, or felloes. It is represented this way in vase painting, both on chariots and as a shield device. The association with such trappings of athletics and warfare bring to mind agonistic competition, but in fact, the wheel and its spinning engage a complex network of relational associations: wheels are toys and love charms and torture devices, their turning like the cosmic cycle or a maenad's ecstatic dance.

Several extant androntes feature wheels on their pebble-mosaic floors. Two are from houses at Olynthos, one is from Megara, and one is from Athens, its anteroom also featuring a mosaic wheel. The first, from Room j in House A.VI.6 at Olynthos, features a four-spoke wheel at its center, surrounded by a circular frame of waves; a swastika meander alternating with squares in a checkerboard pattern forms the outer frame that borders the *trottoir* (figure 4.1).[2] The mosaic at the threshold is a black and white lozenge pattern. Also from Olynthos, from Room j of the House of the Comedian at the bottom of the East Hill, is a black wheel on a white ground; the outer square frame is a wave pattern that encompasses the rectangular threshold mosaic of alternating black and white triangles, the points of which meet at the center in a "butterfly design."[3] A floor from Megara elaborates on the wheel motif: the

2. Robinson 1932, pp. 20–21, fig. 3; *Olynthus* VIII, pp. 107, 290, no. 6. The mosaic is 2.95 x 2.95 m.

3. Robinson 1932, p. 23, fig. 5; *Olynthus* VIII, pp. 66, 290, no. 10, pl. 17. The mosaic is 1.95 x 1.60 m; its threshold mosaic is 1.00 x 0.95 m. For the House of the Comedian, see *Olynthus* VIII, pp. 63–68.

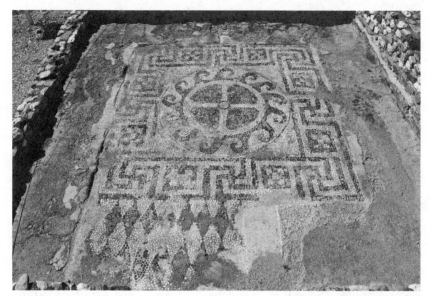

FIGURE 4.1 View of Room j, House A.VI.6, Olynthos, early fourth century. In situ. Photo H. M. Franks

wheel takes up most of the central floor, and between the four spokes are alternating lotus flowers and palmettes.[4] Around the outside of the wheel, in the corners of the room, are four dolphins, animals that most certainly evoke the connections of the symposium and of Dionysos to the sea, as discussed in the previous chapters. At the threshold is a white bird.

The late fourth- or early third-century House of the Greek Mosaics, located southwest of the Athenian Agora, below the Pnyx, has a two-room andron suite (figure 4.2) comparable to that of the Villa of Good Fortune at Olynthos (Rooms a and g) or the House of the Mosaics at Eretria (Rooms 8 and 9).[5] The only decoration on the anteroom floor is a wheel, aligned centrally with the door of the courtyard rather than with the off-center doorway to the andron (figure 4.3). This wheel has four spokes rendered in yellow pebbles and attached to the yellow and gray felloes with wedge supports; a hole is depicted in the middle of the central hub. Between the anteroom and the andron proper, in the place where the *trottoir* (here covered in yellow plaster) breaks for the doorway, is a threshold mosaic of yellow lozenges on a

4. Nikopoulos 1972, p. 108, pl. 80:β; Votsis 1976, p. 587, fig. 15; Salzmann 1982, p. 96, no. 70, pl. 51:1–2. The mosaic is 2.75 x 2.40 m.

5. Dörpfeld 1894, p. 508; Daux 1965, pp. 684–685, fig. 2; Thompson 1966, pp. 52–53, pl. 17b; *Agora* XIV, pp. 181–182, pl. 89:c–d.

FIGURE 4.2 View of the andron suite, House of the Greek Mosaics, Athens, late fourth or early third century. Photo courtesy American School of Classical Studies at Athens, Agora Excavations

white ground. The andron floor is also decorated with a wheel, rendered in a technique we have not yet discussed (figure 4.4). Rather than depending primarily on color to delineate an image, this mosaic uses the placement of oblong pebbles (or pebbles set on their sides) at angles to create lines and planes. Pebbles placed parallel to one another give the impression of an unbroken, if mottled or textured, surface, while others set at different densities or at alternative angles visually distinguish a line or a new surface.[6] It may be that this shifting of directionality and density in the surface mimics motion, similar to modern optical illusions, in which parts of a static image— particularly those in the peripheral vision—seem to rotate.[7] Any such effects must have been enhanced under the influence of wine.

The form of this wheel is also somewhat different from those described above. The hub (rendered in yellow pebbles with a white point at the center)

6. Although we have not previously encountered this technique, it is not unique. Parallels from the late fourth or early third century may be found at Apulian Herdonia (Ordona) in Italy (Mertens 1971, pp. 13, 25, fig. 16:b), and a later example, probably dating to the late third or early second century, is located on Thasos (Holtzmann and Picard 1974, pp. 791–792, fig. 5).

7. My limited research into this "illusory movement" (or "self-animating image") phenomenon suggests that the reasons behind this effect are not fully understood. See, for instance, Fraser and Wilcox 1979; Faubert and Herbert 1999; Kitaoka and Ashida 2003; Kuriki et al. 2008; Fermüller, Ji, and Kitaoka 2009.

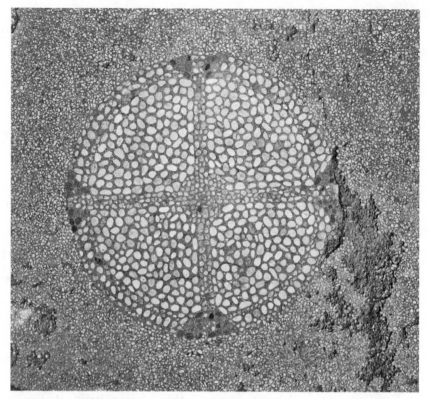

FIGURE 4.3 Wheel, pebble mosaic from the anteroom of the andron, House of the Greek Mosaics, Athens, late fourth or early third century. Photo courtesy American School of Classical Studies at Athens, Agora Excavations

is located in the middle of the room, and is surrounded by two concentric rings; this unit is further enclosed by a rectangular border. The spokes of this wheel extend from the central hub to the inner circular ring or rim, and then continue beyond the outer rim to the interior corners of the frame. Perhaps because of its accommodation of the rectangular space, the wheel's rays are not at right angles to one another, but instead form an X—a shape not unknown among wheels in vase painting. Perhaps more problematic is the extension of spokes past the rim of the wheel and the double rims: Is this, in fact, a wheel at all? If it is not, it is still wheel-like, an adaptation of wheel iconography (or, at the very least, the hub and inner ring form a small wheel). The clear wheel on the floor of the andron's anteroom would, at least, seem to prepare the viewer to see this second set of circles and spokes as a wheel, and the potential visual illusion that results from the technique could suggest the motion of turning.

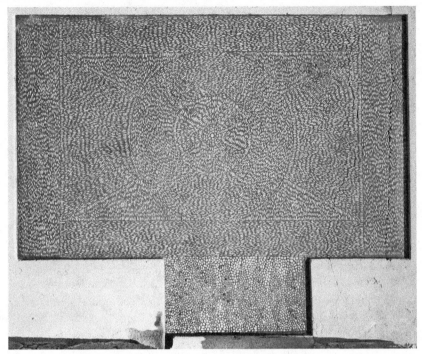

FIGURE 4.4 Wheel, pebble mosaic from the andron, House of the Greek Mosaics, Athens, late fourth or early third century. Photo courtesy American School of Classical Studies at Athens, Agora Excavations

Kinds of wheels

The most widely known pebble-mosaic wheel is not from an andron, but from the floor of Room e, the first of a two-room suite (Rooms e and f), located in the northeast corner of the Villa of Good Fortune at Olynthos (figure 4.5).[8] The function of Rooms e and f is unclear—neither is designed to accommodate *klinai*, as is Room a, the andron in the villa's northwest corner— and so I will not spend much time on this particular example. But it does give us a way in to thinking about the relationship between a wheel's presence in absolute space and abstract notions of movement with which it might be associated. Accompanying the wheel in Room e is the inscription that gives the

8. Room e (4.40 x 3.30 m) is the anteroom to Room f (4.60 x 4.40 m), whose floor bears two inscriptions, one reading *Eytychia kale*, and one, around a square at the center of the room, *Aphrodite kale*. Robinson (1946, p. 209) identifies Room f as a gaming parlor, suggesting that the anteroom wishes those entering good luck, while the *Aphrodite kale* inscription in Room f is an earlier form of the Roman "Venus throw."

FIGURE 4.5 Wheel, pebble mosaic from Room e, Villa of Good Fortune, Olynthos, late fifth or early fourth century. In situ. Photo H. M. Franks

villa its name: it reads *dikaio agathe tyche* ("to one who is just, [grant] good fortune").[9] Robinson, thus, identifies this image as a wheel of good fortune, a symbol of the mutability of life's luck.

One's fortune or fate, personified in the figure of Tyche, became, to use Pollitt's term, "an obsession" of the Hellenistic age.[10] Attributed to the fourth-century sculptor Praxitiles are at least two statues of Tyche personified (one at Megara, for which see Paus. 1.43.6, and an Agathe Tyche that was taken to Rome, for which see Plin. *HN* 36.23); these would seem to anticipate the intensified interest in her depiction across various Hellenistic media. But long before her popularity in the anxious centuries following Alexander's conquests, the impermanence of one's situation in life was a pervasive Archaic and Classical Greek concern. Fortune is at the root of Kroisos's legendary interaction with Solon (Hdt. 1.29–33), who refuses to judge a man lucky until he

9. Robinson (1934, p. 505) offers an alternative translation, where *dikaio* is part of a name, so that the phrase could read, e.g., "To Dikaios, good fortune." While I am reading the inscription as a single phrase, it is possible that *dikaio*, located at the top of the mosaic, should be read separately from *agathe tyche*, which is visually distinguished against a white ground. In addition to the inscription are a four-barred sigma (located in the top middle of the mosaic after *dikaio*) and an alpha (located in a similar position at the entrance), which Robinson reads together as symbols of good luck. See, in addition, Robinson 1946, p. 209.

10. Pollitt 1986, pp. 1–3.

has died happily, and it is a tension in certain tragedies, including Euripides' *Herakles*. It underlies Theognis's observation that "blessed, fortunate and happy is he who goes down to Hades' dark house without experiencing hardship and before he cowers in the face of enemies, transgresses under duress, and tests what is in the minds of his friends" (1013–1016).[11] And Pindar makes reference to it when he says that the god "at one time raises these men's fortunes, then at other times gives great glory to others" (*Pyth.* 2.89).[12]

Common as it is as a theme, the transience of man's fortune is figured in a variety of ways. The chorus of Sophocles' *Women of Trachis*, attempting to comfort Deianeira by reminding her that "the revolving [*kyklousin*] paths of the Bear bring to all suffering and joy in turn . . . joy or loss at once is gone, and then comes back" (129–135), uses as a turning metaphor the circle of the *Arktos* constellation through the cosmos.[13] In a fragment of Sophocles' *Teucer*, a man's lot does not turn, but instead "swings the balance of life to the other side" (fr. 576), and in Aeschylus's *Libation Bearers, tychai* fall, like dice, to show a favorable face (969–971).[14] By the Roman period, the wheel is well established in literature and art as the symbol of the goddess Fortuna, the counterpart to the Greek Tyche—an association that continues up to the modern-day television game show. Robinson argues that the concept of the wheel of fortune also existed in the fifth and fourth centuries, although it is not a visual attribute of Tyche as it is of Fortuna. And there is indeed at least one literary example in which the circularity, the rising and falling, of fate is figured as a wheel. In a fragment of Sophocles, Menelaus describes his fate as "always revolving [*kykleitai*] on the fast-moving wheel [*trochoi*] of the goddess and changing its nature" (871).[15] He further compares this process to the moon—not to its cyclical movement through space, but to its waxing and waning, the change in shape and beauty that comes to fullness and then dissolves over time.[16]

11. Trans. Gerber 1999 (LCL 258).

12. Trans. Race 1997 (LCL 56).

13. Trans. Lloyd-Jones 1994 (LCL 21).

14. Trans. Lloyd-Jones 1996 (LCL 483).

15. Trans. Lloyd-Jones 1996 (LCL 483). For the attributes of Tyche, see Shapiro 1993, pp. 227–228.

16. See Robinson (1946, p. 208) for discussion of this passage. Robinson also cites an Orphic fragment that refers to the wheel of birth (*geneseos trochos*) and an anacreontic that compares the running speed of life to the chariot's wheel; while these apply spinning-wheel imagery to aspects of life, they are not quite wheels of fortune.

A common element among these metaphors for the changes in life's fortunes is a pattern of movement, often cyclical or circular, as when Herodotos's Kroisos warns king Cyrus that men's affairs are *hos kyklos*, like a circle, "which in its turning suffers not the same man to prosper forever" (1.207.2).[17] But while the Greeks may have, at times, figured this circularity as a wheel (as, it seems possible, at the Olynthos villa, where the wheel is framed by explicit reference to *agathe tyche*), they seem not to have adhered to a fixed iconography of a wheel of Tyche. Still, Robinson's look at the wheel of fortune is useful for us, and two important points emerge from this overview. First is the commonplace of revolving movement to reflect and order abstract change as constant, inevitable, and universal. Second, given especially the difficulty in visually representing the perpetual motion of spinning, is the abundance of imagery used to express such movement. Here, then, we are dealing with two layers, or steps, in a single metaphor: one that understands changes in condition as physical motion, often (though not always) as circling or revolving, and one that figures such motion through objects or bodies that turn or spin.

The wheel has a starring role in at least one mythological story, where it appears as a device of unvarying, eternal torture for Ixion. A king of Thessaly, Ixion offended the gods first by committing parricide and then, having been purified of this crime by Zeus, attempting to rape the goddess Hera. His punishment, in addition to fathering the race of Centaurs, was to be bound to a winged wheel (*pteroenti trochoi*)—his "four-spoked fetter" (*tetraknamon . . . desmon*), as Pindar describes it—that turns (*kylindomenon*) perpetually (*Pyth.* 2.21–53).[18] Initially blessed by the gods, Ixion brought on his own fall by his hubris, and so his fate does represent a change in fortune, although, despite his eternal turning, there is no hope that it will be raised again. In representations of his torture, Ixion's wheel is virtually identical in appearance to those of the pebble mosaics, but may feature the addition of feathers, wings, fire, or even serpents.[19] On a kantharos in London from the middle of the fifth century, for instance, Ixion is held captive between Ares

17. Trans. Godley 1920 (LCL 117). Godley translates *kyklos* as a wheel, "men's fortunes are on a wheel," but given the broader implication of *kyklos* (and of *pragma*), and since we are concerned with the image of the wheel, I avoid that translation here.

18. Trans. Svarlien 1990. See also Aesch. *Eum.* 717–718.

19. It is worth noting here that earlier traditions place Ixion's torture in the heavens, where a fiery wheel revolving through the sky could become a celestial body. See, for representations of Ixion's wheel, Simon 1955; Chamay 1984; Shapiro 1994, pp. 75–82.

FIGURE 4.6 Ixion waiting to be bound to the wheel, red-figure kantharos attributed to the Painter of Amphitrite, ca. 460. London, British Museum 1865.0103.23. Photo © Trustees of the British Museum

and Hermes, while Athena approaches, the winged instrument of his punishment in hand (figure 4.6).[20]

Ixion's torture may be related to the *iynx* wheel, a toy and love charm that involves or is related to the small bird called the Eurasian wryneck—the *Jynx torquilla*, a species in the woodpecker family. In Pindar's *Pythian* 4 (213–219), Aphrodite devises the charm, giving it to Jason so that he might seduce Medea and persuade her to join his cause:

> [She] bound the dappled wryneck [*iynga*] to the four spokes of the inescapable wheel
> and brought from Olympus that bird of madness
> for the first time to men, and she taught
> the son of Aeson to be skillful in prayers and charms,
> so that he might take away Medea's respect

20. London, British Museum E155 (1865.0103.23) (red-figure kantharos, ca. 460, attributed to the Painter of Amphitrite): *ARV*² 832, 37.

> for her parents, and so that desire for Hellas might set
> her mind afire and drive her with the whip of Persuasion.[21]

This passage provides us with both a description and a kind of etymology for the device through the bird, as well as an introduction to its function as a love charm, used along with a spoken spell, that influences the mental state of its target.[22] In vase paintings, the wheel is often handled by those in the company of Eros or by Eros himself; it has two holes in the center hub through which a string or leather thong is run, its ends tied to form a loop.[23] One turns the wheel to twist the strings together, and then alternately pulls tight and slackens the ends of the loop to spin the wheel.[24] Theokritos's *Idyll* 2, where "*Iynx*, draw my lover home to me" is repeated, suggests the kind of incantation that might accompany the charm's spinning.[25]

The poor wryneck, called in Pindar the "bird of madness" (*mainad' ornin*), may have been chosen as the emblem of this charm because of the way that, when threatened or held, it throws back its head and, as the *torquilla* species name suggests, twists it in various directions.[26] These unnatural, almost hypnotic contortions are a defense against predators in that they mimic the movements of a snake (as in Arist. *Hist. an.* 2.504a). But they also resemble, as Pindar's wording implies, a state of mania. That the bizarre movement of the wryneck's head was, to the ancient Greeks, a sign of an altered, maddened mentality may be suggested in visual representations of maenads, who sometimes

21. Trans. Race 1997 (LCL 56). See also Segal 1986.

22. Gow 1934. For the wheel in vase painting, see Lezzi-Hafter (2009), who emphasizes the wheel as a symbol of eroticism around the *ephebe* and for women, who might "spin out" like a wheel, when not brought under control.

23. Tavenner 1933, pp. 119–126; Gow 1934, pp. 4–5. An Apulian red-figure pelike and a phiale in Trieste both depict a winged Eros holding one end of the *iynx* wheel's loop in his left hand, so that the wheel and other end of the loop swing beside him: Trieste, Museo Civico S432 (Apulian red-figure pelike, fourth century): *CVA* Trieste, Museo Civico 1, IV.D.19, pl. (1938)20:5, 6; Trieste, Museo Civico S576 (Apulian red-figure phiale, fourth century): *CVA* Trieste, Museo Civico 1, IV.D.22, pl. (1943)25:3–5. A Lucanian red-figure bell krater in Taranto shows a seated woman with the loop of the *iynx* wheel strung between her fingers, Eros standing before her: Taranto, Museo Archeologico Nazionale 5438 (IG8011) (Lucanian red-figure bell krater, late fifth century): *CVA* Taranto Museo Nazionale 3, IV.D.7, pl. (1595)17:1–3.

24. See Gow (1934, pp. 5–7) for a helpful diagram and description.

25. Trans. adapted from Verity 2002, pp. 7–12. See also the scholia, Dübner 1849, pp. 19–20. In Aeschylus's *Eumenides*, too (321–396), although an *iynx* is not mentioned, the chorus's song may work in a similar way, seeking to bind through its own cyclic repetition.

26. See Arnott 2007, pp. 79–81. Nelson (1940, pp. 447–448) provides a nice summary of the bird's odd behaviors.

FIGURE 4.7 Maenads reveling, red-figure pyxis lid from Eretria in the manner of the Meidias Painter, ca. 420–400. London, British Museum E775 (1893,1103.2). Photo © Trustees of the British Museum

take on a similar pose in the midst of their revel, their heads bent back at extreme angles, as on a red-figure pyxis lid from the end of the fifth century, now in London (figure 4.7), or on the fourth-century Derveni krater.[27] It could be the maddened state, shared by the *iynx* bird and the *iynx* wheel's victim, that prompted their shared name. Alternatively or additionally, and in anticipation of the discussion to come, it might be that the whirring (chirping or humming) sound of the spinning wheel had as much or more to do with the

27. London, British Museum E775 (1893,1103.2) (red-figure pyxis lid, from Eretria, 420–400, in the manner of the Meidias Painter): *ARV²* 1328.92. For the Derveni krater, see Barr-Sharrar (2008, pp. 122–148 for the maenads).

device's identification as an *iynx*, since the word is related to *iyzo* (to shout or yell) and *iygmos* (a shout, cry, or shriek).[28]

The *iynx* of Pindar's *Pythian* 4 is a devious tool, but interpretations and explanations of how exactly Aphrodite's device achieved its end vary. The traditional understanding of the wheel's operation is that spinning is the source of its magic: it causes its victim to whirl sympathetically and so draws him or her in (perhaps the modern metaphor of "reeling in" a sexual conquest is a good comparison).[29] Faraone has argued that the magic of Pindar's *iynx* lies instead in the bird as a kind of effigy; its binding and abuse transfers to the intended victim, stinging or burning her, or causing sleeplessness or hunger, until she is goaded into seeking out the spell's practitioner.[30] Johnston, in contrast, looks to the sound of the *iynx*, arguing that the power of both the bird and whirled wheel is located in the *iynx*'s "persuasive, seductive" voice, which, like that of a Siren, not only mesmerized its victim, but also led to "deception, danger, and ultimately . . . destruction," as it of course does for Medea.[31] Pindar's inclusion of the *iynx* bird, for Johnston, has nothing to do with the treatment of the animal or sympathetic transfer of experience (torture or whirling) to the victim, but is rather a "doubling-up" of the tools of aural persuasion at Jason's disposal.[32] Although Johnston, in focusing on sonority, attributes little more importance to the active spinning of the wheel than does Faraone, it is nevertheless worth noting here how integral sound and motion are. Both the visual whirling of the disk (harnessed, like the modern trope of the hypnosis wheel, for purposes of control) and the pull and release on the strings that operate the device produce rhythmic patterns of movement that accompany the whirring tones.

The love and sexual desire that Eros oversees and the powers of erotic persuasion that the *iynx* promises do have a place in the symposium. When Anakreon calls for the preparations of the symposium, it is so that he may

28. Johnston 1995, pp. 182–191.

29. Tavenner 1933, pp. 114–115; Gow 1934, p. 3; Nelson 1940, pp. 451–456. An exchange between Socrates and Theodote in Xenophon's *Memorabilia* (3.11.17–18) might suggest the "reeling in" interpretation.

30. Faraone 1999, pp. 15–19.

31. Johnston 1995, quotes from pp. 185, 204. As Johnston discusses, the *iynx* bird was also known for its song, which Aelian describes as sounding like an *aulos* (Ael. *NA* 6.19.18) and which seems to be evoked in the singing golden *iynges* mounted on the Temple of Apollo at Delphi, whose voice Apollonios of Tyana (Philostr. *VA* 6.15) described as having a "Siren-like persuasiveness"; see Jones 2005 (LCL 17).

32. Johnston 1995, p. 180. See also Tavenner 1933, p. 117.

"tussle with desire," as Hobden phrases it, his eagerness reflecting both the sympotic indulgence of appetites, sexual included, and the agonistic spirit of the setting (Anak. 396).[33] There is far more, of course, that might be said about the sexual mores of the symposium—between men and women, and among the men. But the immediate question for us is, could the mosaic wheels in Greek *andrones* represent the *iynx* love charm? Literature around the symposium does not provide a clear answer, but the mosaics themselves do: since they lack the double hole in the hub and the strings that are crucial to its operation, they are clearly not representations of the *iynx* wheel. Even so, this look at the *iynx* has not been an unfruitful digression. That any icon of a wheel should bring to mind the movement of turning is perhaps obvious, but it has been helpfully borne out in this overview of the *iynx* and of the wheel as a symbol of fate or fortune—which, like the love charm, is only effective when it is in motion, even if we are not privy to its cadence in the same way. What is more, the *iynx*, and Johnston's interpretation in particular, further introduces the idea that turning or spinning is not just experienced (or imagined) visually. It is simultaneously heard and felt as tone and rhythm.

Cosmic harmonies and cyclic rhythms

The union of circling and sonority is exemplified in *choreia*, choral dance, which consists of music and movement, harmony and rhythm, together (Pl. *Leg.* 2.654b, 672e). While there were a variety of dances in ancient Greece, the *kyklios choros*, in which a chorus moved in circles, carried particular resonance and is featured in a number of literary and poetic descriptions of dancing.[34] On Homer's Shield of Achilles, Hephaistos includes a *choron* where young men and women dance together (Hom. *Il.* 18.590–605). They grasp hands, first running around with skillful feet, presumably in a circle, "as when a potter sits by his wheel that is fitted between his hands and makes a trial of it whether it will run" (600–601), and then breaking into rows.[35] Similarly, while it may not be a faithful reflection of actual steps at the mysteries, Aristophanes' chorus in the *Women at the Thesmophoria* nevertheless dances in celebration of the festival, first forming a circle, joining hands, and

33. Trans. Campbell 1988 (LCL 143); Hobden 2013, p. 54.

34. Calame [1977] 1997, pp. 34–38.

35. Trans. Murray 1925 (LCL 171). As Calame ([1977] 1997, pp. 38–40) discusses, even the rows or lines of choral dances are not the rectangular arrangements of tragedy: "the chorus probably sometimes separated into two or several lines which danced in a circle in opposite directions to each other" (p. 40). See also Tölle-Kastenbein 1964, pp. 58–64.

turning rapidly together (947–962), then taking up more stately movements in honor of Apollo, Artemis, Hera, and Hermes (969–983), and finally, with shouts to Bacchus, leaping and spinning around (*anastreph'*) in time to the beat (983–1000).[36] In Kallimachos's hymns, Amazons dance a war dance and a circle dance in honor of Artemis (3.240–242), and Theseus, having slain the Minotaur, leads the Athenian youths in a victorious circle dance (4.310–312) that Plutarch describes as an "imitation of the wanderings in and escape from the Labyrinth, in which the rhythms include alterations and circulations," *parallaxeis* and *anelixeis*, implying turns and reversals (*Vit. Thes.* 21).[37]

The rhythmic revolutions of choral dance make it an ideal metaphor for the steady, cyclical movement of the cosmos. The stars themselves are endowed with two choric movements, the rotation of each individual body around its own axis and the regular, diurnal revolution of their orbit (Pl. *Ti.* 40b–c). That they form an astral chorus, whose dances are "the fairest and most magnificent of all dances in the world" (*Epin.* 982d–e), is a cultural commonplace (as in Eur. *Ion* 1079; anonymous poet, *Greek Anthology* 9.504; Arist. *On Philosophy* fr. 12b).[38] An invocation of the late fifth century attributed to Kritias offers a vivid example (DK 88[81]B19)—

> You, the Self-Made One, who have woven
> The nature of all things in the ethereal whirl [*aitherioi rhymboi*]
> Round whom light and dark shimmering night
> And the scattered throng of stars
> Perpetually dance [*amphichoreuei*][39]

—as does Euripides' description of Achilles' shield, on which "heavenly choruses of stars [*astron t'aitherioi choroi*], Pleiades and Hyades . . . turn Hector's eyes to flight" (*El.* 467–469).[40]

36. Lawler 1964, pp. 93–94.

37. For Theseus and the labyrinth dance, see Hedreen 2011; this is Hedreen's translation, p. 496.

38. Miller 1986, pp. 19–55; trans. Lamb 1927 (LCL 201). The planets, or wandering stars in contrast to the fixed ones, also participate in this dance, albeit along their own paths. As with so many cultural concepts, this one is brought into particular relief through its comic treatment: in this case, Aristophanes (for which see Miller 1986, p. 50) parodies the philosophic emphasis on the rhythms of celestial movements in the eponymous chorus of his *Clouds*, which, insubstantial and ever-changing, represents none of the constancy or stability of the higher heavens, and brings not clarity but intellectual chaos.

39. Trans. Miller 1986, pp. 48–49.

40. Trans. Kovacs 1998 (LCL 9), modified.

Ferrari has helped to demonstrate how deeply rooted this concept is in the Greek imagination. It is reflected in the seventh-century *Partheneion* of Alkman, which, Ferrari has shown, homologizes the *kosmos* (order) of the polis and the celestial through dance: on the stage of the sanctuary, Spartan maidens perform as a chorus of stars, while the song directs the audience's attention to the visible night sky, asking them to imagine it as a similar stage on which dances a chorus of astral maidens, the actual stars of the Hyades.[41] That the city's social order might (or should) reflect the natural patterns of cosmic movement resonates with the concern of other Archaic poets and of Presocratics with "due measure" (*metra*), the ethical order that governs both fair treatment in social transactions and the cyclical divisions of the seasonal calendar, "the right time and the right amount" (Hes. *Op.* 694).[42] Although not applied to the rhythms of dance, as far as I have found, *metra*, like the *choros*, figures the order of social conduct through the cyclic rhythms of time and seasonability, which themselves are governed by the revolutions of the stars in the heavens.[43]

In describing the cosmos as a dance, the sources above suggest that its order is observable. But the movement of the dancing stars, as for earthly *choreia*, is also, literally, sonorous.[44] In Book 10 of the *Republic* (614b–621b), Socrates tells the story of Er the Pamphylian, the only man to hear the music of the cosmic spheres. Er was killed in battle, but returned to life twelve days later to recount the journey of his soul in death, during which he had observed the structure of the universe, including the *syndesmos*, the girders, of the heavens. He describes the cosmos as a series of eight hollow whorls, nested inside of one another around the Spindle of Necessity that serves as the axis for their orbits.[45] The outer circle, where the fixed stars are located, moves with the spindle, and the inner seven (on which, presumably, the five planets, Sun, and Moon are located) move gently in the opposite direction. "On top of each of the circles stood a Siren, revolving around with it and producing a single

41. Ferrari 2008, throughout, but esp. pp. 108–118. For the *Partheneion*, see Alkman, fr. 1 in Davies 1991; Ferrari's appendix (pp. 151–157) also offers a text and translation, modified from Hutchinson 2001, pp. 3–8. See also Peponi 2007.

42. Slatkin 2003.

43. See especially Slatkin 2003, pp. 45–49.

44. For the simultaneous reception of *choreia* by sight and sound, see Ladianou 2005; Peponi 2007, p. 351.

45. For a possible reconstruction of this universe and an overview of some of the difficulties, see Schils 1993.

sound on one note, and the sounds from all eight of them blended into a single harmony" (617b).[46] The euphony of these movements, audible only to the fortunate Er (and, Pythagoras supposedly claimed, to himself), is a concept especially attached to the Pythagoreans of the late sixth and fifth centuries— although, as we saw in the introduction to this chapter, it has a long life that stretches into Early Modern astronomy. Iamblichos's *On the Pythagorean Way of Life*, probably from the third century CE, describes this concord, "caused by a movement and most graceful revolution . . . which arises from unlike and variously different sonic motions, speeds, magnitudes and conjunctions, arranged together in a most musical proportion" (65).[47] Like the voices of a *choros*, which blend in harmony, the correspondence of these celestial tones to the ratios of the musical scale reinforces the concept that rational order—in fact, mathematical measurability—governs the universe.

Plato tells us that the Muses gifted to mankind the capacity to observe this movement in the heavens and to perceive and take pleasure in rhythmic tempos and harmonies, so that we, unlike animals, might synchronize the revolutions of our mortal souls with the universal order (*Leg.* 2.653e).[48] In his *Phaedrus*, this is pursued in a somewhat complicated double metaphor in which mankind's soul is figured as a chariot that, at one time, had taken part in the heavenly dance, following the chariots of the chorus of gods (247a, 250b). Man's soul-chariot is pulled by two horses: an obedient, moderate, white horse and a licentious, impulsive, ill-shaped, dark horse. The charioteer, unable to keep his steeds in check, long ago fell with his chariot out of the dance; the soul was pulled down to earth, while the gods, who are unencumbered by mortal bodies and whose horses are compatible, fly easily to the vault of heaven (247b–248b). But the human charioteer is reminded through *eros* of his previous experience of beauty, and so aspires to rejoin the divine *choros* with his beloved by imitating the course of the god he once followed (253a–c).[49] This process, Belfiore argues, requires striking a balance between the two horses of the soul-chariot: if the charioteer gives in to the dark horse, the chariot careens out of control; but to favor the white horse means to risk

46. Trans. Emlyn-Jones and Preddy 2013 (LCL 276), modified. That the heavenly spheres make any sound is rejected by Aristotle (*Cael.* 2.9, 290b12–291a28), although he notes the rational thinking behind the idea, since, in fact, "things that are themselves in motion create noise" (291a10–11); trans. Guthrie 1939 (LCL 338).

47. Dillon and Hershbell 1991, p. 91. See Dillon and Hershbell's helpful discussion of the legends of Pythagoras and Iamblichos's place in the tradition, pp. 1–24.

48. Miller 1986, pp. 52–55.

49. As regards this passage, I follow Belfiore 2006. See also Kurke 2013, p. 167, n. 42.

excessive restraint, never moving the chariot forward.[50] The soul-charioteer looks to the rhythms and harmonies of the gods' heavenly dance as a guide, learning how and when to rein in or give slack to each horse in order to achieve psychic equilibrium.[51]

Outside of the metaphorical, *choreia* was a crucial component of education, *paideia*, in practice and in philosophy alike.[52] The importance of music in Pythagoras's *paideia* is based on his belief that certain tones and rhythms produced harmony in the soul: pain, anger, jealousy, fear, recklessness, violence, laziness—he "corrected each of these in the direction of moral excellence by means of proper tunes, as though by means of some well-blended, health-giving drugs" (Iambl. *VP* 64).[53] For the Athenian in Plato's *Laws*, children are disordered and impetuous, unable to control their bodies or voices (2.653d), but the pleasure of *choreia* imposes ordered movements upon the chaos of body and soul and teaches them to recognize what is good (653b–654a).[54] The *Timaeus* suggests that *choreia* is effective even before children acquire reason, since it helps to set right the soul's orbits and put them on their natural paths (Pl. *Ti.* 44b–c).[55] Similarly, in his *Republic*, we encounter the claim that the study of *mousike* and *gymnastike* (exercise of the body) together most effectively quiets the impulsive spirit and develops the soul (3.410c–412a).[56] For Plato, at least, then, the orbits of the soul are set right and brought into concord with the divine revolutions through the corporeal experience of ordered movement and through the aural experience of measured harmonies.[57]

Choreia, therefore, brings the individual soul under control, but it also has a social function: it bonds together citizens, who, in the dance, move together as a single unit. "The pleasure felt in shared rhythm and harmony produces emotional, affective bonds between fellow dancers, crafting the powerful image of the collectivity strung together in a chorus"—"a communally acted

50. Belfiore 2006, pp. 185–194.

51. Belfiore 2006, pp. 190–191.

52. Mullen 1982, pp. 54–56; Calame [1977] 1997, pp. 222–225; Kurke 2013, p. 160; Belfiore 2006, p. 207.

53. Trans. Dillon and Hershbell 1991, p. 89.

54. Belfiore 2006, p. 209.

55. Kurke 2013, p. 142.

56. Trans. Shorey 1930.

57. Kurke 2013, pp. 142–145. For a treatment of Plato's concept of the circling *nous* (mind) in the *Timaeus* as distinct from cosmic movements, see Lee 1976.

and embodied form in motion."[58] And it acts centripetally (perhaps like a spinning *iynx*), not only linking the dancers to one another, but also drawing in observers.[59] Further, cyclical rhythm, manifested both visually and aurally in choral dance, structures social time, its circularity and repetition promoting civic stability. As Kowalzig argues in her analysis of rhythm in the *Laws*, Plato's "regulation of . . . chorality is an attempt at controlling the fluidity of social rhythms: to turn the form in continuous forward movement into the patterned regularity of a circle. Circularity seems to denote stability, while in a 'flowing' (linear) world, social power is elusive."[60]

Of course, while there is rhythm in turning, there is also the potential to spin out of control, particularly when Dionysos is involved. For all its rhythm and seductive harmony, the *iynx* wheel creates in its target internal chaos and uncontrollable passion that causes its victim to act impulsively. This is true of other spinning toys as well, including tops and the *rhombos*, also called the "bull-roarer," a flat piece of wood whirled on a string above one's head to produce a deep bellowing sound.[61] Levaniouk investigates the *rhombos*, *konos*, and *strobilos* (the latter two perhaps cone-shaped tops) as objects indexical of the experience of terrified *teletai*, who are whirled and whipped at their initiation into the Dionysiac mysteries. And, as she demonstrates, while these devices are not limited to use in Dionysiac ritual, they do seem to mimic especially the symptoms of Dionysos's disorienting, "noisy" *mania*.[62] The *rhombos* is a bellower, *myketor* (Nonnos, *Dion.* 14.81), that sounds like Dionysos Bromios, the Roarer, and like the deep low of the bull—one of the hallucinations of Pentheus's Dionysiac madness (Eur. *Bacch.* 618). It might also suggest the roll of thunder or of an earthquake, while the *strobilos* and *strombos* tops are like whirlwinds. The "cosmic confusion" of nature's rumbles or whirs occurring in unnatural places—the "rotating earthquake in the air" of Euripides' *Helen* (1361–1362) that could easily serve as a fanciful description of the *rhombos* in use—are special signs of the storms of madness.[63]

Under the influence of Dionysos, the maenads of myth move like the spinning toys, fast and frenzied, running in circles or spinning in

58. Kowalzig 2013a, quote from p. 193.

59. Kurke 2013, p. 145.

60. Kowalzig 2013a, pp. 199–200.

61. Gow 1934, pp. 5–9.

62. Levaniouk 2007.

63. Levaniouk 2007, pp. 181–184, quote from p. 183. See also Padel 1992, pp. 81–88.

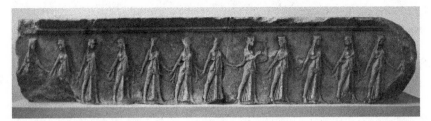

FIGURE 4.8 Dancing maidens, relief, Hall of Choral Dancers, Samothrace, mid-fourth century. Photo B. Wescoat

place.[64] Euripides' bacchants whirl (*heilissomenas; Bacch.* 569–570), and in Sophocles' *Women of Trachis*, the chorus joyfully embraces the speedy turning (*hypostrephon*) of the Bacchic rush (220). Of such movement, Dodds says, with likely accuracy, that "it is easier to begin than to stop Also the thing is highly infectious."[65] In contrast to the orderly depiction of a *choros*—in which, as in the relief from the Hall of the Dancers at Samothrace, each dancer holds her head level and steps forward in time with the others, only minimally disturbing the vertical folds of her skirt (figure 4.8)—maenads are often represented with their arms flung outward or bent at awkward angles, heads thrown back, and drapery swirling around them.[66] We see them, thus, in the frame surrounding Dionysos in the andron mosaic of the Villa of Good Fortune at Olynthos, discussed in chapter 3 (figure 3.5). Further in contrast to the careful harmonies of the orderly chorus and like the *rhombos* or the *iynx*, Dionysos's spinning followers are noisy. They are known for their shout, *euhoi!* (Eur. *Bacch.* 141; Ar. *Lys.* 1294), and Thebes rings with their cries upon the god's arrival (Eur. *Bacch.* 23–24).

Just as the equilibrium of the ordered soul is reflected in the regular rhythms of *choreia*, then, so the internal chaos of ritual *mania* is reflected in the disorder of frenzied spinning. But the wild dances of maenads and the whirling of initiation rites, however they may seem, are not a cautionary or shameful antithesis to the order and balance of the *kyklios choros*: in fact, "the

64. Lawler (1927, pp. 87–88) identifies certain maenads in vase painting as likely turning.

65. Dodds 1951, p. 272.

66. On the Hall of Choral Dancers, dated to the third quarter of the fourth century, see Marconi (2010, pp. 125–133), which includes a comprehensive history of the interpretation of the frieze as well as Marconi's interpretation of the dancers as representing multiple choruses that reflect the various *theoriai* to the sanctuary. Compare to the representation of maenads on the Derveni krater, for which see Barr-Sharrar 2008, pp. 122–148. See also Carpenter (1997, pp. 83–84) regarding the possibility that the pose with head thrown back may have originally suggested singing rather than an ecstatic state.

measure, the grace, the geometrical order of the circling Muses were wedded to the freedom, passion, and mystical rapture of the soaring Bacchants."[67] These bacchants, like Plato's dark horse, are all impulsive lunges and passionate outcries—movements that have the capacity to lead the soul-chariot off course if given free rein, but are nevertheless necessary to its forward movement. Yoked with the white horse, it is the dark horse's compulsion that puts in motion what might otherwise become too restrained. Bacchic madness is temporary, as is the initiation of the *teletai*; their mad dancing shakes internal emotions from the outside, and eventually "makes a peaceful calm appear in the hard pounding of the heart of each person" (Pl. *Leg.* 790e8–791b1). Divine *mania*, in other words, presents an opportunity for individual souls to re-establish balance in concert with one another.[68]

It is not just maenadic spinning, but the *kyklios choros* more broadly that falls within the realm of Dionysos, who is responsible for the socialization of mankind and, along with Apollo and the Muses, is one of the chorus leaders of men (*Leg.* 665b).[69] Indeed, the Dionysiac dithyramb is the circular dance *par excellence*, performed in public ritual contexts like the Athenian Dionysia, in which choruses of mature men and boys (some 1,000 annually) from different tribes competed against one another.[70] Such collective dancing in honor of Dionysos brings us back to the symposium by way of a now-familiar metaphorical theme: the sea.[71] Like the heavens, the sea is evocative of circularity. Its constant rhythm of waves offers an unbroken flow of movement, exemplified in Okeanos, which, *apsorroos* ("flowing back on itself"; Hom. *Od.* 20.65), encircles the *oikoumene* just as the *pontos* encircles an island, and just as the islands themselves, the *Kyklides*, form a circle.[72] And the seas are filled with choruses. As Csapo has argued of a choral ode in dithyrambic style

67. Miller 1986, p. 35.

68. Belfiore 2006, pp. 208–209. For a discussion of maenadism, and particularly the differences between maenadic myth and actual practice, see Henrichs 1982, pp. 142–146.

69. See, for the three choruses, Calame 2013, pp. 91–92; Murray 2013.

70. For an excellent overview of the dithyramb and the current state of our understanding of the form, see Kowalzig and Wilson 2013.

71. Kowalzig 2013a, pp. 194–200; 2013b.

72. Kaplan 1975, pp. 131–136. On a red-figure cup in Warsaw, dancing maidens are labeled with the names of islands—Lemnos, Delos, and Euboia—suggesting that the circular nature of the Kyklides, like the stars of the heavens, could be metaphorically cast as a *choros*: Warsaw, National Museum 142458 (red-figure cup, ca. 430–420, attributed to the Eretria Painter): *ARV²* 1253.58; see, for discussion of this cup with particular bearing on our current concerns, Heinemann 2013, pp. 289–290.

from Euripides' *Electra*, a circling chorus of dolphins dances the Greek ships to Troy (432–435):

> Famous ships, you who once went to Troy with countless oars escorting dances together with Nereids, where the pipe-loving dolphin was leaping, wa-winding in circles at the dark-blue-rammed prow.[73]

Vase painting, too, offers a number of images that draw from both the choral dance and from marine life, or elide the two. On a black-figure cup-krater in Paris, a chorus of men that circles the exterior lip is juxtaposed with a circle of dolphins on the interior lip, dancing on the sea of wine inside; not only does the order and arrangement of the two choruses imply their comparability, but their circles are even visually combined as the drinker tilts the cup toward him.[74] Still others show citizens riding on dolphins. A late sixth-century skyphos in Boston includes hoplites, fully armed, mounted on dolphins in an orderly line (figure 4.9).[75] That this image (and that on the cup's reverse, featuring a similar line of men on ostriches) does indeed refer to a choral setting is indicated by the presence of an aulos player at the right. Such marine choruses both play upon the notion of dolphins—famous in antiquity for their love of *aulos* music in particular—as choral dancers, just as their citizen riders would also be. And they suggest that "a circular (dithyrambic) *choros* 'sailing' or 'swimming' on the wine-dark sea is something like an image of controlled and predictable civic rhythmicity."[76]

 Although its date in the last quarter of the sixth century is quite a bit earlier than the period to which our mosaics date, a psykter attributed to Oltos in the Metropolitan Museum of Art in New York offers one way of thinking about how a symposium context might introduce and play with this particularly complex convergence of citizen status, (dithyrambic) *choros*, the symposium, and the sea (figure 4.10).[77] Around the body of the vase, armed hoplites,

73. Translation from Csapo 2003, p. 72. In addition to Csapo's article, which discusses at length the connections between dolphins and Dionysos, see also Piettre 1996; Descoeudres 2000.

74. Paris, Musée du Louvre CA2988 (Attic black-figure cup-krater, mid-sixth century): Paris, Musée du Louvre 12, 140, pls. (866, 867) 193:1–4, 194:1–2. Csapo 2003, pp. 78–90; Kowalzig 2013b, p. 35.

75. Boston, Museum of Fine Arts, Gift of the Heirs of Henry Adams 20.18 (Attic black-figure skyphos, ca. 520–510). For discussion, see Csapo 2003, p. 82; Kowalzig 2013b, pp. 36–38.

76. Kowalzig 2013a, p. 199.

77. New York: Metropolitan Museum of Art 1989.281.69 (red-figure psykter, attributed to Oltos, ca. 520–510): *ARV²* 1622–1623.

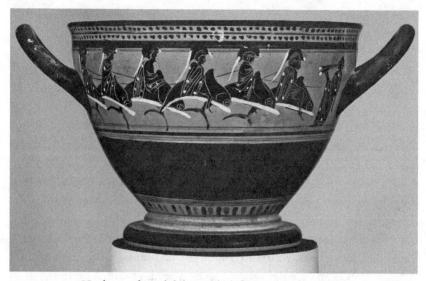

FIGURE 4.9 Hoplites riding dolphins, black-figure skyphos, ca. 520–510. Boston, Museum of Fine Arts 20.18, Gift of the heirs of Henry Adams. Photo © 2018 Museum of Fine Arts, Boston

spears tilted forward and shields at their sides, ride in a circle on the backs of dolphins. During a symposium, the psykter, containing the wine, would have been placed in a krater filled with water to keep it cool. As the psykter bobbed in the krater, the dolphins would have seemed to leap from the water as from the sea, and to turn in circles. In Kowalzig's analysis, the image blends the hoplite phalanx ("an image of civic solidarity and cohesion, and of community integration") with the *kyklios choros* (likewise a symbol and metaphor "of social order, community integration and cohesion") to represent the polis as civic community.[78] But there is more: this seaborne hoplite-dolphin-chorus represents the civic community to which the symposiast viewers of the image—men who had themselves surely, and perhaps even recently, danced a *kyklios choros*—also belong and that the symposium helps to delineate. So, as Heinemann describes, the psykter draws together not only the roles of warrior and *choreutes*, but also that of symposiast, offering "a utopian display, where all these social roles blend into each other as a choros of sympotic soldiers."[79]

78. Kowalzig 2013b, quotes from pp. 40, 41, respectively; 2013a, pp. 199–202. See also Kowalzig and Wilson 2013, pp. 2–3 and 15–18, on the importance of the circular dithyrambic *choros* for civic cohesion in Athens, and p. 22, for its spread throughout the Greek world by the end of the fourth century.

79. Heinemann 2013, p. 308. See also Beaulieu 2016, pp. 177–178.

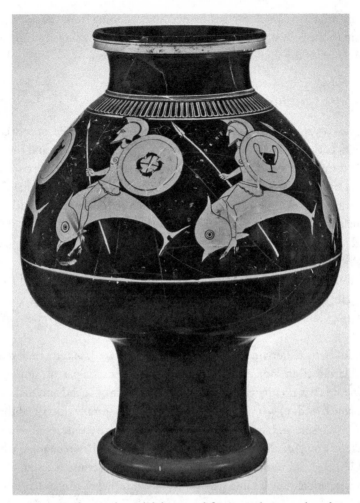

FIGURE 4.10 Hoplites riding dolphins, red-figure psykter attributed to Oltos, ca. 520–510. New York, Metropolitan Museum of Art 1989.281.69. Photo courtesy of the Metropolitan Museum of Art

The vase's sympotic chorus, wrapped around the psykter, and floating on the enclosed sea in a krater, points not just to the shape of the circle, but to *circling*, the revolutions of movement that structure chorus and symposium alike. Heinemann points out that this turning is further underscored by the devices on the shields held by the hoplite riders: the six devices alternate sympotic vessel shapes (a krater, cup, and kantharos) with circular motifs. Two of this latter group are pinwheel shapes, one with the heads and wings of animals, and one with running legs, but I would call special attention to the third, which features four leaping dolphins arranged nose-to-tail in a circle.

They are attached to one another by two lines, running from the belly of one dolphin to the belly of the dolphin directly opposite, crossing at a right angle in the center of the shield. The motif is a dolphin wheel.

Sympotic circling

The Oltos psykter provides a hint, indirect and early as it may be, of conceptual analogies between the circling of the Dionysiac (marine) chorus and the turns and rhythms of the symposium, on the one hand, and between these circles and the motion of a wheel, on the other. Certainly, the circles and circularities of dining ritual were not lost on ancient authors: as Athenaeus (489c) describes, the ancients "believed that the *kosmos* was shaped like a sphere . . . [and so] thought it right to make everything associated with their own dining style resemble what the world that surrounded them looked like."[80] But let us begin this concluding section with Plato, and specifically Books 1 and 2 of his *Laws*. His work, like the psykter, provides a way of thinking about sympotic circling as a kind of choreography, its social function intimately related to that of *choreia*.

If children are fiery in their dispositions (*Leg.* 666a), mature men tend in the other direction. Age makes a man reluctant to participate in singing and dancing, since it no longer gives him the pleasure it once did and makes him feel shame (665d–e)—he is, in other words, more naturally restrained than in youth. As a result, and somewhat paradoxically, adults become less disciplined, and the training of their education, through which they recognize what is good and bad, is forgotten (653d–e). To put to further use the soul-chariot metaphor, adults are inclined to give the white horse too much control, paralyzing the chariot with excessive restraint.[81] To counteract this hardening of the soul, and to continue and practice their education, grown men need to renew the fieriness of youth. Fortunately, Dionysos offers a potion that does precisely this: wine (649a–b, 666b).

The symposium provides a controlled context for the youthful impetuousness and excessive confidence that wine produces (640c, 652a): Anakreon's "youth returns" as he calls for the wine cup, dons a garland, and takes to the dance, in spite of his age (Anak. 53).[82] The

80. Trans. Olson 2009 (LCL 274).

81. Belfiore 2006, p. 210.

82. Trans. Campbell 1988 (LCL 143). For discussion of the "softening" effect of wine on the body, see Murray 2013, p. 117.

symposiarch—who should be both sober and wise—is tasked in the *Laws* with promoting the friendly atmosphere of the group and with their (re-) education (671c–d).[83] In the convivial setting, wine softens the drinkers, like iron when it is heated, and it is the skilled symposiarch who molds them by laying down the laws of the event, so as to "control that banqueter who becomes confident and bold and unduly shameless, and unwilling to submit to the proper limits of silence and speech, of drinking and of music, making him consent to do in all ways the opposite" (671c). The *archon* of the symposium guides the men in their efforts against drunken excesses by imposing order, the "limits of silence and speech" referring, it seems likely, to the circling of the turn to speak or sing. In doing this, he brings about reverence (*aidos*) and shame (*aischyne*). With his guidance, just as when they are first educated through *choreia*, the symposiasts sing appropriate (noble, *kallistos*) songs and sing them appropriately, in turns. Thus, while they are not susceptible to the maenadic frenzy that afflicts women, symposiasts renew their own psychic balance by bringing under control the disease of disorder that wine imposes upon them.[84]

As we see here (from, it must be remembered, a distinctly Athenian perspective), and as we saw in this book's introductory chapter, the ideal symposium involves balance, moderation, and parity. Making use of the concept of *metra* that we encountered above, Kritias warns that drinking toasts from the cups beyond due measure (*hyper to metron*) "offers pleasure in the short term, but causes pain in the long run" (fr. 6, *apud* Athen. 10.433a).[85] These values, as we have also seen, are likewise commonly represented by or culturally figured through the rhythm and harmony of *choreia*. To be clear, I am not claiming that the symposium is conceived as a dance or that it even necessarily involved dance, although it frequently did: dances were performed by drunken symposiasts or hired entertainers, Heinemann's work has suggested that the *choros* was a pervasive sympotic theme, and it seems very likely the case that, at some point in their lives, these men would have danced in a *choros*

83. See Bernadete (2000, pp. 42–87) on the education and intoxication, esp. pp. 83–85, on sympotic drinking.

84. Belfiore 2006, p. 210. It is worth noting that this is a reversal from a fragment of Critias, which praises the moderate Spartan practice of drinking only enough to loosen tongues and create cheer; Plato's suggestion in the *Laws* is that without experiencing the loss of control, one cannot practice self-control. See also Murray 2013, pp. 112–114, 117. Trans. Bury 1926 (LCL 187).

85. Trans. Olson 2009 (LCL 274) = fr. B 6 in West 1992. This is also a theme in Theognis (e.g., 497–498, 499–502), who urges the use of *metra* in drinking and toasting.

themselves.[86] I do, however, wish to suggest that, like dance, sympotic circling *epidexia* is made up of rhythms and harmonies, both literal (in actual music and spoken words, and in the pace at which they move around the room) and figurative (in the social concord that the event promoted). Flowing continuously around the room and back into itself, the turn to drink and speak reaches everyone equally, its cyclic structure regulated by the symposiarch as a chorus's is by the *choregos*. So while the circling of a symposium is not a *choros*, it nonetheless acts like one in its motion and effect.

Here, finally, we might return (full circle, as it were) to the mosaic wheels. It is surely the case that the mosaic wheels mirror the circling of wine around the room. That the icon of the wheel should bring to mind turning—or, more precisely here, patterns of repetitious circling—has been suggested in the above examples of wheels of all types, whose meaning, whether as a symbol of an abstract concept or as a tool or toy, consistently depends upon motion. Turning would have had additional resonance in the andron, where the physical circulation of the wine cup in relative space was not only fundamental to structuring sympotic activity, but was also, at times, deliberately brought into active relationship with the absolute and relational aspects of the andron to produce a particular spatial experience. There can be little doubt, then, that the wheel mosaics engage the circling patterns of the symposium's relative space, but there is more to be said about what this might accomplish.

One great advantage to the wheel (and to other circular designs) as a floor decoration is that it is identical from all angles: there is no top or bottom, no right side up or upside down, no viewpoint from which it must be read. This visually underlines an important spatial aspect of the andron, whose layout suppresses as much as possible any hierarchy among those gathered; while there may have been more desirable seats, no one sits below or behind another, and no one is above or at the head. Unlike the images of Dionysos in the previous chapter, even if a portion of a wheel is hidden from view, its symmetry allows a viewer to easily reconstruct the whole from even a partial glimpse. The icon of the wheel, therefore, has the capacity not just to symbolize the equity among those present, but also to contribute to a spatial experience that enforces that claim. The imagined revolutions of a mosaic wheel do not simply mirror or mimic or allude to the circular movements within the andron. Rather, I suggest, they characterize that movement as a particular (ideal) type of circulation that is regular, even, stable, and constant—that is,

86. Heinemann 2013; see also Murray (2013, pp. 115–116) for the close relationship between choral performance and the symposium.

in other words, rhythmic and harmonious, like the orbits of the Sun and stars (which the Presocratic philosopher Anaximander, in fact, describes as wheels) or the movement of a chorus.[87] As we have seen in our look at actual and metaphorical *choreia*, the results of such measured movements are balance, concord, and consistency, qualities that are not simply desirable in the social context of the symposium, but that are the event's *raison d'être*. Moreover, circling—movement like the flow of Ocean—is *apeiron*, "limitless," having the double implications of infinite motion and permanent bonding.[88] In the symposium, the rhythm of the passing of the cup corresponds to the patterns of speech and silence that structure the event and that bind the symposiasts to one another as *hetairoi* and as citizen members of the polis.

Unlike the mosaics that we looked at in the previous two chapters, which help to figure sympotic circling as another kind of movement, the image of the wheel (located in absolute space) reinforces the revolutions that unfold in the relative space of the andron and, by evoking the relational associations between rhythmic circling and social values, gives them meaning. The spatial metaphor produced, then, is not one in which the symposium is imagined as another kind of experience, but one in which the circularity that governs the event is figured as an ideal pattern of equitability and commensality. Symposiasts may, of course, lose sight of these ideals, but, as we have seen, the "sane madness" (Anak. 2) of Dionysiac disorder—brought on through maenadic frenzy or, for citizen men, through wine—can be a precondition to the restoration of stability: it is the possibility of spinning out of control that gives meaning to order.[89]

87. Anaximander *apud* Aetius P 2.20.I/S 1.25.1c and P 2.25.1/S 2.26.1a(S) (Anaximander nos. 22 and 25 in Graham 2010, p. 58): he uses *trochoi*. See, for a recent and detailed discussion of Anaximander's wheel-cosmos, with bibliography, Gregory 2016, pp. 143–197.

88. Detienne and Vernant [1974] 1978, pp. 286–305. Neither wheels nor sympotic circling appear in this discussion, but Detienne and Vernant do mention in relationship to the concept of *apeiron* passages and pathways to be traveled, the fishing net, and the *periplous*—all concepts that also have a metaphorical life in the symposium. See, more recently, Gregory 2016, on the notion of *apeiron* in Anaximander's philosophy (pp. 85–102) and the reconciliation of this concept with the description of the cosmos as a wheel (pp. 143–167).

89. Trans. Campbell 1988 (LCL 143).

5

The Journey Back

SYMPOSIA OF THE PAST

AT THE BEGINNING of his *Life of Theseus*, Plutarch describes the problem that such an ancient subject poses to the historian (1.1):

> Just as geographers, O Socius Senecio, crowd on to the outer edges of their maps the parts of the earth which elude their knowledge, with explanatory notes that "What lies beyond is sandy desert without water and full of wild beasts," or "blind marsh," or "Scythian cold," or "frozen sea," so in the writing of my Parallel Lives, now that I have traversed those periods of time which are accessible to probable reasoning and which afford a basis for a history dealing with facts, I might well say of the earlier periods: "What lies beyond is full of marvels and unreality, a land of poets and fabulists, of doubt and obscurity."[1]

It happens that the hazy terrain of Greece's early history, into which, Plutarch decides, he must venture, is of interest to us in this final chapter, but his choice of metaphor is also an apt introduction to our subject. The geographer and the historian exist in a particular spatiotemporality: the here and now.[2] The further their subject is from them, in space or time, the more difficult it is to access with precision. When he describes a land to which few (or none) have ventured—a "there" at the most extreme distance from the "here"—the ancient geographer is forced to deal with vague generalities, hearsay, or, even,

1. Trans. Perrin 1914 (LCL 46).

2. For the similar positioning of the scholar, particularly the anthropologist, in a modern context, see Fabian [1985] 2013.

imagination. So, too, the historian's distant "then" is veiled in rumor and myth. The location of these times and places at the edges of knowledge, their resistance to "probable reasoning," and their susceptibility to exaggeration or outright fictionalization are issues that concern Plutarch more than us. But his metaphorical framing of history as a spatial phenomenon—of time as a topography to be traversed—beautifully illustrates the notion that distant "theres" and "thens" are somehow comparable.

In this chapter, I deal with two groups of mosaics: the first depicts abundant vegetation, including flora and vines, that extends across the andron floor; the second features centaurs, the infamous wine-loving half beasts of Greek mythology. Although quite different from one another, both of these subjects are connected to Greek conceptions of ancient, primitive landscapes. The relational space to which these mosaics contribute, then, is an imagined setting for the symposium away from the here and now: drinkers are resituated into a "foreign" (in time if not also in space) locale, where they might enjoy the fruits of nature's bounty or confront the threat of a precivilized wilderness.

The mosaics

An andron mosaic from Sikyon, discovered during excavations in 1941 and probably dating to the end of the fourth century, presents a tapestry of vines and flowers that grow outward from a central rosette (figure 5.1).[3] The tendrils and flowers wind in a pattern, some curling back in toward the rosette, others reaching the corners and sides of the room, ending in an array of floral forms. For clarity of description, these flowers might be divided into two concentric registers, an inner ring around the rosette and an outer layer that extends to the edges of the floor. Immediately circling the rosette are four unopened buds, each pointing toward one of the room's corners. On either side of each bud, alternating pairs of four-petal flowers with a prominent red pistil and five-petal flowers with a smaller red pistil curl away. In the outer register, the flowers at the center of each side of the mosaic's square are trumpet shaped with ten rounded petals and a red pistil at the center. At each corner, a flower having seven pointed petals with serrated edges is flanked by two blooms with eight petals, which curve away from the corner, opening toward the trumpet-shaped blossoms at the center. As this description suggests, although visually

3. The mosaic is 2.86 x 2.81 m. Orlandos 1947, pp. 59–60, figs. 3, 4; Amandry 1942, p. 240, fig. 7; Walter 1943, p. 313; Votsis 1976, pp. 583–584, figs. 11, 12; Salzmann 1982, p. 112, no. 118, pls. 20, 21. For the date, I follow Ciliberto 1991, pp. 18–19.

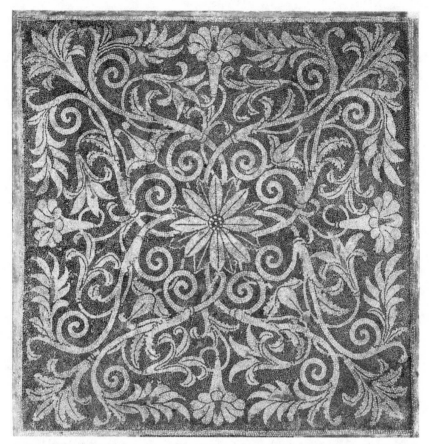

FIGURE 5.1 Floral design, pebble mosaic from Sikyon, late fourth century. Sikyon Archaeological Museum. Photo © Hellenic Ministry of Culture and Sports, Archaeological Ephorate of Corinth

dense, the mosaic's tendrils and florals adhere to a pattern. The mosaic of the room's threshold—which, at least in the museum display, is set at the middle of one of the sides, instead of its usual position off-center—features a griffin with two horns, its left front paw raised (figure 5.2). It is white, with black contour lines and patches of red on the wing, the interior of the front and back left legs, the right foreleg, and on the flank, over the ribs (behind the wing) and at the hip.

In his 1965 article on Greek mosaics, Martin Robertson associated floral tapestry mosaics like this one with a design invented by the painter Pausias, a student of Pamphilos at Sikyon.[4] According to Pliny (*HN* 21.3, 35.125), Pausias

4. Robertson 1965, p. 83, with a postscript, mentioning the Sikyon mosaic, in 1967, pp. 133–134. See also Robertson 1975, pp. 486–489; Ginouvès 1993, p. 130; Ciliberto 1991, pp. 19–23.

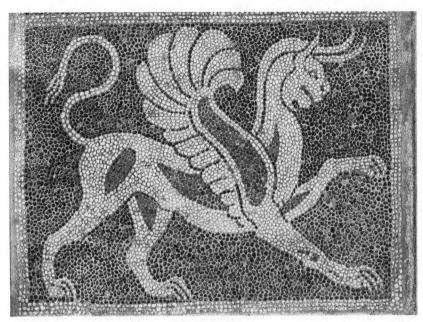

FIGURE 5.2 Griffin, pebble mosaic threshold from Sikyon, late fourth century. Sikyon Archaeological Museum. Photo © Hellenic Ministry of Culture and Sports, Archaeological Ephorate of Corinth

fell in love with a woman who invented the weaving of flowers and so, as a tribute to her, he imitated her garlands in paint. His contemporaries at the Sikyonian school included Apelles, who joined the court of Alexander, and this provides both a date for Pausias in the second half of the fourth century and a northern connection that might explain the appearance of so many mosaics of this design in regions under Macedonian influence. Robertson admits that "the story as a story is not convincing, but it surely implies the existence of pictures ascribed to Pausias in which a great variety of interwoven flowers was introduced."[5] The Pausian connection would seem to be underscored in the example at Sikyon, described above, which Robertson mentions in a postscript to his original article. But there are problems in his assumptions about the way in which painting influenced mosaics—a relationship that, in fact, we still do not entirely understand.[6] Similar vegetal motifs are also common in relief sculpture and metalwork, and on fourth-century

5. Robertson 1965, p. 83.

6. Robertson 1967, p. 134.

South Italian vases, where they are sometimes paired with a female protome.[7] As Dunbabin suggests, these parallels "attest to a common repertory, and a shared interest in vegetal ornament, rather than a direct influence from one medium to another."[8]

In any case, the floral tapestry design, like the concentric frame arrangement or the wheel motif, is well suited visually to the space of the andron: it avoids privileging a particular viewing angle, it is readable even when aspects of the sightline are obscured, and it presents the potential for a complex, at times virtuosic, accumulation of visual detail. From the palace at Vergina, identified as the ancient Macedonian capital of Aigai, is a floral mosaic that likely dates to the late fourth or early third century.[9] An ornate pattern of flowers and vines originates from a central rosette. Open, leafy flowers with curved petals form an inner ring of vegetation around the center, while in an outer ring the tendrils end in bursts of spiky leaves, curlicues, flowers with layers of petals and ornate pistils, and trumpet-shaped blooms whose stems twist around one another. Here, as at Sikyon, the floral tapestry is made even more visually dense by additional, elaborate details, but is nevertheless strictly organized. This pattern of vegetation is enclosed by a double circular frame of cross meander and wave patterns. In the corners between these circles and the outer square border are figures that have the upper torso, head, and arms of a woman, but a bottom half of tendrils that spread outward to either side. Gradations of color create the illusion of volume in its flowers and three-dimensionality in its spiraling vines.

Floral designs similar to the Sikyon and Vergina examples described here are relatively common in the pebble mosaic corpus—this may be in part because their flexibility, in addition to accommodating various viewpoints within a single room, also allows them to be easily integrated with other themes. Vines and flora may serve as the floor's centerpiece, surrounded by figural scenes, as at the Sikyon mosaic discussed in chapter 2 (figure 2.10), or may themselves be a framing device, as in the stag-hunt mosaic from Pella's

7. Salzmann 1982, pp. 16–20; Pfrommer 1987, pp. 125–141. The combination of florals, vines, and a female head in three-quarter view appears in a fragmentary mosaic from Dyrrhachion (at Durrës in Albania), often compared to the mosaic from Vergina, discussed below. Since the context of this fragment—that is, whether it was included in an andron and even the original measurements—is unclear, I will not pursue it further here. See Praschniker 1922–1924, pp. 203–214; Salzmann 1982, pp. 14–16; Anamali 1986; Guimier-Sorbets 1993, with additional bibliography.

8. Dunbabin 1999, p. 15.

9. The mosaic is 6.70 x 6.70 m. Andronikos et al. 1961, pp. 21–22, X:2, XVI, XVII; Andronikos 1964b, p. 7, fig. 14; Kottaridi et al. 2009, pp. 65 and 135–137 for plates; Kottaridi 2011, pp. 302–303, fig. 36.

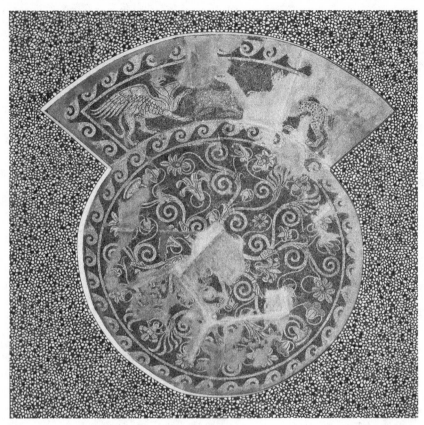

FIGURE 5.3 Floral design and a griffin and panther attacking a stag, pebble mosaic from the tholos associated with Darron's Sanctuary, Pella, late fourth or third century. Pella Archaeological Museum. Photo © Hellenic Ministry of Culture and Sports, Archaeological Ephorate of Pella

House of the Abduction of Helen (figure 1.3).[10] The theme does seem particularly well represented, as Robertson noted, in the regions under Macedonian influence, although whether this reflects geographic or chronological preferences, or is an accident of preservation, is unclear. Also at Pella, for instance, is a mosaic that decorates a tholos, a round room, in the sanctuary of Darron. Evidently encircled by a *trottoir*, the mosaic features vines, anthemia, and various blossoms; on the threshold, a griffin and a spotted panther attack a stag (figure 5.3).[11] And still another mosaic from this area around Darron's

10. Picard 1963; Andronikos 1964a, pp. 295–296; Petsas 1978, pp. 95–97, 99–102, 107–111; Cohen 2010, pp. 30–38, 308, n. 62, with further bibliography.

11. Lilimpaki-Akamati 1987a.

sanctuary, located in Pella's canal district, also makes use of the floral design.[12] As in the Sikyon mosaic discussed above, vines grow from a central rosette, blossom with flowers, and end with a full palmette at each corner and two half palmettes at the center of each side. The mosaic threshold of this room shows a centaur, usually identified as a centauress, presumably because of the absence of a beard and the rendering of nipples and breasts by means of a red pebble encircled by a pattern of white pebbles.[13] She steps to the left (both her front and back right legs are raised slightly) toward a cave and holds a phiale and a rhyton in her hands. The cave's rocky sides are rendered in white, and its triangular opening in black. To the right of the centaur is a tree with two limbs, the trunk and branches of which seem to have been trimmed. Given the inclusion of drinking vessels and the cave setting—both features included in the representations of precivilized drinkers in Attic vase painting—and its appearance with the floral design of the main floor, this is a tempting pair of images to pursue in our discussion of primitivist themes in androns. But because of its apparent association with the sanctuary of Darron (a potential ritual context that has not, to my knowledge, been explored in depth), it may have been subject to different expectations or communal dining rituals. Because of this, I include it here only tentatively, but I do so in part because it brings us to our second group of mosaic subjects, the centaurs.[14]

Centaurs that appear in pebble mosaics take part in a variety of activities. At least one is a hunter, several appear to participate in a kind of ritual drinking, and, in some instances, they engage men in battle in scenes typical of the centauromachies frequently encountered in other media. Of these mosaic centauromachies, most are from uncertain contexts or from rooms that are not androns, but at least one is securely associated with an andron.[15] On

12. Measurements are unavailable. Lilimpaki-Akamati 1987a, 1987b; Ginouvès (1993, pp. 129–131, fig. 117) identifies the mosaic as belonging to the "South House." Lilimpaki-Akamati and Akamatis (2003, p. 24) do not discuss the floral mosaic floor, but do assign the threshold mosaic of a centauress to "a public building in the area of Darron's sanctuary." See also Akamatis 2011, p. 405.

13. Lilimpaki-Akamati and Akamatis 2003, p. 24, fig. 13.

14. The same conditional consideration holds for the tholos mosaic, also associated with Darron's sanctuary.

15. At least four pebble mosaics that feature centaurs are either not from an andron or are without sufficient context to identify them as belonging to an andron: (1) A mosaic fragment found in the area near the Arch of Hadrian in 1950 depicts a hero, probably Herakles, who raises his club in his right hand and grasps the hair of a centaur (perhaps Nessos, or perhaps one of unruly companions of Pholos) in his left; see Robertson 1967, pp. 134–135; Salzmann 1982,

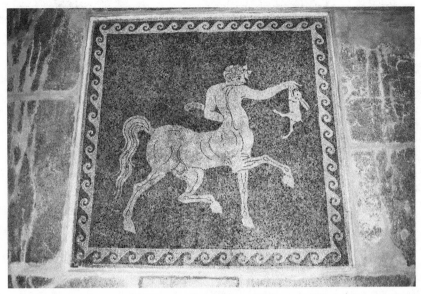

FIGURE 5.4 Centaur, pebble mosaic from Room A, House Δ, Rhodes, late fourth or first half of the third century. Rhodes Archaeological Museum. Photo H. M. Franks

the threshold of the andron of House C10 at Eretria, a centaur attacks a nude Greek man, presumably a Lapith.[16] The centaur, at the right, lunges forward, raising a branch aggressively overhead; the man extends his left arm in a defensive posture, and, in his right hand, raises a weapon of his own.

The mosaic from the andron (Room A) in House Δ on Rhodes, dating to the late fourth or first half of the third century, depicts a quieter scene (figures 5.4 and 5.5).[17] Here a centaur, alone, is framed by a wave pattern. Rendered

pp. 86–87, no. 20, pl. 41:1. (2) A fragmentary mosaic from the court (Room 4) of Building A.VI.3 at Olynthos, found in 1931, features a centauromachy; see *Olynthus* V, p. 7, pls. 4:A, 13:B; Salzmann 1982, pp. 99–100, no. 79, pl. 15:2. (3) The mosaic from the court (Room h) of the House of the Comedian at Olynthos (whose andron, Room j, was decorated with a mosaic floor featuring a wheel and discussed here in chapter 4) includes a battle between a Greek and centaur on the south side of the frame with other scenes including griffins attacking a stag, a lion, and boar confronting one another, and a hunting scene; see *Olynthus* V, p. 12, pls. 9, 17:B; *Olynthus* VIII, pp. 64–65, 288, 290, no. 11; Salzmann 1982, p. 101, no. 86, pl. 12:2. (4) From an unknown context at Sparta is a mosaic featuring a battle between Greeks and centaurs in the frame around a central square, which contains a triton in the center and dolphins on either side; see Oikonomos 1918; Salzmann 1982, p. 125, no. 169, pls. 82:1–3, 102:5, 6.

16. This threshold mosaic is 1.25 x 0.90 m. The mosaic may date to the second half of the third century; at the center of the andron is a rosette of 16 petals. Choremis 1972; Salzmann 1982, p. 92, no. 41, pls. 49:2, 50:1.

17. This mosaic is 3.00 x 2.96 m. Konstantinopoulos 1967, pp. 523–524, pl. 384; Fraser 1969, p. 38; Salzmann 1982, p. 110, no. 113, pl. 46:2.

FIGURE 5.5 Detail of centaur, pebble mosaic from Room A, House Δ, Rhodes, late fourth or first half of the third century. Rhodes Archaeological Museum. Photo H. M. Franks

in white with contour lines and details of the musculature in black, and set against a featureless background, the centaur strides to the right, his right foreleg and back left leg raised. The equine half of his body is depicted in profile, while the human torso twists, so that it is seen from the back. His right arm is extended, and in that hand he grasps the front legs of a white hare, whose back legs hang, splayed open. In his bent left arm, the bottom half of the forearm and hand hidden by his torso, the centaur cradles a *lagobolon*, a hunting stick with a curved end, thrown horizontally and used primarily in hare hunting.[18] His face is in profile, although everything below his nose is obscured by his raised right arm, and he wears an ivy wreath, the leaves articulated with lead strips, in his hair.

Slightly older, probably from the middle of the fourth century, is a partially preserved mosaic, which was likely from an andron and which was found in 1938 in a vineyard east of the town of Vasilikon and near the church of St. Konstantinos at Sikyon (figure 5.6).[19] Assuming that it was, when complete, a symmetrical composition, this mosaic features a rosette at its center,

18. For an overview of the *lagobolon*, see Nankov 2010, pp. 38–43.

19. The mosaic is 2.80 x (est.) 2.80 m. Orlandos 1939, p. 123, fig. 3; Robertson 1939, p. 198, pl. 13:c; Luce 1940, p. 239; Votsis 1976, p. 582, fig. 8; Salzmann 1982, pp. 111–112, no. 117, fig. 22:1.

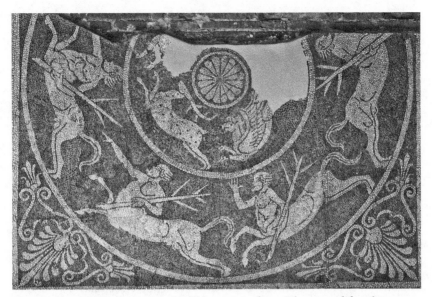

FIGURE 5.6 Centaurs running, pebble mosaic from Sikyon, mid-fourth century. Sikyon Archaeological Museum. Photo © Hellenic Ministry of Culture and Sports, Archaeological Ephorate of Corinth

surrounded by two concentric rings. In the preserved portion of the inner ring, griffins bound toward a speckled, antlered deer, and, in the outer ring are four centaurs. Three move to the left, while the fourth runs to the right. They are shown in a gallop, their back hooves touching the ground, while front legs are stretched out before them, their speed further reflected in their short hair, which flies behind them. Their horse bodies are rendered in profile, while their human torsos turn slightly to be seen from an angle. Their heads are depicted in profile; all are bearded. In the nearer hand (the left for the centaurs running to the left, and the right for the fourth centaur, facing right), each holds a long tree limb with between two and four branches extending from its upper end. The other hand, preserved in only two of the extant centaurs, varies in its position: one bends this arm at a right angle and spreads his fingers, another extends the arm forward, his hand seeming to point or reach toward the companion ahead of him. In each preserved corner of the room, between the circle and the edges of the floor, is an anthemion.

Centaurs appear as the subjects of two mosaics from Pella: one, the centauress in front of a grotto from the threshold of the andron in the building adjacent to the sanctuary of Darron, was described above; the other is from the House of Dionysos (House I.1) near the agora. The latter (figure 5.7) decorates the threshold of an andron, the main floor of which features a

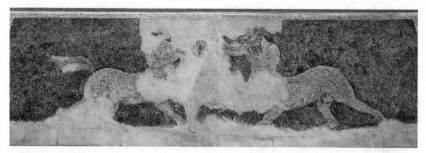

FIGURE 5.7 Pair of centaurs, pebble mosaic threshold from House I.1 (House of Dionysos), Pella, late fourth century. Pella Archaeological Museum. Photo L. Hutchison, © Hellenic Ministry of Culture and Sports, Archaeological Ephorate of Pella

lion hunt (figure 1.8).[20] In this panel, two centaurs face one another. The one on the right is bearded, and he holds a shallow cup or bowl to his mouth. The one on the left is a female: the breasts are rendered similarly to those of the centauress from the Darron sanctuary, but the identification is further supported here by her jewelry. She wears a necklace, a bracelet on her right wrist, and possibly earrings, all rendered in yellow pebbles. She may have held another kind of cup or bowl. Terracotta strips are used to delineate details of contouring, of the male centaur's hair, and of their tails.

Westgate discusses centaurs as part of the larger iconography of wild animals—including many we have encountered already: griffins, sphinxes, lions, panthers, and boars—in mosaics. She concludes that these types of animals and hybrid monsters embody qualities like aggression, courage, strength, and athleticism that recall for the fifth- or fourth-century viewer the ways in which ("aristocratic") citizens of the Archaic sixth century defined their masculinity.[21] Unlike other beasts, with the exception of the panther, the centaurs are also infamous for their love of wine, and Guimier-Sorbets underlines their susceptibility to drunkenness, which so often resulted in savage behavior in Greek mythology. She argues that their appearance in the andron presents the symposiasts with cautionary examples of the misuse of wine.[22] Central to both Westgate's and Guimier-Sorbets's interpretations is the centaurs' animalistic—or, one might say, barbaric—nature. Centaurs are, to use, as

20. The preserved portion is 2.84 x 0.70 m. Salzmann 1982, p. 105, no. 97, fig. 36:1; Makaronas and Giouri 1989, p. 140, pl. 25:γ.

21. Westgate 2011.

22. Guimier-Sorbets 2004, pp. 909–910.

Cohen does, Baudelaire's description of another bestial aggressor, "à la fois plus et moins qu'un homme" (both more and less than a man), unable to control their passion for wine or for women, whom they frequently attempt to rape, often at the critical social moment of the wedding.[23] Their animality, thus, "pervert[s] human activities" and requires the aggressive intervention of Greek men.[24] Thus, in addition to suggesting the drinker's capacity to become like the uncivilized centaur when wine is involved, images of centaurs in the andron may have given the symposiast a chance to imagine himself as a hero who confronts such beasts.

Imagining the earliest symposia

I suggest below that these mosaics, both the florals and the centaurs, situate symposia into landscapes of a primitive past. It is in this distant setting—the mytho-history out of which developed the civilized life of the polis—that the Athenians, at least, located the origins of convivial drinking. Topper has recently focused attention on this ancient understanding of the symposium's development, which departs in important ways from the concerns of modern scholars, and so as a foundation for further discussion, I turn to a detailed look at her arguments in *The Imagery of the Athenian Symposium*.[25]

One of Topper's starting points is the question of how to understand vase paintings that show symposia in which the participants are positioned on the ground or on cushions, rather than on couches.[26] Some of these symposia without *klinai* are defined by the same kinds of activities that characterize those with couches: the attendees drink, they sing, talk, play games, and embrace their companions. And, notably, they recline. So it is specifically the absence of furniture, divorced in these images from the recumbent posture, that marks these events as different from "normal" sixth- or fifth-century symposia. As Topper describes, the modern view of "the symposium as an institution

23. Baudelaire 1868, quote from p. 348. See discussion in Cohen 2010, pp. 185–186.

24. Cohen 2010, pp. 184–186.

25. I depend primarily on Topper (2012), and particularly on her chapters 1 ("Ancient Visions of the Sympotic Past," pp. 13–22), 2 ("Symposia of the Primitive," pp. 23–52), and 4 ("The Symposium and Its Foreign Pasts," pp. 86–104), although her argument runs throughout. Topper (2009) anticipates some of these arguments.

26. For the association of reclining with luxury practices, see, e.g., Athen. 10.428b; Murray 1983a, p. 263; 1983b, p. 198; 1983c, p. 50; 1994, pp. 48, 53; Boardman 1990, pp. 124–126, 129–130; Burkert 1991; 1992, p. 19; Morris 2000, pp. 182–184; Hobden 2013, p. 9; O'Conner 2015, p. 102.

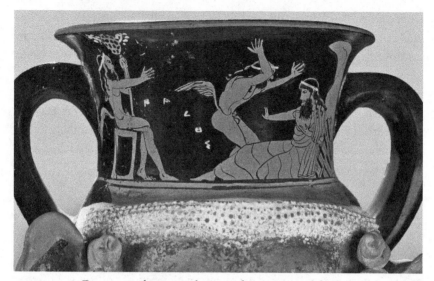

FIGURE 5.8 Dionysos reclining on the ground in a cave, red-figure head kantharos, Toronto Class, ca. 470. London, British Museum E786. Photo © Trustees of the British Museum

that came into its own with the introduction of the dining couch provides no context for understanding" these images.[27] That they do not simply represent alternative forms of contemporary symposia is suggested by the diversity of figures shown to recline on the ground, which include not only men, but also Dionysos, heroes, centaurs, and even women. Topper argues (successfully, in my view) that these images of symposia on the ground reflect an Athenian conception of the drinking party as it existed and developed in the ancient past—an idea also hinted at, for instance, in Plato's *Statesman* (272b), where the earth supposedly provided soft grasses as couches for the earliest generations of men. According to this narrative, the symposium is an institution with a deep Hellenic history that underwent a civilizing evolution before reaching the form familiar to Archaic and Classical citizens. Over the course of this process, drinking, once solitary, became a group activity, and drinkers, who always reclined, moved from the ground to, first, cushions, and then eventually to couches. An Attic red-figure head kantharos in London supplies a useful example of how this might be worked out visually. On this vase, Dionysos himself appears twice: on one side, attended by two satyrs, he drinks alone, leaning against the rocky wall of a cave and holding a large cup in his left hand against his chest (figure 5.8); on the opposite side, the cave wall is gone, and the god

27. Topper 2012, p. 23.

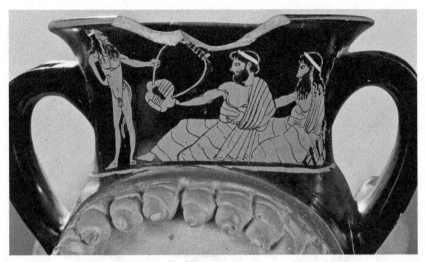

FIGURE 5.9 Dionysos reclining on the ground with a companion, red-figure head kantharos, Toronto Class, ca. 470. London, British Museum E786. Photo © Trustees of the British Museum

is joined by a male companion, who reaches to take the lyre offered by a satyr standing to the left (figure 5.9).[28] In both images, the drinkers recline on the ground. Topper interprets the juxtaposition of these scenes as "two stages in a progression toward the civilized symposium, as the god moves out of the cave and acquires human companionship and music, two prominent features of civilized conviviality."[29] While one is further along in the civilizing process, both images nevertheless seem to depict early moments in the sympoium's development, prior to the introduction of furniture.

That those who occupy caves exist in an "uncivilized (or precivilized) state that precluded the companionship the symposium fostered" is a premise of the comedic drinking party that Odysseus and Silenos arrange for Polyphemos in Euripides' satyr play, *Cyclops* (536–589).[30] This symposium, where Polyphemos drinks alone, is held on the ground in view of the

28. London, The British Museum E786 (Attic red-figure head kantharos, Toronto Class, ca. 470): *ARV²* 1537.3.

29. Topper 2012, p. 37. See, in contrast, Cazzato, who identifies the rusticity of outdoor symposia in poetry as "an imaginative foil with which the user of the cup could compare his own manner of drinking" (2016, pp. 192–206, quote from p. 192). I am not convinced, however, that Cazzato's conclusions exclude or contradict Topper's. See also Yatromanolakis 2009, pp. 428–445; and, for solitary drinking, Villard 1992.

30. On caves as reflective of hard primitivism, see Topper 2012, pp. 36–42. For further analysis of Polyphemos's symposium, see Cazzato 2016, pp. 198–199.

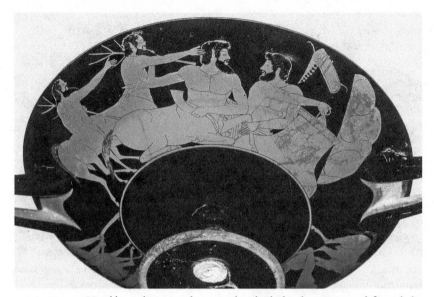

FIGURE 5.10 Herakles reclining on the ground with Pholos the centaur, red-figure kylix attributed to the Carpenter Painter, early fifth century. Basel, Antikenmuseum Basel und Sammlung Ludwig BS489. Photo A. Voegelin, courtesy of Antikenmuseum Basel und Sammlung Ludwig

Cyclops's cave (not inside it, presumably, because the mouth of the cave is part of the stage set), and his barbarism is underlined by additional abnormalities like the daytime setting, the extra-strong wine, and his threat to consume his guest. Here, in other words, reclining on the ground is one of a cluster of elements that signal the Cyclops's primitive nature and, as in the earlier images of Dionysos above, the scene's un- or precivilized setting. It is hardly a surprise that such a monster would pervert a convivial social event, but the sympotic practices of the hero Herakles suggest that his drinking habits, too, belong to a world that is not fully—or, at least, consistently—civilized. An early devotee of wine drinking, Herakles does sometimes make use of the couch in vase painting, but he might also recline, as he does on a red-figure kylix in Basel, on the ground.[31] In this image, he is accompanied by the centaur Pholos, and dips his cup directly into a pithos of unmixed wine (figure 5.10). A stony surface at the right suggests that the pair is in a cave, and two

31. Basel, Antikenmuseum Basel und Sammlung Ludwig BS 489 (Attic red-figure kylix, Carpenter Painter, early fifth century): *ARV*[2] 454. The image of Herakles and Pholos drinking appears elsewhere, although they do not always recline; in fact, much more frequently they are shown standing on either side of a pithos, as on a red-figure stamnos in Tarquinia: Tarquinia, Museo Nazionale Tarquiniense 711 (red-figure stamnos, attributed to the Kleophrades Painter, early fifth century): *ARV*[2] 187.59, 1632.

FIGURE 5.11 Symposiasts reclining on the ground under grapevines, black-figure kylix interior in the manner of the Andokides or Lysippides Painter, second half of the sixth century. Oxford, Ashmolean Museum 1974.344. Photo © Ashmolean Museum, University of Oxford

centaurs approach from the left, gesturing excitedly toward the drink. On the reverse of the same cup is the result of the beasts' exposure to wine: wielding tree limbs and boulders, quintessential weapons of primitive men and beasts, the centaurs attack the hero. Although Herakles attempts, therefore, to recline in a companionable sympotic manner, this cup suggests that it is an impossibility in this "precivilized" moment, where his partner is half beast and the setting is a cave.[32]

Some images of symposia on the ground strike a different tone from the lone drinker in the cave, the Cyclops's perverse banquet, and Herakles' unsuccessful attempts at civil drinking with centaurs. These events are held outdoors, in the presence of animals and natural landscape elements. The interior of a black-figure cup at the Ashmolean Museum, for instance, features six men reclining on the ground underneath a vine laden with grape clusters (figure 5.11), and on a red-figure cup, also in Oxford, one man approaches

32. Topper 2012, pp. 40–41; see also Noel 1983, p. 144.

FIGURE 5.12 Symposiasts reclining on the ground, black-figure skyphos attributed to the Heron Group, ca. 525–475. Athens, Agora Museum P32413. Photo courtesy American School of Classical Studies at Athens, Agora Excavations

another, who reclines on a striped cushion, while a goat at the right looks on.[33] On a black-figure skyphos from the Athenian Agora, three symposiasts, reclining on a long cushion, are flanked by tree stumps on which large birds perch (figure 5.12).[34] While drinking alone in a cave or with a centaur reflects one notion of an ancient, precivilized Greece, these more idyllic outdoor settings resonate with another conception of Athens's deep past—specifically, the early, innocent era of the city's foundation. It is in a similar setting that Ferrari similarly understands vase paintings of well-bred Athenian girls at fountain houses. These images use the visual "language of genre" (specifically, the depiction of "ordinary" activities rather than specific events) to describe the city's earliest years, a time before the introduction of violence necessitated the confinement of women to the household.[35] In this time of primitive innocence, young women of citizen families could go about the city openly and

33. Oxford, Ashmolean Museum 1974.344 (Attic black-figure kylix, in the manner of the Andokides Painter or Lysippides Painter, latter half of the sixth century): *ABFV*, pp. 107–108, fig. 177; Oxford, Ashmolean Museum 516/G262 (Athenian red-figure cup, Oltos, ca. 525–475): *ARV²* 1600.23, 63.92, 1622.

34. Athens, Agora Museum P32413 (Attic black-figure skyphos, Heron Group, ca. 525–475): Camp 1996, pp. 246–247, no. 22, fig. 7, pl. 72; Lynch 2011, pp. 110–118, 197–200, no. 28.

35. Ferrari 2003, pp. 44–51, quote from p. 50.

without fear of assault; they are sometimes joined by deer, animals that might also wander through primitive symposia and that "allude to a special closeness of the early city with nature."[36]

These images suggest that concord with the natural world and peaceful, lawful existence characterize Athens's earliest era. Although they are limited to the late sixth and first half of the fifth century, and while they do come from Athens, the vases seem to reflect a broader Hellenic notion of what the past was like. Their distinctive qualities, for instance, are shared by the earliest, golden race of Hesiod's Myth of Races (*Op.* 109–120):

> Golden was the race of speech-endowed human beings which the immortals, who have their mansions on Olympus, made first of all. They lived at the time of Cronus, when he was king in the sky; just like gods they spent their lives, with a spirit free from care, entirely apart from toil and distress. Worthless old age did not oppress them, but they were always the same in their feet and hands, and delighted in festivities, lacking in all evils; and they died as if overpowered by sleep. They had all good things: the grain-giving field bore crops of its own accord, much and unstinting, and they themselves, willing, mild-mannered, shared out the fruits of their labors together with many good things, wealthy in sheep, dear to the blessed gods.[37]

Unbothered by cares and the necessity of labor, and blessed by the gods, these men—not, technically, an era or age of men as in our modern thinking, but a race, *genos*, that happened to live in the past—feasted on food provided from the earth itself. They disappear, and are followed by the foolish and prideful silver men (127–142), then a race of bronze, lovers of war (143–155), and then the heroes—demigods more noble and righteous than those who came immediately before them (156–173). Succeeding the fortunate heroes is Hesiod's own race of iron, plagued by labor, sorrow, disease, and death.

Other poets and philosophers, too, describe pasts whose inhabitants enjoyed similar lives of untroubled natural bounty. In a poem often called *Purifications*, the pre-Socratic philosopher Empedokles describes an ancient age in which men knew only the goddess Aphrodite and worshipped her with perfumes and honey, rather than with animal sacrifice, the "greatest

36. Ferrari 2003, p. 49.

37. Trans. Most 2007 (LCL 57). On the Myth of Races, see Gatz 1967, pp. 106–201; Vernant 1983, pp. 3–32; Most 1998; Currie 2012; van Noorden 2015, pp. 65–82.

abomination" (DK 31[21]B128 *apud* Porphyr. *De abst.* 2.20).[38] Dikaiarchos, a peripatetic of the fourth century whose *Life of Greece* is partially preserved in Porphyry's *On Abstinence* (4.2.1–9), describes life under the reign of Kronos, when men were intimates of the gods (4.2.1), "killed no animate being" (4.2.2), and lived without war (4.2.5). During this age, the earth "bore [to them] much fruit ungrudgingly" (4.2.2).[39] Indeed, Dikaiarchos reasons, the earth must have naturally produced all they needed because the arts, including agriculture, were unknown to them, and their simple vegetarian diet must have kept sickness away, since none of them practiced medicine (4.2.4). These visions of a harmonious and plentiful past also appear in the passage of Plato's *Statesman* mentioned above, in which the Stranger lays out the myth of the earliest men (271d–272b). Even animals of this era refrained from eating one another (271e), and for men there were "fruits in plenty from the trees and other plants, which the earth furnished them of its own accord, without help from agriculture" (272a).[40] What is more, "the abundant grass that grew up out of the earth furnished them soft couches" (272b).

Such ancient landscapes, in which men feasted in happy concord with nature, enjoying the fruits of the earth and reclining on couches of grass, represent a way of thinking about the past that Lovejoy and Boas call "soft primitivism"—an existence of simple luxury in which nature acts as a "gentle or indulgent mother," and from which the human condition declines.[41] (As Theognis laments, "The violence of men, their base gains and insolence... cast us from prosperity into misery" [833–836].)[42] In contrast to this softness is "hard primitivism," a state of "material deprivation and physical suffering."[43] According to this latter conception, early men, "confused and brutish" (Eur. *Supp.* 198–199), lived like ants in underground caves (Aesch. *PV* 452–453) and suffered in sickness (Hippok. *Off.* 3.10–49) until a god raised them from this state with the gifts of reason and knowledge (of agriculture, medicine, construction, sailing, and the means to trade with one another).[44] As for

38. Trans. Inwood 2001, pp. 145–146 (CTXT 99), 269 (fr. 122).

39. Trans. Mirhady 2001, pp. 62–67 (fr. 56). See also Saunders 2001, pp. 243–249.

40. Trans. Fowler and Lamb 1925 (LCL 164).

41. Lovejoy and Boas 1935, p. 10.

42. Trans. Gerber 1999 (LCL 258).

43. Blundell 1986, p. 203.

44. Trans. Kovacs 1998 (LCL 9); see lines 198–213 for the divine gifts. See Aesch. *PV* 436–506, for the catalogue of Prometheus's gifts to humankind. Hippokrates, in contrast to Dikaiarchos,

the vase paintings discussed above, those in which the earliest symposiasts reclined on the ground in the company of friendly animals suggest a soft view of ancient Athens, while representations of the lone drinker in the cave and the uncivilized symposia with centaurs are closer to a hard primitivism. That said, while offering different lenses through which to imagine the distant past, these conceptions are not so directly opposed as they might appear: hard primitivism, for all its lack of comfort, could embody the admirable values of freedom and simplicity, while the ancient soft life lacked acquaintance with the arts and technologies that make modern life better.[45]

As Lovejoy and Boas lay out in their *Primitivism and Related Ideas in Antiquity*, further complicating the notion of primitivism is that it is understood chronologically and culturally, as both a temporal and a spatial condition.[46] Topper's concise explanation helpfully articulates how this works: "The further one moved in time or space from the presumed centers of civilization, the more likely one was to encounter people living in this state of relative innocence."[47] Thus, like certain ancient, precivilized peoples, the Skythians to Greece's northeast, described in Herodotos's Book 4, are hard-living. They are nomadic milk drinkers (2) without fortified towns (46); the weather is brutal, subjecting them to eight months of harsh winter (28); there are no learned men among them. Herodotos finds them to be admirable in one way only, and that is in their capacity to survive (46). Their life even seems to contain "hardened" versions of soft primitivist tropes: Skythians do not shed the blood of animals in sacrifice, but this is because they strangle the victim instead (60); they have fire, but, lacking timber, are forced to use bones as kindling (61); they have abundant gold, but bury it with their kings (71). In contrast, those rumored to exist even further afield than the Skythians, the races living at the mysterious edges of the earth or beyond them, enjoyed a life of soft luxury, comparable to that of the prehistoric golden race. The Hyperboreans and the Ethiopians of Homer, Herodotos, and Pindar live into extreme old age (Hdt. 3.23), free from disease (Pind. *Pyth.* 10.41–42); nature provides for them (Hdt. 3.18), and they survive without toil (Pind. *Pyth.*

mentioned above, asserts that in their primitive state humans were constantly suffering from disease because they ate like animals, while the current diet reflects the accumulated knowledge of what foods harmonize best with their constitution.

45. See Lovejoy and Boas 1935, pp. 192–194; Blundell 1986, p. 204; Topper 2012, pp. 43–47. Utopias are a common subject for comedic skewering; see, e.g., Konstan 1995, pp. 15–90; 1997; Hubbard 1997, pp. 25–27; Ceccarelli 2000; Ruffell 2000.

46. Lovejoy and Boas 1935, pp. 1–10.

47. Topper 2012, pp. 26–27; Lovejoy and Boas 1935, pp. 1–9.

10.42); their intrinsic morality means there is no need for laws and justice (Pind. *Pyth.* 10.43–44; Hom. *Il.* 1.423: *amymonas*, blameless or noble, of the Ethiopians); the gods take special delight in their glorious, abundant feasts (Pind. *Pyth.* 10.34–36; Hom. *Il.* 1.423–424, 23.205–207; Hom. *Od.* 1.21–25, 5.281–287).[48]

Straddling, or, perhaps, eliding these geographic and chronological primitivisms are the Isles of the Blessed, also known as the Elysian Fields.[49] These prosperous islands, where "the grain-giving field bears honey-sweet fruit flourishing three times a year" (Hes. *Op.* 172–173), are reportedly located at or beyond the shores of the far western Ocean at the edges (*peirata*) of the world (Hom. *Od.* 4.563; Hes. *Op.* 167–168).[50] They are inaccessible, but are nevertheless conceived geographically. And yet, Elysion also has a complex temporal existence: Zeus sent the heroes to inhabit these islands after death, and so this landscape preserves an ancient race that no longer exists elsewhere in the world (Hes. *Op.* 170–173). The Isles of the Blessed thus resist spatiotemporal precision, resembling both a revival of the conditions of Hesiod's bygone golden race (as a reward for the likewise bygone *genos* of heroes) and the geographically distant lands of the Hyperboreans and Ethiopians. Like these other far-off places, the Elysian Fields offer a constant springtime of gentle breezes, golden flowers, and glorious trees (Pind. *Ol.* 2.71–73) where it never snows or rains (Hom. *Od.* 4.566–568). Their inhabitants, it seems, enjoyed an eternal symposium. Plato, although he does not locate them explicitly in Elysion, describes the banquets rewarded to pious men (*hosioi*) in the afterlife (*Resp.* 2.363c–d). Wearing garlands and reclining, they drink wine together (after all, "the finest reward of virtue is to be drunk for all eternity").[51] It is impossible, here, not to mention Lucian's second-century CE description of one of the Isles of the Blessed in his *True Story* (2.13–15). As far as it is outside of our chronological interests, it suggests the endurance of these themes, offering a sharp satire of a number of Golden Age (and paradisiacal afterlife) tropes, including trees bearing cups that fill instantly with wine when plucked![52]

48. See Ferguson 1975, pp. 17–22.

49. Lovejoy and Boas 1935, pp. 290–303; Blundell 1986, pp. 160–162; Topper 2012, pp. 79–80.

50. Trans. Most 2007 (LCL 57). See Cole 2003 for a discussion of the meadows of Elysion and Dionysos's role as a mediator for "initiates" in the afterlife.

51. Trans. Emlyn-Jones and Preddy 2013 (LCL 237).

52. Cazzato (2016, pp. 193–195) brings this story into relationship with sympotic disourse and poetic traditions.

The first-century Nile Mosaic from the sanctuary complex at Praeneste (Palestrina) likewise falls well outside of the lifetime of our mosaics, but it provides a useful example of one way in which the overlap of epochal and geographical primitivisms, so evident in the literature, might also be visualized.[53] Divided, loosely, into three registers, the mosaic represents the landscape of Egypt during the annual flooding of the Nile. Occupying the lower third, the Delta is depicted as a densely populated urban space, in which figures in Greek dress enjoy feasts and festivities. Beyond, in the middle register, are older, Egyptian-style buildings. Far fewer figures are to be found here than in the bustling Delta scenes, underlining this landscape's "remoteness and quaintness."[54] The upper third of the mosaic shows the Nile beyond the First Cataract, where manmade structures disappear entirely and the wild takes over. Indeed, here, a variety of real and mythical animals (the only figures of the mosaic that are named with inscriptions) dominate the landscape, and the only humans to be found are hunters. Emphasizing the horizontality of the mosaic's original context of display—which was not, to be clear, related to dining—and the viewer's position at its lower section, Ferrari reads it as I have described it here, moving from the modern, Graeco-Roman Delta nearest the viewer to the obscure sources of the Nile at the distant upper edge.[55] Read in this way, she argues, the river's course traces its way through successive stages of civilization "in an imaginary itinerary through time: from the empire of the successors of Alexander, through the venerable ruins of the Egyptian civilization, and across the threshold of culture into the timeless landscape of nature."[56] The familiar— the Hellenistic Egypt that is temporally, geographically, and visually closest to the viewer—appears here in abundant detail as a living space. As one's eye "travels" upstream and away from the here and now, it confronts the remains of pharaonic Egypt, including sites and rituals that predated Alexander's arrival. Then, in the part of the mosaic least accessible visually, is a precivilized land at the edges of the *oikoumene*, dominated not by men and their monuments, but, instead, by fantastic beasts. The mosaic presents, in other words, "a map of the progress of mankind."[57]

53. The bibliography on the Nile Mosaic, currently in the Museo Nazionale Prenestino, Palestrina (5.85 x 4.31 m) is extensive, but see, for instance, Gullini 1956; Whitehouse 1976; Steinmeyer-Schareika 1978; Meyboom 1995; Ferrari 1999.

54. Ferrari 1999, p. 365.

55. Ferrari 1999, pp. 365–366.

56. Ferrari 1999, p. 366.

57. Ferrari 1999, p. 366.

The integration of chronological and geographic (or cultural) primitivisms so effectively visualized in the Nile Mosaic is also evident in the representations of ancient symposia on Athenian vases, although it takes a different form. Certain symposiasts who recline on the ground may wear the eastern-style *kidaris* or hold foreign drinking vessels, elements that, Topper argues, "make sense as part of a worldview that conceived of the past as a time characterized by universal barbarism."[58] According to this way of thinking, contemporary foreign lands "were sometimes represented as timeless repositories of ancient customs and traditions," while the Greeks themselves had progressed, leaving behind "humanity's common primitive roots" in the development of their civilization.[59] Visually, then, the symposia of an early, precivilized Athens could be represented not only through outdoor settings or the absence of *klinai*, but also by the inclusion of symposiasts who take on the "barbaric" attributes used in other images to represent non-Hellenic contemporaries. In other words, these elements mark a local past as "foreign" in that its stage of civilization was comparable to that of contemporary barbarian lands. The earliest moments of the Greek symposium's long history, then, are conceived and represented in these images as at once foreign and familiar, distant and local.

It is of course the case that the Athenian understanding of their city's earliest symposia does not necessarily reflect a pan-Hellenic way of thinking; the peculiar Athenian belief in their autochthonous origins and the political implications of this tradition may have provided a special impetus for imagining their ancestors' early symposia on the ground.[60] But certain other features that describe these events—the natural surroundings, lush vegetation, the incivility and disruptiveness of drunken centaurs, all explored above—*are* typical, as we have seen, of the ways in which primitive eras and landscapes are imagined in diverse sources, whose origins and influence extend well outside of sixth- and fifth-century Athens. In other words, while Athens conceived of its own past in a particular way, this conception seems, nevertheless, to depend upon notions of chronological and cultural primitivisms that existed more broadly. While the vases precede our mosaics, therefore, the salient point, to which Plutarch pointed us at the opening of this chapter, is that encounters with a fantastic landscape or with unfamiliar customs do not

58. Topper 2012, p. 86. The *kidaris* has also been interpreted as a sign of the symposiast's barbarian behavior (as, e.g., in Osborne 2007, p. 38) or as an adoption of foreign objects as signs of elite status (as, e.g., in Miller 1991).

59. Topper 2012, pp. 93–94.

60. Topper 2012, pp. 48–50.

FIGURE 5.13 Grapevines, polygonal tesserae mosaic from Maroneia, second half of the third century. In situ. Photo H. M. Franks, digital rendering S. Holzman

necessarily happen only in the distant geographies of the current world. They are also possible through a confrontation with the past.

Past primitivisms in the andron

While the centaurs, to which I return below, point to a specific spatiotemporal moment in Greece's own early mytho-history, the florals are more difficult to pin down. Guimier-Sorbets has proposed that the mosaic vines are connected to the chthonian aspect of Dionysos, who produces fertility in nature.[61] Like the krater of wine, which places Dionysos at the physical and metaphorical center of the event, these mosaics also position the god, the divine source of vegetation and of the vine, as the core of the andron and of the symposium. This case would seem to be especially clearly made by a mosaic uncovered in 1973 at Maroneia in the Thracian Rhodope region of northern Greece (figures 5.13 and 5.14).[62] Probably dating to the middle or second half

61. Guimier-Sorbets 2004, pp. 912–919. She depends on Metzger (1944–1945) concerning the chthonian identity of Dionysos. In an earlier essay, Guimier-Sorbets (1999, pp. 23, 27, 30–31, 33–34) posits a connection between the foliage and eastern iconography, focusing on a possible connection between the hybrid woman with foliage base (e.g., at Vergina) and the more ancient Anatolian "Mistress of Animals" motif.

62. The mosaic is 3.40 x 3.70 m. Tsibidis-Pentazos 1974, p. 59, fig. 48; 1977, pp. 83–84, figs. 107, 108:a, b; Salzmann 1982, p. 123, no. 164, pl. 79:1, 2.

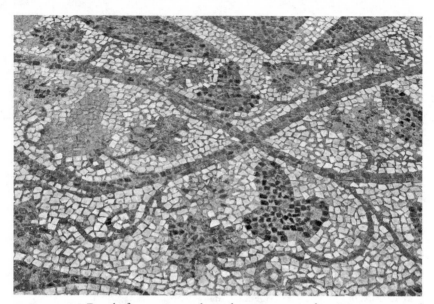

FIGURE 5.14 Detail of grapevines, polygonal tesserae mosaic from Maroneia, second half of the third century. In situ. Photo H. M. Franks

of the third century, this mosaic uses polygonal tesserae, shards of stone that are inconsistent in their outlines, but flat on their upper side, so that they produce a more even surface than the naturally shaped pebbles typical of the previous century. The Maroneia mosaic adheres generally to the vegetal theme described above, but features a specifically Dionysian twist. Its central motif, a four-petal flower enclosed by a square and circle, is surrounded by grapevines that grow out of two opposite corners of the central square. Yellow and green leaves and black, red, and yellow clusters of fruit hang from crisscrossing red vines. The exterior square frame of the mosaic floor, set apart from the inner panel by a bead and reel pattern, is decorated with continuous waves. Anthemia fill the corners between the circle of grapevines and the square frame, and on two sides there are a pair of small circles enclosing a cross—wheels, it would seem. Dionysos's intimacy with lush flora—and particularly, of course, the grapevine—is widely attested, and may relate to the associations with death and rebirth that were likely emphasized in his mystery cult.[63] The presence of abundant foliage in an andron, and the representation of grapevines in particular at Maroneia, surely does evoke the Dionysiac by symbolizing the god's presence in some way.

63. See, e.g., Otto 1965, pp. 141–147; Metzger 1944–1945, pp. 323–339; Seaford 2006, pp. 22–23; Cabrera 2013.

But the kind of natural splendor in which Dionysos delights and that he produces also characterizes the idyllic landscapes of the distant past and the edges of the world. According to the tropes of soft primitivism, the earth's spontaneous production of flowers, fruits, and vines, and even, at times, of wine itself, goes hand in hand with the kind of landscape in which men, unburdened by worldly cares, enjoy true equity with one another and concord with nature. This is the kind of landscape that is the setting for both the unceasing feasts of the Isles of the Blessed and, if we follow Topper, for the earliest convivial drinking. And it offers an appealing setting for Classical symposiasts away from the here and now of the andron. I suggest, in other words, that the mosaic tapestries of vines and flora that spread over andron floors might prompt these men to imagine themselves reclining outdoors in similar remote, fecund landscapes. As Cazzato has discussed, early sympotic poetry sometimes does exactly this, describing the sights and sounds of the open air as a way of envisioning an "alternative setting to the *andron*."[64] In his poems, Alkaios watches the stars rise and hears cicadas chirping (347 V), a bird's song announces the coming spring (367 V), and flowers blossom (347 V). "What are these birds that have come from Ocean, the limits of the earth?" he asks in one fragment, imagining the natural world into the sympotic setting (345).[65] I suggest that, although they do so visually, the mosaics similarly conjure an outdoor setting of idyllic simplicity and abundance that is perpetually in the fresh bloom of springtime.

Such a setting has an obvious appeal: within the relational space of the andron, natural bounty, equitable leisure, and freedom from worry contribute to the evocation of a paradise that is understandably desirable, even if it cannot truly exist. Like those at sail in a symposium-at-sea, symposiasts encounter the joy, sumptuous spectacle, or simple rusticity of this space together, sharing in a remote location, far from the here-and-now cares of the *oikos* and the stresses of the polis, and participating in an event that was also enjoyed by occupants of the there and the then (fortunate ancestors, heroes, or, even, the mythicized, blessed races that live at the edges of the earth). One thing that does seem likely is that the wine cup's movement from couch to couch does not play quite the same role here as it did in previous chapters, since, at least in my reading of these mosaics, its circulations do not help to imagine the symposium as another kind of experience altogether. The event remains a symposium, but one located in another place or at another time. Even so, the cup's

64. Cazzato 2016, pp. 200–206, quote from p. 200.

65. Trans. Campbell 1982 (LCL 142).

circling *epidexia*, its rhythmic moving through relative space, still performs a crucial role. In addition to affirming the commensal nature of the gathering, as it does in all symposia, it may also help to locate more precisely the imagined setting of the event. The presence of this defining sympotic movement suggests that the symposium underway is not the lonely Cyclopean banquet of a precivilized world. Rather, it occupies an idyllic sweet spot, a moment at which a symposiast might experience the benefits of both nature's abundance, visually laid out before him in the mosaic blooms, and the convivial company of men.

Other particulars of how this space might be imagined during the symposium—and how the men occupying it might have imagined themselves—are unclear, and indeed may have varied. Such a setting may encourage drinkers to follow a model of tranquil camaraderie that characterizes both the peaceful, prosperous past and the perpetual banquets of the most distant *eschata*. A symposium imagined to take place in a distant past might expand the event intergenerationally, so that drinkers are not only the beneficiaries of the natural landscape, but also become the companions of their remote ancestors, who practiced the symposium in its earliest form. A foreign shore suggests the possibility of feasting, like the blessed Ethiopians, with the gods themselves, while an Elysian-type setting introduces as potential drinking companions the greatest and most just men of previous eras. As Socrates wonders of this distant place in a quite different context, "What would any of you give to meet with Orpheus and Musaeus and Hesiod and Homer?" (Pl. *Ap.* 41a).[66] It seems possible that, amid the role playing, poetics, singing, and repartee that made up the fourth-century symposium, the setting evoked by the floral mosaics might allow the drinkers to do just this.[67] Even so, it is worth remembering that, idealized as a primitive paradise away from the here and now may be, it remains a fragile space. The setting is still subject to the men who occupy it, and they present the same dangers here that they do in every symposium—drinkers may be inclined to excess consumption, to disruption, hubris, or violence, any of which might shatter the bucolic fantasy. Even in an imagined golden era, then, there may be threats to the sympotic ideals of balance and commensality.

While grounded in Archaic poetry, Cazzato's analysis of the trope of the symposium *en plein air* points us toward still another potential tension

66. Trans. Fowler 1914 (LCL 36).

67. König (2012, pp. 40–41, 76–79) discusses the interest of Plutarch and Athenaeus in communing vicariously with past symposiasts.

in the imagined removal of later symposia from the andron to the rustic outdoors. For Cazzato, the juxtaposition of the simple setting (which she primarily refers to as agrarian, avoiding association with the landscapes of the past) and the intellectual sophistication of sympotic poetry presents an "ironic mismatch between the more primitive agrarian symposion conjured up by the imagery and its implied context of performance."[68] In our mosaics, too, there is the potential for similar irony: the mosaics visualize the lush carpet of flowers and vines that, in an imagined Golden Age setting, would spring naturally from the earth; in reality, however, they are wholly artificial, a self-conscious, distinctly manmade, ordered, and organized tapestry. While the mosaics facilitate the imagination of a natural setting, they simultaneously highlight the *un*natural opulence and luxury of the andron itself.

If floral carpets might resituate the symposiasts in a past idyllic paradise or a distant Elysion, the centaurs present them with a relational space characterized not by its abundance and peacefulness, but by its rusticity and its potential for brutality. Because of their insistence on inserting themselves (unsuccessfully) into human social institutions, centaurs are positioned at a specific, if delicate, mytho-historical moment, one at which (Greek) humanity is moving forward toward the civilized society of the polis, while the composite beasts of the precivilized past are still an influential presence. In this way, the centaurs' primitivism (their "fierce . . . insolent, lawless" nature, as described by Sophocles' Herakles in *Trach.* 1096) is conceived temporally, at a point of transition between the world as it was and the world as it is now. It is also, like the soft primitivism of the idyllic paradise, conceived spatially. These half men are creatures of the wilderness. Even the noblest among them lived on mountains and in caves (Cheiron on Mount Pelion, for instance), as opposed to the city.[69] The centaurs' unsuitability for civilized life, in other words, is defined by both their temporal and spatial distance from the Classical polis, which, as the here and now, operates as both a physical and chronological marker of the "center." That their behavior is incompatible with polis life is even suggested by Theognis, who fears "lest this city be destroyed by pride like the centaurs that devoured raw flesh" (541–542).[70]

68. Cazzato 2016, p. 202. This is not unlike, in some ways, the later pastoral genre.

69. Padgett 2003, p. 3.

70. Resonating with Theognis's comment here and hinting at the centaurs' adherence to primitivist tropes in their behavior is Pholos's banquet, at which he serves Herakles cooked meat, while eating his own raw (Apollod. *Bibl.* 2.5.4).

A symposium imagined as happening in a setting in which centaurs run wild, or hunt, or do battle with men (or even, like those at Pella, drink quietly), is a symposium imagined as happening at a moment and in a landscape where potential conflict and savage behavior are close to the surface. It presents to the symposiasts the potential of moving forward and inward toward the civilization of polis life, or of falling away into primitive wilderness, where civil and civic commensality dissolve. In this way, the specific moment evoked by the centaurs might serve as a kind of spatiotemporal metaphor for the fragile balance that is at the core of every symposium: those gathered confront both the promise of a civilized, commensal ideal and the threat of disruption—a return to an uncivilized primitivism—under the influence of hubris, excessive drunkenness, or even violence.

As Tilley describes, narratives are crucial for the conceptual mapping of landscape because they "introduce temporality, making locales markers of individual and group experiences."[71] They operate, in other words, in Harvey's relational space, endowing both the absolute and the relative—respectively, the physical landscape and the relationships of bodies in and movements through that landscape—with cultural meaning. The mosaic images we have encountered in this chapter work in a way that is perhaps comparable to the verbal act of narration. Like a narrative, the image of a centaur or of abundant vegetation introduces temporality, marking the andron as the kind of landscape that existed in the past or that could only exist in the present at geographical locales so extreme as to be inaccessible—a place at a spatiotemporal distance, in any case, from the drinker's here and now. And this distance provides a lens through which to read the relative experience of the group. Surrounded by the soft primitivism of a golden paradise, the commensality of the symposium extends to include ancestors or heroes, positioning the symposiasts as not just recipients of, but participants in a long-standing cultural tradition. In the context of a harder past, they confront the possibility that the ideal commensality of the event may be threatened by primitive, bestial behavior. Like the edges of the earth, the distant past is a place of men and monsters, of familiar traditions and foreign customs; there, the symposiasts may banquet among heroes and renowned ancestors, but any one, giving in to excess, might work against a civilized end.

71. Tilley 1994, p. 33.

Conclusion

"SPACE IS NEITHER a mere 'frame,' after the fashion of the frame of a painting, nor a form or container of a virtually neutral kind, designed simply to receive whatever is poured into it."[1] With this assertion, Lefebvre enjoins his reader to move away from the notion of space as a passive backdrop for action as well as from the treatment of space as a static, or even a physical, thing—an object. Over the course of *The Production of Space*, Lefebvre makes the argument for space both as the result of and as a contributor to the fluid dialectics between the tactile reception of the material world, the social practices with which it engages, and the internalized processes by which it is understood, culturally and individually.[2] Although I have depended on Harvey's theoretical structure of space as a network of the absolute, relative, and relational in articulating how experiential metaphors emerge, Lefebvre's work nevertheless undergirds my approach to the spatial experience of the andron during the symposium—a context that offers a clear illustration of his claim that space is simultaneously a social product and a means of social production. He helps us to address a concluding question: What do the experiential metaphors that are the subject of this study accomplish in the context of the symposium? Are they merely party tricks, presenting imagined stage sets for the frivolity of sympotic performance? While this may have been the case at times, the final argument of this book is that the experiential metaphors produced in the andron were in fact a crucial way in which the symposium played its social

1. Lefebvre 1991, pp. 93–94.

2. Lefebvre (1991) articulates this core set of ideas in several places, esp. pp. 31–46, 169–176, 401–405, but it is present throughout *The Production of Space*. My use of Lefebvre here is further informed by Merrifield 1993; Soja 1996, pp. 60–82; Simonsen 2005; Harvey 2006, pp. 279–283; Thalmann 2011, pp. 20–24, 193–198.

role, bolstering the solidarity of the group and the shared identity of those present.

Lefebvre understands space as a network of relations between *perceived* (physical, tactile space), *conceived* (the intellectual systematization and representation of space), and *lived* (the interaction with space through senses, imagination, and emotion, as well as the associated symbolisms) experiences.[3] The perceived, physical space of the andron includes the room itself, but the perceived is not unoccupied space, and so it is also within this category that the passing of the cup and of conversation *epidexia* (the movements through space that fall into Harvey's relative category) unfolds. Although materially the mosaics are part of perceived space, their imagery engages with the realm of Lefebvre's conceived, which he describes as a representation of space that most often reflects a society's dominating, usually political, ideology.[4] Our mosaics are not representations of space in quite the way that Lefebvre imagines, but because they "map" conceptual landscapes onto the space of the andron and within the ritualized context of the symposium, they are constructions that both draw from and contribute to precisely the ideological systematization of spaces with which he is concerned. When the *eschata* are glimpsed from a *kline*, or when a symposiast witnesses Dionysos in his traversal of the *oikoumene*, those landscapes are imagined in relationship to Greece and to the Greeks. In the metaphor of the andron as *oikoumene*, the world itself is diminished and schematized, made accessible to Greek eyes and brought under Greek (male, citizen) control. Similarly, when symposiasts imagine themselves reclining in a primitive past, their projection of contemporary practice into an ancient landscape both endows the tradition with a deep, local history and situates that history into a particular cultural narrative of Greece. And the wheel depends upon the commonplace of rhythmic revolving that orders the earth and heavens, situating Greek cultural space and custom in concert with the systematic, stable organization of the universe. While our mosaics may not strictly be representations of space, then, they

3. Lefebvre 1991, pp. 31–46. There is some overlap here with Harvey's network, and Harvey (2006, pp. 279–283), acknowledging that both systems are limited in different ways, attempts to integrate them, even producing a grid of possible spaces that result from their combination. It is possible to structure the emergence of the experiential metaphor through Lefebvre, but here, I use Lefebvre to focus on the andron as a site of social production.

4. Maps are a particularly good example of the political underpinnings of Lefebvre's conceived space; see, e.g., Harley 1988.

nevertheless depend upon conceptions of space that, ultimately, both arise from and reinforce dominant Greek worldviews.[5]

That said, it is Lefebvre's lived experience, a space's emotional power and symbolism, in which I am most interested at this concluding juncture. Because this aspect of space is individually felt, it has the potential to subvert or counteract the ideological domination of the conceived. But it might also be anticipated and manipulated, and the nature of the symposium—its regularized structure and patterns of movement, the recognizable form of the andron, as well as the participants, who themselves are, for the most part, investors in and beneficiaries of the dominant cultural ideologies—helps to establish consistency in the experience of this aspect of space. The symposium is, after all, a feasting ritual, marked by symbolic gestures and differentiated from the experience of daily life.[6] In his extensive anthropological work on feasting (which, if we follow his definition of the feast as a "communal consumption of food and/or drink," includes the symposium), Dietler underscores the way in which such activities present a complicated site for both the reproduction and the manipulation of power relations, through, in part, intense emotional experience.[7] The affective power of ritual may be achieved through "theatrical media and sensory mechanism commonly employed (in various combinations) in performance," including "music, dancing, rhythmic verse, role acting, evocative staging and costumes, and intoxication."[8] Within the isolation of the andron, precisely these elements— including the "staging," to which the mosaics contribute—produce the shared experience of being bound together in symbolic circularity or metaphorically embarking together on journeys to foreign landscapes or

5. The political and social functions of the symposium, both actual and metaphorical, within the polis and among its citizens, have been much discussed. For overviews and bibliography, see Murray 1983a, 1983b, 1983c, 1990a, 1990b; Levine 1985; Morris 1996, pp. 21, 32–34; 2000, pp. 183–185; Kurke 1997, pp. 112; 1999, pp. 17–18; Hammer 2004; Corner 2010, pp. 357–364; Hobden 2013, pp. 154–156, 190–194; Cazzato 2016. See also Nevett (2007), who discusses the household as supporting an egalitarian ideology among citizens. This function also resonates with what Bell (1992, pp. 82–88) calls the "redemptive hegemony" of ritualization, by which she means, briefly, a lived reproduction of (or a performative resistance that effectively, then, reproduces) the order of power.

6. Here, I depend upon Dietler's (2001, p. 67) definition of ritual "symbolically differentiated from everyday activities," and his identification of feasting as a ritual. See also Bell 1992, p. 74.

7. For Dietler's definition of "feast," see Dietler and Hayden 2001, p. 3. For the role of ritual in power relations, see Dietler 2001, p. 71.

8. Dietler 2001, p. 71.

distant pasts. This imagined experience facilitates the group's conceptual removal from the polis context, underlining the dependence of each upon the others present, both "constituting and euphemizing the broader social relations in terms of the basic commensal unit."[9] Like most every aspect of the symposium, there is tension in the possibility of failure; the group's departure, even metaphorically, from the safety of the familiar introduces the potential of loss, of personal isolation rather than mutual support, of spinning off course, of shipwreck, wandering, suffering, exile. But, like the achievement of balance and moderation, the successful experiential metaphor must have been worth the risk of failure. These metaphors were a primary means through which a group of men might generate the feelings of fraternity and commensality, unity and equity—the lived experiences of the space—that were the ideal results of the sympotic event.

Without entering the debate around the elitist identity of the symposium in the Archaic period and while acknowledging the potential geographical and chronological variations in its social role, it is clear that, from its early history, the symposium—at once inclusive and exclusive, private and public—was a site of social delineation. In the polis, this process is necessarily political. We see the ways in which it might become explicitly partisan in episodes like the Mutilation of the Herms, where a small *hetaireia* uses the symposium to shore up alliances and advance a self-interested political agenda. And Theognis (115–116) warns us of the risk of trusting too completely a friendship made under the influence of wine. But generally, and ideally, the event strengthened bonds among citizens. It consolidated the power of the group by creating a lived experience of intimate, emotional connections among its members, channeling potentially harmful competition into a productive and primarily symbolic structure, and reinforcing the individual identity of the adult, male Hellene in relationship to other adult, male Hellenes. This book has made the argument that experiential metaphors were a crucial part of this process. Through them, symposiasts were prompted to consider what they had in common, and what they were not, through heroic models or through confrontations with the foreign. They were stranded together on distant shores or faced with epic challenges. They were subjected equally to the god's transformative promise and to the risks of following him too closely. They were unified in a single, cyclic

9. Dietler 2001, p. 73.

motion. They were reminded of the antiquity of the symposium, and their participation in this tradition connected them to one another and to their forebears. These metaphors were critical to the social function of the symposium because they actively produced an intimate, emotional, and exclusive experience. The lived space of the andron was exactly that—not abstractly applied, but deeply felt.

References

ABFV = J. Boardman, *Athenian Black-Figure Vases: A Handbook*, London 1974.

ABV = J. D. Beazley, *Attic Black-Figure Vase-Painters*, Oxford 1956.

Agora XIV = H. A. Thompson and R. E. Wycherley, *The Agora of Athens: The History, Shape, and Uses of an Ancient City Center* (*The Athenian Agora* XIV), Princeton 1972.

Akamatis, I. M. 2011. "Pella," in *Brill's Companion to Ancient Macedon: Studies in the Archaeology and History of Macedon, 650 BC–300 AD*, ed. R. J. Lane Fox, Leiden, pp. 393–408.

Aldington, R., and G. Orioli, eds. 1933. *Last Poems by D. H. Lawrence*, New York.

Allain, M. L. 1977. "The Periplous of Skylax of Karyanda" (diss. The Ohio State Univ.).

Amandry, P. 1942. "Chronique des fouilles 1940–41," *Bulletin de correspondence hellénique* 64–65, pp. 231–253.

Amphipolis 2014 = "Mosaic Floor Discovered in Amphipolis Tomb," *Archaeology Magazine*, October 14, 2014: http://www.archaeology.org/news/2619-141014-greece-amphipolis-mosaic (accessed July 3, 2016).

Anamali, S. 1986. "Illyriens et Hellenes à Dyrrhachion," *Dossiers, histoire et archéologie* 111, pp. 34–36.

Andronikos, M., C. Makaronas, N. Moutsopoulou, and G. Bakalaki. 1961. *Τὸ ἀνάκτορο τῆς Βεργίνας*, Athens.

Andronikos, M. 1964a. "Ancient Greek Painting and Mosaics in Macedonia," *Balkan Studies* 5, pp. 287–302.

———. 1964b. *Vergina, the Prehistoric Necropolis and the Hellenistic Palace* (Studies in Mediterranean Archaeology 13), Lund.

———. 1994. *Vergina II: The Tomb of Persephone*, Athens.

Andronikos, M., C. Makaronas, N. Moutsopoulou, and G. Bakalaki. 1961. *Τὸ ἀνάκτορο τῆς Βεργίνας*, Athens.

Antonaccio, C. M. 2000. "Architecture and Behavior: Building Gender into Greek Houses," *Classical World* 93.5, pp. 517–533.

Arnott, W. G. 2007. *Birds in the Ancient World from A to Z*, London and New York.

ARV² = J. D. Beazley, *Attic Red-Figure Vase-Painters* 2, Oxford 1963.

Ault, B. A. 2000. "Living in the Classical Polis: The Greek House as Microcosm," *Classical World* 93, pp. 483–496.

Avramidou, A. 2006. "Attic Vases in Etruria: Another View on the Divine Banquet Cup by the Codrus Painter," *American Journal of Archaeology* 110.4, pp. 565–579.

Baldassare, I. 1984. "Pittura parietale e mosaic pavimentale dal IV al II sec. AC," *Dialoghi di archeologia* 2, pp. 65–76.

Balland, A. 1967. "Une transposition de la grotte de Tibère à Sperlonga: El Ninfeo Bergantino de Castelgandolfo," *Mélanges d'archéologie et d'histoire de l'École française de Rome* 79, pp. 421–502.

Barnett, R. D. 1976. *Sculptures from the North Palace of Ashurbanipal at Nineveh (668–627 B.C.)*, London.

Barr-Sharrar, B. 2008. *The Derveni Krater: Masterpiece of Classical Greek Metalwork* (Ancient Art and Architecture in Context 1), Princeton.

Barringer, J. M. 1995. *Divine Escorts: Nereids in Archaic and Classical Greek Art*, Ann Arbor.

Basch, L. 1987. *Le muse imaginaire de la marine antique*, Athens.

Baslez, M.-F. 2003. "Voyager au-delà: La symbolique du voyage dans la pensée grecque," in *Voyageurs et antiquité classique: Textes rassemblés par Hervé Duchêne*, Dijon, pp. 86–100.

Baudelaire, C. 1868. "Salon de 1859," *Curiosités esthétiques: Salon 1845–1859*, Paris, pp. 245–358.

Beaulieu, M.-C. 2016. *The Sea in the Greek Imagination*, Philadelphia.

Belfiore, E. 2006. "Dancing with the Gods: The Myth of the Chariot in Plato's 'Phaedrus,'" *American Journal of Philology* 127.2, pp. 185–217.

Bell, C. 1992. *Ritual Theory, Ritual Practice*, New York.

Bergmann, B. 1992. "Exploring the Grove: Pastoral Space on Roman Walls," in *The Pastoral Landscape*, ed. J. D. Hunt, Washington, D.C., pp. 21–46.

———. 2001. "Meanwhile, Back in Italy . . . : Creating Landscapes of Allusion," in *Pausanias: Travel and Memory in Roman Greece*, ed. S. E. Alcock, J. F. Cherry, and J. Elsner, Oxford, pp. 154–166.

Bergquist, B. 1990. "Sympotic Space: A Functional Aspect of Greek Dining-Rooms," in *Sympotica: A Symposium on the* Symposion, ed. O. Murray, Oxford, pp. 37–65.

Bernadete, S. 2000. *Plato's "Laws": The Discovery of Being*, Chicago.

Bill, C. P. 1901. "Notes on the Greek θεωρός and θεωρία," *Transactions of the American Philological Association* 32.1, pp. 196–204.

Black, M. [1954–1955] 1981. "Metaphor," in *Philosophical Perspectives on Metaphor*, ed. M. Johnson, repr. Minneapolis, pp. 63–82.

Blackman, D. 2001. "Archaeology in Greece 2000–2001," *Journal of Hellenic Studies, Archaeological Reports* 47, pp. 1–144.

Blazeby, C. K. 2011. "Woman + Wine = Prostitute in Classical Athens?" in *Greek Prostitutes in the Ancient Mediterranean, 800 BCE–200 CE*, ed. A. Glazebrook and M. M. Henry, Madison, pp. 86–105.

Blomqvist, J. 1979. *The Date and Origin of the Greek Version of Hanno's* Periplus: *With an Edition of the Text and a Translation*, Lund.

Blundell, S. 1986. *The Origins of Civilization in Greek and Roman Thought*, London.

BNJ = I. Worthington, ed. *Brill's New Jacoby*: http://referenceworks.brillonline.com/browse/brill-s-new-jacoby (accessed 8 February 2016).

Boardman, J. 1958. "A Greek Vase from Egypt," *Journal of Hellenic Studies* 78, pp. 4–12.

———.1976. "A Curious Eye Cup," *Archäologischer Anzeiger*, pp. 281–290.

———. 1988. "Trade in Greek Decorated Pottery," *Oxford Journal of Archaeology* 7, pp. 27–33.

———.1990. "*Symposion* Furniture," in *Sympotica: A Symposium on the* Symposion, ed. O. Murray, Oxford, pp. 122–131.

———. 2014. *The Triumph of Dionysos: Convivial Processions, from Antiquity to the Present Day*, Oxford.

Boesch, P. 1908. *ΘΕΩΡΟΣ: Untersuchung zur Epangelie griechischer Feste*, Berlin.

Bookidis, N., J. Hansen, L. Snyder, and P. Goldberg. 1999. "Dining in the Sanctuary of Demeter and Kore," *Hesperia* 68.1, pp. 1–54.

Bourdieu, P. 1977. *Outline of a Theory of Practice*, trans. R. Nice, Cambridge.

———. 1984. *Distinctions: A Social Critique of the Judgment of Taste*, trans. R. Nice, Cambridge, Mass.

Bowie, E. L. 1993. "Greek Table-Talk before Plato," *Rhetorica: A Journal of the History of Rhetoric* 11.4, pp. 355–371.

Briant, P. 1991. "Chasses royales macédoniennes et chasses royales perses: Le thème de la chasse au lion sur la chasse de Vergina," *Dialogues d'histoire ancienne* 17, pp. 211–255.

Bruneau, P. 1976. "La mosaïque grecque classique et hellénistique," *Archeologia* 27, pp. 12–42.

Buccino, L. 2013. *Dioniso Trionfatore: Percorsi e interpretazione del mito del trionfo indiano nelle fonti e nell'iconografia antiche*, Rome.

Buck, C. D. 1953. "ΘΕΩΡΟΣ," in *Studies Presented to David Moore Robinson on His Seventieth Birthday* 2, ed. G. E. Mylonas and D. Raymond, St. Louis, pp. 443–444.

Bundrick, S. D. 2005. *Music and Image in Classical Athens*, Cambridge.

———. 2015. "Athenian Eye Cups in Context," *American Journal of Archaeology* 119.3, pp. 295–341.

Bunnens, G., and J. M. Russell. 2012. "A Bit-Hilani at Til Barsib? Clarifications and Further Evidence," in *Ugarit-Forschungen: Internationales Jahrbuch für die Altertumskunde Syrien-Palästinas* 43, ed. M. Dietrich and O. Loretz, Münster, pp. 31–35.

Burkert, W. 1985. *Greek Religion*, trans. J. Raffan, Oxford.

———. 1991. "Oriental Symposia: Contrasts and Parallels," in *Dining in a Classical Context*, ed. W. J. Slater, Ann Arbor, pp. 7–24.

———.1992. *The Orientalizing Revolution: Near Eastern Influence on Greek Culture in the Early Archaic Age*, trans. M. E. Pinder and W. Burkert, Cambridge, Mass.

Burton, J. 1998. "Women's Commensality in the Ancient Greek World," *Greece and Rome* 45.2, pp. 143–165.

Buxton, R. 1994. *Imaginary Greece: The Contexts of Mythology*, Cambridge.

Cabrera, P. 2013. "The Gifts of Dionysos," in *Redefining Dionysos*, ed. M. Herrero de Jáuregui, A. I. Jiménez San Cristóbal, and R. Martín Hernández, Berlin, pp. 488–503.

Cahill, N. 2002. *Household and City Organization at Olynthus*, New Haven.

Calame, C. [1977] 1997. *Choruses of Young Women in Ancient Greece*, trans. D. Collins and J. Orion, repr. Lanham, Md.

———.2013. "Choral Practices in Plato's *Laws*: Itineraries of Initiation?" in *Performance and Culture in Plato's* Laws, ed. A.-E. Peponi, Cambridge, pp. 87–108.

Camp, J. McK. II. 1996. "Excavations in the Athenian Agora: 1994 and 1995," *Hesperia* 65.3, pp. 231–261.

Carey, S. 2002. "A Tradition of Adventures in the Imperial Grotto," *Greece and Rome* 49.1, pp. 44–61.

Carney, E. 2002. "Hunting and the Macedonian Elite: Sharing the Rivalry of the Chase," in *The Hellenistic World: New Perspectives*, ed. D. Ogden, London, pp. 59–80.

Carpenter, R. 1966. *Beyond the Pillars of Heracles*, New York.

Carpenter, T. H. 1997. *Dionysian Imagery in Fifth-Century Athens*, Oxford.

Catoni, M. L. 2010. *Bere vino puro: Immagini del simposio*, Milan.

Cazzato, V. 2016. "Symposia *en plein air* in Alcaeus and Others," in *The Cup of Song: Studies on Poetry and the Symposion*, ed. V. Cazzato, D. Obbink, and E. E. Prodi, Oxford, pp. 184–206.

Ceccarelli, P. 2000. "Life among the Savages and Escape from the City in Old Comedy," in *The Rivals of Aristophanes: Studies in Athenian Old Comedy*, ed. D. Harvey and J. Wilkins, London, pp. 453–471.

Chamay, J. 1984. "Le châtiment d'Ixion," *Antike Kunst* 27, pp. 146–150.

Charitonidis, S. 1968. "Κορινθία," *Archaiologikon Deltion* 21, *Chronika* 1, pp. 121–132.

Choremis, A. 1972. "Μωσαϊκὼν δάπεδον ἐξ Ἐρετρίας," *Athens Annals of Archaeology* 5, pp. 224–227.

Ciliberto, F. 1991. "Pittura su tavola e mosaico pavimentale: In margine ad un mosaico a ciottoli di Sicione con decorazione floreale," *Hefte des Archäologischen Seminars der Universität Bern* 14, pp. 11–26.

Coccagna, H. A. 2011. "Embodying Sympotic Pleasure: A Visual Pun on the Body of an *Aulētris*," in *Greek Prostitutes in the Ancient Mediterranean, 800 BCE–200 CE*, ed. A. Glazebrook and M. M. Henry, Madison, pp. 106–121.

Cohen, A. 2010. *Art in the Era of Alexander the Great*, Cambridge.

Cole, S. G. 2003. "Landscapes of Dionysus and Elysian Fields," in *Greek Mysteries: The Archaeology and Ritual of Ancient Greek Secret Cults*, ed. M. B. Cosmopoulos, London, pp. 193–217.

Conticello, B., and B. Andreae. 1974. *Die Skulpturen von Sperlonga* (Antike Plastik 1), Berlin.

Corner, S. 2010. "Transcendent Drinking: The Symposium at Sea Reconsidered," *Classical Quarterly* 60.2, pp. 352–380.

———. 2012. "Did 'Respectable' Women Attend Symposia?" *Greece and Rome* 59.1, pp. 34–45.

Csapo, E. 2003. "The Dolphins of Dionysos," in *Poetry, Theory, Praxis: The Social Life of Myth, Word, and Image in Ancient Greece*, ed. E. Csapo and M. Miller, Oxford, pp. 69–98.

Currie, B. 2012. "Hesiod on Human History," in *Greek Notions of the Past in the Archaic and Classical Eras*, ed. J. Marincola, L. Llewellyn-Jones, and C. Maciver, Edinburgh, pp. 37–64.

CVA = Corpus Vasorum Antiquorum, 1925–. Publication information varies.

D'Agostino, B. 1999. "*Oinops pontos:* Il mare come alterità nella percezione arcaica," *MÉFRA* 111.1, pp. 107–117.

Daraki, M. 1982. "ΟΙΝΟΥ ΠΟΝΤΟΣ: La mer dionsyiaque," *Revue de l'histoire des religions* 199, pp. 4–22.

———.1985. *Dionysos*, Paris.

Daszewski, W. A. 1985. *Corpus of Mosaics from Egypt* 1: *Hellenistic and Early Roman Period*, Mainz am Rhein.

Daux, G. 1965. "Chronique des fouilles et découvertes archéologiques en Grèce en 1964," *Bulletin de correspondance hellénique* 89, pp. 683–1008.

Davidson, J. 1998. *Courtesans and Fishcakes: The Consuming Passions of Classical Athens*, New York.

Davies, M., ed. 1991. *Poetarum melicorum graecorum fragmenta* 1, Oxford.

Davies, M. I. 1978. "Sailing, Rowing, and Sporting in One's Cups on the Wine-Dark Sea," in *Athens Comes of Age: From Solon to Salamis*, ed. W. A. P. Childs, Princeton, pp. 72–92.

Dawkins, R. M. 1929. *The Sanctuary of Artemis Orthia at Sparta*, London.

Delplace, C. 1980. *Le griffon de l'archaïsme à l'époque impériale: Étude iconographique et essai d'interpretation symbolique*, Brussels.

Demangel, R. 1923. *Topographie et architecture: Le Sanctuaire d'Athéna Pronaia* 1: *Les Temples de Tuf (FdD* II.2.1), Paris.

Demerliac, J. G., and J. Meirat. 1983. *Hannon et l'empire punique*, Paris.

Dentzer, J.-M 1971. "Aux origines de l'iconographie du banquet couché," *Revue archéologique*, n.s., fasc. 2, pp. 215–258.

———.1982. *Le motif du banquet couché dans le Proche-Orient et le monde grec du VIIe au IVe siècle avant J.-C.*, Rome.

Derrida, J. 1974. "White Mythology: Metaphor in the Text of Philosophy," trans. F. C. T. Moore, *New Literary History* 6.1: *On Metaphor*, pp. 5–74.

Descoeudres, J.-P. 2000. "Les dauphins de Dionysos," in *Homère chez Calvin: Figures de l'hellénisme à Genève*, Geneva, pp. 325–334.

Detienne, M. 1979. *Dionysos Slain*, trans. M. Muellner and L. Muellner, Baltimore.

———.1989. *Dionysos at Large*, trans. A. Goldhammer, Cambridge, Mass.

Detienne, M., and J.-P. Vernant. [1974] 1978. *Cunning Intelligence in Greek Culture and Society*, trans. J. Lloyd, repr. Sussex.

Deubner, L. 1932. *Attische Feste*, Berlin.

DK = H. Diels and W. Kranz, *Fragmente der Vorsokratiker*, 6th ed., Berlin 1952.

Dietler, M. 1990. "Driven by Drink: The Role of Drinking in the Political Economy and the Case of Early Iron Age France," *Journal of Anthropological Archaeology* 9.4, pp. 352–406.

———. 2001. "Theorizing the Feast: Rituals of Consumption, Commensal Politics, and Power in African Contexts," in *Feasts: Archaeological and Ethnographic Perspectives on Food, Politics, and Power*, ed. M. Dietler and B. Hayden, Tuscaloosa, pp. 65–114.

———. 2006. "Alcohol: Anthropological/Archaeological Perspectives," *Annual Review of Anthropology* 35, pp. 229–249.

Dietler, M., and B. Hayden. 2001. "Digesting the Feast—Good to Eat, Good to Drink, Good to Think: An Introduction," in *Feasts: Archaeological and Ethnographic Perspectives on Food, Politics, and Power*, ed. Michael Dietler and Brian Hayden, Tuscaloosa, pp. 1–20.

Dillon, M. 1997. *Pilgrims and Pilgrimage in Ancient Greece*, London.

Dillon, J., and J. Hershbell. 1991. *Iamblichus, On the Pythagorean Way of Life: Text, Translation, and Notes*, Atlanta.

Dodds, E. R. 1951. *The Greeks and the Irrational*, Berkeley.

Dörpfeld, W. 1894. "Die Ausgrabungen am Westabhange der Akropolis. I," *Mittheilungen des Kaiserlich Deutschen Archaeologischen Instituts Athenische Abteilung* 19, pp. 496–509.

Dougherty, C. 2001. *The Raft of Odysseus: The Ethnographic Imagination of Homer's Odyssey*, New York.

Dragatsis, I. C. 1925–1926. "Το εν Πειραιει Σεραγγειον," *Archaiologike Ephemeris*, pp. 1–8.

Driessen, J., H. Fiasse, M. Devolder, P. Hacıgüzeller, and Q. Letesson. 2008. "Recherches spatiales au Quartier Nu à Malia (MR III)," *Creta Antica* 9, pp. 93–110.

Dübner, F. 1849. *Scholia in Theocritum*, Paris.

Ducrey, P. 1989. "Architecture et poésie: Le cas de la Maison aux mosaïques à Érétrie," in *Architecture et poésie dans le monde grec: Hommage à Georges Roux*, ed. R. Étienne, M.-T. Le Dinahet, and M. Yon, Lyons, pp. 51–62.

Ducrey, P., and I. R. Metzger. 1979. "La Maison aux mosaïques à Érétria," *Antike Kunst*, pp. 3–13.

Dunbabin, K. 1971. "The Triumph of Dionysus on Mosaics in North Africa," *Papers of the British School at Rome* 39, pp. 52–65.

———. 1979. "Technique and Materials of Hellenistic Mosaics," *American Journal of Archaeology* 83.3, pp. 265–277.

———. 1994. "Early Pavement Types in the West and the Invention of Tessellation," in *Fifth International Colloquium on Ancient Mosaics*, ed. P. Johnson, R. Ling, and D. J. Smith, Ann Arbor, pp. 26–40.

———. 1999. *Mosaics of the Greek and Roman World*, Cambridge.

Durand, J.-L., F. Frontisi-Ducroux, and F. Lissarrague. 1989. "Wine: Human and Divine," in *A City of Images: Iconography and Society in Ancient Greece*, ed. C. Bérard, C. Bron, J.-L. Durand, F. Frontisi-Ducroux, F. Lissarrague, A. Schnapp, and J.-P. Vernant, trans. D. Lyons, Princeton, pp. 121–130.

Edmonds, J. M. 1957–1961. *The Fragments of Attic Comedy after Meineke, Bergk, and Kock*, 3 vols., Leiden.

Elsner, J. 2000. "Between Mimesis and Divine Power: Visuality in the Greco-Roman World," in *Visuality Before and Beyond the Renaissance*, ed. R. S. Nelson, Cambridge, pp. 45–69.

Eretria VIII = P. Ducrey, I. R. Metzger, and K. Reber, *Le quartier de la Maison aux mosaïques* (*Eretria, fouilles et recherches* VIII), Lausanne 1993.

Fabian, J. [1985] 2013. "Culture, Time, and the Object of Anthropology," in *Time and the Work of Anthropology: Critical Essays 1971–1991*, repr. London, pp. 191–206.

Faraone, C. 1999. "The Wheel, the Whip, and Other Implements of Torture: Erotic Magic in Pindar *Pythian* 4.213–19," *Classical Journal* 89.1, pp. 1–19.

Faubert, J., and A. M. Herbert. 1999. "The Peripheral Drift Illusion: A Motion Illusion in the Visual Periphery," *Perception* 28, pp. 617–621.

Fehr, B. 1971. *Orientalische und griechische Gelage*, Bonn.

Ferguson, J. 1975. *Utopias of the Classical World*, London.

Fermüller, C., H. Ji, and A. Kitaoka. 2009. "Illusory Motion Due to Causal Time Filtering," *Vision Research* 49, pp. 1–15.

Ferrari, G. 1986. "Eye-Cup," *Revue archéologique*, pp. 5–20.

———. 1999. "The Geography of Time: The Nile Mosaic and the Library at Praeneste," *Ostraka* 8.2, pp. 359–386.

———. 2003. "Myth and Genre on Athenian Vases," *Classical Antiquity* 22, pp. 37–54.

———. 2006. "Architectural Space as Metaphor in the Greek Sanctuary," in *Artful Mind: Cognitive Science and the Riddle of Human Creativity*, ed. M. Turner, Oxford, pp. 225–240.

———. 2008. *Alcman and the Cosmos of Sparta*, Chicago.

Ferrari Pinney, G. 1983. "Achilles Lord of Scythia," in *Ancient Greek Art and Iconography*, ed. W. G. Moon, Madison, pp. 127–146.

Ferrari, G., and B. S. Ridgway. 1981. "Herakles at the Ends of the Earth," *Journal of Hellenic Studies* 101, pp. 141–144.

FGrH = F. Jacoby, *Fragmente der griechischen Historiker*, Berlin 1923.

Fiori, C., N. Tolis, and P. Canestrini. 2003. *Mosaici a Ciottoli: Capolavori e decline dell'arte musiva più antica da Pella a Delos*, Ravenna.

Fisher, N. 2000. "Symposiasts, Fish-Eaters and Flatterers: Social Mobility and Moral Concerns," in *The Rivals of Aristophanes: Studies in Athenian Old Comedy*, ed. D. Harvey and J. Wilkins, London, pp. 355–396.

Foucher, L. 1965. "Le char de Dionysos," in *La mosaïque gréco-romaine: II^e Colloque International pour l'Étude de la Mosaïque Antique [CIEMA II]*, ed. H. Stern and M. Le Glay, Paris, pp. 55–61.

Fowler, H. N. 1897. "Archaeological News," *American Journal of Archaeology* 1, pp. 333–387.

Franks, H. 2009. "Hunting the *Eschata*: An Imagined Persian Empire on the Lekythos of Xenophantos," *Hesperia* 78, pp. 455–480.

———.2012. *Hunters, Heroes, Kings: The Frieze of Tomb II at Vergina*, Princeton.

———. 2014. "Travelling in Theory: Movement as Metaphor in the Ancient Greek Andron," *Art Bulletin* 96.2, pp. 156–169.

Fraser, A., and K. J. Wilcox. 1979. "Perception of Illusory Movement," *Nature* 281, pp. 565–566.

Fraser, P. M. 1969. "Archaeology in Greece, 1968–69," *Journal of Hellenic Studies, Archaeological Reports* 15, pp. 3–39.

Freeman, K. 1946. *The Pre-Socratic Philosophers: A Companion to Diels,* Fragmente der Vorsokratiker, Oxford.

French, D. 1985. "The Year's Work: Tille 1984," *Anatolian Studies* 35, pp. 5–6.

———.1986. "The Year's Work: Tille 1985," *Anatolian Studies* 36, pp. 5–6.

Frickenhaus, A. 1912. "Der Schiffskarren des Dionysos in Athen," *Jahrbuch des Deutschen Archäologischen Instituts* 27, pp. 61–79.

Frontisi-Ducroux, F. 1989. "In the Mirror of the Mask," in *A City of Images: Iconography and Society in Ancient Greece*, ed. C. Bérard, C. Bron, J.-L. Durand, F. Frontisi-Ducroux, F. Lissarrague, A. Schnapp, and J.-P. Vernant, trans. D. Lyons, Princeton, pp. 151–166.

———.1995. *Du masque au visage*, Paris.

Gagné, R. 2016. "The World in a Cup: Ekpomatics in and out of the Symposium," in *The Cup of Song: Ancient Greek Poetry and the Symposium*, ed. V. Cazzato, D. Obbink, and E. E. Prodi, Oxford, pp. 207–229.

Gatz, B. 1967. *Weltalter, goldene Zeit und sinnverwandte Vorstellungen*, Hildesheim.

Gentili, B. 1988. *Poetry and Its Public in Ancient Greece: From Homer to the Fifth Century*, trans. A. T. Cole, Baltimore.

Ginouvès, R. 1993. *Macedonia: From Philip II to the Roman Conquest*, Athens.

Goldberg, M. 1999. "Spatial and Behavioural Negotiation in Classical Athenian City Houses," in *The Archaeology of Household Activities*, ed. P. M. Allison, London, pp. 142–161.

Gordon, R. 1979. "The Real and the Imaginary: Production and Religion in the Greco–Roman World," *Art History* 2, pp. 5–34.

Gould, J. [1989] 2001. "Dionysus and the Hippy Convoy," in *Myth, Ritual, Memory, and Exchange: Greek Literature and Culture*, repr. Oxford, pp. 269–282.

Gow, A. S. F. 1934. "ΙΥΝΞ, ΡΟΜΒΟΣ, Rhombus, Turbo," *Journal of Hellenic Studies* 54, pp. 1–13.

———.1965. *Machon: The Fragments*, Cambridge.

Graf, F. 1985. *Nordionische Kulte: Religionsgeschichtliche und epigraphische Untersuchungen zu den Kulten von Chios, Erythrai, Klazomenai und Phokaia*, Zurich.

Graham, D. W. 2010. *The Texts of Early Greek Philosophy: The Complete Fragments and Selected Testimonies of the Major Presocratics*, part 1, Cambridge.

Graver, M. 1995. "Dog-Helen and Homeric Insult," *Classical Antiquity* 14.1, pp. 41–61.

Gregory, A. 2016. *Anaximander: A Re-assessment*, London.

Guarducci, M. 1983. "Dioniso sul carro navale," *Numismatica e antichità classiche* 12, pp. 107–118.

Guimier-Sorbets, A.-M. 1993. "La mosaïque hellénistique de Dyrrhachion et sa place dans la série des mosaïques grecques à décor vegetal," in *L'Illyrie méridionale et L'Épire dans l'Antiquité* 2, ed. P. Cabanes, Paris, pp. 135–141.

———. 1999. "Echos des arts d'Orient dans la mosaïque et l'art decorative grec des IVe et IIIe siècles av. J.-C.," in *La mosaïque gréco-romaine: VIIe Colloque international pour l'étude de la mosaïque antique (CIEMA VII)*, ed. M. Ennaïfer and A. Rebourg, Tunis, pp. 19–37.

———. 2004. "Dionysos dans l'andrôn: L'iconographie des mosaïques de la maison grecque au IVe et au IIIe siècle avant J.-C.," *Mélanges d'archéologie et d'histoire de l'École française de Rome* 116.2, pp. 895–932.

———. 2011. "Les themes dionysiaques sur les mosaïques hellénistiques d'Asie Mineure (Turquie)," in *11th International Colloquium on Ancient Mosaics, October 16th–20th, 2009, Bursa, Turkey*, ed. M. Şahin, Istanbul, pp. 437–446.

Gullini, G. 1956. *I mosaici di Palestrina*, Archeologia Classica I, Rome.

Hammer, D. 2004. "Ideology, the Symposium, and Archaic Politics," *American Journal of Philology* 125.4, pp. 479–512.

Hardiman, C. I. 2011. "Wrestling with the Evidence: Decorative Cohesion and the House of the Mosaics at Eretria," in *Euboea and Athens: Proceedings of a Colloquium in Memory of Malcolm B. Wallace*, ed. D. W. Rupp and J. E. Tomlinson, Athens, pp. 189–207.

Harley, J. B. 1988. "Maps, Knowledge, and Power," in *The Iconography of Landscape*, ed. D. Cosgrove and S. Daniels, Cambridge, pp. 277–312.

Hartog, F. 1988. *The Mirror of Herodotus: The Representation of the Other in the Writing of History*, trans. J. Lloyd, Berkeley.

Harvey, D. 2006. "Space as a Keyword," in *David Harvey: A Critical Reader*, ed. N. Castree and D. Gregory, Malden, Mass., pp. 270–293.

Hazzard, R. A. 2000. *Imagination of a Monarchy: Studies in Ptolemaic Propaganda*, Toronto.

Hedreen, G. 1992. *Silens in Attic Black-Figure Vase-Painting: Myth and Performance*, Ann Arbor.

———. 2004. "The Return of Hephaistos, Dionysiac Processional Ritual and the Creation of a Visual Narrative," *Journal of Hellenic Studies* 124, pp. 38–64.

———. 2007. "Involved Spectatorship in Archaic Greek Art," *Art History* 30.2, pp. 217–246.

———. 2011. "Bild, Mythos, and Ritual: Choral Dance in Theseus's Cretan Adventure on the François Vase," *Hesperia* 80.3, pp. 491–510.

Heinemann, A. 2013. "Performance and the Drinking Vessel: Looking for an Imagery of Dithyramb in the Time of 'New Music,'" in *Dithyramb in Context*, ed. B. Kowalzig and P. Wilson, Oxford, pp. 282–309.

Hellström, P. 1996. "The Andrones at Labraynda. Dining Halls for Protohellenistic Kings," in *Basileia: Die Paläste der Hellenistischen Könige*, ed. W. Hoepfner and G. Brands, Mainz am Rhein, pp. 164–169.

———. 2011. "Feasting at Labraunda and the Chronology of the *Andrones*," in *Labraunda and Karia. Proceedings of the International Symposium Commemorating Sixty Years of Swedish Archaeological Work in Labraunda*, ed. L. Karlsson and S. Carlsson, Uppsala, pp. 149–157.

Hellström, P., and T. Thieme. 1981. "The Androns at Labraunda: A Preliminary Account of Their Architecture," *Medelhavsmuseet Bulletin* 16, pp. 58–74.

Helly, B. 1968. "Des lions dans l'Olympe!" *Revue des études anciennes* 70, pp. 271–285.

Henderson, J. 1991. *The Maculate Muse: Obscene Language in Attic Comedy*, 2nd ed., Oxford.

Henrichs, A. 1975. "Die beiden Gaben des Dionysos," *Zeitschrift für Papyrologie und Epigraphik* 16, pp. 139–144.

———. 1982. "Changing Dionysiac Identities," in *Jewish and Christian Self-Definition* (Self-Definition in the Graeco-Roman World 3), ed. B. F. Meyer and E. P. Sanders, London, pp. 137–160, 213–236.

———. 1987. "Myth Visualised: Dionysos and His Circle in Sixth-Century Attic Vase-Painting," in *Papers on the Amasis Painter and His World*, ed. M. True, Malibu, pp. 92–124.

———. 1990. "Between City and Country: Cultic Dimensions of Dionysus in Athens and Attica," in *Cabinet of the Muses: Essays on Classical and Comparative Literature in Honor of Thomas G. Rosenmeyer*, ed. M. Griffith and D. J. Mastronarde, Atlanta, pp. 257–277.

Herrero de Jáuregui, M. 2015. "The Construction of Inner Religious Space in Wandering Religion of Classical Greece," *Numen* 62, pp. 667–697.

Himmelmann, N. 1996. *Sperlonga: Die Homerischen Gruppen und Ihre Bildquellen*, Opladen.

Hobden, F. 2009. "*Symposion* and the Rhetorics of Commensality in Demosthenes 19, *On the False Embassy*," in *Rollenbilder in der athenischen Demokratie: Medien, Gruppen, Räume im politischen und sozialen System*, ed. C. Mann, M. Haake, and R. von den Hoff, Wiesbaden, pp. 71–87.

———. 2013. *The Symposion in Ancient Greek Society and Thought*, Cambridge.

Hodder, I. 2005. "Archaeology, Standards of Living, and Greek Economic History," in *The Ancient Economy: Evidence and Models*, ed. J. G. Manning and I. Morris, Stanford, pp. 91–126.

Hoepfner, W., and E.-L. Schwandner. 1994. *Haus und Stadt im klassischen Griechenland*, rev. ed., Munich.

Holtzmann, B., and O. Picard. 1974. "Thasos. Les abords ouest de l'agora: La zone antique," *Bulletin de correspondence hellénique, Chroniques et Rapports* 98.2, pp. 789–793.

Hopman, M. G. 2008. "Revenge and Mythopoiesis in Euripides' *Medea*," *Transactions of the American Philological Association* 138.1, pp. 155–183.

——. 2012. *Scylla: Myth, Metaphor, Paradox*, New York.

Hubbard, T. K. 1997. "Utopianism and the Sophistic City in Aristophanes," in *The City as Comedy: Society and Representation in Athenian Drama*, ed. G. W. Dobrov, Chapel Hill, pp. 23–50.

Hunter, R. L., ed. 1983. *Eubulus: The Fragments*, Cambridge.

Hutchinson, G. O. 2001. *Greek Lyric Poetry: A Commentary on Selected Larger Pieces*, Oxford.

Inwood, B. 2001. *The Poem of Empedocles*, rev. ed., Toronto.

Isler-Kerényi, C. 1982. "Il trionfo di Dioniso," *Numismatica e antichità classiche* 11, pp. 137–160.

——. 1983. "Dionysos auf einer attischen Vase des vierten Jahrhunderts: Mythologie oder Utopie?" in *Antidoron: Festschrift für Jürgen Thimme*, ed. D. Metzler, B. Otto, and C. Müller-Wirth, Karlsruhe, pp. 95–100.

——. 2015. *Dionysos in Classical Athens: An Understanding through Images*, Leiden.

Jacob, C. 1991. "Aux confines de l'humanité: Peuples et paysages africains dans le 'Périple d'Hannon,'" *Cahiers d'Études Africaines* 31.121–22, pp. 9–27.

James, A. W. 1975. "Dionysus and the Tyrrhenian Pirates," *Antichthon* 9, pp. 17–34.

Jameson, M. 1990a. "Domestic Space in the Greek City-State," in *Domestic Architecture and the Use of Space*, ed. S. Kent, Cambridge, pp. 92–113.

——. 1990b. "Private Space and the Greek City," in *The Greek City from Homer to Alexander*, ed. O. Murray and S. Price, Oxford, pp. 171–195.

Jeanmarie, H. 1951. *Dionysos: Histoire du culte de Bacchus*, Paris.

Johnston, S. I. 1995. "The Song of the *Iynx*: Magic and Rhetoric in *Pythian 4*," *Transactions of the American Philological Association* 125, pp. 177–206.

Jones, C. P. 1991. "Dinner Theater," in *Dining in a Classical Context*, ed. W. J. Slater, Ann Arbor, pp. 185–198.

KA = R. Kassel and C. Austin, *Poetae comici graeci*, vols. 1 (1983) and 2 (1991), Berlin.

Kaplan, M. 1975. "ʼΆπειρος and Circularity," *Greek, Roman, and Byzantine Studies* 16.2, pp. 125–140.

Kent, S. 1990. "Activity Areas and Architecture: An Interdisciplinary View of the Relationship between Use of Space and Domestic Built Environments," in *Domestic Architecture and the Use of Space*, ed. S. Kent, Cambridge, pp. 1–8.

Ker, J. 2000. "Solon's *Theôria* and the End of the City," *Classical Antiquity* 19.2, pp. 304–329.

Kerényi, C. 1976. *Dionysos: Archetypal Image of Indestructible Life*, trans. R. Manheim, Princeton.

Kitaoka, A., and H. Ashida. 2003. "Phenomenal Characteristics of Peripheral Drift Illusion," *Vision* 15.4, pp. 261–262.

Klöckner, A. 2010. "Getting in Contact: Concepts of Human-Divine Encounter in Classical Greek Art," in *The Gods of Ancient Greece: Identities and Transformations*, ed. J. N. Bremmer and A. Erskine, Edinburgh, pp. 106–125.

Knigge, U., and W. Kovacsovics. 1983. "Kerameikos: Tätigkeitsbericht 1981," *Archäolgischer Anzeiger*, pp. 209–224.

Koller, H. 1958. "Theoros und Theoria," *Glotta* 36.3/4, pp. 273–286.

Kondis, I. D. 1967. "Artemis Brauronia," *Archaiologikon Deltion* 22, pp. 156–206.

König, J. 2012. *Saints and Symposiasts: The Literature of Food and the Symposium in Greco-Roman and Early Christian Culture*, Cambridge.

Konstan, D. 1995. *Greek Comedy and Ideology*, Oxford.

———. 1997. "The Greek Polis and Its Negations: Versions of Utopia in Aristophanes' *Birds*," in *The City as Comedy: Society and Representation in Athenian Drama*, ed. G. W. Dobrov, Chapel Hill, pp. 3–22.

Konstantinopoulos, G. 1967. "Ἀρχαιοτήτης και Μνημεία Δωδεκανήσου," *Archaiologikon Deltion* 22, *Chronika* 2, pp. 514–540.

———. 1973. "Νέα Εγρήματα εκ Ρόδου και Αστυπαλαίας," *Athens Annals of Archaeology*, pp. 114–124.

Kottaridi, A. 2011. "The Palace of Aegae," in *Brill's Companion to Ancient Macedon: Studies in the Archaeology and History of Macedon, 650 BC–300 AD*, ed. R. J. Lane Fox, Leiden, pp. 297–333.

Kottaridi, A., E. Kontogoulidou, M. Tiliopoulou, N. Kladouri, and P. Kamatakis. 2009. *The Palace of Aegae: 2007–2008, the Commencement of a Major Project*, Thessaloniki.

Kowalzig, B. 2013a. "Broken Rhythms in Plato's *Laws*: Materialising Social Time in the Chorus," in *Performance and Culture in Plato's* Laws, ed. A.-E. Peponi, Cambridge, pp. 171–211.

———. 2013b. "Dancing Dolphins on the Wine-Dark Sea: Dithyramb and Social Change in the Archaic Mediterranean," in *Dithyramb in Context*, ed. B. Kowalzig and P. Wilson, Oxford, pp. 31–58.

Kowalzig, B., and P. Wilson. 2013. "Introduction: The World of Dithyramb," in *Dithyramb in Context*, ed. B. Kowalzig and P. Wilson, Oxford, pp. 1–27.

Kunisch, N. 1990. "Die Augen der Augenschalen," *Antike Kunst* 33.1, pp. 20–27.

Kuriki, I., H. Ashida, I. Murakami, and A. Kitaoka. 2008. "Functional Brain Imaging of the Rotating Snakes Illusion by fMRI," *Journal of Vision* 8, pp. 1–10.

Kurke, L. 1997. "Inventing the *Hetaira*: Sex, Politics, and Discursive Conflict in Archaic Greece," *Classical Antiquity* 16.1, pp. 106–150.

———. 1999. *Coins, Bodies, Games, and Gold: The Politics of Meaning in Archaic Greece*, Princeton.

———. 2005. "Choral Lyric as 'Ritualization': Poetic Sacrifice and Poetic *Ego* in Pindar's Sixth Paian," *Classical Antiquity* 24.1, pp. 81–130.

———. 2013. "Imagining Chorality: Wonder, Plato's Puppets, and Moving Statues," in *Performance and Culture in Plato's* Laws, ed. A.-E. Peponi, Cambridge, pp. 123–170.

Labraunda III.2 = J. Crampa, *Labraunda* III: *The Greek Inscriptions, Part 2*, Stockholm 1972.

Ladianou, K. 2005. "The Poetics of *Choreia*: Imitation and Dance in the *Anacreontea*," *Quaderni Urbinati di Cultura Classica*, n.s., 80.2, pp. 47–58.

Ladstätter, G. 2000. "Aigeira (Griechenland)," *Jahresbericht 1999 des Österreichischen archäolgischen Instituts. Jahreshefte des Österreichischen archäologischen Instituts in Wien, Beiblatt* 69, pp. 370–371.

———. 2001. "Aigeira (Griechenland)," *Jahresbericht 2000 des Österreichischen Archäolgischen Instituts. Jahreshefte des Österreichischen archäologischen Instituts in Wien, Beiblatt* 70, pp. 253–254.

Lakoff, G., and M. Johnson. 1980. *Metaphors We Live By*, Chicago.

Langridge-Noti, E. M. 2013. "Consuming Iconographies," in *Pottery Markets in the Ancient Greek World (8th–1st Centuries B.C.): Proceedings of the International Symposium Held at the Université libre de Bruxelles, 19–21 June 2008*, ed. A. Tsingarida and D. Viviers, Brussels, pp. 61–72.

———. 2014. "'To Market, To Market': Pottery, the Individual, and Trade in Athens," in *Cities Called Athens: Studies Honoring John McK. Camp II*, ed. L. A. Riccardi and K. Daly, Lanham, Md., pp. 165–196.

Lawler, L. B. 1927. "The Maenads: A Contribution to the Study of the Dance in Ancient Greece," *Memoirs of the American Academy in Rome* 6, pp. 69–112.

———. 1964. *The Dance in Ancient Greece*, London.

LCL = Loeb Classical Library, 1912-. Cambridge, Mass.

Lee, E. N. 1976. "Reason and Rotation: Circular Movement as the Model of the Mind (Nous) in Later Plato," in *Facets of Plato's Philosophy*, ed. W. H. Werkmeister, Amsterdam, pp. 70–102.

Lefebvre, H. 1991. *The Production of Space*, trans. D. Nicholson-Smith, London.

Levaniouk, O. 2007. "The Toys of Dionysos," *Harvard Studies in Classical Philology* 103, pp. 165–202.

Levine, D. B. 1985. "Symposium and the Polis," in *Theognis of Megara: Poetry and the Polis*, ed. T. J. Figueira and G. Nagy, Baltimore, pp. 176–196.

Lewis, S. 2003. "Representation and Reception: Athenian Pottery and Its Italian Context," in *Inhabiting Symbols: Symbol and Image in the Ancient Mediterranean*, ed. J. B. Wilkins and E. Herring, London, pp. 175–192.

Lezzi-Hafter, A. 2009. "Wheel without Chariot—A Motif in Attic Vase-Painting," in *Athenian Potters and Painters* 2, ed. J. H. Oakley and O. Palagia, Oxford, pp. 147–158.

Lilimpaki-Akamati, M. 1987a. "Ἀνασκαφική ἔρευνα στην περιοχή Καναλιού της Πέλλας," in *Archaiologiko Ergo sti Makedonia kai sti Thraki* 1, Thessaloniki, pp. 137–145.

———. 1987b. "Ἕνα νέο ψηφιδωτό δάπεδο της Πέλλας," in *Ἄμητος: Τιμητικός τόμος για τον Καθηγητή Μ. Ἀνδρόνικο* 1, Thessaloniki, pp. 455–469, pls. 93, 94.

Lilimpaki-Akamati, M., and I. M. Akamatis, eds. 2003. *Pella and Its Environs*, Thessaloniki.

Ling, R. 1998. *Ancient Mosaics*, London.

Lissarrague, F. 1990a. *The Aesthetics of the Greek Banquet*, trans. A. Szegedy-Maszak, Princeton.

———. 1990b. "Around the *Krater*: An Aspect of Banquet Imagery," in *Sympotica: A Symposium on the* Symposion, ed. O. Murray, Oxford, pp. 196–209.

Lloyd-Jones, H., and P. Parsons, eds. 1983. *Supplementum Hellenisticum*, Berlin.

Lolos, Y. 2011. *Land of Sikyon: Archaeology and History of a Greek City-State* (*Hesperia* Suppl. 39), Princeton.

Lovejoy, A. O., and G. Boas. 1935. *Primitivism and Related Ideas in Antiquity*, Baltimore.

Luce, S. B. 1940. "Archaeological News and Discussions," *American Journal of Archaeology* 44.2, pp. 234–251.

Luke, J. 1994. "The Krater, *Kratos*, and the *Polis*," *Greece and Rome*, 2nd ser., 41.1, pp. 23–32.

Luz, C. 2013. "What Has It Got in Its Pocketses? Or, What Makes a Riddle a Riddle?" in *The Muse at Play: Riddles and Wordplay in Greek and Latin Poetry*, ed. J. Kwapisz, D. Petrain, and M. Szymański, Berlin, pp. 83–99.

Lynch, K. M. 2007. "More Thoughts on the Space of the Symposium," in *Building Communities: House, Settlement and Society in the Aegean and Beyond* (British School at Athens Studies 15), ed. R. Westgate, N. Fisher, and J. Whitley, London, pp. 243–249.

———. 2011. *The Symposium in Context: Pottery from a Late Archaic House near the Athenian Agora*, Princeton.

Maass, E. 1888. "ΔΙΟΝΥΣΟΣ ΠΕΛΑΓΙΟΣ," *Hermes* 23.1, pp. 70–80.

Mackay, E. A. 2010. *Tradition and Originality: A Study in Exekias* (British Archaeological Reports, International Series 2092), Oxford.

Makaronas, C., and E. Giouri. 1989. *Οι οικίες αρπαγής της Ελένης και Διονύσου της Πέλλας*, Athens.

Marconi, C. 2010. "*Choroi, Theôriai,* and International Ambitions: The Hall of Choral Dancers and Its Frieze," in *Samothracian Connections: Essays in Honor of James R. McCredie*, ed. O. Palagia and B. D. Wescoat, Oxford, pp. 106–135.

Marinatos, N., and D. Kyrtatas. 2004. "Epiphany: Concept Ambiguous, Experience Elusive," *Illinois Classical Studies* 29, *Divine Epiphanies in the Ancient World*, pp. 227–234.

Massenzio, M. 1970. *Cultura e crisi permanente: La "xenia" dionisiaca*, Rome.

Matthäus, H. 1993. "Zur Rezeption orientalischer Kunst-, Kultur-, und Lebensformen in Griechenland," in *Anfänge des politischen Denkens in der Antike. Die nahöstlichen Kulturen und die Griechen*, ed. K. A. Raaflaub, Munich, pp. 165–186.

———. 1999–2000. "Das griechische Symposium und der Orient," *Nürnberger Blätter zur Archäologie* 16, pp. 41–64.

Mayor, A. 2000. *The First Fossil Hunters: Paleontology in Greek and Roman Times*, Princeton.

Mayor, A., and M. Heaney. 1993. "Griffins and Arimaspeans," *Folklore* 104.1–2, pp. 40–66.

McCabe, D. F., and J. V. Brownson. 1986. *Chios Inscriptions: Texts and Lists*, Princeton.

McCartney, E. S. 1934. "The Couch as a Unit of Measurement," *Classical Philology* 29.1, pp. 30–35.

McDonald, W. A. 1951. "Villa or Pandokeion?" in *Studies Presented to David Moore Robinson on His Seventieth Birthday* 1, ed. G. Mylonas, St. Louis, pp. 365–373.

McGinty, P. 1978. "Dionysos's Revenge and the Validation of the Hellenic World-View," *Harvard Theological Review* 71.1–2, pp. 77–94.

Merrifield, A. 1993. "Place and Space: A Lefebvrian Reconciliation," *Transactions of the Institute of British Geographers*, n.s., 18.4, pp. 516–531.

Merry, W. W., J. Riddell, and D. B. Monro. 1886–1901. *Commentary on the* Odyssey, Oxford.

Mertens, J. 1971. *Ordona* III: *Rapports et études*, Brussels.

Metzger, H. 1944–1945. "Dionysos chthonien d'après les monuments figurés de la période classique," *Bulletin de correspondence hellénique* 68–69, pp. 296–339.

———. 1951. *Les représentations dans la céramique attique du IVe siècle*, Paris.

Metzger, I. R. 1980. "Bemerkungen zur dionysischen Thematik des Hauses mit den Mosaiken in Eretria," *Antike Kunst* 23, pp. 45–47.

Meyboom, P. G. P. 1977. "I mosaici pompeiani con figure di pesci," *Mededeelingen van het Nederlands Historisch Instituut te Rome* 39, pp. 49–93, pls. 46–58.

———. 1995. *The Nile Mosaic of Palestrina: Early Evidence of Egyptian Religion in Italy* (Religions in the Graeco-Roman World 121), Leiden.

Michaud, J.-P. 1970. "Chronique des fouilles et découvertes archéologiques en Grèce en 1968 et 1969," *Bulletin de correspondence hellénique* 94, pp. 883–1164.

———. 1973. "Chronique des fouilles et découvertes archéologiques en Grèce en 1972," *Bulletin de correspondence hellénique* 97, pp. 253–412.

Miller, J. 1986. *Measures of Wisdom: The Cosmic Dance in Classical and Christian Antiquity*, Toronto.

Miller, M. C. 1991. "Foreigners at the Greek Symposium?" in *Dining in a Classical Context*, ed. W. J. Slater, Ann Arbor, pp. 59–82.

———. 1997. *Athens and Persia in the Fifth Century B.C.: A Study in Cultural Receptivity*, Cambridge.

———. 2003. "Art, Myth, and Reality: Xenophantos' Lekythos Re-Examined," in *Poetry, Theory, Praxis: The Social Life of Myth, Word, and Image in Ancient Greece; Essays in Honour of William J. Slater*, ed. E. Csapo and M. C. Miller, Oxford, pp. 19–47.

———. 2011. "Manners Makyth Man: Diacritical Drinking in Achaemenid Persia," in *Cultural Identity in the Ancient Mediterranean*, ed. E. S. Gruen, Los Angeles, pp. 96–134.

Mirhady, D. C. 2001. "Dicaearchus of Messana: The Sources, Text and Translation," in *Dicaearchus of Messana: Text, Translation, and Discussion*, ed. W. W. Fortenbaugh and E. Schütrumpf, New Brunswick, N.J., pp. 1–142.

Mitchell, A. G. 2009. *Greek Vase-Painting and the Origins of Visual Humour*, New York.

Molholt, R. 2011. "Roman Labyrinth Mosaics and the Experience of Motion," *Art Bulletin* 93.3, pp. 287–303.

Mommsen, H. 2002–2003. "Dionysos und sein Kreis im Werk des Exekias," *Trierer Winckelmannsprogramme* 19–20, pp. 21–44.

Monteagudo, G. L. 1999. "The Triumph of Dionysus in Two Mosaics in Spain," *Assaph: Studies in Art History* 4, pp. 35–60.

Montiglio, S. 2000. "Wandering Philosophers in Classical Greece," *Journal of Hellenic Studies* 120, pp. 86–115.

———. 2005. *Wandering in Ancient Greek Culture*, Chicago.

Morgan, J. 2010. *The Classical Greek House*, Bristol.

———. 2011. "Drunken Men and Modern Myths: Re-Viewing the Classical Andrōn," in *Sociable Man*, ed. S. D. Lambert, Swansea, pp. 267–290.

Morris, I. 1996. "The Strong Principle of Equality and the Archaic Origins of Greek Democracy," in *Demokratia: A Conversation on Democracies, Ancient and Modern*, ed. J. Ober and C. Hedrick, Princeton, pp. 19–48.

———. 2000. *Archaeology as Cultural History: Words and Things in Iron Age Greece*, Malden, Mass.

———. 2005. "Archaeology, Standards of Living, and Greek Economic History," in *The Ancient Economy: Evidence and Models*, ed. J. G. Manning and I. Morris, Stanford, pp. 91–126.

Morrison, J. S., and R. T. Williams. 1968. *Greek Oared Ships, 900–322 B.C.*, London.

Most, G. W. 1998. "Hesiod's Myth of the Five (or Three or Four) Races," *Proceedings of the Cambridge Philological Society* 43, pp. 104–127.

Mullen, W. 1982. *Choreia: Pindar and Dance*, Princeton.

Murray, O. 1983a. "The Greek Symposion in History," in *Tria Corda: Scritti in onore di Arnaldo Momigliano*, ed. E. Gabba, Como, pp. 257–272.

———. 1983b. "The Symposion as Social Organisation," in *The Greek Renaissance of the Eighth Century B.C.: Tradition and Innovation. Proceedings of the Second International Symposium at the Swedish Institute in Athens, 1–5 June, 1981*, ed. R. Hägg, Stockholm, pp. 195–199.

———. 1983c. "Symposium and Männerbund," in *Concilium Eirene* 16, ed. P. Oliva and A. Frolíková, Prague, pp. 47–52.

———. 1990a. "The Affair of the Mysteries: Democracy and the Drinking Group," in *Sympotica: A Symposium on the* Symposion, ed. O. Murray, Oxford, pp. 148–161.

———. 1990b. "Sympotic History," in *Sympotica: A Symposium on the* Symposion, ed. O. Murray, Oxford, pp. 3–13.

———. 1994. "Nestor's Cup and the Origins of the Greek *Symposion*," *Annali di archeologia e storia antica*, n.s., 1, pp. 47–54.

————. 2013. "The Chorus of Dionysus: Alcohol and Old Age in the *Laws*," in *Performance and Culture in Plato's* Laws, ed. A.-E. Peponi, Cambridge, pp. 109–122.

————. 2016. "The Symposion between East and West," in *The Cup of Song: Studies in Poetry and the Symposion*, ed. V. Cazzato, D. Obbink, and E. E. Prodi, Oxford, pp. 17–27.

Nankov, E. 2010. "Why One Needs 'The Odd Man Out'? The Deer Hunter with *Lagobolon* from the Frescoes in the Thracian Tomb near Alexandrovo," *Archeologia Bulgarica* 14.1, pp. 35–55.

Neer, R. 2002. *Style and Politics in Athenian Vase-Painting: The Craft of Democracy, ca. 530–460 BCE*, Cambridge.

————. 2010. *The Emergence of the Classical Style in Greek Sculpture*, Chicago.

Nelson, G. 1940. "A Greek Votive Iynx-Wheel in Boston," *American Journal of Archaeology* 44.4, pp. 443–456.

Nevett, L. 1994. "Separation or Seclusion? Towards an Archaeological Approach to Investigating Women in the Greek Household in the Fifth to Third Centuries B.C.," in *Architecture and Order: Approaches to Social Space*, ed. M. P. Pearson and C. Richards, London, pp. 98–112.

————. 1995. "Gender Relations in the Classical Greek Household: The Archaeological Evidence," *Annual of the British School at Athens* 90, pp. 363–381.

————. 1999. *House and Society in the Ancient World*, Cambridge.

————. 2007. "The Greek House and the Ideology of Citizenship," *World Archaeology* 39.2, pp. 229–245.

————. 2010. *Domestic Space in Classical Antiquity*, Cambridge.

Nightengale, A. W. 1998. "Theoria as Theater: The Pilgrimage Theme in Greek Drama," in *Papers of the Leeds International Latin Seminar* 10, pp. 131–156.

————. 2001. "On Wondering and Wandering: *Theoria* in Greek Philosophy and Culture," *Arion* 9, pp. 23–58.

————. 2004. *Spectacles of Truth in Classical Greek Philosophy: Theoria in Its Cultural Context*, Cambridge.

Nikolaou, K. 1983. "Three New Mosaics at Paphos, Cyprus," in *Colloque international sul mosaico antico: Ravenna, 6–10 settembre 1980, Colloque international pour l'étude de la mosaïque antique* 3, Ravenna, pp. 219–225.

Nikopoulos, I. 1972. "Αρχαιότητες και μνημεία Αθηνών—Ελευσίς," *Archaiologikon Deltion* 25, *Chronika* 1, pp. 91–120.

Noel, D. 1983. "Du vin pour Herakles!" in *Image et céramique grecque*, ed. F. Lissarrague and F. Thelamon, Rouen, pp. 141–152.

Oakley, J. H., and R. H. Sinos. 1993. *The Wedding in Ancient Athens*, Madison.

O'Conner, K. 2015. *The Never-Ending Feast: The Anthropology and Archaeology of Feasting*, London.

Oikonomides, A. N. 1977. *Hanno the Carthaginian, Periplus or Circumnavigation of Africa*, London.

Oikonomos, G. P. 1918. "Ψηφιδωτὸν ἐν Σπάρτῃ," *Archaiologikon Deltion* 4, pp. 171–176.

Olson, S., and A. Sens. 2000. *Archestratos of Gela: Greek Culture and Cuisine in the Fourth Century BCE*, Oxford.

Olynthus V = D. M. Robinson, *Mosaics, Vases and Lamps Found in 1928 and 1931* (*Excavations at Olynthus* V), Baltimore 1933.

Olynthus VIII = D. M. Robinson and J. W. Graham, *The Hellenic House* (*Excavations at Olynthus* VIII), Baltimore 1938.

Olynthus XII = D. M. Robinson, *Domestic and Public Architecture* (*Excavations at Olynthus* XII), Baltimore 1946.

Orlandos, A. K. 1939. "Ἀνασκαφαὶ Σικυῶνος 1938," *Praktika tis en Athenais Archaiologikis Etaireias*, pp. 120–123.

———. 1947. "Ἀνασκαφαὶ Σικυῶνος, 1941," *Praktika tis en Athenais Archaiologikis Etaireias 1941–1944*, pp. 56–60.

———, ed. 1977. "Κεφάλαιον Α' Ἀνασκαφαί—Ρόδος," *Ergon*, pp. 166–171, figs. 144–147.

Osborne, R. 2007. "Projecting Identities in the Greek Symposion," in *Material Identities*, ed. J. Sofaer, Malden, Mass., pp. 31–52.

———. 2014. "Intoxication and Sociality: The Symposium in the Ancient Greek World," *Past and Present* 222, Suppl. 9, pp. 34–60.

O'Sullivan, T. 2006. "The Mind in Motion: Walking and Metaphorical Travel in the Roman Villa," *Classical Philology* 101.2, pp. 133–152.

———. 2007. "Walking with Odysseus: The Portico Frame of the Odyssey Landscapes," *American Journal of Philology* 129, pp. 497–532.

———. 2011. *Walking in Roman Culture*, Cambridge.

Otto, W. F. 1965. *Dionysus: Myth and Cult*, trans. R. B. Palmer, Bloomington.

Padel, R. 1992. *In and Out of the Mind: Greek Images of the Tragic Self*, Princeton.

Padgett, J. M. 2003. *The Centaurs' Smile: The Human Animal in Early Greek Art*, Princeton.

Pailler, J.-M. 2009. "Une mer vraiment dionysiaque," *Pallas* 81, pp. 191–200.

Panagiotopoulou, A. 1994. "Representations de la Meduse dans les mosaïques de Grèce," in *IV Coloquio Internacional Sobre Mosaico Antiguo: Palencia-Mérida, Octubre 1990*, Palencia-Mérida, pp. 369–382.

Papadopoulos, M., and P. Markoulaki. 2013–2014. "Dionysus' Watercraft in Cult and in Art," *Journal of Hellenic Religion* 7, pp. 31–44.

Parke, H. W. 1977. *Festivals of the Athenians*, London.

Payne, H. G. G. 1931. "Archaeology in Greece, 1930–1931," *Journal of Hellenic Studies* 51.2, pp. 183–210.

Pellizzer, E. 1990. "Outlines of a Morphology of Sympotic Entertainment," in *Sympotica: A Symposium on the* Symposion, ed. O. Murray, Oxford, pp. 177–184.

Peponi, A.-E. 2007. "Sparta's Prima Ballerina: 'Choreia' in Alcman's Second 'Partheneion' (3 'PMGF')," *Classical Quarterly* 57.2, pp. 351–362.

Petrakos, V. 1961–1962. "Eretria," *Archaiologikon Deltion* 17, p. 152, fig. 166:α–β.

Petridou, G. 2015. *Divine Epiphany in Greek Literature and Culture*, Oxford.

Petsas, P. 1978. *Pella: Alexander the Great's Capital*, Thessaloniki.

Pfrommer, M. 1987. *Studien zu alexandrinischen und grossgriechischen Toreutik frühhellenistischer Zeit*, Berlin.

Picard, C. 1963. "Le mosaïste grec Gnôsis et les nouvelles Chasses de Pella," *Revue archéologique*, pp. 205–209.

Piettre, R. 1996. "Le dauphin comme hybride dans l'univers dionysiaque," *Uranie* 6, pp. 7–36.

Platt, V. 2011. *Facing the Gods: Epiphany and Representation in Graeco-Roman Art, Literature, and Religion*, Cambridge.

———. 2016. "Sight and the Gods: On the Desire to See Naked Nymphs," in *Sight and the Ancient Senses*, ed. M. Squire, London and New York, pp. 161–179.

Podzuweit, C., and D. Salzmann. 1977. "Ein mykenischer Kieselmosaikfussboden aus Tiryns," *Archäologischer Anzeiger*, pp. 123–137.

Pollitt, J. J. 1986. *Art in the Hellenistic Age*, Cambridge.

Porteous, J. D. 1990. *Landscapes of the Mind: Worlds of Sense and Metaphor*, Toronto.

Praschniker, C. 1922–1924. "Muzakhia und Malakastra," *Jahreshefte der Österreichischen archäologischen Instituts in Wien, Beiblatt* 21–22, pp. 5–224.

Prier, R. A. 1989. *Thauma Idesthai: The Phenomenology of Sight and Appearance in Archaic Greek*, Tallahassee.

Rabinowitz, A. 2009. "Drinking from the Same Cup: Sparta and Late Archaic Commensality," in *Sparta: Comparative Approaches*, ed. S. Hodkinson, Swansea, pp. 113–191.

Rangabé, M. 1852. *Mémoire sur la partie méridionale de l'île d'Eubée*, Paris.

Rathje, A. 1990. "The Homeric Banquet in Central Italy," in *Sympotica: A Symposium on the Symposion*, ed. O. Murray, Oxford, pp. 279–288.

Reber, K. 1989. "Zur architektonischen Gestaltung der Andrones in den Häusern von Eretria," *Antike Kunst* 32, pp. 3–7.

Redfield, J. 1985. "Herodotus the Tourist," *Classical Philology* 80.2, pp. 97–118.

Reusser, C. 2002. *Vasen für Etrurien: Verbreitung und Funktionen attischer Keramik im Etrurien des 6. und 5. Jahrhunderts vor Christus*, 2 vols., Zurich.

Rice, E. E. 1983. *The Grand Procession of Ptolemy Philadelphus*, Oxford.

Ricoeur, P. 1977. *The Rule of Metaphor: Multi-Disciplinary Studies of the Creation of Meaning in Language*, trans. R. Czerny, Toronto.

Ridgway, B. S. 2000. "The Sperlonga Sculptures: The Current State of Research," in *From Pergamon to Sperlonga: Culture and Context*, ed. N. T. de Grummond and B. S. Ridgway, Berkeley, pp. 78–91.

Robertson, M. 1939. "Archaeology in Greece, 1938–39," *Journal of Hellenic Studies* 59.2, pp. 189–209.

———. 1965. "Greek Mosaics," *Journal of Hellenic Studies* 85, pp. 72–89.

———. 1967. "Greek Mosaics: A Postscript," *Journal of Hellenic Studies* 87, pp. 133–136.

———. 1975. *A History of Greek Art*, Cambridge.

————. 1982. "Early Greek Mosaic," in *Macedonia and Greece in Late Classical and Early Hellenistic Times*, ed. B. Barr-Sharrar and E. N. Borza, Washington, D.C., pp. 241–249.

Robinson, B. 2011. *Histories of Peirene: A Corinthian Fountain in Three Millennia* (Ancient Art and Architecture in Context 2), Princeton.

Robinson, D. M. 1932. "Mosaics from Olynthos," *American Journal of Archaeology* 36.1, pp. 16–24.

————.1934. "The Villa of Good Fortune at Olynthos," *American Journal of Archaeology* 38.4, pp. 501–510.

————.1946. "The Wheel of Fortune," *Classical Philology* 41.4, pp. 207–216.

Romm, J. 1989. "Herodotus and Mythic Geography: The Case of the Hyperboreans," *Transactions of the American Philological Association* 119, pp. 97–113.

————. 1992. *The Edges of the Earth in Ancient Thought: Geography, Exploration, and Fiction*, Princeton.

Rotroff, S. 1996. "The Missing Krater and the Hellenistic Symposium: Drinking in the Age of Alexander the Great," Broadhead Classical Lecture 7, University of Canterbury, New Zealand.

Ruffell, I. 2000. "The World Turned Upside Down: Utopia and Utopianism in the Fragments of Old Comedy," in *The Rivals of Aristophanes: Studies in Athenian Old Comedy*, ed. D. Harvey and J. Wilkins, London, pp. 473–506.

Rusten, J., ed. 2011. *The Birth of Comedy: Texts, Documents, and Art from Athenian Comic Competitions, 486–280*, Baltimore.

Rutherford, I. 1998. "Theoria as Theatre: Pilgrimage in Greek Drama," *Proceedings of the Leeds Latin Seminar* 10, pp. 131–156.

————. 2000. "Theoria and Darsan: Pilgrimage and Vision in Greece and India," *Classical Quarterly*, n.s., 50.1, pp. 133–146.

Salmond, A. 1982. "Theoretical Landscapes: On Cross-Cultural Conceptions of Knowledge," in *Semantic Anthropology*, ed. D. Parkin, London, pp. 65–87.

Salzmann, D. 1979. "Ein wiedergewonnenes Kieselmosaik aus Sikyon," *Archäologischer Anzeiger* 94.2, pp. 290–306.

————.1982. *Untersuchungen zu den antiken Kieselmosaiken von den Anfängen bis zum Beginn der Tesseratechnik*, Berlin.

Saunders, T. J. 2001. "Dicaearchus' Historical Anthropology," in *Dicaearchus of Messana: Text, Translation, and Discussion*, ed. W. W. Fortenbaugh and E. Schütrumpf, New Brunswick, N.J., pp. 237–254.

Schauenburg, K. 1970. "Zu attisch-schwarzfiguren Schalen mit Innen Friesen," *Antike Kunst, Beiheft* 7, pp. 33–40.

Schefold, K. 1934. *Untersuchungen zu den Kertscher Vasen*, Berlin.

Scheibelreiter-Gail, V. Forthcoming. "Mosaiken in Aigeira," in *Aigeira II. Forschungen im öffentlichen Zentrum von Aigeira in hellenistischer und römischer Zeit (2011–2015)*, ed. W. Gauss, Vienna.

Schils, G. 1993. "Plato's Myth of Er: The Light and the Spindle," *L'antiquité classique* 62, pp. 101–114.

Schmitt, P., and A. Schnapp. 1982. "Image et société en Grèce ancienne: Les représentations de la chasse et du banquet," *Revue archéologique*, pp. 57–74.

Schmitt-Pantel, P. 1990. "Sacrificial Meal and *Symposion:* Two Models of Civic Institutions in the Archaic City?" in *Sympotica: A Symposium on the* Symposion, ed. O. Murray, Oxford, pp. 14–33.

———. 1992. *La cité au banquet: Histoire des repas publics dans les cités grecques* (Collection de l'École française de Rome 157), Paris.

Schwarzmaier, A. 2008. "Dionysos, der Maskingott: Kultszenen und Theaterbilder," in *Dionysos: Verwandlung und Ekstase*, ed. R. Schlesier and A. Schwarzmaier, Berlin, pp. 80–93.

Seaford, R. 2006. *Dionysos*, London.

———, trans. [1996] 2015. *Euripides:* Bacchae, Oxford.

Segal, C. 1986. *Pindar's Mythmaking: The Fourth Pythian Ode*, Princeton.

Seyer, M. 2007. *Der Herrscher des Jäger*, Vienna.

Shapiro, H. A. 1993. *Personifications in Greek Art: The Representation of Abstract Concepts, 600–400 B.C.*, Zurich.

———. 1994. *Myth into Art: Poet and Painter in Classical Greece*, London.

Shear, T. L. 1973. "The Athenian Agora: Excavations of 1971," *Hesperia* 42.2, pp. 121–179.

Shipley, G. 2011. *Pseudo-Skylax's Periplous: The Circumnavigation of the Inhabited World*, Bristol.

Shorey, P., trans. 1930. *Plato:* The Republic 1, London.

Simon, E. 1955. "Ixion und die Schlangen," *Jahreshefte des Österreichischen archäologischen Instituts in Wien* 42, pp. 5–26.

———. 1969. *Die Götter der Griechen*, Munich.

———. 1976. *Die griechischen Vasen*, Munich.

———. 1983. *Festivals of Attica: An Archaeological Commentary*, Madison.

Simonsen, K. 2005. "Bodies, Sensations, Space, and Time: The Contribution from Henri Lefebvre," *Geografiska Annaler*, Series B 87.1, pp. 1–14.

Slater, W. 1976. "Symposium at Sea," *Harvard Studies in Classical Philology* 80, pp. 161–170.

Slatkin, L. M. 2003. "Measuring Authority, Authoritative Measures: Hesiod's *Works and Days*," in *The Moral Authority of Nature*, ed. L. Daston and F. Vidal, Chicago, pp. 25–49.

Small, D. 1991. "Initial Study of the Structure of Women's Seclusion in the Archaeological Past," in *The Archaeology of Gender: Proceedings of the 22nd Annual Chacmool Conference*, ed. D. Walde and N. D. Willows, Calgary, pp. 336–342.

Soja, E. 1996. *Thirdspace: Journeys to Los Angeles and Other Real-and-Imagined Places*, Cambridge, Mass.

Sourvinou-Inwood, C. 2003. *Tragedy and Athenian Religion*, Lanham, Md.

―――.2005. *Hylas, the Nymphs, Dionysos, and Others: Myth, Ritual, Ethnicity*, Stockholm.

Squire, M. 2016. "Introductory Reflections: Making Sense of Ancient Sight," in *Sight and the Ancient Senses*, ed. M. Squire, London, pp. 1–35.

Stehle, E. 1997. *Performance and Gender in Ancient Greece*, Princeton.

Steinhart, M. 1995. *Das Motiv des Auges in der griechischen Bildkunst*, Mainz.

Steinmeyer-Schareika, A. 1978. *Das Nilmosaik von Palestrina und eine ptolemäische Expedition nach Äthiopien*, Bonn.

Stephani, L. 1864. "Der Greif," *Compte-rendu de la Commission impériale archéologique*, St. Pétersbourg, pp. 50–141.

Stewart, A. 1977. "To Entertain an Emperor: Sperlonga, Laokoon, and Tiberius at the Dinner-Table," *Journal of Roman Studies* 67, pp. 76–90.

―――.2014. *Art in the Hellenistic World*, Cambridge.

Stigen, A. 1961. "On the Alleged Primacy of Sight—with Some Remarks on *Theoria* and *Praxis*—in Aristotle," *Symbolae osloenses* 37.1, pp. 15–44.

Strootman, R. 2014. *Courts and Elites in the Hellenistic Empires: The Near East after the Achaemenids, c. 330 to 30 BCE*, Edinburgh.

Svarlien, D. A., trans. 1990. *Pindar: Odes*, The Annenberg CPB/Project: http://www.perseus.tufts.edu/hopper/text?doc=urn:cts:greekLit:tlg0033.tlg002.perseus-eng1:2 (accessed January 11, 2016).

Tavenner, E. 1933. "Iynx and Rhombus," *Transactions of the American Philological Association* 64, pp. 109–127.

Thalmann, W. G. 2011. *Apollonius of Rhodes and the Spaces of Hellenism*, New York.

Themelis, P. 1970a. "Ἀρχαιότητες καὶ μνημεῖα Εὐβοίας," *Archaeologikon Deltion* 25.B.1, pp. 247–255.

―――.1970b. "Μοσαϊκὸν δάπεδον ἐξ Ἐρετρίας," *Athens Annals of Archaeology* 3, pp. 35–37.

―――.1979. "Σκύλλα Ἐρετρική," *Archaiologike Ephemeris*, pp. 118–153.

Thompson, D. J. 2000. "Philadelphus' Procession: Dynastic Power in a Mediterranean Context," in *Politics, Administration, and Society in the Hellenistic and Roman World*, ed. L. Mooren, Leuven, pp. 367–388.

Thompson, H. A. 1966. "Activity in the Athenian Agora 1960–1965," *Hesperia* 35, pp. 37–54.

Thureau-Dangin, F., A. Barrois, G. Dossin, and M. Dunand. 1931. *Arslan-Tash*, Paris.

Thureau-Dangin, F., and M. Dunand. 1936. *Til Barsib* (Bibliothèque archéologique et historique 23), Paris.

Tilley, C. 1994. *The Phenomenology of Landscape*, Oxford.

―――.1999. *Metaphor and Material Culture*, Malden, Mass.

Tölle-Kastenbein, R. 1964. *Frühgriechische Reigentänze*, Waldsassen.

Topper, K. 2009. "Primitive Life and the Construction of the Sympotic Past in Athenian Vase Painting," *American Journal of Archaeology* 113.1, pp. 3–26.

―――.2012. *The Imagery of the Athenian Symposium*, Cambridge.

Touchais, G. 1977. "Chronique des fouilles et découvertes archéologiques en Grèce en 1976," *Bulletin de correspondence hellénique* 101.2, pp. 513–666.

Tsakirgis, B. 2005. "Living and Working around the Athenian Agora: A Preliminary Case Study of Three Houses," in *Ancient Greek Houses and Households: Chronological, Regional, and Social Diversity*, ed. B. A. Ault and L. C. Nevett, Philadelphia, pp. 67–82.

———. 2016. "What Is a House? Conceptualizing the Greek House," in *Houses of Ill Repute: The Archaeology of Brothels, Houses, and Taverns in the Greek World*, ed. A. Glazebrook and B. Tsakirgis, Philadelphia, pp. 13–35.

Tsibidis-Pentazos, E. 1974. "ΞΡΑΚΗ Μαρώνεια," *Ergon* 59, pp. 58–61.

———. 1977. "Ἀνασκαφή Μαρωνείας," *Praktika tis en Athenais Archaiologikis Etaireias*, pp. 83–86.

Ulisse 1996 = *Ulisse: Il mito e la memoria*, Catalogue of an exhibition held in Rome, Palazzo delle Esposizioni, February 22–September 2, 1996, Rome 1996.

Van Noorden, H. 2015. *Playing Hesiod: The "Myth of Races" in Classical Antiquity*, Cambridge.

Verity, A., trans. 2002. *Theocritus: Idylls*, Oxford.

Vernant, J.-P. 1983. *Myth and Thought among the Greeks*, London.

Versnel, H. S. 1970. *Triumphus: An Inquiry into the Origin, Development, and Meaning of the Roman Triumph*, Leiden.

———. 1987. "What Did Ancient Man See When He Saw a God? Some Reflections on Greco-Roman Epiphany," in *Effigies Dei: Essays on the History of Religions*, ed. C. van der Plas, Leiden, pp. 42–55.

Villard, P. 1992. "Boire seul dans l'antiquité grecque," in *Sociabilité à table: Commensalité et convivialité à travers les âges*, ed. M. Aurelle, O. Dumoulin, and F. Thelamon, Mont-Saint-Aignan, pp. 77–81.

Von Bothmer, D. 1972. "Greek Vase Painting: An Introduction," *Bulletin of the Metropolitan Museum of Art* 31.1, pp. 3–9.

Von Lorentz, F. 1937. "Barbaron hyphasmata," *Mitteilungen des Deutschen Archäologischen Instituts, Römische Abteilung* 52, pp. 165–222.

Votsis, K. 1976. "Nouvelle mosaïque de Sicyone," *Bulletin de correspondance hellénique* 100, pp. 575–588.

Walker, S. 1983. "Women and Housing in Classical Greece," in *Images of Women in Classical Antiquity*, ed. A. Cameron and A. Khurt, London, pp. 81–91.

Wallis, C. G., trans. [1939] 1991. *Kepler:* Epitome of Copernican Astronomy and Harmonies of the World, repr. Amherst, N.Y.

Walter, O. 1943. "Archäologische Funde in Griechenland vom Herbst 1941 bis Herbst 1942," *Archäologischer Anzeiger*, pp. 289–339.

Walter-Karydi, E. 1988. *The Greek House: The Rise of Noble Houses in Late Classical Times*, Athens.

Wecowski, M. 2002. "Towards a Definition of the Symposion," in *ΕΥΕΡΓΕΣΙΑΣ XΑPIN: Studies Presented to Benedetto Bravo and Eva Wipszycka by Their Disciples*, ed. T. Derda, J. Urbanik, and M. Wecowski, Warsaw, pp. 337–361.

———. 2014. *The Rise of the Greek Aristocratic Banquet*, Oxford.

West, M. L. 1992. *Iambi et elegi graeci ante Alexandrum cantati 2: Callinus, Mimnermus, Semonides, Solon, Tyrtaeus, Minora, Adespota*, Oxford.

Westgate, R. 1997–1998. "Greek Mosaics in Their Architectural and Social Context," *Bulletin of the Institute of Classical Studies of the University of London* 42, pp. 93–115.

———. 2002. "Hellenistic Mosaics," in *The Hellenistic World: New Perspectives*, ed. D. Ogden, London, pp. 221–251.

———. 2010. "Interior Decoration in Hellenistic Houses: Context, Function, and Meaning," in *Städtisches Wohnen im östlichen Mittelmeerraum, 4 Jh. v. Chr.–1 Jh. n. Chr.: Akten des Internationalen Kolloquiums vom 24.–27. Oktober 2007 an der Österreichischen Akademie der Wissenschaften* (Archäologische Forschungen 18), ed. S. Ladstätter and V. Scheibelreiter, Vienna, pp. 497–528.

———. 2011. "Party Animals: The Imagery of Status, Power, and Masculinity in Greek Mosaics," in *Sociable Man*, ed. S. D. Lambert, Swansea, pp. 291–322.

———. 2015. "Space and Social Complexity in Greece from the Early Iron Age to the Classical Period," *Hesperia* 84.1, pp. 47–95.

White, M. J. 1980. "Aristotle's Concept of Θεωρία and the ᾿Ενέργια-Κίνησις Distinction," *Journal of the History of Philosophy* 18.3, pp. 253–263.

Whitehouse, H. 1976. *The Dal Pozzo Copies of the Palestrina Mosaic* (British Archaeological Reports, International Series 12), Oxford.

Williams, C. K., II, and J. E. Fisher. 1976. "Corinth, 1975: Forum Southwest," *Hesperia* 45.2, pp. 99–162.

Worman, N. 2015. *Landscape and the Spaces of Metaphor in Ancient Literary Theory and Criticism*, Cambridge.

Yatromanolakis, D. 2009. "Symposia, Noses, Πρόσωπα: A Kylix in the Company of Banqueters on the Ground," in *An Archaeology of Representations: Ancient Greek Vase-Painting and Contemporary Methodologies*, ed. D. Yatromanolakis, Athens, pp. 414–464.

Young, R. S. 1965. "Early Mosaics at Gordion," *Expedition* 7.3, pp. 4–13.

Ziskowski, A. 2014. "Bellerophon in Corinthian History and Art," *Hesperia* 83, pp. 81–102.

Index